Studio Art Therapy

of related interest

Spirituality and Art Therapy
Living the Connection
Edited by Mimi Farrelly-Hansen
ISBN 978 1 85302 952 3

The Artist as Therapist
Arthur Robbins
ISBN 978 1 85302 907 3

A Multi-Modal Approach to Creative Art Therapy
Arthur Robbins
ISBN 978 1 85302 262 3

Medical Art Therapy with Children
Edited by Cathy Malchiodi
ISBN 978 1 85302 677 5

Contemporary Art Therapy with Adolescents
Shirley Riley
ISBN 978 1 85302 637 9

Art-Based Research
Shaun McNiff
ISBN 978 1 85302 621 8

Principles and Practice of Expressive Arts Therapy
Toward a Therapeutic Aesthetics
Paolo J. Knill, Ellen G. Levine and Stephen K. Levine
ISBN 978 1 84310 039 3

Inner Journeying Through Art-Journaling
Learning to See and Record your Life as a Work of Art
Marianne Hieb
ISBN 978 1 84310 794 1

Studio Art Therapy
Cultivating the Artist Identity in the Art Therapist

Catherine Hyland Moon

Foreword by Mildred Lachman-Chapin

Jessica Kingsley Publishers
London and Philadelphia

First published in the United Kingdom in 2002
by Jessica Kingsley Publishers
116 Pentonville Road
London N1 9JB, UK
and
400 Market Street, Suite 400
Philadelphia, PA 19106, USA

www.jkp.com

Library of Congress Cataloging in Publication Data
A CIP catalog record for this book is available from the Library of Congress

British Library Cataloguing in Publication Data
A CIP catalogue record for this book is available from the British Library

ISBN 978 1 85302 814 4

Contents

Foreword

This is a time of the interdisciplinary. Boundaries of each of the sciences and arts have become permeable as it becomes clear there are fruitful insights that can come from working with two or more fields together. They cross-fertilize each other. I did my undergraduate work in economics, but I was also interested in psychology. I wondered why economists didn't delve into the psychological processes by which people act to make significant economic decisions. And why not add the insights of cultural anthropology as well? This is beginning to happen now, to everyone's enrichment.

The profession of art therapy is such a combination: the artist joins with the mental health professional, becoming the art therapist. This new profession, roughly six decades old, has blossomed, growing in size and use by the public, with many graduate training programs throughout the country, and many graduates out there doing very fine work. The basic principle here is that art (visual art in this case) can provide a way to reach people in their deepest areas of self: their creative drive and their "desire."

To be competent to work alongside the established helping professions, such as counseling, social work, psychology, and psychiatry, training in art therapy was designed to develop the necessary clinical therapeutic skills. However, art therapists were adding something unlike what other disciplines were providing: experience and training as artists.

That the use of the arts can be helpful – if not also sometimes healing – is now widely accepted by many artists, art educators, and healthcare professionals. What needs now to be articulated are the special gifts art therapists, as artists, bring to clinical practice. Lest our contributions be considered solely in terms of techniques, both in treatment and assessment, the time has come to broaden the horizon of what art therapists can do, how art therapy can work, and what more can be offered by the profession. In order

to do this, the definition of art therapists working as artists needs to be defined.

Cathy Moon has done this in her book. Our field has needed it. She has, for the first time I believe, seriously probed for definitions of the artist self in relation to work done with clients, and to consider the problems and particulars of such a relationship. Happily, this is not "clinical" writing. She is not out to prove or convince through data. She convinces through showing, as the best writing does – showing here what happens with her clients and herself (hardly "case histories"). She relates her own rich inner experiences and thoughts about these interactions. She tells stories, and she tells them well. Her long training and experience give her the requisite therapy skills to perform as a healthcare professional even as she chooses to work more directly through artistic means.

One thread of my thinking as I read this book was: how does this differ from what other highly skilled therapists do, or for that matter what artists or art educators untrained as therapists can do? I have witnessed and experienced both therapists and art teachers who bring to their clients the kind of acute sensitivity and empathic response that Cathy does. But these are the rare and gifted ones who go beyond their specialized training. Verbal therapists might use art in their practices, but this is not the same as the art-based model the author describes. Art educators do start with art, but rarely focus on the inter-personal in the way a trained therapist would.

The two basic tenets of the author's approach are aesthetics and the relationship between client and therapist. They must, she holds, be used together. Artists and art educators know about aesthetics; healthcare professionals know about working with their relationships with clients. But Cathy Moon shows that, in being aware of both together, the art therapist works in a special way. She calls her method a "relational aesthetic."

It begins with her acknowledging the aesthetic side of herself, defining it in terms of her body senses, her awareness of sights, sounds, smells, touch. As they combine and are sharpened by her giving credence to what they tell her, she senses the "poetry" of what is happening around her and in her. Opening to the power (sometimes overpowering) of these poetic antennae, she can produce her own artwork and invite the client to do the same. Faced with the stranger who comes to her for help, she can acknowledge the poetic and artistic visions of this person. As she says, an art-based

model of art therapy highly values the artistic identity in both the therapist and the client. It is at the crossroads of the artistic vision of both client and therapist that the relationship bears fruit.

What is this thing that everyone is credited with having, something that Cathy Moon calls "artistic vision?" Dave Hickey, an art critic, calls it "desire" in its French sense of deep personal longing; Wallace Stevens, a poet, calls it the life of the imagination; Winnicott, a psychoanalyst, calls it the transitional space that is the primary experience of the infant in turning one thing into another, making a metaphor (without which ability, he says, sane adjustment to the world can not happen). Artistic vision is, as we see it, an attribute of being human that does not necessarily manifest itself in an art product. It becomes the mechanism to find the repository of ultimate personal truth – something barely articulated by most of us. But when personal pain is experienced, it is here that the therapist and client search. Meaning is what they try to find, plus a way of manifesting this unique and personal meaning in the world through their own creativity. And it is here that both client and therapist, making or using the arts, seek for an approximation of personal meaning. While most other therapists, using primarily verbal means and rational, conscious dialogue, are on the same quest, the approach of the artist to the "artistic vision" is direct, going where the pain is, where the creative drive is, and using the poetry of the arts as the basis for dialogue.

While this has been more or less the basic premise of the field, the author has added to it in several ways. She has made it the governing principle of her practice, making for subtle but pervasive differences in the way she works. Through beautifully written accounts of interactions with clients (and people in her own life) we live with these persons as we would in a play or novel, getting inside them as we observe through her. She speaks of this multisensory observation – or aesthetic attunement – as if she were watching performance art. That is, the very behavior of clients (as well as the art they produce) become art experiences that she, as an artist, responds to as a fully aesthetic experience. She trains her students to do this as well, reproducing in the book some of their attempts to write about what they experience in this heightened way. It helps when she gives concrete examples, which she does throughout the book.

Another significant addition she has made is to explore how she contributes her own art making to the therapeutic process. While I and others have been working this way and writing about it for some time, she expands on the practice, analyzes many aspects of it, recounts stories about her clients, and, most significantly for the thesis of the book, provides one important example of how the art therapist can function as an artist. The crossroads of artistic vision between client and therapist can be seen here, as the client can identify with the person of the therapist who searches to express personal meaning, some "desire," in her own art. They become partners. The therapist is no longer the expert doing something to or for the client.

As I have experienced it, many art therapists avoid this unorthodox way of working, deeming it somewhat dangerous – that is too intimidating for the client, too narcissistic in its therapist focus and detracting from the clarity of attention to the client. This is where clinical experience and judgment come into play, and why the graduate training to become an art therapist is long and demanding.

Her approach is holistic in many ways. First, she responds aesthetically to all aspects of clients – as if they themselves were artworks before her. Second, as she engages all her senses, she must engage somehow with all the arts. There are now expressive art therapies disciplines in all art fields: visual arts, music, drama, dance, poetry, and prose writing. Using them all as needed becomes part of her way of working, as it does now for many practitioners.

She uses the word "poetic" often, giving it broad meaning as a way of accessing the imaginative, paradoxical, "lying" world that is "real" to the client. In speaking of the verbal interaction that takes place with the client, she suggests that words themselves be "multilingual," that they be couched in the metaphorical richness of poetic speech so as to better access the client's inner world. This suggestion is given in the context of discussing the artwork produced. It is a far cry from "interpreting artwork," a crude technique of beginnings in the field.

This is a passionate book.

There is the passion to re-envision how the profession can expand as the unique sensibilities and skills of the artist are seamlessly incorporated into the identity of the art therapist. As if she were in the process of

producing an artwork herself, she examines how she works with clients. She delves, she asks herself questions, she welcomes the input of all her senses as she observes, she plays by trying out this and that, she allows the not-knowing of the artistic process rather than engaging in more "scientific" categorizing, she unburdens herself by doing something (making marks, forming clay) in hopes of coming close to that elusive meaning that pushes to be let out. At the same time she is at one with the discipline of materials, and the framework of time and space, and the relationship to the client. She teaches the client how to do this. She becomes the client's model.

There is a passion to find meaning in her client's life as well as in her own. She wants to share this. She believes that her passion for the arts has some "poetic" goal even while the disciplines and limits of the concrete world — materials, payments, outcome, cost-benefit and profits, career successes — are ever present too.

She wants her passion to show in her writing of this book as well. It is a testament to her own thesis: she writes artistically from the fullness of her belief in her artist self, which speaks for what is the best she has to offer.

Argue with her ideas if you will. But the integrity and, yes, the beauty of this book stand before you as does any song, poem, play, painting.

It is a passionate and wise offering.

Mildred Lachman-Chapin
Sedona, AZ, 2001

Acknowledgments

As I have worked my way through the writing of this text, I have thought about whom I might include in my acknowledgments. Despite having thought a great deal about it, I know whatever I write will be inadequate. Inevitably, I will leave out people who have been instrumental in shaping my thinking and supporting my work. Having written this text, I am firmly convinced that one person does not write a book. I may have been the scribe, but I've had a whole slew of people who have helped along the way, doing everything from radically shaping my thinking to cooking a nourishing meal in order to fuel my writing in a practical way.

These are some of the people I would like to thank.

First, I would like to thank the clients whose stories are told in this text, and the many clients I have worked with whose stories are not directly told. They have been my most important teachers, not just about art therapy but also about life. I have met, in the treatment context, some of the most authentic, honest, caring, and courageous human beings. Among them, I would specifically like to thank Ann Zeller. Her consultation, via e-mail, was invaluable in helping me understand a client's perspective of art therapy and helped to shape the book.

I am also indebted to many colleagues. Among them are many of the staff members at Harding Hospital in Worthington, Ohio. After having been exposed to many other treatment settings through my own experiences and through the supervision of students and professionals, I realize what a top-notch, caring, and professional staff they were. I feel fortunate to have done my growing up as a therapist among them. In particular, I would like to thank Don Jones, my mentor in art therapy, who taught me by example what it means to practice a studio approach to art therapy.

Within the world of art therapy there are many people who have influenced and inspired me. In particular, I would like to thank Lori Vance, Michael Franklin, and Randy Vick. They have been my art therapy "buddies" as well as professionals for whom I have the greatest respect. Randy, along with Lynn Kapitan, and Karen Blomain read through an earlier version of the manuscript. I am grateful for their honest, thoughtful, and sometimes challenging feedback. The book is a much better one for having passed by their eyes. I would like to thank Millie Lachman-Chapin for writing the Foreword to the book and for being a support and an inspiration. I would also like to acknowledge my dear friend and sister in art therapy, Debra DeBrular. Deb is now deceased, but her spirit is still very much alive in me. I think she was an angel on my shoulder during the writing of this text, urging me on and inspiring me just as she always did when she was alive.

Last, I am grateful for the love and support of my family. Bruce, my art therapy colleague, friend, and husband contributed everything along the continuum of book-writing support, from challenging my thinking to cooking and cleaning at times when I was a slave to my computer. My children, Jesse and Brea, tolerated my unavailability at times and pulled me away from the work at other times. I needed both. I am grateful to my parents who, for some reason, were fully supportive of my crazy decision at age 18 to study art in college, in spite of its utter impracticality. And finally, I want to thank my mom for believing in me. That has made all the difference.

Author's Notes

The stories in this book about my work with clients came from my more than twenty years of experiences as an art therapist in four different settings. The accounts are written in the style of creative nonfiction, rather than clinical case histories. Therefore, detailed descriptions of the context for the work are not always given. I include brief explanations of the contexts here in order to help orient the reader.

For sixteen years, I worked at a private psychiatric hospital. My first position there was as an activity therapist for the adult day treatment program. I facilitated art therapy groups, but also led physical conditioning sessions, worked in the garden, drove the bus, played volleyball, and engaged in an assortment of other activities with the clients.

The second position I had was at the same hospital but in the inpatient setting and included some work done with clients post-discharge. There my job was exclusively focused on art therapy. I again worked primarily with adults but also did some work with adolescents and children, both in individual and group sessions. The hospital was based on a milieu approach to treatment, meaning that every aspect of the clients' environment was considered part of the therapy. Thus, all activities, including art therapy, were viewed as prescribed treatment. Sometimes clients received an art assessment at the onset of treatment, a one-hour session designed to gain an empathic sense of their strengths and concerns. Most of my time, however, was spent doing two types of groups, one called Studio Art Therapy and the other called Expressive Art. The Studio group was set up like an artists' studio, with each person working on their own piece and focused on individual goals, which varied from person to person. The sharing that occurred among the artists was casual rather than structured. The Expressive Art group was a process-oriented group where there was more emphasis on group dynamics and the use of art to explore and express meaning. As my thinking about art therapy evolved, I began to see less of a distinction between the two kinds of groups. I gravitated more toward the studio model, but incorporated opportunities for clients to engage with each other in exploring the meaning of their work and in supporting one another.

When I left the hospital I started a private practice in art therapy. My personal studio and private practice space were one in the same, located at the back of an historic building in the center of the city. It was an unorthodox space for a private practice, since one had to walk through the nonprofit community art gallery at the front of the building to get to the studio. I had no waiting area or secretary. It was

much more like a studio than an office. My private practice clients consisted of children, adolescents, and adults.

At the same time, I was also doing contract work with an agency that provided services for children and their families. I worked as a mobile therapist, meaning I traveled to the clients' homes to see them, rather than expecting the clients to come to me. The child was the identified client, but the philosophy of the agency was to work with the entire family for the benefit of the child. The work I did as a mobile therapist gave me an entirely new view of treatment. I became the invited guest into people's homes and encountered the very real, often very chaotic, activities of their daily lives. This was a far different experience than working in the safe, contained environment of a hospital!

I identify the people who came to me for art therapy services as "clients." I don't really like the term. It sounds colder than the way I envision therapy relationships. However, it is the best term I have found. "Patients," while it seems more humane, also is sometimes perceived as connected to the medical model, where the individual is in a helpless position and the professional is the expert. "Consumers," a more current term, seems to suggest a mere business relationship. The term I would prefer is "people I work with" or "people I work for." However, I feared this would cause the obvious confusion, in that the reader might mistakenly interpret this to mean professional colleagues or supervisors. Thus, I use the word "client," a somewhat impersonal, but at least respectful, term. Perhaps a new word will evolve into use in time, one that reflects a respectful, caring, professional relationship. For now, I have to live with the inadequacies of our language.

The stories told in this text reflect real people and real situations. The names have all been changed and some details of the stories altered out of respect for clients' privacy.

A final note I would like to make concerns the art images contained in this book. There are no images of clients' artworks. In part, this is due to the fact that I have never been one to collect client work. I have always considered the work to be theirs, to do with as they wished. In cases where I had the opportunity to borrow the work in order to photograph it for inclusion in the book, I decided not to do so. My decision was based on three reasons. First, in no instance did it seem that including the image would strengthen or clarify the intentions of the book. Second, my impulse, if I included work at all, was to include work that would look good in the book. So I was suspect of my motives. Did I want to include clients' artwork as some kind of "evidence" that I was a good art therapist? I worried that this distorted motivation would affect the honesty of my writing, since I would have to shape the writing to fit the images I chose. My third, and primary reason, however, for not including client artwork is simply that I wanted the emphasis of the book to be on the artist identity of the art therapist.

Introduction

The process of a book's coming to life is not fully complete until your imagination meets mine on the page (Wells 1992, p.i)

I am fumbling around in my mind for a story to begin this book. I can't decide which one to tell. I make a couple of starts, then delete them from my computer screen. None of them seems right.

I think about the time I took a group of students to Don Jones's studio. He showed us paintings and shared his personal art history. I think of the day, many years ago, when I was working at the psychiatric hospital and called my vet, only to find out my dog had cancer. I didn't expect the news. It triggered a flood of tears, not just for my dog but also for my mother who was going through chemotherapy at that time. I think of the rope bridge Ryan, a 13-year-old client, made out of wood, twine, and clay. He took months to construct it, carefully cutting out each plank, stringing it together, so that it formed a rickety bridge over danger-filled waters. These are not the only stories; I think of others as well.

What I want is one riveting story. I want it to introduce succinctly the text that is to follow. Instead, multiple stories surface, bobbing up like buoys on the water. I wonder, are they there to mark boundaries, warn of danger?

When I hear from Sarah, a former client, after many years of having no contact, she reminds me of the day I found out my dog had cancer. She remembers it as one of the most meaningful days she had while she was in treatment, because she saw me, a staff member, cry.

When Ryan's parents pulled him out of treatment against my recommendation, his last communication to me before he walked out the door for the last time was to tap me on the shoulder and tell me he loved me.

The paintings Don showed us were a combination of work done in his personal studio and work done alongside clients, in the context of art therapy. There seems to be, for him, a seamless relationship between the two.

Maybe the boundary warnings have to do with crossing over therapeutic taboos. All the stories that keep bobbing up are those that play along the edge of what is or is not considered acceptable in therapy – crying, loving, making art, being vulnerable – all this with clients.

But this is what my art brings me to. It is constantly reminding me of my humanity. When I want a succinct, riveting story, it gives me bobbing boundary markers. Perhaps I will obey the warnings of these buoys, or maybe I will swim defiantly past them; I might decide to ignore them, or maybe just rearrange them as I see fit. Who knows? They are there as my guides. It's up to me to decide when they serve as a containing sanctuary and when they are an invitation to break through and explore new territory.

This book is an attempt to articulate an art-based theory and practice of art therapy. In some ways, the topic feels like familiar territory. My ideas about studio art therapy have been evolving over the years through my work with clients, my interactions with other artists and art therapists, and the reading I have done. At the same time, the topic feels like new territory to explore. It is one thing to understand something from a practice level, and quite another to try to articulate that understanding in a clear and organized fashion. That the focus is art, a complex and elusive topic, makes the challenge even greater.

The content of this book might be of interest to anyone who believes in or is drawn to the idea that the arts have therapeutic or healing potential. It is written, however, particularly with art therapists in mind. It is an attempt to articulate what, I suspect, many other art therapists understand at an

intuitive and practical level. It needs to be written, simply, so we can claim the knowledge, share it, and believe in it.

The profession of art therapy has its roots in the studio. Many of the individuals who played significant roles in the development of art therapy, both in the United States and in Britain, identified themselves as artists interested in using their art to help others (Junge and Asawa 1994). In the 1960s, art remained central to the shared visions of the founders of the professional art therapy organizations in both countries. Ault (1994) recalls that a common driving force among founders of the American Art Therapy Association was the "absolute belief in the value and importance of using art making and imagery in the treatment of patients" (p.252). He said there was an understanding that knowledge in psychology and clinical skills were also needed but that "the art was central to the process, not an adjunct technique" (p.252).

From these humble beginnings the profession has grown (and sometimes groaned!) over the years in its efforts to become recognized as valid among the other, more established, helping professions. Much of this struggle for recognition has been focused on defining the profession and establishing theoretical constructs for the practice of art therapy. The "borrowing" of theoretical material from other counseling or psychotherapy disciplines has been central to this process of self-definition. Elements from these complementary forms of therapy have been combined with or modified by the practice of using art making in therapy. In the early years of our profession, psychoanalytic and psychodynamic theory dominated (Kramer 1958; Naumburg 1950, 1953). Since that time, additional strands of thinking about the use of art in therapy have emerged: gestalt art therapy (Rhyne 1973a, 1973b), Jungian art therapy (Dougherty 1974; Edwards 1987; Keyes 1974; Wallace 1987), phenomenological art therapy (Betensky 1973), cognitive art therapy (Silver 1975, 1976, 1987), existential art therapy (B. Moon 1990), narrative art therapy (Riley and Malchiodi 1994), and others. The profession's search for identity has evolved through "trying on" the theories or philosophies of our older siblings in the therapeutic professions (Rubin 1987). Through this search for a good fit we have been able to discover what is suitable and what is not, and to develop an understanding of the unique aspects of an approach in which art making is an essential feature. The process of integrating compo-

nents of theory and practice from related disciplines has enriched our collective body of knowledge and sharpened our understanding of the different applications of art therapy.

An unfortunate, albeit predictable, side effect of this search for identity has sometimes been the denial of aspects of our core identity as a profession in order to fit in with the established and powerful majority, most often identified with the medical model. As the old saying goes, we have sometimes "thrown out the baby with the bath water." It is ironic but true that the aspect of our identities most often denied or compromised has been our sense of ourselves as artists. As McNiff (1998b) suggests, a shadow aspect of our creative collaborations with other disciplines is a lingering dependence by which we look to other professions for self- definition and justification (p.86). The irony, of course, is that our contribution as artists is the aspect of our professional identity that makes us unique among the other therapeutic professions. It is what we have to offer that is distinctive.

Most, if not all, art therapists have struggled to find firm footing in two worlds – that of art and that of therapeutic practice. Significant contributions to articulating the parallels between artistic and therapeutic processes have been made by Kramer's (1958, 1961, 1971) focus on art and sublimation, Robbins's (1980, 1987, 1989, and Robbins and Sibley 1976) object relations approach, Schaverien's (1992) analytic approach, and Lachman-Chapin's (1979, 1983a, 1985, 1987, 1993b) eclectic approach, among others.

We are yet a young profession, still engaged in the struggle to articulate and practice our particular art-based brand of expertise while resisting the lure to pattern ourselves after colleagues from psychology, counseling, or related fields (Allen 1992; Hall 1999; Wadeson 1983). Rubin's (1984) call for "the development of meaningful theoretical constructs from the matrix of art therapy itself" (p.190) has been echoed by other art therapists (Julliard and Van Den Heuvel 1999; Franklin 1996; Malchiodi 1999b; McNiff 1986b; Robbins 1992). The deepening of our understanding of art therapy occurs as we engage in thoughtful reflection about the ways we practice our profession, and will hopefully result in "theories that are less often borrowed and more often isomorphic with art" (Rubin 1994, p.254).

This text is an attempt to make a contribution toward such a theoretical base and to articulate the practical application of an art-based approach.

The term "studio art therapy" sometimes indicates nostalgia for a bygone era of art therapy practice, and at other times refers to a trendy, loosely defined approach in which being "artsy" is considered a sufficient basis for therapeutic work. This book is not written from either of these perspectives. Instead, it is an attempt to cull from art therapy's collective body of knowledge in combination with my years of experience as an art therapist, a model of art therapy wherein the products and processes of art constitute the core of the work rather than serving as the basis for theoretical adaptations from other disciplines.

At times, there has been a tendency to pit "studio" art therapy against "clinical" art therapy, as if they are mutually exclusive ways of working. Art therapists who embrace a studio approach (and in extreme cases eschew therapy altogether) may be reacting to the demands of managed care, the threat to identity that licensure in related fields sometimes poses (Wadeson 1999), and the "clinification syndrome" whereby the skills and characteristics of practitioners from other disciplines begin to supplant the specialized skills of the art therapists (Allen 1992). In this polarized conception, it is easy to identify clinical with an analytical, detached, or coolly dispassionate way of working and to associate the studio model with a spontaneous, passionate, or intuitive approach to therapeutic work that evidences little in the way of a theoretical basis.

Perhaps the solution, however, is not to eschew clinical practice but to develop an understanding of the specific and unique ways that clinical work is manifested in an art-based art therapy practice. By "clinical" I mean direct work with clients that addresses identified needs and is based on the use of specific skills and knowledge from within a particular field. Being clinical does not imply to me a dispassionate, analytical way of working, but rather an informed way of working. It is, in fact, quite possible to be a strong clinician who works from an art-based model of art therapy.

The term "studio art therapy" is at times used interchangeably with "art as therapy" or an "art-based approach to art therapy," terms that may very well have different meanings to different people. This is in part due to the fact that art therapists practice in diverse ways, and partly due to the fact that "what exactly the studio approach to art therapy is remains largely undefined" (Malchiodi 1995b). For the purposes of this book, a studio art therapy approach refers to an intentional, disciplined, art-based art therapy

practice. In such a practice, art remains central to all facets of the work, including: conceptual understandings; attempts to understand clients; creation of the therapeutic space; development of treatment methods; interactions with clients; and communications that occur in relation to the work. The artist aspect of our identity is neither downplayed nor venerated, but instead provides the constellating force that informs practice. It is the core from which we work. The methods, materials, and characteristics of the arts and the art-making process are the primary constituents of the theoretical and practical applications of studio art therapy.

This does not mean that studio art therapy occurs in a vacuum. It is both influenced and informed by theoretical perspectives from fields like psychology, medicine, sociology, anthropology, and biology. However, the tendency has been for art therapy not merely to interact with and be enriched by other perspectives but to be subsumed by them. This has resulted in art therapists who function as caseworkers, psychotherapists, social workers, child life specialists, or counselors while making use of the arts in their work.

The distinctions between using art as a tool or technique in one's practice of therapy and working from an art-based model of art therapy are critical for understanding the unique contributions of art to health and healing and for the development of a body of knowledge in our field. This is not to say that one way of practicing is better than the other, but rather that there are significant differences. In our efforts to understand these differences, our curiosity is an important ally, leading us to wonder, examine, reflect upon, and conduct research about our art-based practices.

My interest in writing about a studio art therapy model comes from my belief that the arts have something singular to offer to the therapeutic professions, something that distinguishes the arts therapies from related disciplines. If our field is to survive, it behooves us to develop and cultivate these unique contributions, for art remains art therapy's "only real excuse for existing as a separate discipline" (Ulman in Agell *et al.* 1981). If we are to continue in our commitment as a service profession to improving the quality of life for individuals and society at large, it makes sense that we not attempt merely to duplicate what is widely available through other disciplines, but instead focus on what we have to contribute as our specialty.

There are some who argue that a studio approach to art therapy is extinct, no more than a relic of a bygone era when therapists had the luxury of months, sometimes years, to work with clients. It is true that studio art therapy as practiced in long-term treatment settings, especially in inpatient psychiatric settings, is no longer a common scenario in today's healthcare market. The advent of managed care has led to decreased use of inpatient care, a decrease in lengths of stay, and an increased level of critical care needed for those who are hospitalized. It is difficult, if not impossible, to engage clients who do not normally make art in the creation of developed, authentic, emotionally invested artworks within the framework of short-term treatment. The art therapist cannot expect the normal incubation period for a work of art to be rushed along in order to fit the timeline of third-party payers.

This leads to a questioning of the current relevance of a studio art therapy approach. Our former ways of working as art therapists cannot simply be forced into the framework of today's reality. What is crucial, however, is that we refrain from making the assumption that since the old ways of doing studio art therapy are no longer practical, studio art therapy must be entirely obsolete. Though the literature is sparse in regard to the use of a studio approach in short-term settings, there are models that offer effective adaptations of studio concepts. Characteristics such as time for in-depth art making, openness of the environment, flexibility in approach, individual versus group focus, and directive versus nondirective approaches have all been addressed (Allen 1983; Deco 1998; Luzzatto 1997; McGraw 1995). In considering the adaptation of a studio art therapy approach to the current healthcare environment, it is helpful to ask two questions: What about studio art therapy remains relevant to the current reality? What new possibilities are opened up for studio art therapy within the present context?

In responding to the first question, I'd like to offer a story.

I know only his name, Andrew, and that he is eight years old. He is leaning against the nurses' station when I arrive at the children's inpatient unit. His hair is dark and tousled, his t-shirt wrinkled as if he slept in it the night before. When I introduce myself and tell him why I am there, he willingly follows me down the hall. As we walk, I

tell him a little about the art therapy assessment I am to do with him. One of the things I make sure he understands is that this is the one and only time he and I will meet. He seems to accept this easily, saying, "okay" in a quiet voice.

When we reach the room, I show him the art materials and tell him he can make anything he wants. He looks up momentarily, as if to make sure it is really okay for him to use the enticing array of clay, chalk, paper, paint, markers and other materials on the counter. I nod my head and smile slightly. He selects the oil pastels and works intently, his head bent low over his paper.

When he is finished, he tells me about his image. He says it is a picture of the horse race track where his parents worked when he was very small. He tells me they all lived in a house near the horse barn and he says he liked it there. His story is so pleasant, his demeanor so congenial, his looks so innocently arresting that I am not prepared for the stories that come next.

He makes three more pictures during the hour-long session. I give him some directions, but his pictures seem to bear little relationship to what I say. His first picture is of a sparsely furnished living room. About it he says, "My mom and dad got a divorce so I lived with my mom and my dad lived in another house. I went to the babysitter when my mom was at work. But one time my mom left me at the babysitters and she never came back to get me."

I wait for him to finish the story, but it dawns on me that he is finished. He means she *never* came back. My heart swells up in my chest. I think of my own young son and the mother in me aches for Andrew.

His next image is of the front of a barn, with a hayloft area that is bright yellow. He tells me how he and his sister went to live with his father after his mother left. He says, "Sometimes my dad would leave us with this man. He was supposed to take care of us but sometimes he would do bad things to my sister in the barn. I tried to stop him. I turned the lights on so he would stop." I feel my heart get heavier in my chest. Tears well up in my eyes but I fight them back.

The last picture Andrew draws is of a long counter with bar stools lined up against it. His final story is a short one. "One day my

dad took me to a bar and left me there. Just like my mom, he never came back."

By the time we are making our way back down the hall toward the children's unit, I feel as if I am having to drag myself along. My feet feel like cement, my heart seems to have settled in the pit of my stomach. I look at Andrew's small frame and marvel at how he can move at all, given all the heavy stories and images he carries with him.

When I leave the unit, I head across the hospital grounds. I sigh heavily as I walk, not at all sure I am ready for the adult outpatient art therapy group I am to lead. As I approach the building, I see that three people are already there waiting. We go inside and before long, the other four group members arrive as well. We sit in a circle. As is our custom, we begin the session by sharing the thoughts and feelings each of us brings to the group that day. I participate, as I always do, in this opening ritual.

It is a group that has been together for over a year. Their developmental level is such that I work at a relatively high level of transparency. But today, I don't know what to share. I don't want to burden them with my sorrow and sense of helplessness. I also am clear that I must keep confidential the things Andrew shared with me. Yet I know that I need to tell them something of the truth. They are very sensitive and perceptive. They will know something is bothering me and may imagine all sorts of catastrophes if I tell them nothing.

When it is my turn, I say, "I just came from doing an art assessment with a young boy. He told me some heartbreaking stories, more than any child should have to bear. I'm feeling sad and also kind of frustrated. I know I will never see him again and I wonder what good I have done him."

Karen's head shoots up from its normal position of chin to chest. A fragile-looking woman with her own heartbreaking childhood stories, Karen seldom makes eye contact. When she talks, her speech is normally soft and timid. Today is different. She looks directly at me and, in a clear, impassioned voice, says, "Don't you ever think the hour you had with that boy had no meaning. You gave him a chance to tell his story. I never had that chance."

I have never forgotten Karen's words. They remind me of how simple and yet how awesomely powerful is this work we do as art therapists. When I was so focused on the limitations, on what I could *not* do, she jolted me back to the recognition of what I was called to do, even in the most meager of circumstances. I think of this now as I consider what it is about a studio model of art therapy that remains relevant in the current healthcare marketplace.

It seems to me that studio art therapy's contribution relative to brief therapy is its potential for dramatic intensity. While the fast-paced, revolving door model of managed care is not suited to the slow incubation process necessary for deeply developed art works, it *is* suited for artistic expressions that "cut to the chase" in terms of critical issues. Along with the establishment of safety and stability, short-term therapy is concerned with the identification of critical issues for follow-up care. Art making offers a person a way to tell his or her story with a focused intensity that honors the original events upon which it is based, yet does not threaten the stability and integrity of the person telling the story. Like any effective short-term therapy, studio art therapy does not offer a "quick fix" but instead helps the client become aware of points of access to a healthier, richer, more deeply satisfying life.

The second question raised regarding the relevance of studio art therapy to today's healthcare market has to do with what new possibilities are opened up for art therapists in the current context. As the old maxim goes, "necessity is the mother of invention." This has been true in the field of art therapy as previously secure employment opportunities in hospitals and agencies funded by third-party payers have dissipated. As a result, the practice of art therapy has diversified. Out of necessity, art therapists have begun to create their own job scenarios and newly defined roles. When the panic this has inspired has been kept at bay, the creation of a more satisfying, more fulfilling, more passion-driven (rather than security-driven), and more effective practice of art therapy has been possible.

I have written about our potential as art therapists not merely to adapt to our circumstances, but to have a part in creating the situations within which we work (C. Moon 1997a). There are many art therapists who have taken advantage of the changing healthcare picture to re-vision their roles

as art therapists. Among other things, this has led to a renewed interest in collaboration with the art world.

I offer a description of my own current private practice as an example of such re-visioning. After making a long-distance move to another part of the country, I decided I wanted to establish an art therapy practice independent of managed care funding. I felt I had done my time in the managed care system and could no longer participate in a service profession that had become financially driven and lost its ethic of care. I also was interested in working in a space that resembled a studio more than an office. I wanted the space to be my ally in inviting clients to engage fully in art making. My problem was that it was cost prohibitive to build or rent such a space.

The idea for my solution came when I attended the membership meeting of a community-based, non-profit art gallery. An all-volunteer organization, it operated on a shoestring budget and a last-minute time schedule. The members at the meeting mentioned their longing for the days when a grant had paid for a part-time gallery coordinator. I went home and wrote up a proposal, indicating my willingness to put in a few hours a week as a gallery coordinator in exchange for the use of the room behind the gallery as a combination personal studio/private practice space. They eagerly accepted my proposal, and it has worked out well all around. The gallery is much more organized and has made some positive changes with my help as coordinator. I am able to offer art therapy services on a sliding fee scale due to my rent-free, bartered space. This arrangement has also positioned my art therapy practice in close alliance with the regional art scene and my own commitment to art making and community involvement in the arts, something that is well suited to my vision of art therapy.

My ability to re-vision my role as an art therapist and to make it a reality required no more than imaginative faculties and a willingness to take action. I was able to see the drama of the current job market as something to which I did not need merely adapt, but also as something I could participate in creating. Taking an active role in creating our work scenarios, within necessary limits, can be empowering. The goal is not to create the "perfect" art therapy job, but to create the best one we can out of the circumstance and potential we encounter. My own work scenario is not the perfect solution; it has its problems. These challenges keep me actively engaged in envisioning what else it and I might become.

My interest in writing about studio art therapy comes out of my concern for and commitment to my profession. It also comes out of my personal passion for the arts and my belief in their healing potential. I know I am not unique in this passion. Over the years I have talked to many students considering graduate education in art therapy. Almost without fail, they cite a desire to help people and personal experiences with the healing effects of art making as their reasons for wanting to enter the profession. I know many practicing art therapists whose guiding ethic, in the face of a shifting and sometimes shifty healthcare market, remains centered in a profound belief in the healing potential of the arts. In writing about a studio approach to art therapy I recognize, with a sense of humility, I am attempting to articulate a grass-roots wisdom that is quietly being lived out in studios and offices, in prison cells and halfway houses, in school rooms and nursing homes, in hospitals and residential treatment settings across the United States and around the world. I will attempt to do justice to this collective wisdom, at the same time that I know I will never be able to fully capture the richness and diversity of studio-based work.

My intention in writing this book is not to capture the passion of a studio art therapy approach but to allow the passion to infuse my writing, to become not so much something I write about as it is something I allow to be articulated through me. I attempt, therefore, to write in a way that is both professional and poetic, a testament to my commitment to cultivating the artist identity in all that I do as an art therapist, including the writing of this text.

I also believe it to be crucial to ground theoretical material in practical applications. It is through story that people read themselves into a text, making theory accessible and practical applications "real." Therefore, this text contains stories about my work as an art therapist, as well as the work of art therapy students and those who seek help through art therapy. My own experiences as an artist and art therapist are my richest and most accessible sources. Having practiced art therapy for over twenty years, my experiences have included work with people of all ages in environments ranging from the traditional setting of a private psychiatric hospital to the not-so-traditional settings of a community gallery space and home healthcare. While my experiences have been rich and varied, I recognize that they are also limited. I will not be able to address directly all the appli-

cations possible for a studio art therapy approach. It is my hope that you, the reader, will be able to envision yourself into the stories of this text through the particulars of your own life and work.

The focus of my work has been that of a visual art therapist, and so the focus of this book will emphasize the theory and practice of a visual art based model of therapy. However, I do not draw a strict dividing line between the arts. There is a sense of movement in visual objects, a musical quality to the reading of poetry, a dramatic intensity to storytelling, a poetic sensibility within a musical piece, a visual impact in a dance enactment. The way I conceive of this work and the way I practice it reflects my view that the boundaries between the arts are flexible and the different forms of art making can be mutually enlivening. In this book, I refer to both art therapy and the arts therapies, viewing each of the creative arts therapies (poetry, music, dance/movement, drama and psychodrama therapies) as distinct entities as well as interchangeable parts of a whole. What is applicable to visual art therapy is often (though not always) applicable to the other art therapies.

My commitment in writing this book is to be as true as possible to the passion of my convictions about the arts therapies. I am a strong supporter of the profession of art therapy and I am interested in challenging myself and other arts therapists to push farther, deeper, wider, toward new understandings of the unique contributions of the arts therapies. I believe absolutely in the healing potential of the arts and in the value of art therapy, but I don't believe we have come to understand fully the possibilities inherent in the therapeutic use of the arts. In writing this book about studio art therapy I describe the things about art and therapy I have come to know intimately; I articulate the still tentative ideas I am in the process of discovering; and I pose questions I hope will motivate you, the reader, to continue to push at the edges of what the arts therapies might become.

How We Conceive
of the Work We Do

*The idea was to look at what was already in the world and transform it into art
by the process of seeing – naming and pointing out – rather than producing
(Lippard 1995a, p.126)*

The first job I had as an art therapist was at a day-treatment program for
adult psychiatric clients. The staff frequently accompanied the clients on
excursions to explore the neighboring community. On one such trip we
went to a research center. The tour began in a meeting room where we all
sat around a large conference table and our tour guide told us about the
work of the research center. It was obvious that she was conscious of who
her audience was because she spoke to our group of "mental patients" as if
she were speaking to a group of young children, and as if we were all nearly
deaf! I found this offensive and reprehensible. At the same time, I must
confess, I was insecure about my professional status and desperately wanted
to impress upon her that I was not a patient but a staff member. In reality, we
were not introduced and she had no way of knowing the position I held
within this group.

As we sat and listened to her lecture I leaned back in my chair, tilting it
so that I was precariously balanced on the two back legs. I am sure I had
done this hundreds, thousands of times in my life, never once having fallen
over. But at that moment the unthinkable happened and before I had time
to catch myself I lay on top of my tipped-over chair, arms and legs flailing
like an overturned bug. As the patients tried to stifle their laughter I lay

there humiliated, figuring I had positively identified myself in the tour guide's mind as one of those "mental patients."

Over the years, as I have reflected on this seminal event in my career as an art therapist, I have come to think of it as a message to myself: "Get off your high horse and get yourself grounded! Know what it is like to have your world turned upside down! Your becoming a good therapist is not about putting yourself apart from the people you work with; it is about coming to know intimately their pain, their humiliation, and their ability to rise above it." For I did, you see. I rose above it. I got up off the floor, righted my chair and knew, without a doubt, that I was one of them.

How we conceive of the work we do makes all the difference in the world. As an artist, my art is an expression of my life. If I approach my role as an art therapist by knowing the unique gift I bring is my artist identity, then my work is also an expression of my life. I can see the poetry in falling backwards in a chair and in getting up in the midst of a community of people who snickered, not to make fun of me but to welcome me into the fold.

Using our artistic sensibilities to envision our work

Good (1994) suggests "being an art therapist is the development of a way of living in this world that sees things from an image and aesthetic point of view... What is developed is a way of looking at the world." (p.256). It is this "way of looking at the world" that forms the foundation for the work we do as art therapists. How we envision our work and its relationship to the rest of our lives has direct bearing on everything that follows. Our ability to conceptualize our work in artistic terms, therefore, is fundamental to developing a studio approach to art therapy.

Like most art therapists, I was initially attracted to the field because of its basis in artistic practice. I try to keep my love for art alive in my work, not just by producing art objects, but also by seeing the artistic potential in every aspect of my work. The groundwork is laid for this arts-enlivened practice by the very way I conceive of the work I do. The story of falling backwards in my chair could have been simply an account of a young professional's arrogance and subsequent humiliation. It could have been a bit

more, an entertaining anecdote, were I to transform it into a humorous tale about my early days as a novice therapist. Instead, it became for me a fully alive and profoundly meaningful story because I used my artistic sensibilities to reconceptualize the incident. I sought the poetic truth contained in the metaphor of falling backwards in my chair.

This use of our artistic sensibilities to envision our profession lays the groundwork for an art-based art therapy practice. It grounds our professional identities, our way of thinking about what it is that we do and why we do it, in the arts. If the way we have of conceiving of our work is intimately linked not only with noetic facility, but with poetic vision, kinesthetic sensitivity, artistic inspiration, dramatic attunement, and aural responsiveness, then our work will become infused with these same qualities. Rather than distancing ourselves from the arts with the false notion that doing so is more professional and more clinically oriented, I am suggesting that we firmly situate ourselves in an artistic way of conceiving art therapy so that our ideas about being professional and clinical are shaped by our identities as artists. In this way we come to know the particular and specific versions of "clinical" that become manifest through the arts.

To conceive of the work we do with our artistic sensibilities sets the stage for an alignment between our stated intentions (to do art therapy) and our actual practice. In other words, if our conceptualization of our work is art-based, there is an increased likelihood that everything that ensues in terms of theory and practice will also be art-based. By embracing art as the central component of our professional vision, we strengthen the authenticity of our work as art therapists.

Many different art forms might be used as vehicles for envisioning our work, including music, dance, drama, poetry, and visual art. We need not be proficient in the practice of each of these, nor do we need to be trained in the discipline of intermodal creative arts therapy. However, the arts are available to all of us as potential informants for developing our vision of the work we do. Whether or not I consider myself an accomplished poet, I can still love the way certain words sound together when they are spoken aloud. I can love how those sounds together begin to form a certain beat, and then find myself humming a tune to go along with the ta-ta-ta-cha, ta-ta-ta-cha of the beat. I may even begin to move around in response to the sounds, allowing the beat and rhythm to move through me. All this activity may

remind me of a particular time in my life and I may get out my sketchbook and try to channel the feeling of that time into an image on paper. The image I make may inspire me to jot down a few descriptive words about it. Then I might read these few words out loud and love the way they sound together. In this way, the various manifestations of the arts feed and nurture one another.

While I may identify myself as a visual arts therapist and believe that this is my area of greatest proficiency, this is no reason to limit myself to visual art as my only means of conceiving of my work. I may still be able to hear the rhythmic qualities in a client's way of telling a story, see the rocking/fidgeting movements of an elderly patient as a kind of dance enactment, or attend to group process as a drama unfolding. What is most critical is not the type of artistic modality used to explore the meaning and nature of our work, but that the arts are used as the basis of this exploration.

When I think about my work as an art therapist and make use of the arts to envision what it is that I do, I often think in terms of stories. These stories might reveal themselves in text, as one might expect, or they might reveal themselves in images, movement, or performance art pieces that combine various art forms. In this book, the way I communicate my stories is through visual art or the written word, simply because these are the art forms that best lend themselves to a book format. Keep in mind, as you read, that story making and story telling can come in many other forms as well.

Finding the stories stuffed in the cracks of our lives

A fitting place to begin developing an artistic perspective of the work of art therapy is by attending to the stories of our own lives and work. It is through these ordinary tales that we come to know and make meaning. We do this first by noticing the metaphors that present themselves and, second, by trying to discern the significance and meanings they hold for us. We are familiar with relating to our dreams in this way, but don't necessarily think of approaching the events of our daily lives with this same artistic perspective.

We can heighten awareness of the significance of daily events by portraying them through drawings, storytelling, journaling or other artistic

means, just as we do when we want to consider the messages of our dreams. In order to discern meaning, we can use these artistic retellings for self-reflection or we can share them with other people in order to gain multiple perspectives.

We often think it is only the dramatic moment or the monumental event that is worthy of being told as a story. But really, it is the small and seemingly insignificant occurrences that build one upon the other to create a life. The telling of these stories is a way to give honor to the ordinary, to see significance in the mundane. When any small event is seen as worthy of being made into a story, then anyone can be recognized as a storyteller. And the most telling event may appear in the surprising guise of the discounted, nearly forgotten occurrences we presumed to have been trivial.

The challenge is to rediscover the stories stuffed in the cracks of our lives, the ones we have put aside or disregarded but not forgotten. The telling of these stories can inform us about the work we do.

Many years ago I made a large ceramic container that emerged from its first firing in the kiln with severe cracks, the marks of its making and its inability to hold itself together. It was clear to me that if I were to glaze it and put it through a second firing the cracks would become larger, possibly causing the clay to break into jagged pieces. I decided to follow an unconventional route and fill in the cracks with Spackle, then paint the vessel rather than glaze it. As I began to paint I found my hand being guided by the cracks and fissures on the clay body. The cracks became the starting point, the inspiration, something to work with. I had thought I was painting the piece as a last-ditch effort to salvage it from ruin. I was not expecting much. To my surprise, I loved the way the piece turned out. By using the cracks and fissures as my inspiration, instead of trying to barge ahead with completing the piece in the manner I had been taught (glazing and second firing), I did not save it from ruin. What happened instead was more akin to our saving each other. I lent my painting abilities, attempting to make what I could of the vessel's cracked imperfection, and that tenacious piece of earth lent me its flaws as a road map. Through a cooperative venture, we were both renewed.

This is a small story, a simple one. It is about how the creative process, the relationship between maker and made, informs my life. Through the process of painting inspired by cracks, the vessel took on new meaning. At

the time of its making, it informed me about my relationship with my father. He was unable to hold himself together, the person he used to be breaking apart due to the effects of Alzheimer's Disease. And I, of course, just like all the king's horses and all the king's men in the Humpty Dumpty rhyme, couldn't put him together again. What I could do was be with him, cracks and all. And together we made something out of the life we had been given.

This simple story also informs me about my work as an art therapist. It reminds me that it is unlikely I will ever save anyone from ruin by barging in with my techniques and theories and reputation. But if I am willing to be with them and to be guided by the cracks of our lives – the marks of our making and our inability to always hold ourselves together – then there is a chance that together we may find new life.

Profession as an intimate interplay of work, love, and life

What it means to be a professional has come to be associated with participating in an activity for gain or livelihood, thus leading to concerns about financial security and the acquisition of prestige or favor. The passionate intent inherent in the word "profession" has been stifled or, worse, diluted, by such concerns. An artistic way of conceiving of our work helps us to become connected once again with the meaning of the word "profess," to avow publicly. Such an open declaration occurs not merely by publicly *speaking* about what we believe in but by taking *action* in response to that which we are called to do. Ideally, our profession is determined by coming to know what we are passionate about, being aware of the needs of the world, and finding a way to bridge passion and need through the actions we take. This is the work we are called to do.

When this idea of profession is the grounding for our life work, it is difficult to conceive of that work as something done in isolation from the other aspects of our lives. Instead, aspects of work, love, and life complement and enhance one another. There is an intimate weaving between our roles as parent, spouse, student, sibling, artist, activist, hobbyist, teacher, art therapist, administrator, and so on. We live our lives in response to that to which have been called. We follow our passionate convictions.

This intimate weaving of work, love, and life does not imply a lack of boundaries. Just as the making of a piece of art can take the chaos of a life and give it a sense of order and coherence, so too can living one's life artfully carry with it an ordering function. An artistic conception of my work can help me understand how the different roles I play complement and fuel one another. When I strain to keep these roles separate they become competitors for my time and energy. I become burned out at work, feel guilty that I have spent too little time with my children, or worry that I will be perceived as meeting my own needs through my clients. An artistic vision of my work allows me to explore how the personal and professional aspects of my life can enhance and enrich one other. It enables me to operate out of the concept of abundance rather than scarcity.

Historically, the dominant paradigm in psychology has taught us to keep strict boundaries between our personal and professional lives, lest we try to meet our own needs through our clients or lest we become depleted by the unbounded demands of our clients. The same has been true in the art world, where the images of great artists have often been linked with lone figures who sacrifice family and intimate relationships for the sake of their art (Levine 1989).

The polarization of the personal and the professional has been challenged on both fronts, in the field of psychology and in the art world. Feminist psychological theory has suggested a more flexible idea of boundaries, one in which empathic connection occurs precisely because boundaries are not fixed and rigid (Jordan 1991). In a similar way, artists like Mierle Laderman Ukeles have challenged the distinct and antagonistic separation of art from life. Inspired by the conflict she experienced in trying to produce art while responding to the demands of raising a family, Ukeles began to explore the commonalities between creative activity and household maintenance. This led her to the creation of art over the course of more than thirty years in which the idea of service became both the structure and content for her performances and installations. In one of her more well-known projects, she became the self-appointed artist-in-residence of the New York City Sanitation Department, where her artworks were made in order to "honor and confirm the dignity of maintenance work as a life-sustaining, life-enhancing activity" (P.C. Phillips 1995, p.183).

I find this concept that the boundaries between the personal and the professional are in relationship, rather than in opposition, to one another, to be much more compatible with an artistic view of my work and life. Having flexible boundaries does not preclude me from making clear decisions about such matters as whether I will give out my home phone number to clients or whether I will schedule appointments on the same evening that my daughter plays volleyball for her school team. These are the necessary and practical aspects of managing a life. Having flexible boundaries does, however, enable me to think of qualities I possess – for example, my capacity to nurture – as pervading many aspects of my life rather than being compartmentalized according to the role I take on. When I think in terms of the interrelationships between my various roles, I see how my skills as a mother can enhance my nurturing role in the therapeutic setting, and how my ability to nurture clients makes me better at mothering my own children. A flexible concept of boundaries supports the idea that our personal and professional lives can be mutually enhancing and enriching.

To conceive of our work as intimately connected with other aspects of our life is also in alignment with the artistic process. Seldom does what is expressed through art remain a disconnected fragment of experience. More often, the original conscious intent of a piece of art evolves during the creative process. We are influenced by what is going on around us, by the events of our daily lives. Connections are made between seemingly unrelated events, feelings, or experiences. The more we are open to and willing to work with the happenstance of the artistic process, the more enlivened the work becomes. Conversely, rigid fixation on an idea about what the work must look like when it is finished can cause the artwork to become awkward or forced looking, and drained of life. The process of enlivening is further enhanced when viewers are added and the multiple ways of seeing a piece of art bring new perspectives. An artistic conception of our work is not too rigidly fixed and bound, but instead is enlivened and enriched by the occurrences, events, and experiences of our daily lives.

Reflections on love, life, and my work with James

When James, a 14-year-old client, began looking for the biggest, fattest, juiciest worm he could find, I knew I was in trouble. His other hand held a thorn, plucked from a nearby tree. His look was menacing and wounded and calculating all at the same time. I had been the one who, upon a visit to his home for a therapy session, suggested a walk around his neighborhood. This hunt for weapons and victims is not what I had in mind.

When James found his prey, a worm nearly as thick as my pinkie finger, he dangled it in front of me and asked if I knew what he was going to do with it. But it wasn't really a question. It was more of a brag, a taunt, a proclamation of his status as the worm world dominator. Anyway, I knew. And I dreaded what was about to unfold before me, didn't know what to do about it.

You see, I'm the kind of person who finds wasps in my house and leaves the fly swatter hanging on its hook, goes to find a jar instead. I trap the wasp inside the jar and walk it outside, let it fly free. I'll step over ants on the sidewalk, open the door to let a fly out. I name the spiders in my house. I do have my limits – ants in my sugar jar, mosquitoes buzzing around my head, cockroaches setting up camp in my house – but in general, if something is not hurting me, I let it be.

So, when James dangled the worm and flashed his crooked grin and waved the thorn around in the air like a sword, I wanted him to stop. I wanted to pull out my bag of therapeutic interventions and throw some limit-setting-consequences-inappropriate-prompt-and-redirect-prosocial-jibber-jabber his way. Mostly I just wanted to say, "No! Don't!" But I didn't.

Instead I tried to "listen," even though what he had to tell me was hard to hear. I tried to listen with my eyes and ears and heart. Now, when I look back, I realize that what he was doing to the worms was not so far astray from my own guidelines about not inflicting pain without provocation, but I didn't realize this at the time. Then, I was too caught up in my own conflict over what to do. In the end, I did decide on the noninterference route, but I never got completely

comfortable with that choice, even when, by the end of the walk, I was clear that it was the right choice.

At first, I heard it as a story he was telling me about himself. James, the lowliest of the low, fat, vulnerable. Not particularly liked, for no apparent reason, no fault of his own. Picked on, victimized. Then, as we walked the city block around the housing projects where he lived…as he picked the thorns and selected the worms and ceremoniously lined them up and watched them squirm or impaled them or severed them…as he carried on a near-monologue for 45 minutes (this boy who rarely spoke except in swear words and demands and tough guy talk)…as his spoken word text on the art of torturing worms was woven alternately with vignettes from his early childhood…then I became absorbed in the performance art he was allowing me to witness. He told me and he showed me. How important it was to find the fattest worm. How he never let one get away. How he looked for it and looked for it…ever the predator. About doing experiments to see what the effect of dipping worms in bleach or ammonia would be. About watching them sizzle and burn. About how they don't feel pain. And oh, by the way, how the kids in the neighborhood used to beat him up for no reason. Just because he was there, because he was fat, because he was squirming like these worms do. "Oh, see this one. Watch what happens when I cut it in half. See, it doesn't really hurt it. Naw, they don't feel pain. Wait, let me try to find a better thorn and I'll show you something else. Did I ever tell you about the time I was climbing a tree and I got a thorn stuck in my leg? I was like this, here let me show you. I had one leg up in the tree and I was pulling my other leg up and it must have scraped like this against one of the thorns. It didn't even hurt at first, I didn't even know it was in there. But later it was throbbing and they made me go to the hospital to get it out and that hurt so much I was like 'Oh, oh' when they were taking it out and sweat was pouring down my face and my back. It hurt really really bad. See that kid over there? He was one of those kids who set the fire at Linden High School. Me? Naw, I don't hang around him. He thinks he's tough. I could beat him up if I wanted to. Now let me show you something else. Here, I'm going to line up these worms side by side. Wait, this

one's a little too long. I can fix that. Die, you mother fucker, die! I don't know why those kids didn't like me. I just don't know."

His performance ended behind his family's apartment. His finale involved a wire coat hanger he used to poke and prod a line-up of writhing worms. He poised as if ready to go in for the kill. For the first time that day, he looked directly at me. By that time I was both in awe of and shaken by the eloquence of his performance. Having never mastered the art of therapeutic neutrality, I knew he could see how he had affected me by the look on my face. He said, "What I'm doing with these worms really bothers you doesn't it?" I said, "Well, actually, what I was thinking about was you, your pain." His response was "Hm." And for a second he looked at me and shook his head up and down. Then he kicked at the worms and dropped the coat hanger on the ground before he turned around and went inside his apartment to paint.

It is 1997 and my son Jesse, at age 17, has been receiving flyers daily from colleges around the country. He is getting his initiation into adulthood by becoming the recipient of a large serving of unearned, unsolicited junk mail. He is also being pestered by his father about getting a summer job. His reaction to all this, one spring evening, is to respond to anything directed his way with adolescent surliness. On this particular evening I happen to be in one of my more sensitive, less reactive, moods as the mother of a teenager. I offer to spend some time with him after dinner, to sort through the pros and cons of various job possibilities. He accepts my offer.

After dinner we find a quiet space in the house and begin to talk. However, we don't really say too much about the practical aspects of job hunting. Instead, he begins to talk to me about how hard it is to become an adult, about all the things that are changing in his life, about how much more is expected of him and how he feels like his childhood is slipping away before he's ready. These are big admissions for this adolescent boy, a lot of words about himself and his feelings from this son who rarely speaks of such things. I tell him that sometimes I hate being an adult. I tell him it inhales deeply, our family euphemism for "it sucks!". We laugh together. Then he chokes

on his words when he tells me he wants to stay a kid forever and he is scared about growing up. I hold him, this child of mine who is now bigger than me, and for a long time we just sit and cry.

Nearly a year later, in early April, I go for a walk with James. This time he leads the way to his old baseball field. As we walk, he talks and talks and talks. The message is clear – he needs me to listen. He talks about the kids who used to live in the neighborhood, the shortcuts they would take to get to the baseball field, how their shoes would get all wet with dew on these early summer mornings. At the field, he gives me the grand tour – of the dugout and the ball diamond and the concession stand now closed. Then we sit on the metal bleachers and he describes the summer of his dreams, when the boys he did not know came to accept him as one of their own, when he could hit home runs over the back fence, when the juice of hot dogs at the end of a winning game dribbled down their chins and they laughed and smacked each others' backs and told stories that turned their Little League games into the World Series. We sit there for a long time, looking out at the ball field, imagining the plays he describes, listening to the cheers of the crowd and the arguments of parents over whether or not the umpire made the right call, smelling the summer grass, feeling the gritty dirt circulating in the air, watching James run out behind the field with his friends after a practice to play on the piles of coal bits. James talks about how times have changed too. About how he is too old to play in the Little League any more. When I forget my listening role and suggest he play with another league or work as an assistant coach for the younger kids, he reminds me, by ignoring or quickly dismissing what I say, that this is a story about the loss of childhood. And nothing can bring that back.

James never comes right out and says he wants to be a child forever and he is scared of growing up. And I don't hold him in my arms and cry with him. But he tells me just the same. And on that chilly spring day, I sit on those metal bleachers after the sun begins to dip behind the houses and shiver under my coat, holding him as best I can with my eyes and ears and heart.

It is 1962 and I am 7 years old. My sister Liz, my cousin Mary and I are trekking through the woods to get to the creek we love to splash around in on hot summer days. When we reach the water we wade in with our tennis shoes on to avoid slipping on the slimy rocks. We gather small stones in our pockets, the kind that enchant us with their wondrous wet colors, even though we know their dry version will be a dull, dusty gray. Satisfied with the treasures we have accumulated, we head home along the creek bed. We laugh and tell jokes along the way, carelessly swinging our arms and twirling with abandon. Until suddenly we find ourselves surrounded by a swarm of bees. Liz and Mary scream and swat, flailing their arms like windmills gone berserk. They start to run and I run too, away from the creek bed, away from the insects whose home we have so obviously threatened. I don't know why I don't scream or flail my arms. Maybe because I am last in line and so I have some warning, see the bees swarming around Liz and Mary before I actually am in the middle of them myself. I just move back from them, get out of their way, show respect for their fierce self-protection. I don't know if that's why I am the only one who doesn't get stung. I only know how lucky I feel when I see Liz and Mary crying while my mother lays cool rags on their stinging arms and legs.

It is many years later, in early spring. I arrive at James's house and find him and his grandmother, with whom he lives, out on the back porch with the neighbor girl. I step onto the porch and immediately find myself in the midst of something thick, angry, and menacing. Sharp words zip past my ear, barely missing. I try to listen, to figure it out, duck when I need to. I nearly choke with exasperation when Grandma says the neighbor girl can go to the store with her, reverses her decision because James demands that he go or no one, and then blames James when the girl begins to cry! I wonder, have I made no impact at all in the 8 months I have worked with this family? Then the phone rings and the grandfather screams at his wife from inside the house, "Louise! the phone!!!" She is in the middle of telling me something, so she asks James to go in and tell the grandfather she

will be there in a moment. The grandfather storms out of the house almost instantly, railing at her for not coming when he called. With a good deal of huffing and puffing and zinging and dodging, the grandparents and the neighbor girl manage to go off to the store to buy some food for dinner. That's what they really need, really want. Nourishment. Sustenance. To be able to live from day to day. But it is so painfully hard to negotiate this with one another.

At home that evening, I read an e-mail from our friend Steve. He tells us he was hurt and disappointed that we had not sent birthday gifts to him and his son on time. All these things buzz around inside my head. Don't get too close, come closer. It's what we all want – nourishment I mean – food, love. I try not to scream and flail my arms back at Steve. I hear in his criticism the invitation to be closer.

That night I think of James and Steve while I'm falling asleep. I think of stone treasures wet and colorful, dry and dull. Sometimes one way, sometimes another as I hold them in my hand, in my heart. I wonder if I will be stung. I'm never sure if it's luck or skill that allows me to come through unscathed.

James is my challenge, my master resister. He tells me he doesn't like art. I see him twice a week and Wednesdays are art days. It is an agreement we have made and I expect him to stick with it no matter how much he does not feel like making art, no matter how many diversions he manufactures, no matter even if he defiantly refuses. On occasion, he has broken his side of the bargain and not made art, but I have never broken mine; I always bring the supplies and I always expect him to make art. He stretches his side of the bargain to the limit, seeing if he can get away with fifteen minutes of painting, ten minutes, five, looking for a picture to paint from but not actually painting. I don't fuss with these details, just expect him to paint, just believe in him. I know he is able to save face by "winning" these little bits of control. And that is all right with me, because he is experiencing what it is like to be in relationship with someone who holds him accountable, who believes in his ability to live up to that responsibility, and who is willing to believe in him no matter how much he tries to undermine that belief.

We could have had this kind of relationship without making art together. But the fact that our work together is focused on the painting of an icy mountain landscape adds some other layers beyond accountability and respect. I know this is a brave thing for him to do, to make this painting. He does not like to do anything if he doesn't believe he is good at it, can win at it, or can be in control of it. His willingness to paint fits none of these categories. He has invited me along, asked me to work on the painting too. So we work on the painting together. Oh, it is couched in, "I suck at this and I need you to doctor it up." And it is one more way he has of exerting some control over the situation by acting as if he has roped me into doing it for him. That's okay with me. I don't need to hear him say he is afraid of traveling through this barren, icy landscape alone, that he is afraid he will be exposed and vulnerable without my help. I am honored he trusts me to be his companion.

It is a Wednesday afternoon. James and I reach an impasse with our painting. He wants the lake he added to have a shimmering quality to it and I have no iridescent paint. I have not been able to find it at the stores where I have looked. I tell him I will keep looking. I have a place in mind I will try to get to.

The following Monday I walk into the bees' nest of chaos and conflict at James's house, where they are all embroiled in figuring out how to negotiate a trip to the grocery store. It is time for me to leave and I am more than ready. I am worn out. Out of the blue, James says to me, "You got that shiny paint, didn't you." It is more of a statement than a question. He smiles and nods his head when I say yes. He had no way of knowing; his is a statement of faith. He believes in me! Hurray!

That night I am greeted at home with, "Arlen says he wants to meet you, Mom." This comes from my 15-year-old daughter Brea, talking about one of her volleyball cohorts, one of her partners in flirtation. "Why?" I ask. "I don't know," she replies, "he just said he wants to meet you." I will get nothing more from her. She has laid out the compliment and that's all I'll get. It's such a little tidbit she's thrown my way, so few words. I think they mean, "You must be pretty

cool, Mom, because one of the cool guys has heard about you and wants to meet you." Wow.

Sometimes these acts of bestowing favor are so subtle I nearly fail to recognize them as such. They are spit up in the whitewater ride of being a mother, a therapist. When I do see them I want to grab at them, pull them to me, own them so I can pull them out like a trophy to show my friends. But if I want to stay in the raft I have to keep paddling. If I reach for them I will only lose my balance and miss my chance to glimpse what I've been offered.

It is another day at James's house and he shares a dream he has had about me. He says he dreamed I was being chased by clowns who were trying to tickle me. He and his grandmother and even his tough old goat of a grandfather were laughing with me in the dream. What does it mean? And what significance does it have that James shares it with me? I don't know. Oh, I could guess at its meaning, could apply some theoretical analysis. But really, I don't know. It is a little dollop of something that James put in the soup of our relationship. It changes the texture, color, and taste of that soup a tiny bit. But I can't quite name how. I think I like it, but I'm not even sure of that yet. It is an odd ingredient – this shared laughter – to throw in with the worm torture art piece.

James is my challenge. He is difficult and unruly and sometimes an hour and a half with him and his grandparents can make me feel like I have put in an entire workday. With some clients I can stay on the outer edges of my work – relying on my years of experience, my accumulated knowledge, my reputation, my self-confidence – and I can get by. But with James, I walk in the front door of his house and I am in the wilds. I never know what I will encounter. He is a great reminder to me that in the big scheme of things I hardly know anything at all. So his gift to me is that he pushes me to be a seeker. He turns all my years of experience topsy-turvy and shakes it all up so that I really have no choice but to be with him, authentic, in the moment, two human beings trying to find our way.

Conclusions

The basis for any approach to therapy is established first and foremost, prior to any practical applications, in the ways the work is conceptualized. In a studio approach to art therapy, the arts themselves provide the most fitting means for formulating ideas about our work and its relationship to our lives.

The way we see and conceptualize our work has the potential to challenge the polarization of the personal and the professional. Through seeing, naming, and responding to the artistry of daily activities, our conception of these activities is transformed. We are able to see our work as intimately connected to other aspects of our lives and to see the potential for all aspects to be mutually enriching.

Thinking, imagining, wondering, searching, reflecting, and questioning are all aspects of formulating a concept of art therapy that serves as the basis for our work. When these methods of developing a conceptual basis for art therapy are drawn from artistic vision, there is integrity to our work. From the inside out, art becomes the thread that links our vision to our practice.

The Process of Cultivating an Artist Identity

The challenge of art is the same challenge that life presents us with moment by moment: Can we awaken from our casual viewing of a stupendous world? (London 1989, p.54)

In springtime I hear the distant whirr of machinery as the farmers prepare the soil for planting. I picture the strong steel tines reaching down into the earth and dislodging what has become settled and compact. I imagine the earth taking big, deep breaths as it feels the air move into and around it after a long winter of being closed and unyielding.

I am not so different from the soil. I too need to be periodically cultivated, readied for what is to come, remade into a hospitable environment where new growth might take place. I think of what the land has to teach us. If our calling is to provide a hospitable environment for people to grow emotionally, spiritually, and functionally, perhaps we need to be attentive to the necessity of being loosened from what we have settled into or of being released from what has beaten us down. Perhaps we need to experience our own brokenness – to "break new ground," to become "all broken up," to experience a "breakthrough," to have someone "break us in," to "break away," to "break into," or even to "break down" – as part of the process of readying ourselves for the work we are called to do. The land is a reminder to us that we are made ready to nurture others through our own experiences of brokenness.

As art therapists, a crucial aspect of our readiness to provide a hospitable environment for new growth in ourselves and in others is the

cultivation of our identity as artists. This cultivation involves a devotion to the arts that both opens us up so that we breathe in life more freely and unsettles us so that what is familiar and comfortable is turned upside-down. It is a never-ending process of refining our sense of artistic vision and our capacity for aesthetic empathy. Empathy, the softening of boundaries that allows us to project our subjective state onto an object or person, occurs in art making as well as in our capacity to resonate with clients' affective experiences. Thus, there is a natural link between the empathic response and the artistic response (Lachman-Chapin 1979). In cultivating the artist within, we become better equipped to empathically connect with and cultivate the artist in others.

In operating out of an approach to therapy where the art process and product provide the constellating focus, it is not only common sense but also ethical responsibility that prompt us to engage in our own ongoing artistic development. Certainly this points to the necessity of fully engaging ourselves in our own art making, but there is more involved in the development of our artist identities. The cultivation of an artist identity involves the intentional, disciplined development of our artists' eyes, ears, hands, and hearts so that this identity permeates and informs everything we do as art therapists. Through careful attention, rigorous study, and disciplined practice we keep ourselves loosened up, open, receptive, and ready to provide fertile ground for new growth in ourselves and in those persons we serve.

Careful attention: Honing artistic sensibilities

I walk past the desk of a co-worker. Piles of paper, old coffee cups, pens, paper clips, a tennis ball, family photos, and a wind-up frog sit atop the desk. It is easy to think of it as cluttered. What if I looked upon it as an art installation instead, reflecting on its meaning, subjected to its mystery?

I walk past a group of adolescents on their way home from school. They are all clad in baggy t-shirts and jeans. They chatter noisily and move about with a lot of energy, laughing in unison. It is easy to think of them as "typical" teenagers, to laugh and shake my head at the way they all dress the same and try to impress one another with their "uniqueness." What if I try, instead, to see what they express about themselves by the way they move? I

then see how they are pulled in, pushed away, and sent spinning by this time in their lives, how animated they are, and how complex.

I move through the walkways and stairs and gates of the subway system only dimly aware of what I classify as noise. What if I listened, instead, as if I were hearing a piece of music? I hear how the low rumble sounds a soothing base, how the clatter of trains on tracks adds a beat, how the shuffling of feet and intonations of voices add a lilting variety, how the screech of the train approaching adds an element of surprising variation, how these sounds layer one upon the other to form a piece of daily life music.

The world is full of opportunities to hone my artistic sensibilities – to listen for the poetry in casual conversation, to hear the music in everyday sounds, to bring rapt attention to the potential dramatic enactment in the simplest of experiences, to see the visual artistry in what is right in front of me, to discover the performance art in the small acts of daily life. The sharpening of our artistic sensibilities as therapists begins with careful attention to the world around us. If we practice experiencing our everyday lives through the eyes and ears and hands and hearts of artists, we may become so accustomed to this way of perceiving our world that we experience our clients, our work, our colleagues, and our workplaces in the same way.

The cultivation of an artist's identity through careful attention relates to refining empathic observation skills. Empathy is "central to an understanding of that aspect of the self which involves we-ness, transcendence of the separate, disconnected self" (Jordan 1991, p.69). At the same time, empathy can occur only if a person has a clearly differentiated sense of self. Empathy requires a softening of boundaries whereby there is an ability to resonate with the feelings of another while maintaining an awareness of the differences between self and other (Jordan 1991). Developing empathic observation skills involves learning to be present with, focused on, and receptive to what is right in our midst. It requires using all our senses – sight, smell, touch, taste, and hearing – as the tools of our trade, as would any artist. It also requires that we are attentive to what is within us, to the inner murmurings, the intuitive responses, the visceral reactions to that which we encounter.

The word "attend" comes from the Latin word, *attendere*, which means "to stretch toward" (*Webster's New World Dictionary* 1988). As art therapists

who are working from an artist identity, we must stretch toward becoming simultaneously aware of external, sensual experiences and internal, intuitive responses.

Maintaining this dual awareness requires unlearning the habitual social conventions of Western society, whereby we are taught to ignore "politely" or disregard much of the nonverbal input that constitutes our daily social interactions. As examples, I have been socialized to pretend not to notice when the person I am talking to is trying to stifle a yawn; I have been socialized to laugh along with two people who use sarcastic humor as a way of relating, as if I am unaware of the tension between them. The positive impact of these social mores is the fostering of tolerance. The negative impact is the systematic denial of our own sensual and intuitive ways of knowing. The practice of graciously tolerating certain behaviors by acting as if one doesn't notice them may, over time, lead to *not noticing* many behaviors, even generalizing beyond the "taboo" behaviors to an overall dulling of awareness, particularly of nonverbal communications. The cultivation of our artistic sensibilities means we must unlearn this not noticing, and instead give greater attention to sensual and intuitive input.

The refinement of our artistic sensibilities involves a shift away from the dominant paradigm in Western society that overvalues verbal, discursive interactions and analytical thinking (Talbott-Green 1989). It brings sensual and intuitive ways of apprehending our experiences to the fore, as equal and interdependent "partners" with our rational intellect. The quality brought to our cognition through the honing of our artistic sensibilities is empathy. Rational analysis of a situation is characterized by cautiousness and prudence, resulting in objective distance. Our artistic sensibilities, by involving the intimacy of our sensory experiences, our intuition, and our capacity for vicarious introspection (Lachman-Chapin 1979) offer a balancing effect, a carefulness that is "full of care" and results in the enhancement of empathy.

The intentional cultivation of artistic sensibilities is no easy task. Our learned behaviors and social conventions will work against the development of increased awareness. In Western society, the fast-paced living many of us are involved in is not conducive to giving careful attention to the experiences of our daily lives. Like the cultivation of any skills, developing our artistic sensibilities requires intentional commitment and practice.

However, it is not something that requires taking time away from the tasks of our daily lives. Instead, it can best be accomplished by immersing ourselves more fully and consciously in the small acts of living, by looking for the poetic possibilities in everyday objects and occurrences.

Most of us cannot be continually attuned to the nuances of our surroundings. The development of empathic observation skills takes concerted effort and practice. But our efforts and practice in this vein can be rewarding. Refining observational skills through cultivating artistic sensibilities allows for "a sense of feeling connected and affectively joined and at the same time" able to "cognitively appreciate one's separateness" (F.F. Kaplan 1983). This leads us to a richer, more acutely discerning and empathically connected relationship with the world around us, and ultimately with the clients we serve. If we are able to perceive an office desk as an art installation, the movements of a group of adolescents as an expressive dance, or the sounds of the subway as a form of music, then we will be more likely to perceive the clients we serve through the compassion of our aesthetic sensibilities.

The practice of cultivating an artistic perception of the world may seem to be a romantic notion, leading only to an appreciation of the beauty around us and to a positive, rosy perception of our clients. This is certainly not the case. As our engagement with the earth reminds us, cultivation involves dislodging, turning over, loosening, and experiencing brokenness. It involves uncovering that which has been hidden, settled, and comfortable. Habitual practices, such as referring to a client as "an eating disorder" or a group of human beings as "my caseload," are turned upside-down when we become attuned to perceiving the particular nuances of individual lives. The client who was once viewed as cooperative and compliant may be perceived as having a darker, more malevolent side as well. Simplistic labeling of a client as "resistant" may give way to recognizing the therapist's attempts to assert dominance over the client and the reciprocal maneuvers on the part of the client to preserve autonomy. While the cultivation of artistic sensibilities promises to open us up to a deeper appreciation of life, it also promises to unsettle us. We are likely to become sensitized to our more complex and sometimes disturbing qualities, as well as those of our clients, our work environments, and our world. The purpose of the cultivation of artistic sensibilities is to break us open, so that we are made ready

to nurture others through our own experience of brokenness. Far from being a naïve romantic ideal, the cultivation of artistic sensibilities involves courage and hard work.

Dedicated study

Dedicated study is also required in order to cultivate an artist identity. The study involved occurs on multiple levels. First, there is the level that comes to mind for most people when the word "study" is mentioned, that of applying our mental faculties to the acquisition of knowledge. Second, learning takes place through immersion in the arts. Third, learning occurs through turning our attention to self-study.

Acquisition of knowledge

Acquiring a knowledge base to support the practice of a studio approach to art therapy can occur through a variety of different means and venues. Courses, lectures, workshops, symposiums, and conferences provide the opportunity to garner knowledge about specific topics. Art therapy texts and journals, as well as books and journals from related professions, provide a rich resource for ongoing learning. Interpersonal education occurs through formal structures like supervision as well as through informal contacts and conversations with colleagues. Visits to galleries and museums, along with attendance at cultural events, also contribute to continuing education.

Graduate education in art therapy provides the foundation for practice in the field. Specific areas of study in both graduate and continuing education have the potential to contribute specialized knowledge applicable to an art-based approach to art therapy. Learning about the materials, techniques, and applications of art enables us to become skilled in our craft. Familiarizing ourselves with the history of art helps us to understand how our work as art therapists intersects with the whole of art history and to appreciate our place in this history. By studying the psychology of creativity, we better understand the interface between therapeutic and artistic processes. Through examining the phenomenon of outsider art and the relationship of art therapy to art education, we more clearly compre-

hend the contextual basis for the development of our field. Maintaining an awareness of current trends in the art world, especially those relating to the use of art as a means of personal or communal healing, helps us see the potential for collaboration between art therapy and the art world. We also learn from each other about ways to integrate our understandings of art and art history into our art therapy practices.

These subjects and more are the focus for ongoing acquisition of knowledge through the use of our mental faculties. Lest this task seem too daunting, it is important to remember that the key word here is "ongoing." There will always be more to know than any of us will ever have time to learn. The crucial factor is to remain a learner, committed to an ever-developing base of knowledge.

Immersion in the Arts

The second level of study requires what I refer to as "immersion." Immersion is the act of plunging into and surrounding ourselves with a focal area of study. We become involved with the study of art not merely through our mental faculties but also through our living, breathing selves. We attend dance performances, listen to musical groups, view plays or performance art pieces, listen to poetry, and visit art galleries, art museums and alternative art spaces. We do these things in order to be exposed to the effects and influences of art; to allow them to play upon our senses; to comfort, provoke, or soothe us.

Exposing ourselves to the art of others often is a key ingredient for our own involvement in making art. There is a contagious quality to creativity. When we see other people embroiled in their artistic process or view the end result of their creative efforts, our own drive to produce art is aroused. Other artists remind us of what is possible in our own art making. The art we observe is internalized and becomes an ingredient for the stew of our own artistic process, challenging us to create something new and authentic to our personal artistic vision.

An additional benefit that comes of exposing ourselves to the art of others is an increase in sensitivity toward art. A significant aspect of any art therapist's practice is the ability to perceive the artwork of clients with accuracy and empathy. Exposing ourselves to diverse artistic expressions is

a way of exercising our perceptual acuity and expanding our visual vocabu-
lary. Thus we are better prepared to respond to the artistic productions of
our clients and to provide them with art examples that fuel their creative
thinking.

The single most important aspect of immersion goes beyond being an
observer of the arts to being engaged in making art of our own. We come to
know, through the act of making, what colors to mix together to obtain a
certain shade of green paint, how to repair cracks in a clay pot, the
technique involved in layering pastel colors, how to sharpen woodcarving
tools, and other such skills. Only by becoming familiar with the basic
materials and techniques of art is it possible for us to help others learn how
to communicate through the language of artistic expression. In this way we
also come to an intimate knowledge of the emotional impact of the art
process – the fear inspired by a blank canvas, the sense of frustration caused
by a clay pot shattered in the kiln, the excitement sparked by a newly
birthed image, and the satisfaction of having brought a work to
completion. These are essential experiences to know, not from a detached,
intellectual perspective (for example, reading about it in a book) but from
the intimate, paint-on-one's-pants, clay-on-one's-hands, gutsy,
self-exposing, plunging-into-the-darkness way of knowing that comes
from making art.

Others in the field have written about the importance of art therapists'
commitment to their own art making and of the potential negative reper-
cussions when this does not happen (Abbenante 1994; Agell 1986; Allen
1992; Ault 1994; Bouchard 1998; Gilroy 1989; Good 1994; Kapitan
1997; Kramer 1971; Kramer as quoted in McMahan 1989; Malchiodi
1994; Malchiodi and Catteneo 1988; Schaverien as quoted in Steinhardt
1998; Wix 1996). I add my voice to theirs. Yet it is my hope that my ex-
pression of concern is not experienced as a reprimand. Art therapists have
also recognized the difficulty in continuously developing knowledge and
skills in both art and therapy (Ault 1977; Feen-Calligan and
Sands-Goldstein 1996; Fleming 1993; Lachman-Chapin 1993b;
Malchiodi 1999a). There are many compelling reasons why art therapists
find it difficult to make art, and an art therapist who feels chastised or
guilt-ridden is not likely to feel inspired or motivated to make art.

Much has been written on the topic of the artist's struggle with art making (for example, Audette 1993; Bayles and Orland 1993) that is relevant for the art therapist as well. In relation to the predominance of women in the field of art therapy, examples of this genre of literature referring to obstacles for women artists are particularly salient and germane (Chicago 1975; Fleming 1993; Junge 1988; Olsen 1965; Sang 1989; Woolf 1929; Zeidenstein 1988). For female art therapists, the normal self-doubts of the artist may be compounded by fears that art making, as a self-indulgent activity, will interfere with the ability to be caregivers, the very role women are taught verifies femininity.

As professionals, we must be cautious not to engage in self-blaming around the issue of our own art making. On the other hand, we can do much for one another in supporting our efforts as artists. These supportive acts can range from activities on a national or international scale to those occurring between two colleagues. Supportive efforts include activities such as exhibits of artworks by art therapists and slide shows of art therapists' art at national conferences; gallery exhibits of art therapists' work; open studios as an element of art therapy graduate programs (Wix 1995); creative collaborations between art therapists (for example, Moon and Schoenholtz 1998); and artistic exchanges between art therapists (Franklin, Moon, *et al.* 1998, 2000). Bayles and Orland (1993) suggest that "what separates artists from ex-artists is that those who challenge their fears, continue; those who don't quit. Each step of the art making process puts that issue to the test" (p.14). Any efforts we put forth to support one another and to challenge the fears that are an inevitable part of the artistic process not only support us as individual artists, but also support the strength of our collective identity as art therapists.

While it is imperative for us to be compassionate and understanding with one another in regard to our difficulty with engaging in dedicated art making, it is also imperative that we challenge each other to make art none the less. The reasons for this are fourfold. First, as stated above, immersion in our own art making provides an ongoing means of self-education in the art and craft of our work that cannot be gained in any other way. Second, we have a moral responsibility to only ask or expect our clients to engage in work we find value in and are willing to do ourselves. Third, active engagement in art making provides a necessary and healthy challenge to us to

maintain authenticity in our work. Fourth, the strength of our collective identity as art therapists is intimately tied with serious engagement in personal art making.

In regard to the notion of maintaining authenticity in our work, it is important to remember that the practice of art therapy differs from that typically associated with a Western view of artists and art making. While the commercial art world tends to emphasize the individual artist and to credit the objects created to that individual's artistic activity, art therapy fits into an alternate view of the visual arts that is more communally based and more socially responsible. In art therapy, art making frequently occurs in the presence of one or more other people. These "others" are not the curious strangers encountered by artists who draw portraits in malls or paint city-scapes on the street corner. They are therapists intimately involved as guides, witnesses, and companions, or clients engaged as comrades in artistic and therapeutic pursuits. The intent of their work together is antithetical to what Gablik (1991) describes as the "disconnectedness and separation of the aesthetic from the social" (p.5). The work of art therapy is deeply tied to concerns for quality in intra- and interpersonal relationships and is based in an ethic of care.

With this in mind, it seems that our efforts toward authenticity in our work as art therapists compel us to consider engagement in personal art making that is also communally based and concerned with an ethic of care. This art making might take many forms. The "community" might be two people who make art in each other's presence, risking exposure of the raw creations as they are forming. The "community" might be a few art thera-pists from different geographical locations who send artworks to each other and who make art in response to the art objects received, thus setting up an exchange firmly based in the realm of the arts (Franklin, Moon *et al.* 1998). The "community" might be members of the public, as can occur in community-based art therapy (for example, see Timm-Botos 1995). Even the venue of the public art exhibit can be used to deepen our authenticity as art therapists. The act of self-exposure involved in displaying our art publicly may lead to empathy for our clients in their acts of self-exposure within the therapeutic session, if we dare to exhibit work we experience as risky, vulnerable, or raw. We might further the empathic connection if we risk engaging the viewing audience in responding to the work we display

or perform. No matter what form the communal art making takes, it seems an important pursuit for art therapists to consider.

Self-study

The third level of study is self-study. This is an attempt to come to know oneself with as much truth as is possible, for the one "instrument" the artist uses at all times, no matter what media is employed or what content is depicted, is the self. To study the self does not mean ruthless self-analysis. Empathy and sensitivity work much better. None the less, to be unflinchingly honest in our self-study is no easy task. In the words of Willa Cather (1943), "Artistic growth is, more than it is anything else, a refining of the sense of truthfulness. The stupid believe that to be truthful is easy; only the artist…knows how difficult it is" (p.571).

A graduate student I was working with for a period of time reacted quite strongly to some critical feedback I gave her on an evaluation. Her anger almost felt palpable in the room as she spoke about what I had written. Her reaction was so extreme that I was sure the issues were much larger than her relationship with me. However, her issues aside, *I* also had a strong reaction to what she said to me. I was enraged. I felt as if all the effort I had put into our relationship for nine months was completely discounted and that she cast me unfairly in the role of the evil witch. Her subsequent rejection of the caring, nurturing aspects of my identity and her perception of me as the "critical mother" figure caused much disquiet inside me. I was not accustomed to, and did not like, being perceived this way. I sought supervision regarding my relationship with the student, but I knew this was not enough.

In order to examine my own issues, in a way that was disentangled from the relational dynamic, I decided to make some art. I engaged with the distasteful, evil, critical mother part of me by giving her a forum to express herself through art. Inspired by the work of a colleague who made an artwork on a similar theme (C. Moon 2001), I created "The Bitch Queen" (Figure 3.1). Rather than attempt to keep these denigrated aspects of feminine identity under wraps, I decided to allow them to come to life.

Figure 3.1

In the process of creating "The Bitch Queen" I discovered there were things I liked about her. I found her to be strong, spunky, and unafraid to speak her mind. Though I wouldn't want her to take over completely, neither would I want to lose her. Much to my amazement, I even found her to be playful and to possess a keen sense of humor. Through the art process I was able not only to accept the "bitch queen" and discover her admirable characteristics but I also found myself responding to her with a sense of delight. By cooperating with her through the act of creating, rather than rejecting her, I was able to come to know her more clearly and completely. By using my art as a means of self-study, I became less likely to entangle my own issues with those belonging to my student.

The idea of self-study as a significant aspect of ongoing learning is not unique to art therapy. Heuristic study, the "process of internal search through which one discovers the nature and meaning of experience and develops methods and procedures for further investigation and analysis" (Moustakas 1995, p.24) provides a research model based on self-study. Most institutions involved in the training of counselors and therapists incorporate aspects of self-study in their curricula and either encourage or require their students to be in personal therapy concurrent with their academic studies. Likewise, personal therapy on an as-needed basis and

ongoing supervision are considered responsible professional practice for counselors and therapists. For the art therapist, engaging in art making as a means of self-study is an essential component to both education and ongoing professional development. Making art may be an integral aspect of supervision (Durkin *et al.* 1989; Malchiodi and Riley 1996), a way to address counter-transference issues post-session (Fish 1989; Kielo 1991; Lavery 1994; Wadeson, Geiser, and Ramseyer 1990), an essential component of personal therapy, and an additional means for self-understanding and self-awareness. Art offers "a way of nonintellectual knowing, through emotion and body" (Richards 1995). The use of art making to access our inner awareness and wisdom helps us stay authentically connected to the experiences of our clients in art therapy. It also helps us to develop and maintain a trusting relationship with our own artistic process, which is critical if we are to be authentic in our encouragement of clients to do the same.

Disciplined practice

Along with careful attention and rigorous study, the development of an artist identity demands disciplined practice. It often surprises me how people who consider themselves non-artists are quick to explain the origins of artistic ability. They want to ascribe artistic ability to a special giftedness confirmed upon a chosen few or, in a similar vein, to the happenstance of genetics. In my experience as an artist and in helping others cultivate their artistic abilities, I have found that the majority of satisfying art making comes about as a result of slogging hard work. It comes from doing a thing over and over again; from going forward in spite of numerous setbacks, frustrations, and perceived "failures"; from a willingness to dedicate time, attention, and energy to the task of making art. If there is any special gift or genetic endowment that contributes to the shaping of artistic abilities, it seems to me that it is, more than anything else, the gift of a deep, abiding and insistent *need* to make art. Beyond that, whatever successes occur as an artist can be largely attributed to disciplined practice and the ongoing development of a trusting relationship with art making.

Disciplined practice in art making is an aspect of the artistic process that has received little attention in popular literature. The emphasis in much

contemporary writing has been on ridding oneself of critical voices, freeing the creative spirit, and fostering spontaneity (for example, Cassou and Cubley 1995; Gold 1998). Such an emphasis may be a suitable antidote at a societal level for an overemphasis on work, competition, and material possessions. In and of itself, however, this position of advocating spontaneity over discipline is not an adequate emphasis for an art therapist. Such an emphasis, though counteracting an overly self-conscious attitude toward art making, runs the risk of discounting any kind of reflective attitude toward the art product (Maclagan 1982). Some of the clients we work with may need help in quelling the internal critic or facilitating spontaneous expression, but there are other clients for whom this type of focus would be counter-productive. For various reasons, clients may be in need of a more structured, disciplined approach to art making (B. Moon 1994). They may even need to develop an internal critic who can help discern productive and counter-productive actions in art making. Kramer (1971, 1979) emphasizes the manipulation of materials as a way to manage psychic processes. By imposing form and structure in art, the client can transform destructive impulses and produce work that is socially acceptable and personally edifying. Lusebrink (1990) presents a conceptual model, the Expressive Therapies Continuum, for understanding the complex kinesthetic/sensory, perceptual/affective, cognitive/symbolic, and creative levels of expression and interaction that occur when using art media. A purely spontaneous, expressive emphasis in art therapy fails to take into account the complex nature of the artistic process, and the potential of art therapy to effectively respond to diverse needs.

As art therapists it is our responsibility to engage ourselves in our personal art making not merely as a passing whim but as an intentional, disciplined practice. We have to know through personal experience the dialectics of the artistic process – expression and containment, destruction and creation, control and spontaneity – if we are to be adequately equipped to assist our clients in choosing art processes and media that best fit their goals for therapy. If we only have a superficial relationship with our own art-making process, it is unlikely that we will have the depth and breadth of knowledge necessary to serve as someone else's guide through the processes and product-making of the arts.

Disciplined practice does not mean that we must eschew spontaneous expression in favor of painstakingly rendered realism or a strict focus on the formal elements in art. Disciplined practice has to do with a commitment of time, energy, and attention. More than anything else, discipline has to do with sticking with something, past the point where it becomes difficult or frustrating or challenging. If we do not persevere in the relationship with our own art making, how can we ask this of our clients? And if we do not ask this of our clients, where is the integrity in our work?

What occurs when we engage with our art making in a disciplined way is we experience first hand the paradox inherent in art making – that discipline and spontaneity are partners in the artistic process. The more we practice, the more we do something again and again, the more comfortable we become and the freer we are to be spontaneous. What has been noted in relation to the art therapy context, "once the boundaries have been established the freedom has begun" (B. Moon, 1990, p.50), also has relevance in our own art making. On the flip side of the relationship, spontaneity can help give us a "jump start," engaging our passionate energy for art making so that we have the impetus to slog through the more difficult periods when we can't seem to mix the right color of paint, or the clay won't hold its shape, or we step back and realize we've overworked a piece. If discipline becomes dominant, turning our art making into nothing more than dogged obligation and drudgery, it is our sense of spontaneity and playfulness that we need to come to the rescue. If spontaneity is dominant, the work becomes shallow and poorly crafted. Discipline helps bring depth and meaning to the work, along with a development of the technical expertise necessary for expressing one's intentions clearly through art. Maintaining balance between discipline and spontaneity is an ongoing process. Understanding this process first hand enables us to be more empathic and informed guides as we help clients achieve artistic and therapeutic aims.

It is tempting to avoid discipline altogether because of the seductive "high" offered by spontaneous expression. It appears there is no way to fail in such instinctive artistic release since there are no standards to which to be held accountable. Once the element of discipline is introduced, the manner in which the object is crafted becomes important and attention is given to the character and quality of expression. For some art therapy clients, it may be fitting that the emphasis of the work is on the process of art making as a

cathartic release. But when the art therapist's personal and professional work is exclusively focused on spontaneous expression, there is a significant aspect of the art process missing. In such cases, it is likely that the range of art experiences offered to clients will also be limited and some clients may not receive the art therapy approach that best meets their treatment needs.

Bayles and Orland (1993) suggest it is our fears that most often interfere with our ability to engage in serious, disciplined art making. For those who work in spite of their fears, "naive passion, which promotes work done in ignorance of obstacles, becomes – with courage – informed passion, which promotes work done in full acceptance of those obstacles" (p.50). If we are to be helpful to clients with the various problems and potentials they bring to the art therapy studio, we need to be competent in helping them not only achieve cathartic expression but also well-crafted objects that are the product of their "informed passion."

I am aware that this focus on disciplined art making may stir up feelings of dismay or self-reproach in some art therapists. This is not my intention, as I know there are many compelling reasons why art therapists have difficulty making their own art in a consistent way over time. However, puttering with art materials or slapping together an art product at the moti- vation of a guilty conscience, just to be able to say, "There! I've made some art!" is not the answer. If it is used as the solution, I fear this will be reflected in the kind and quality of art therapy we offer our clients. Instead, I believe the answer lies in finding ways to integrate the practice of art making into our lives so that it is in sympathy with the work we do and the lives we lead as art therapists. This is no small challenge!

Engaging in disciplined art making has to do with a commitment of time, energy, and attention. The first step in looking at how to integrate disciplined art making into a busy and committed life is to try to put aside preconceived notions of what it means to be a disciplined, committed artist. Perhaps we have the idea that a certain commitment of time is required in order to be considered a "serious" artist. We might think a *real* artist has a particular kind of space within which to make art. Maybe we hold certain criteria for determining who is a true artist, based on the use of certain kinds of art materials or the creation of a certain size or quantity of art products. We might think that exhibiting artwork is the earmark of a disci-

plined, committed artist. In fact, art making varies greatly in its manifestation, and art therapists pursue art making for a variety of reasons – therapy, catharsis, problem solving, healing, aesthetic concerns (Wadeson *et al.* 1999), pleasure, activism, and so on. If we can begin with the concept that committed, disciplined art making comes in many shapes, sizes, and varieties, we will be much more likely to find scenarios that work for us as individuals.

Since many (and probably most) of us believe our lives to be plenty busy already, it makes sense to first look at how we might integrate art making into the routine of our daily lives. The following are some suggestions. These are not meant to be either dogmatic or exhaustive but hopefully will spark new ideas and adaptations that fit the individual circumstances encountered by each of us in our busy lives. The key for each of us is to discern where we are currently expending time, energy, and attention, and to discover how slight adaptations can be made to integrate art making into our normal routines.

1. Consider making art along with your clients. Though this goes against recommended practice in some art therapy training programs, it is an option that merits consideration. (I write in much more detail about this topic in Chapter Eight.)

2. Consider having an ongoing art piece at your place of employment. It would need to be a piece that lends itself to being worked on over time. Materials that do not involve a lot of preparation and clean-up time are suitable for such an endeavor. The working area for the art piece could be a private space, like a personal office, or a more public space where other staff and clients would see the piece in progress. Ideally, your employer would support your efforts and you would have time during your regular workday to devote to development of the art piece. In most settings this will not be the case and time to work on the piece will be before or after the scheduled workday, during breaks, or during the lunch hour.

3. As a variation on (2), have an ongoing art project at work that is something you are making with other staff and/or clients. This job-related emphasis may make it more acceptable in the eyes of

the employer as something to be engaged in during work hours. It also may help you maintain a commitment to art making because you are accountable to other people as well as yourself. Without this accountability it is easy to be pulled toward other demands of the job and away from art making.

4. Carry a sketchbook with you wherever you go. Use it whenever you get a chance – during breaks at work, during team meetings, during lectures or presentations, when you are stuck in a traffic jam, when you are riding public transportation, when you are waiting for your child to finish baseball practice, and so on. This may be one of those art forms not viewed as "serious" art making. But why not? If your time, energy, and attention are only available in small snatches, then a sketchbook is a very natural form for disciplined art making. It also provides a rich resource of ideas when you have more prolonged art-making time available.

5. If you have young children, make art with or alongside them. Find ways of working that allow your child some amount of independence so you can devote your efforts toward your own art making as well.

Along with integrating art making into the activities of our daily lives, an ideal for many of us is to have art making time set apart from our daily routine. Some art therapists are able to set aside time for art-making in a consistent and disciplined way, but others find the demands of work, school, and/or family life take precedence and the art making time gets squeezed out. For those who have difficulty finding time for art making, it can be helpful to be accountable to someone else for the necessary commitment of time, energy, and attention. I have mentioned that there are ways we can be supportive of one another in regards to our artistic identity. The flip side of this is to seek out this support in a way that helps us be accountable. The following are some suggestions for how to do this.

1. Find an "art partner" and set up regular times to get together and make art.

2. Form an artists' support group. The group meetings can consist of making art together and/or sharing art that is made between group meetings.

3. Take an art class. The regular meeting times, financial commitment, community of learners, and intellectual stimulation all can help spark devoted art making.

4. Enlist the help of an art mentor. Set up regular times to meet for advisement, coaching, or instruction in regard to the development of a body of work.

5. If you are someone who is motivated by an investment of money, rent a studio space. If you are someone who is inspired by working in close proximity with other artists, rent a space cooperatively with other artists, or rent a space that is part of an established artists' community.

6. If you are motivated by structure, make use of a book that guides your art-making process (for example, Allen 1995a; Malchiodi 1998).

7. Commit to participating in an individual or group exhibit at a gallery or alternative space so that you have a goal and deadline for completing a body of work.

8. Work with other artists on collaborative projects such as performance art, large-scale murals, installations, and so on.

9. Become involved in an art exchange with other artists or art therapists who live in other parts of the country. Agree on a timetable for the completion of art pieces. Send the artworks (or photos of artworks) to art exchange partners and then make art in response to what you each receive.

These ideas for integrating art into the existing activities of our lives and for setting aside time for art making are intended to be practical and realistic in nature. They are also intended to be in keeping with the busy and demanding lives of most art therapists. They can be adapted, modified, or replaced with other ideas for integrating art making into daily life. The

underlying imperative remains – make art! We must keep making art, in spite of all the obstacles (real or imagined) that may exist. There is no more important foundation upon which to cultivate an artist identity than to get to the studio (or kitchen, or office, or subway, or other suitable place) and make art.

Conclusions

The cultivation of an artist identity is a life-long pursuit. It involves the development of our artistic sensibilities and a commitment to continuing education through didactic learning, immersion in the arts, and self-study. It requires our willingness to engage in the disciplined practice of our craft.

The paradoxical counterpart to any pursuit of knowledge is the experience of becoming keenly aware of what we don't know. While not always a particularly comfortable position to be in, not-knowing has positive ramifications for both our artistic and therapeutic encounters. Our willingness to be in a position of uncertainty creates the likelihood that we will be able to appreciate the ongoing process of learning and enables us to be open to our own experiences as well as the experiences of others. Not-knowing creates an open space into which new knowledge and new understanding can easily make its way (Edwards 1992; Franklin, Farelly-Hansen, *et al.* 2000). A necessary part of any artistic process, this creative confusion prevents us from "being blind to the unseen and deaf to the unheard" (Brederode 1999, p.155).

The process of cultivating our artist identities is a process of readying. It creates in us increased clarity and confidence, as well as an increased awareness of uncertainty. This delicate balance of knowing and not knowing enables us to engage in artistic and therapeutic encounters with openness and a welcoming attitude toward growth in others and ourselves.

Creating the Studio Space

Our personal relationships to history and place form us, as individuals and groups, and in reciprocal ways we form them (Lippard 1997, p.9)

Warm summer air sifts in through the house where Simon and his family live. It is one of those evenings when Simon, in spite of his love for painting, must resist my tempting array of brightly colored jars. During his life-span, all five years of it, he has learned that running away, or doing funny things to make people laugh, or whining, or lying on the floor and screaming will put him in charge of the adults in his life.

Tonight he is crouched under the kitchen table, saying "no" when I remind him it is time to make art. As I approach him he scurries away, giggling, to find another "hiding" place. I do not follow him. I sigh loudly, so he can hear me. I say, " I am ready to make art. I feel sad that Simon is not ready to join me. I will sit on this kitchen chair and wait for Simon to be ready." He runs by me, close but out of reach, attempting to bait me. I say, "I am ready to make art. I feel sad that you are not ready to join me, Simon. I have the paints you love to use. I will sit in the kitchen with the paints until you are ready. When you are ready, I will be here."

While this is going on, Simon's mother watches from the living room, trying not to laugh at her little charmer. Simon's dad yells at him from time to time, demanding that Simon join me in the kitchen, but does not have any follow-up response when Simon disregards him. I maintain my vigil, remaining firmly planted in my chair and consistently letting Simon know that I will be available to him when

he is ready to join me. Before long, the desire for the paints I hold becomes stronger than his need to be in control. He comes over and asks me what we are going to paint today. I respond by letting him know I am glad he has joined me, that I believe in him and his ability to join me. I say I will tell him what we are going to do once we have carried our supplies out to the back porch, our "studio" on these warm days.

We head out to the porch, arms full of paints, brushes, paper, rags, and a jar of water. We take the only route available in this tiny house, the same route we always take, through the parents' bedroom. Since the door to the bedroom is wide open it never occurs to me that someone is in there. But surprise! We walk in on Simon's father while he is changing his pants! I mumble an apology and back out quickly. Simon's father scurries out a moment later, completely dressed again and laughing uncomfortably. Once again, Simon and I proceed to our porch studio.

The words "Studio Art Therapy" often conjure up an image of a spacious room with lots of light, an abundance of easels, canvases stacked against the walls, and shelves nearly dripping with art supplies. Adjacent rooms, in this art therapy studio of the imagination, house the ceramics studio, the sculpture studio, and the wood shop. It is imagined to be a place where paint can be spattered on table tops and bits of clay dropped on the floor with no harm done, a place where the evidence of works of art in various stages of completion are all about.

There are art therapy studios that fit or at least come close to this description. They are the kind of places that many artists and art therapists covet. The reality is, however, art therapists are often working in spaces that are less than ideal. These spaces include environments like the day room of a nursing home, an office barely bigger than a broom closet, the bedside of a medically ill person, the living room of a client's home, the kitchen of a women's shelter, the recreation room of a hospital psychiatric unit, and so on. Many of these spaces serve multiple purposes and are used by people other than the art therapist or art therapy clients (sometimes concurrently with art therapy sessions). This leads many art therapists or program administrators to the erroneous assumption that a studio model of art

therapy would be impossible due to the limitations of the setting or the lack of resources to transform the setting. The ability to imagine the ideal studio setting becomes a roadblock rather than a point of access toward making that ideal as real as possible. It becomes the *only* image of the place where a studio approach to art therapy can be practiced.

Whatever the setting, the art therapy studio never is something we merely acquire as passive recipients. We take part in shaping and molding our workspaces. Whether intentionally or unintentionally, we are instrumental in creating the kind of art therapy studio we will provide for our clients. There may be aspects of the physical space that are unalterable "givens," and people in administrative positions may exert considerable influence over the character of the studio setting. However, we still have a responsibility to be intentional in creating, out of whatever space, materials, and philosophical raw materials we are handed, a studio environment conducive to therapeutic work.

Art therapy studios come in all varieties. Few of them are ideal spaces. Many of them are different places from the ones we once envisioned ourselves working in. They take on the characteristics of the setting and so may be tidy, professional, spacious, and well stocked, or they may by unkempt, "homey," tiny, and depleted. They may be within the structure of a safe, contained environment or they may be plopped down smack in the chaos of boundary-less lives. They may run as smoothly as a well-oiled machine or they may be full of unexpected, unanticipated surprises, even half-dressed fathers!

The creation of an effective therapeutic studio environment has been discussed in art therapy literature. Aspects of the studio environment that have been addressed have included the arrangement of the physical space, the kinds and quality of materials provided, the presence of the therapist as an element of the environmental milieu, tailoring the space to fit the needs of clients, and the philosophical underpinnings of the studio (Allen 1995b; Ault 1989; Cane 1983; Case and Dalley 1992; Cheney 1993; Deco 1998; Gold 1998; Henley 1992b, 1995a, 1997b; McGraw 1995; McNiff 1995; B. Moon 1998; Perdoux 1996; Rubin 1984; Wadeson 1980, 1987). These aspects, in combination with the ineffable "spirit" of the studio, are the basic ingredients for the creation of an art therapy studio.

The ability to use our artistic sensibilities to envision our practice of art therapy means we are able to see multiple possibilities within circumstance and place. To consider the "poetry of place" is to allow the flexible, subtle, imaginative, innovative, and versatile qualities of our artistic sensibilities to help us find points of access toward our ideals. The practice of a studio model of art therapy is possible anywhere.

I was fortunate to have worked for many years in the type of setting that other art therapists often covet, a private psychiatric hospital where the art therapy studio was not perfect but was not far removed from the imagined studio described above. I have supervised students whose practicum placements were in settings where the space for them to work was anything but the ideal and the art supplies were meager or nonexistent. I currently have a private practice located in the back room of a community gallery space. I also do contract work for an agency that provides mobile therapists for families. In this work, my "studio" is most often the client's home. These various experiences have given me the opportunity to create, or help create, many studio environments, sometimes in the most unlikely of places.

A sense of "place" is created not only out of the physical space and material resources but also out of our ability to make use of chance and circumstance as necessary environmental ingredients. My work as a mobile therapist is a good case in point. In terms of physical space, my "studios" have been the kitchens, living rooms, and porches of cramped, run-down apartments where the low-income families I work with live. The agency that hired me provides no art materials and the families I work with often do not have even the most rudimentary of supplies, like glue, rubber bands, or a hammer. Yet I still practice studio art therapy. The back of my car is my art cupboard. One of my clients, a five-year-old, rushes out when I come and begs to be the one to open the tailgate so he can see what treasures my car holds. When the weather is nice, the "studio" is the yard or the porch. At other times we clear away food, full ashtrays, toys, magazines, and old mail from the kitchen table or the coffee table to make room for the art supplies. For the hour or two I am there, the living room or porch or kitchen becomes transformed into a "homey" art studio, replete with younger sisters who eat the art supplies, fathers who yell, neighbors' kids who stop by and want to paint too, big sisters who burn dinner, mothers who pull curlers from their hair to rush off and play bingo while children cry and beg them

not to go, and police who stop by because they heard some noise and wondered if everything was all right. It is a far cry from the idealized image most people have of a quiet studio environment, a sanctuary set apart from the rest of life. Instead, it is a studio smacked down, dead center, in the middle of life. The poetry of these places is found in the pungent smell of burning food, the staccato notes of conflict, the way the lives of family members bump and twirl and tangle into a frenzy and then smooth out again into love and longing. We never lack for "stuff" to work with, so in this way it is an ideal studio environment. Against all the odds, and perhaps because the odds are against us, we make art.

The spirit of the studio

Bachelard (1958), in discussing the structures we live in, states, "A house that has been experienced is not an inert box. Inhabited space transcends geometric space" (p.47). What is true for our homes is also true of our workspaces. Our studios and offices transcend their physical character-istics. What is it that gives a space that animating, vital, essential quality we identify as the "spirit" of the place? What kind of spirit or prevailing tone do we want to establish in our art therapy studios? These questions are as important, if not more important, than questions regarding the physical space of the studio, though undoubtedly the spirit and the physicality of a space are intertwined.

Identifying and creating the desired spirit of a studio space is a difficult topic to write about, for the spirit of a place has to do with qualities not easily named, located, or defined. It seems easier to begin by identifying what we must work against in order to create a healthy studio environment.

In Western society, the artist's studio is often viewed as a sacred, myste-rious place where skills not attainable by "common folk" are employed in order to create objects to be held in awe. Conversely, artists' studios are also commonly viewed as the site for frivolous activity undertaken as a hobby or undertaken by those too undisciplined to get a "real" job. The art therapist must combat these ideas in order to establish an atmosphere where each person is viewed as uniquely capable of artistic expression, where the process of creating is as important as what is created, where spontaneous expression and disciplined practice are understood to be interdependent

aspects of creativity, and where both the person creating and the thing
created are treated with respect and dignity.

Misconceptions about the "therapy" aspect of art therapy also can
interfere with the creation of a healthy studio environment. In my
experience, the most common and damaging misconception held by
neophyte clients in a setting where studio art therapy is practiced is the
belief that artworks will be interpreted or analyzed by the art therapist.
There is good reason for this misunderstanding, since interpretation of
artworks has been a common occurrence in art therapy practice. The client
in a studio setting rarely views analysis or interpretation of artworks as
potentially enlightening or enriching; more often an analytical perspective
is perceived to be intrusively probing, critically judgmental, or both. For
many clients, this belief has an intimidating, potentially stifling influence
that strongly interferes with the artistic process. If clients are to receive
maximum benefits from the art therapy studio, they must experience it as a
place both physically and psychologically safe.

If these misconceptions about art and art therapy are what we must
work against in a studio approach to art therapy, what is it we want to foster
in place of these ideas? Kramer (1994) identifies the healthy studio
environment as a place where there is "space for improvisation, openness to
the unexpected, acceptance of the eccentric" (p.92). Allen (1995b) identi-
fies the primary attribute of a studio setting to be energy, while McNiff
(1995) describes the studio as an "ecology of mutual influences" (p.181)
and Henley (1995a) believes the effective studio provides both inspiration
and sanctuary. While we all may nod our heads in enthusiastic agreement
with these descriptions, the question still remains: how do we create such
an atmosphere? And how do we create it not only in the most ideal but also
in the most challenging of studio environments?

Creating a sense of place

Barbara, a volunteer at the community art gallery where I work, tells
me she loves being in this space. I agree. I look around at the
punched-tin ceiling hovering high above us, the undulating,
polished wood floors beneath our feet, the white walls that have

been spackled and painted over innumerable times. I wonder what it is about this quirky place that works its magic on us, that draws us here to volunteer our time. Is it the charm of its flaws? The stories it holds from years gone by? The comforting way it creaks and groans when we move through it, as if expressing its empathy for our troubles? I am not sure. I only know I like being here.

I hurry to the back room where my studio and private practice space is located. I must gather some art materials for the session I am to have at Simon's home. Light from the ten-foot high windows floods the room, falling across the insulation that pokes out around the window frames, glinting off the coil of electrical wires that hang suspended from the ceiling. I make a mental note: I must call the electrician again to see when he will be back to finish the job. I run my eyes over the shelves that line one wall. They are filled with fabric and yarn lined up in tempting arrays of color; jars of pencils and coffee tins full of crayons like small treats; broken bits of ceramic tile and beads like glittering jewels; paint jars and brushes and magazines and all the things that make an ever-available art feast here in this humble space. I think about what Simon needs to nurture him today and pick up a box of wood scraps and the glue gun. I hurry back through the gallery space, waving good-bye to Barbara as I go. I open the tailgate of my vehicle and add the wood and glue gun to the supplies already in my mobile "art cupboard."

When I arrive at Simon's house I hear Thomas, his father, yelling something in a combination of English and Spanish. I see their rusty station wagon with one side dipping toward the ground as if it can hardly hold itself up. Around the perimeter of the house are rocks, weeds, and litter posing as a lawn. Before I reach the front door Simon's younger sister, Camille, runs out, bare bottom and legs exposed to the brisk autumn air. Carmen, her older sister, is chasing her, waving a pair of pants in the air and demanding that Camille "get back here this instant!" Camille spots me and stops up short, shouting exuberantly, "Cathy Moon!" Her sister scoops her up and carries her into the house while Camille struggles to escape again. I follow them in.

Once inside, I survey the surroundings. The kitchen table is strewn with papers, half-eaten food, an overflowing ashtray, children's toys, and a couple of bags of groceries that have not yet been put away. Thomas greets me with, "Look at this mess, Cathy. I can't stand this. Nobody cleans up around here." Trudy, Simon's mother, walks in and Thomas turns his attention to her. He asks in an accusing tone why Carmen has not done the dishes, put away the groceries, and picked up the toys lying around. Trudy shrugs, asks him to stop yelling, and greets me. I can hear Simon's voice coming from his bedroom. He is crying and yelling loudly. Trudy explains that she has just told him there are no more Popsicles left and he is upset. She confides in me that it has been a difficult day for Simon. He might give me some trouble.

I walk over to his room and peer in. I greet him. His room looks as if a bomb has exploded in it, clothes and toys hanging out of drawers, spilling out of the closet, covering the floor like a churning sea. Simon sits in a heap in the middle of it all. I take a deep breath and think about making our studio space today, a place for Simon and me to make art together, here in the midst of the yelling, running, chasing, exuberant cries, struggle, strewn papers, chewed food, cigarette butts, complaining, spilling, and chaos. I sigh. It is not the first time I have wished I could meet with Simon in the relative quiet of my private practice space. It would be so much easier. Then I remind myself of the richness here, of the abundance we have to work with in creating our studio space. It will be no quiet sanctuary studio, but it has the potential to be an energetic, creative, fully alive place.

In order to create a sense of place in unlikely spaces, it is necessary to shake loose from a common notion about the ideal studio space of the artist. It is not unusual to find descriptions of the idyllic studio as a place set apart, "a place as free of outside intrusions as possible" (Audette 1993, p.38) where the artist works in splendid isolation. Gold (1998) even extends this idea of a distraction-free environment to exclude music, the outdoor environment, and the keeping of a journal.

The idea of the lone artist working within the protection of a secluded environment is a relatively recent phenomenon in Western art. It was roughly during the seventeenth century that art as a "portable commodity" (for example, the framed painting) became common and the artist's work was no longer undertaken almost exclusively in the context of architecture. The artist was thus freed from waiting passively for commissions and from the constraints of working solely for art patrons who dictated the work to be done. Increased freedom of expression by artists and the stimulation of commerce in art were the results of this shift (Museum of Contemporary Art, San Diego 1997). The merits of viewing art as an individual pursuit and the idea of art for art's sake are currently being challenged in the art world. While freedom of expression is valued, there is concern that art is "not connected in any profound sense with the world, but is used more as a kind of solace, or retreat, from it" (Gablik 1995, p.47). Indeed, Kapitan (1997) points to the potential danger of the art therapist's retreat to the studio as a way of turning away from the needs of the world, in particular to deny or hide from the culture of violence all around us.

From both practical and philosophical perspectives, it is clear that the idea of a studio space totally removed from the distractions and disturbances of life does not fit a studio art therapy model. From a practical perspective, the quiet, secluded sanctuary space is seldom the setting we inherit in art therapy practices. Out of the variety of art therapy studio environments, a private practice space is most likely to have the ambiance of a quiet space set apart from the rest of the world. More often though, art therapy studios are busy, noisy, active places that shape and are shaped by the surrounding environment.

Philosophical considerations point to the reality that the majority of clients we serve would not come to us if the resolution of problems could occur in solitary, isolated pursuits. There would be no need. Most of our clients' difficulties occur in the context of relationships – with the self, others, the culture, and the environment – and so therapy must be relational and contextual in nature in order to be of benefit. From both a practical and a philosophical perspective it is important that art therapy studios maintain a connection *with* the world rather than serve as a retreat *from* the world.

This is not to say that the idea of the studio as sanctuary is irrelevant to art therapy practice. The quiet, contained, soothing environment of the

sanctuary may be precisely what would be most beneficial for a particular client at a particular point in time. It is highly unlikely, however, that all clients at all times would receive maximum benefit from a sanctuary-like studio setting. The art therapy studio is set up to serve a variety of needs; therefore, one of its characteristics must be flexibility. Henley (1992b) suggests partitioning the therapeutic studio into work stations or mini-studios differentiated by media or technique, by individual or group needs, or by degree of stimulation needed. In other situations, such as mobile therapy, home hospice work, or bedside art therapy in a medical hospital, there is no permanent place where art therapy occurs. In these situations the degree of flexibility required is even more challenging. The art therapist must continually create the therapeutic studio in each succes-sive environment, at each session. In these settings it is clear that if there is to be a therapeutic studio the art therapist must be the carrier of the spirit of the studio, ready to act as catalyst and co-creator in setting up the studio environment out of whatever is at hand.

Milieu therapy

In my own training and early years of working as an art therapist, I was fortunate to have worked at Harding Hospital, a private psychiatric hospital in Ohio influenced by the milieu therapy approach developed at the Menninger Clinic in Topeka, Kansas. In brief, this approach involved the philosophy of treating the person rather than the disease and in attending to all aspects of the environment as influential components of the treatment program. The attempt was made to provide a consistent and uniform approach to each individual patient. All of the hospital staff members – nurses, attendants, therapists, housekeeping staff, and doctors – were considered to be significant figures in the milieu setting and all were encouraged to consistently convey the prescribed attitude for each individual patient. Patients attended group activity therapy sessions, but the purpose of any activity for particular individuals could vary widely. It was understood that a singular therapeutic activity could be employed with very different therapeutic intentions and conveyed with a very different therapeutic "attitude" (for example, kind firmness) according to the needs of the individual patient. In this way a rich and varied array of individual-

ized treatment was possible within the limitations of the available physical space and materials.

While the contained, controlled environment this approach provided is seldom, if ever, possible in today's healthcare environment, the underlying philosophy and way of working is still relevant in three ways. First, it continues to be crucial for therapists to attend to all aspects of the environment as being influential, as having potential to either interfere with or enhance the therapeutic work. Second, it remains a reality that everyone in the environment affects the therapeutic work and plays a part in creating the spirit of the studio. Third, the need persists, in the current treatment context, for a studio environment with enough flexibility to intentionally address the needs of individuals.

The first lesson of a milieu therapy approach, with the emphasis on attending to all aspects of the environment as having the potential to either interfere with or enhance the therapeutic work, may seem like a daunting task. If we approach the environment with the idea of shaping it according to our own ideals, then it is an overwhelming task. If, instead, we think in terms of entering into a creative partnership with the environmental elements, we are more likely to feel energized and empowered. When aspects of the environment are beyond our ability to control, it makes sense to consider how we can make use of these aspects to further therapy. For example, it is not possible for me to ensure that I will encounter a neat, tidy and orderly space when I arrive at Simon's house. As a co-creator of the studio environment within the home setting, it is my job not only to do what I can to help create the minimal order I deem essential, but also to creatively harness the available activity and energy so that it becomes part of the creative fervor. This may involve something as subtle as a shift in my perception from viewing it as a "messy house" to a "lively home." Or it may involve something much more overt, such as gathering discarded materials from the environment to be incorporated into our art making, literally taking what is richly and abundantly available and working with it.

Second, a milieu therapy approach is relevant in that it points to the reality that everyone in the environment affects the therapeutic work. Everyone helps to create the spirit of the studio. I can fight against this reality by attempting to ignore the influence of other people or by attempting to control what other people do (usually with the underlying

assumption that my way is the right way and their way is the wrong way!). Another alternative is to work with everyone in the environment, in a spirit of collaboration, to create the studio space. Nowhere has this necessity become clearer to me than in my job as a mobile art therapist working with people in their homes.

Before addressing the third lesson of a milieu therapy approach, I offer the following story in order to illustrate a controlling versus collaborative approach to working with whoever is part of the therapy environment.

I am working with Tom, an adolescent boy, in the cramped kitchen of his family's apartment. It is mid December and the normal sprinkling of drop-in visitors has increased to a steady rain of people knocking at the door or "popping in." Friends and relatives stop by to drop off holiday cookies, share news of sales at local stores, play cards, or gossip about neighbors. I am frustrated. Tom is easily distracted and must constantly be redirected back to his artwork, pulled from enticing card games, movies, or bits of gossip.

Tom's adult stepbrother, Max, a frequent visitor, arrives at the apartment. As often occurs, he is stopping by on his way home from work. Tom jumps up from the table to greet him and they engage in a friendly tussle, showing off moves they have learned from wrestling shows on television. I am frustrated. I speak to Charlene, Tom's mother, about my concerns. She agrees that Tom is easily distracted by the visitors but says she cannot ask friends and family members to leave her home. Interpreting Charlene's reluctance to be a lack of assertiveness, I ask her permission to speak to Max myself. With some hesitation, she agrees.

When an opportune moment arises, I step aside with Max and relay my concerns to him. I let him know that I have no bad feelings toward him, but believe his visits aggravate Tom's distractibility. I ask him if it would be possible for him to visit at times other than those I have scheduled with Tom. He apologizes quickly, saying he didn't know he was causing trouble and telling me "no problem, no problem." I am not sure he has heard me in the way I intended, but I am reassured that he will change his visits to other days or times.

It is the following Tuesday and I arrive at Tom's house for our session. We manage to make it through the whole session with no disruptions from visitors. Even Max does not show up. As I am preparing to leave, Tom informs me that his father is really angry with me. He says his father does not like what I said to Max. This mystifies me since I believe I talked to Max in a sensitive manner and had Tom's best interests at heart. Tom's father, Pete, is not home at the time, so I have no way to check this out with him.

It is two days later and Pete scowls in my direction when I arrive at their apartment, acknowledging me only with a grunt and then turning away. I decide to meet this head on. I tell him Tom informed me that he was angry with me. As soon as I say this, a torrent of angry words is unleashed from Pete's mouth. It begins with, "You're damn right I'm angry! How dare you tell my son he's not allowed in my house!", and continues with a jumble of shouts, curses, and unfavorable descriptions of certain body parts. It is not the first time I have heard Pete unleash his anger like this, but it is the first time it has been directed toward me. I try to respond to him calmly, explaining the situation from my perspective, but he hears none of it and storms out of the house.

For several weeks I am uncertain about what to do. Max has resumed his visits, but he makes them quick stops and avoids me while he is there. Pete is not around so I have no opportunity to discuss things with him. One day I arrive and Max is settled into the couch, watching a videotaped movie. I am uncomfortable with how the situation has been left unresolved, so I ask Max if I may speak to him. My intention is merely to acknowledge the disagreement I had with his father and to ask him his view of the matter. Before I can get these words out, Max is reassuring me that he is on his way out and scurries through the front door.

Tom has watched this interchange and tells me his father is going to be really mad at me. I tell Tom I know this, but say I am concerned about the disruptions to our sessions. I tell him I want him to have the time, space, and attention he deserves. At this point, I still think I know, and am doing, what is best for Tom. Tom sets me straight. He informs me, "Actually, I'm kind of mad at you too." "Why?" I ask. He

speaks to me quite articulately about the relationships in his family, about how important it is to them to be a family. In a much more restrained way than his father, he lets me know that I have over-stepped my bounds by attempting to dictate how and when they make connections with one another. He does not say, "How dare you!?" but I realize he is only being kind. He has every right to say this to me.

The next time I come to their house Pete is home. Almost imme-diately he begins haranguing me again for the way I have treated his son, berating me for "kicking Max out." I listen to him, try to hear what he is telling me through the yelling and swearing. Then I ask him if I can talk to him about it. He grunts and sits down on the couch. I think this is the closest he will come to telling me he is listening, so I begin to speak. I tell him why I raised this issue in the first place, that I was trying to protect Tom's time with me. I tell him I think Tom is worth the time. Pete begins to protest, grumbling about that being "a bunch of bullshit." I take a deep breath, say in an even voice, "But I am sorry." I can tell I have Pete's attention now, even though he does not look at me. "I am sorry that I caused hurt feelings and anger in your family. I did not mean to do that. I did not consider how all of you would feel." Brusquely, Pete says, "That's okay, all's forgotten." He waves his hand through the air as if erasing what's been between us, gives me a quick smile, and turns his attention to the newspaper. This seems a rather abrupt ending to our conversation, not in keeping with my view of talking through a conflict. But I have learned my lesson. I ponder the cleared space between us and keep my mouth shut.

Many months later, when I arrive at Tom's house it is not Max who is there, but Tom's friend Shereen. She is sitting at the kitchen table eating a bowl of cereal. Shereen's parents are going through some kind of crisis and she is staying with Tom's family for a few days. I have a bag of clay with me. Tom tells me Shereen likes art. I take this as a message and invite her to join us in our work. As it turns out, Shereen is a good influence on Tom. She challenges him when he becomes resistant and encourages him to express his feelings with

the clay. She tells him she wishes she had an art therapist to work with.

This is not always the way it goes. Sometimes the visitors crowd out any possibility of risk taking or self-revelation on Tom's part. Sometimes, I suspect, he uses their presence to avoid what he needs to address in therapy. But this is the rhythm of his life and I have joined in it with him. Together we create the studio space out of what is at hand. At times we engage the visitors as allies, as co-creators. At other times we escape to the back porch to work or take a walk around the neighborhood, creating quiet, fleeting sanctuaries out of the chance and circumstance of his life.

The third aspect of milieu therapy that remains relevant to the studio art therapist has to do with creating a flexible studio environment. When it is possible, the physical space can be a strong communicator of flexibility and can provide the potential for adaptation to individual needs. In considering the milieu to be more than the physical space, it also becomes possible to create this flexible, adaptable studio environment even when there is no permanent site in which the studio is housed or when the studio is less than the ideal environment. In such cases, the flexible, adaptable spirit of the studio is conveyed by shifts in therapeutic intention and in the therapeutic attitude conveyed. This flexibility and adaptability can occur in spite of, and perhaps even in response to, the limitations of available physical space and materials.

As an example, one of the limitations of my private practice space is that it is not conducive to absolute privacy. Since it exists within a semi-public space, there is no way to unconditionally guarantee that a session will not be disrupted. Those who pass through the space are the many volunteers involved in the arts organization, as well as students and instructors from the fencing studio on the floor above. The one and only bathroom in the building is located in the back room of the gallery. I have made physical adjustments to the space – "please do not disturb" signs and a folding screen to provide visual privacy. I have made it known to those who use the building that the privacy of my space is to be respected, and I speak to persons who intrude on the space due to a lack of awareness or sensitivity. I make every attempt to schedule sessions when the building is not otherwise

in use. Though rare, intrusions still occur. The clients who see me for art therapy (or, in the case of children, their parent or guardian) are made aware of the situation before we begin to work together and are willing to accommodate to the limitations of the space. Beyond this, there is nothing I can do (within my financial means) to change the reality of the physical space. The flexibility called for thus becomes flexibility of therapeutic intention and the therapeutic attitude conveyed.

For Rory, an eight-year-old boy who is easily stimulated, my therapeutic intention is to help him make good choices about how he responds to these disruptions. When people who have come to use the bathroom distract him, I use an attitude of kind firmness to redirect him back to the task at hand. I try to help him discover ways to redirect himself. For Megan, a 16-year-old girl who has a history of sexual abuse, my therapeutic intention is to help her establish clear boundaries about what she will share, when she will share it, and with whom. I model ways of handling intrusions, such as allowing her to overhear me setting limits with someone who has infringed on our space. I support her setting of boundaries by working by her side, in quiet attention to the artwork, until the person in the bathroom has left and she is ready to talk openly again. My therapeutic attitude is one of support, particularly to her process of empowerment. In both my work with Rory and my work with Megan I consider this "limitation" of the setting also to be an opportunity. It gives us a here-and-now experience of disruption and intrusion with which to work and thus provides a place to practice what will occur in many ways in the rest of life. The opportunity occurs within the context of an adaptable studio environment, where flexibility in therapeutic intention and therapeutic attitudes fosters healthy responses to the circumstances of life as they present themselves.

The physical space of the studio

Most of us hold inside a vision of the perfect studio space. We may be painfully aware of how our current workspace falls short of our imagined ideal. Or perhaps we recognize our good fortune, seeing the attributes of our physical environment in spite of its shortcomings. We may understand that the setting could be worse, and that many art therapists work in more

challenging spaces. Or perhaps we don't really give our workspace much thought, accepting it as a reality without questioning whether or how it might be transformed, without considering whether it is in need of transformation.

It is easy to identify circumstances that can interfere with re-imagining our workspaces. We may cite lack of money, time, resources, support, or creative energy as reasons why we don't seriously consider the intentional reshaping of our physical spaces. At the same time, we are always actively engaged in creating our workspaces, both intentionally and unintentionally. In writing about gallery spaces, O'Doherty (1976) asserts that "space is…not just where things happen, things make space happen" (p.27). Indeed, the arrangement of tables and chairs, the lights turned on or left off, the order or mess in evidence, the sounds or silences promoted, the abundance or scarcity of art materials, the visibility or invisibility (behind closed doors) of materials, all play a part in creating the art therapy studio space.

If we are to cultivate an artist identity in all aspects of our work, it makes sense that we use our artistic sensibilities to reconceptualize our workspaces. To consider our work environments as works of art brings an intentional focus to the creation of therapeutic space and engages our artist identity in the process. Architecture, interior design, environmental sculpture, and installation art all have relevance for us when we begin to think of our physical spaces as works of art in and of themselves. For art therapists fortunate enough to have input into the designing of art therapy facilities, these art forms provide useful guidelines, ideas, and inspiration. Most of us, however, inherit the space we work in. We have no input into the architectural construction or the interior design of the space. We have no budgetary allowances for extensive remodeling or additions to the existing space. Given these realities, installation art offers a practical model for reconceptualizing our workspaces.

Installation art is a site-specific artwork. It comprises not just a group of discrete art objects but an entire ensemble, providing viewers with the experience of being surrounded by an environment of art (Atkins 1990, p.90). The term covers a broad spectrum of works that diverge from the mainstream view of art as an autonomous object displayed in a gallery, museum, or other place set apart. Instead, the intention of installation art is

to create a sense of place that is to be experienced rather than viewed. Installation art involves the "ability to become, rather than merely represent, the continuum of real experience by responding to specific situations" (Museum of Contemporary Art, San Diego 1997, p.13).

Artists who create installations go beyond the use of traditional art materials to include found and constructed objects. The installation artist is concerned with more than the visual impact of any single component of the work and is instead focused on the effect of the overall environment. Attention is paid to the influence of lighting, auditory effects, olfactory sensations, and the way time, use, and chance reshape the work.

The emphases of installation art make it particularly suitable as a way to re-envision our art therapy studios. In general, installation art emphasizes relationship to its surroundings and relationship to the people who will interact with and within it. These emphases are consistent with the concerns of art therapy where contextual and relational issues are the focus of the work done in the studio setting.

Relationship to surroundings

Considering our art therapy workspaces as installation artworks may help overcome some of the roadblocks to re-imagining our spaces. It may help us see beyond what is "wrong" with the space and to see instead the potentialities inherent in it. Rather than working from the mindset of struggling to beautify or improve a physical site, the installation artist will "take advantage of the ambiance of a physical space" so that the "surrounding environment becomes inseparable from the objects placed within it" (Museum of Contemporary Art, Chicago 1992, p.77). The architecture of a place and the surrounding environment are considered essential elements of the installation, as important as anything placed within it. This way of viewing our spaces might help us to see aesthetic possibilities in aspects of the space once thought of as liabilities: the closet-sized room, the ceiling with exposed pipes, the dim lighting, the noise from overhead, the concrete-block walls. It might also help us make intentional use of characteristics of the space viewed as assets but merely taken for granted: the view out the windows, the practical tile floor, the smells emanating

from the bakery next door, the curved shape of the entryway, the well-insulated walls.

The installation artist intentionally makes use not only of the sensual conditions of the space but also the social and historical conditions connected to the place. Again, these are not viewed as liabilities to overcome or to be ignored but as essential elements of the artwork. As art therapists, we can bring this same perspective to viewing our spaces as installation art. For example, an art therapist working in a newly con-structed building set amid historical architecture might think of ways to create a space that is connected to the history surrounding it, rather than isolated from it. Architectural elements from demolished buildings might constitute some part of the installation art, or the curved arches found in many of the doorways of surrounding buildings might be echoed with an arched entranceway made of chicken wire and papier mâché. In a similar fashion, an art therapist whose practice space is located in a poverty-stricken area of an inner city might consider ways to create a studio space that is connected to, rather than isolated from, the surrounding social issues. The materials used to create the installation might not be purchased art supplies but instead be the found objects littering the streets. What would be the effect of a textured wall created by row upon row of the bottoms of glass bottles embedded in plaster, as opposed to wallboard covered with white paint?

The emphasis on relationship to surroundings, evoked by the concept of installation art, is more challenging but still relevant for art therapists whose workspace is transient or communal in nature. No matter where we work, we create our studio spaces either intentionally or unintentionally. Even the art therapist who works in a medical hospital, traveling from bedside to bedside, creates the work space out of and in the midst of the pungent odors of antiseptics and urine, the beep of monitors, the visual feast of art carts, the clutter of tubes and IV poles – in short, whatever is at hand. Even the art therapist whose studio space is also the dining room of a nursing home has the capacity to take advantage of the ambiance created by the smell of cooked food, the clatter of pots and pans, the murmur of voices in the background, the abundance of tables and chairs. The art therapist who sees hospice patients in their homes can enlist the qualities of history and place to "rethink the concept of home, to understand it not as the place

where one is from, nor where one might be at present, but rather as the place to which one might be going...this imagined space" (Becker 1996, p.109). The challenge is to make use of the sensual, historical, and social context of place as raw material for the creation of a sense of place.

Relationship to people

A second feature commonly found in installation art is a focus on relationship to the people who will interact with the space. "Installation involves the environment, a larger space where the viewer, instead of standing outside the art and looking in, becomes part of it" (Saar and Saar, 1994). This is particularly relevant to the re-imagining of art therapy workspaces as works of art. The art therapy studio is intended to be a place where people come to interact. We may think most often in terms of interactions between therapist and client, interactions clients have with one another, and interactions between client artists and their art materials, but the client also interacts with and activates the space. Not only does the space exert its influence, but the people in the space also play a part in forming and shaping their surroundings. The environment of high art attempts to maintain control over how the viewer interacts with the art. This is most strikingly communicated by the "no touch" policy common in museums and galleries. In contrast, many installation artworks invite and even encourage the viewer's interactions. By extending this invitation "the artists relinquish control over their works, allowing chance to constantly intervene in their formation... Ideally, each work is finished by the active spectator, but each participant will interact with the work differently, so the piece will never exist in precisely the same way" (Museum of Contemporary Art, Chicago 1997, p.14). In a similar manner, individual clients will continually "finish" the work of art that is the art therapy studio environment. As art therapists, we are instrumental in creating environments intended for habitation and use. The clients who pass through the art therapy studio space will inevitably leave their marks on the sense of place that is communally created. We can enhance this aspect of the environment by inviting and even encouraging clients' interaction with the space.

It is our responsibility as therapists to consider the effect of the space on the clients who will be part of and partake of it. When we think of creating

a therapeutic space we may become stuck in trying to create the "perfect" space. We may, for example, debate the relative merits of background music versus no background music (B. Moon 1998). If we decide to play musical tapes or compact discs, we may attempt to determine the optimal types of music for creating a therapeutic space. The reality is, the people who enter the studio space will have diverse musical tastes and cultural preferences. They will have had a wide range of experiences with different types of music. These experiences will engender associations with the music that vary from individual to individual and range from positive to negative. There is no "perfect" or perfectly therapeutic music. Using educated clinical judgments that reflect a *consideration* of the effects of a space on the clients who inhabit it is not the same as attempting to *control* the effects of a space. From the vantage point of installation art, considering the effects of a space on the people who participate in it is about intentionally creating a space that leaves ample room for chance encounters to redefine and reshape it.

This way of thinking about our studio space leads to the idea of therapist and client being co-creators of the space. This idea could be enacted in many different ways. In most installation artworks there is an identified artist who creates the initial environment and then other people co-create through participating in or moving through the space. We might also conceive of our co-creation of a studio environment with clients in a similar manner, with the therapist as the identified artist and the clients as co-creators whose interactions with the space extend the shaping of it. In this case, the art therapist's role might be to provide a welcoming space, where clients experience a sense of belonging and an invitation to become a part of the creative mix. A sense of welcome can be conveyed through simple gestures, like a vase of fresh flowers or a bowl filled with brightly polished stones placed in the center of the table. A sense of welcome is also conveyed when individuals experience a space as "for" them. For example, when gay-oriented magazines are among those provided for collage making, a subtle message of acceptance is conveyed to the person who is homosexual (Addison 1996).

Another possibility is for the therapist to use the artist-in-residence model, initiating and actively working on the environment as an installation art piece. The intention here would be to facilitate, instruct, and inspire client participation in the actual construction of the installation. For

example, the therapist might use lumber to build a simple, 6'x 8'x 4' framed space within the studio room, title it *The Imagination Station*, provide a variety of construction materials, and invite clients to collaborate in transforming it into a private space for contemplation. The therapist might also take cues from the client in creating the studio environment. For example, upon entering the art therapy studio, a young child immediately clambers under the table and refuses to come out. The therapist gathers fabric and other art materials and successfully engages the child in creating a cave-like space under the table.

A third possibility would be for the art therapist to enlist the client as co-creator, from the stage of conceiving and planning the space through the actual creative execution. In this case, the therapist would function as a consultant and creative partner. Determinations about the arrangement and construction of the space would occur in full collaboration with the clients. The art therapist would facilitate the creative process by maintaining a safe, creative, therapeutic atmosphere and attending to practical matters such as purchasing supplies.

No matter how we engage clients as co-creators of the therapeutic space, it is important to be clear about roles. Co-creating does not mean that the art therapist abdicates all responsibility for providing a therapeutic presence and context. Co-creating is a cooperative venture that relies on the expertise of all participating parties. Our expertise as art therapists is precisely what we have to offer to the collaborative effort. Theoretical understandings, accumulated knowledge, and practical experiences in art and art therapy are our expert contributions. It would be unfair to expect this of our clients, and unfair to withhold our expertise from them. Our clients, on the other hand, also have valuable expertise to offer. To the co-creative process they contribute the accumulation of their own lived experiences, problems, needs, hopes, and potentials. They are the experts in who they are and what they need. It would be unfair to expect ourselves as therapists to have this depth of knowledge and understanding of our clients; it would be a waste of knowledge to ignore our clients' expertise. The co-creative process thus demands clarity of roles in which both the therapist and the client contribute from their particular areas of expertise.

The ways this co-creative process might play out are endless. Some of the elements of the space may be more "fixed" in nature, whereas other

elements may lend themselves to change and revision over time. This is consistent with the concept of installation art, since it is at times a temporary artwork, at times a permanently installed environment, and at times a work that is intentionally sensitive to temporal influences. The fixed elements of an environment provide consistent points of reference. They lend a sense of structure and security to an environment. In contrast, elements of the environment that lend themselves to change and revision over time reflect the ebb and flow of life. These changing elements connect people in the environment to the changing realities of internal and external experiences.

Some environmental elements invite active engagement by participants, an affirmation of the individual's capacity to contribute to the shaping of the environment. A wall or other surface provided for graffiti is a common and simple example of such an element. Another example comes from a man I know who works as a graphic artist for a newspaper. One day he brought a piece of cloth and a pile of polished stones to work with him. Without explaining his actions, he placed them in a visible area of the communal workspace and arranged them in a spiral. The next day he arranged them in a different configuration. Over time, others took turns arranging the stones. He would even arrive in the morning to find the stones arranged by those who worked on the night shift! His contribution to the environment was effective, at least in some small way, in inviting and affirming the contributions of individuals to the shaping of the workplace.

Relationship to intentions

In order to work toward creating the most effective therapeutic studio, it is important to consider the intentions for the space. What is its purpose? What kinds of activities will occur within the space? Who will inhabit it and what are their needs? What type of atmosphere is desired? What attitudes, beliefs, and possibilities will the space convey?

The comfort of fit between a place and its intentions can be observed and experienced through the ordinary environments of our daily lives. For example, a kitchen is intended as a place to prepare or concoct food for bodily nourishment. When the cupboards are too high for easy reach, the counters are so low they cause back strain, the lighting is poor, and the

refrigerator is not reliable for keeping food cold, the intentions of the kitchen are compromised. The same principles hold true for our art therapy studios. There must be a comfort of fit between our stated intentions and the space we create. Otherwise, the intentions of the therapeutic space are compromised.

The places we inhabit or visit in our daily lives provide us with analogues for some of the various intentions of art therapy studio spaces. For example, a playground has a similar purpose to that of an art therapy studio if the studio is intended to be a place for playful activity. The same studio where play happens may also serve as a space for contemplation and thus find an additional analogue in the chapel environment. Elements of these two very different kinds of places – playgrounds and chapels – can inspire the creation of a studio space that serves both playful and contemplative needs.

Considering the qualities of these daily life spaces and their effects on the people who inhabit them brings the sensual, social, and historical consideration of place to a more personal level. "Place" is created not merely from our connection to the specific environment we inhabit at any given moment but from our relationships to the myriad spaces we have inhabited throughout our lives. According to Lippard (1997), "each time we enter a new place, we become one of the ingredients of an existing hybridity... By entering that hybrid we change it" (p.6). The effect we have on each new place comes, at least in part, from the relationships we have had to other places. Sensitizing ourselves to the qualities of different spaces and their effects on us is a helpful step in sensitizing ourselves to the effects of our art therapy studios on the clients who inhabit them.

Not everyone's reaction to a particular place is the same. By being attentive to the characteristics and qualities of the spaces we interact with in our daily lives, we can become sensitized to our own variable responses to differing environments. We can also use our imaginations to visualize moving through various spaces, taking note not only of the visual qualities, but also the smells, sounds, tactile experiences, and ambiances evoked. Initially, it is helpful just to observe, without making judgments and without attempting to relate the imagery to our actual workspaces. The purpose of this imagining is to become aware of the subtle effects of place.

By way of example, the following is a description of my own imaginary encounters with different environments. The places chosen bear some similarities in intent to art therapy workspaces. Initially, I merely attempt to take notice of and to describe the qualities of these places.

I begin at a door. It says "kitchen." When I open it, I immediately smell the bread baking. Its aroma invites me in, teases me, and reminds me of a hunger I didn't know I had. The light is bright, from both inside and out. It exposes the mild disarray, the evidence of activity – a fine dusting of flour over everything; opened canisters, bottles, bowls, and spoons spilling over the counters and table. It is warm in here. Comforting. Barely audible music plays in the background, as if someone has become so engrossed in cooking they are no longer aware of what is playing. I see a white, arched doorway. Curious to know where it leads, I move through it.

I find myself in a hallway that leads to another door. This door has a placard on it that reads "confessional." I quietly open the door and slip inside. This space is small, dark, confined. Everything about it is hushed – the muted sounds, the red velvet colors, the faint smell of incense. The floor is carpet, deeply padded. I sink in it when I step. There is a kneeler and a chair, both heavily padded as well, both worn from use. I sit in the chair and finger the smooth place on the armrest where other fingers have played across its surface. I imagine both nervous, scratching fingers and dreamily calm fingers. The arched window in front of the kneeler has a wooden grate over it, a curtain behind the grate. A faint breeze from somewhere behind the curtain stirs it. I stand up to find its source, opening the door of the confessional.

I enter an old garden where the remains of stone walls act as backdrops for lively bursts of flowers. There are garden tools leaning up against a pile of stones, some dirt-encrusted gloves on the ground. Some of the earth has recently been turned over, exposing the damp, black soil. In other places the weeds are having their way, running amok and vainly showing off their spindly, spare-flowered beauty. Purple clematis creeps up over an arched wooden trellis and trails down over it, managing to adorn without overwhelming it. I wind

my way around the garden on pathways of gravel that crunch with each step. I feel the sun on my shoulders, a slight breeze ruffling my hair. I could stay in this place a long time, but something urges me to move on.

Through the branches of the surrounding trees I can make out a utilitarian-looking brick building. It seems out of place in this lush environment. I walk toward it and see a sign over the door that reads "laboratory." When I reach the door and pull it open, it squeaks loudly. I walk in and the door shuts with a thud behind me. I am struck immediately by the hollowness of the room, the way sounds bounce around with no place to land. Everything is enamel white or metallic gray. Waist-high counters hold instruments: microscopes, surgical scissors, tweezers, test tubes, beakers, and some things I don't recognize. There are rows and rows of drawers beneath the counters, each labeled in careful handwriting. I am intrigued by the things neatly arranged on the counter: papers with strange marks scribbled on them, beakers full of amber- and copper-colored liquids, small trays holding unfamiliar objects. I wonder what discoveries lie in wait in this room. And I wonder who spends their time here, hour after hour methodically examining, recording data, testing, and retesting. I do not want to disturb the work in progress here, so I make my way toward the outer door and push my way through it.

Once outside, I notice the breeze has picked up and the trees are beginning to sway gently. All around me the world is darkening. Ahead of me I see a sign pointing toward a long wooden staircase. The word "Observatory" is printed on the sign. I make my way up the stairs to a small, domed building. I open the door and take a peek inside, not sure if this is public or private space. I forget my manners once I open the door and don't even think about whether I am intruding. I walk in. The room is circular. The walls are glistening white. The floor is covered with a thick, nappy carpet in neutral tones. In the center of the room are large floor-pillows covered with deep-blue fabric. But it is the ceiling that draws my attention, enticing me to crane my neck upward. I settle into the pillows and, lying on my back, gaze up at the domed, glass ceiling to watch the

darkening sky. Bolts of lightning shoot across, first at a distance, then closer and closer. Finally, sheets of rain pelt down. I "soak it all in" – the light show, the symphony of sounds, the crackling life around me – and yet I stay dry, safe, comforted. I decide I will stay here awhile, wait for nightfall in the hope that the clouds will pass over and reveal a night sky dotted with stars.

Art therapists practice with varying intentions, shaped both by the therapist's personality and the needs of clients. Some therapists prefer neat, organized spaces and work with clients who require the containing effect of such an environment. Other therapists prefer a lively, visually busy environment and work with clients whose creativity is stimulated in a helpful way by such a setting. At times, the therapist's preferences must give way in order to create a space that serves the best interests of the clients who inhabit it.

Each of the places described above can be thought of as an analogue for the art therapy workplace, but it is inevitable that the "goodness of fit" for these analogies will vary from one art therapist to another. For example, some art therapists might be comfortable thinking of their art therapy studios as similar in intent to a confessional, while other art therapists might strongly object to this idea. Our varying viewpoints come both from our different ways of practicing art therapy and from our different experiences with places throughout our lives. The important point here is that we consider the ordinary spaces of our lives as potential resources for understanding the interactions between people and place. If we see similarities of intent between the confessional and the art therapy studio, how is this conveyed through the creation of a sense of place? What characteristics of the confessional might be incorporated into the art therapy space? Are there characteristics of the confessional that should be eliminated from the art therapy studio because they are antithetic to the kind of atmosphere we wish to create? These same questions can be asked not only of the places already mentioned – kitchens, confessionals, gardens, laboratories, and observatories – but of other environments that have some parallel purposes to those of the art therapy workplace. How about examination rooms, mines, classrooms, art studios, libraries, sanctuaries, playgrounds, or adventure camps? Perhaps there are more distasteful places that provide

some uneasy but truthful analogies of intent, places like prisons, gambling casinos, or interrogation rooms. An unflinchingly honest look at these corresponding qualities might also help us identify characteristics of our workspaces of which we wish to rid ourselves.

The five imaginary spaces I described above can be considered potential sources of information about the effects of place. I begin by merely listing the qualities I notice. There were smells of incense and smells that evoked hunger in me. Smooth, velvet, padded, worn tactile qualities and soft, musical, muted sounds contrasted with the hollow, metallic characteristics of place. There were many dualities I noticed: darkness and light; openness and confinement; indoor and outdoor; order and disarray; functional and sensual; private and public; familiar and unfamiliar; exposure and protection. The visual color palette included white, gray, and neutral shades along with lush green, velvety red, deep blue. The theme of arched or circular shapes repeated in the architectural elements of window, trellis, dome, and round room. The quality of seeing work in progress, along with the materials, tools, and instruments being used, was a significant aspect of the kitchen, garden, and laboratory environments. Other spaces were less encumbered by objects and were simply places to be.

Once I have taken note of these characteristics of place, I begin to consider how I might incorporate some of these elements in my art therapy studio. The first step is to articulate the intentions I have for the space. I think of my studio space and its purpose. It is a place for children, adolescents, and adults, as well as families or other groups of people. My first intention is that people will feel welcome and experience a sense of belonging when they enter the space. Ideally, the environment will be my ally in inviting art making, so my second intention is to convey the possibilities of both creative work and creative play. Third, my intention is that it be experienced as an emotionally and physically safe environment. And my fourth intention is that the studio be flexible enough to adjust and adapt to the needs of the people who become part of the creative mix.

I think about these intentions – to evoke a sense of welcome and belonging, to invite art making, to communicate safety, to be flexible – and the characteristics of space that will carry these messages.

If people are to feel welcomed and as if they belong, it seems to me they will need to experience the studio as a place that has anticipated their

arrival. There are practical matters related to this intention. Since people of many different ages will be in the space, the ideal will be to have furniture of a comfortable fit for people of a variety of shapes and sizes. I'll want it to be wheelchair accessible as well. It will be important for people to be able to find others like themselves – old, young, disabled, black, white, Asian, Native American, Latino, gay, straight, and so on – in the literature in the waiting area, the art on the walls, the magazines used for collage, the music played, and the art books on the shelves. And I'll want this same diversity to be expressed in the art materials I provide: traditional art media from a variety of cultures; modified tools to accommodate various disabilities; supplies that have been traditionally associated with women (for example, quilting supplies), men (for example, wood, hammer, and nails) and children (for example, finger paints); found objects that stimulate various senses; and a range of supplies that support diverse ideas about what constitutes art, ranging from fine arts to found objects.

There are other, less practical, characteristics that might evoke a sense of welcome and belonging. I think of the art therapist's studio I visited where a bread machine sent its homey, comforting aroma wafting through the air. The smell of incense might be too strong, but fragrant herbs and flowers from my garden might be an option. They would add, along with their scent, a message that this is a special place for honored guests. A tray with crackers and the fixings for tea would add to this effect. Or I could opt for the art supplies to serve as a metaphor for emotional sustenance, and place in the center of the table a glass bowl filled to the brim with brightly colored crayons.

When I think about my second intention for the space, to invite art making, I think of a place where the art materials are enticingly arranged to convey their latent possibilities. I think of a space that evokes curiosity. A painted, cardboard refrigerator box "room" in which newly acquired found objects are placed creates enough of a sense of the hidden to invite explora-tion. I also think of a space that begs for interaction. Creating an invisible, suspended "wall" of packing tape on which objects can be stuck or unstuck would be such an invitation. A collection of wind-up toys would also invite playful interaction.

I remember the kitchen and laboratory of my imagination, where there was evidence of the process of making. I want my studio to have this effect

as well, with works in various stages of completion in view. I might designate one part of the studio to be more like the laboratory, for "clean" art making, and another to be like the kitchen, for messy art concocting. The subtle smells of the studio – paint, wood, clay – might add to the enticing effect as well.

My third intention, for a space that is experienced as physically and emotionally safe, can be addressed at both pragmatic and metaphoric levels. I'll want to create easy, unobstructed pathways for people of different sizes who are on foot or in wheelchairs. I'll need to consider the materials I purchase to ensure that they are not toxic. The placement and accessibility of materials or tools that have the potential to cause harm is another aspect of safety to address. In addition, painting racks, shelves, or other areas used for the safe storage of works in progress convey the message that the artworks are treated with care and respect.

Emotional safety can also be evoked by the quality and character of the space. I think of rounded shapes – nests, bowls, wombs – as places that hold in a protective, nurturing way. I look at my space to see the potential for creating rounded, domed, or arched shapes. My budget won't allow for costly architectural changes, but I might use an old arched garden trellis to embellish an entranceway. Painting *trompe l'œil* arches over the windows, creating a round painted floor mat, or simply rearranging the furniture in a circular fashion may be other ways to create rounded spaces. Adding soft fabrics in deep earth colors to the environment – pillows, chair cushions, or drapes – might add to the protective, womb-like ambiance of the environment.

My fourth intention is to create a flexible space. This intention is affirmed by the dualities I noticed in the spaces I imagined – openness and containment, indoor and outdoor, functional and sensual, and so on – and in the places I inhabit in my daily life. As humans, we seem to have divergent needs that are met by the spaces we create and inhabit.

I think about ways to create spaces within a space. Folding screens, large plants, draped fabric, or furniture are examples of objects that can be arranged to partition off a section of a room. I might want to create a quiet, semi-private space for contemplation or respite from the busy atmosphere of the studio. The confessional I imagined provides the inspiration for subdued lighting and padded, soft furniture or carpet. To this I might add

floor pillows and some art books for browsing. Ideally, it would be nice to have the counterpart to this contemplative place – a contained space within the environment where it is safe to splash paint, sand wood, or slop around with wet clay. Along with these contained spaces, it will be important to have an open area where the space is shared and the contagious nature of art making is fostered.

Flexibility in the art therapy workspace might be conveyed in other ways as well. Furniture that could be easily rearranged – cabinets on wheels, art supply carts, stackable chairs, folding tables, and so on. – would provide the opportunity to recreate the space in response to varying needs such as openness versus containment, intimacy versus community, or stimulation versus calm.

Combining expected elements of a workspace – tables, easels, art supplies, and so on – with unusual objects or effects conveys the possibilities for both mastery and experimentation. For surprising elements, I might want to have a mannequin in the corner whose outfits change daily or weekly, or I might want to string together pie plates that hang from the ceiling and form a visually interesting mobile as well as a potential instrument for impromptu drumming.

A single intention can be met in a variety of spaces and in a number of different ways. Transitional spaces, or places that serve multiple purposes, provide different challenges to the art therapist from a permanent site dedicated as art therapy studio space. Thus, art therapists who work in office spaces barely bigger than closets, at the bedsides of medically ill persons, in the living rooms of people's homes, in the kitchens of women's shelters, or in the recreation rooms of hospitals will each find unique ways to respond to a single intention, ways that are in harmony with the potentials and limitations of each of the workspaces. For example, when the art therapy session takes place in the client's home, creating a sense of welcome takes on new meaning due to the therapist's status as guest. The intention to create a sense of welcome may play itself out in the creation of a ritual space for art making – perhaps through an act as simple as spreading a drop-cloth on the floor and arranging art supplies in the middle of it.

By sensitizing ourselves to the effects of place and articulating our intentions for our workspaces, we can rise to the challenge of creating art therapy environments responsive to the needs of the clients we serve.

Conclusions

Art therapy workspaces are not merely places we passively acquire. We are instrumental in creating – out of the physical space, the material resources, and our ability to make use of chance and circumstance – the spaces we will inhabit with our clients. When we consider our work environments as works of art, we bring an intentional focus to the creation of therapeutic space and engage our artistic identity in the process.

The creation of a studio environment involves attention both to the spirit that is conveyed as well as to the physical structures. An effective art therapy studio fosters a belief in the ubiquitous nature of creative ability and conveys respect for both clients and their artwork. It is a flexible space, adaptive to the needs of the individuals who inhabit it. The art therapy studio serves as a creative sanctuary while also maintaining an intimate connection with the world of which it is part.

Installation art offers us a helpful model for reconceptualizing the physical characteristics of our workspaces. Its emphases on relationship to the surrounding environment and relationship to the people who inhabit the space make it particularly relevant for environments where art therapy is practiced. In addition, sensitive attunement to the characteristics of the places we encounter in our daily lives can provide us with inspiration for creating environments in harmony with our therapeutic intentions.

The viewing of our art therapy environments as works of art enables us to see with fresh eyes the potentials inherent in the concept of "studio." We engage in "ever-changing transactions between internal imagery and goals on the one hand, and an external topography on the other hand" (Sarason 1990, p.32). In this way the studio becomes more than an inert physical structure. It becomes activated space, charged with the energy of our artistic vision and the encounters between people and art making that occur within it.

Responding to Clients through the Poetry of Their Lives

Therapists need to be aware of this aesthetic quality as a universal trait of objects and actions (Arnheim1992, p.150)

I arrive at Kyle's house, unsure of what to expect. Three weeks ago, when I met with him and his family for the first time, Kyle downplayed the seriousness of his angry outbursts, even though he had recently punched a hole in the wall of his bedroom and shoved his grandmother hard enough to bruise her arm. Today, this strapping, 15-year-old boy is polite to me, but the swear-words and loud voice he directs toward his mother and grandmother erupt with little warning, like a pot boiling over. His family members seem to be afraid to get too close, so they yell back at him or try to be solicitous.

Kyle acts tough, but his tenderness and insecurity show up when it's time to make art. He wants me to work on his art with him, like a younger boy might. We spend the session working together on a painting and it goes well, until it is time to clean up. Kyle tries to assert his bossy authority by telling me I am to clean the brushes; he does not want to help clean up. I do something unusual for his household – I calmly talk to him about the nature of our relationship. We come to an agreement: this time I will clean the brushes and he will clean the palette knife, next time we will swap jobs.

I complete my part of the bargain and then step into the living room to speak with Kyle's grandmother. I return to the kitchen after several minutes and Kyle faces me, clean palette knife in hand. I

notice a strange look on his face as he says to me, "Here, feel this," and pushes the palette knife in my direction. Something in his look, his words, his gesture…something makes me wary. I am on guard; instinct or savvy kicks in, but it does not prevent what is about to happen. I turn my hand palm up but hold it close to my body, protectively. I ask him, "Why? Why do you want me to feel it?" He answers me without words, pushing the knife forward and laying it on my open palm. For barely a split second it rests there before I register the pain it is causing and jerk my hand away. There is a bright red mark on my palm where the hot metal blade has burned me. I realize he must have heated the blade over the burner of the gas stove while I stepped into the other room.

I am angry and stunned. Never before have I had a client intentionally hurt me. I let him know that I am angry, that I do not come here to be hurt, that if I am to continue seeing him I expect him to treat me with respect and to not hurt me.

Later, I reflect on what happened. I think I handled the situation well. I was clear about my limits. I let him know of my anger but did not retaliate in response. I made it clear that his relationship with me is to be different than his relationship with his grandmother, where he is the intimidator and she is bullied and belittled into serving him. I think all these things and yet, two days later, when it comes time to return to his house for another session, I am dreading it. I put off going there, finding last-minute things I must do before the session. I arrive late. And the next week it is the same thing, the same dread that envelops me on the way to his house. I don't want to be there.

That week I have an appointment with my supervisor. I talk about my dread. My supervisor does not say much, only listens. I am troubled about why I do not want to go there. I know it is not just about his having hurt me. I want to understand my response to him, so I puzzle out loud about what he has "said" through his behavior. I wonder how my response relates to what he is expressing. I try to "hear" past my anger and hurt to what he has said to me with his dramatic act of burning. I attempt to understand the poetic expression of his actions. They "sound" something like this to me:

This is what my life has been like. Can you feel this? I have been burned. When I least expected it, when I did nothing to deserve it, when I tried to protect myself from it, I got burned. And so I am burning inside. I am hurt, in pain, full of rage. I want you to know my pain intimately, because this is what it will be like to work with me. And I want to know if you can take this. Can you take this burning, rageful hurt and pain? Because this is what I will hand you, this is what I have to give you. It will not be easy working with me. It will hurt sometimes, and make you angry, and take you by surprise, and make you not want to come back. Will you come back? This is what my life has been like. Can you feel this? Can you take this? Will you come back?

I say these words out loud and I am struck by the power of his simple actions. Kyle has let me know what working with him will be like. I am confronted with the challenge: will I come back? I know the question is not only will I come back tomorrow or the next day, but also will I come back over the long haul. This is a boy who has been deeply wounded and he will need help for a long time. It is a fair question: am I in or am I out?

I do go back. The next time I appear at Kyle's door for our session, he looks a little surprised to see me. But he quickly changes his demeanor, acts nonchalant. "Hey," he says, and opens the door wide to let me in.

I go back for the long haul: one year, two years, and I am still seeing him. I no longer dread my sessions with Kyle, even though they are often challenging and difficult. By considering his behaviors not merely as manifestations of his pathology but as expressions of the poetry of his life, and by responding not merely with "appropriate" therapeutic limits but also with the empathy of my own poetic sensibilities, I am able to hear his "burning" question and to respond, "I'm in."

We come to know who we are through our idiosyncratic responses to the world around us. We are informed by the way we are allured or repelled, by how something pleases us or steers us toward indifference, by what or who

we choose to be around. The particular oak tree with wide, rooted lap, the one that held me and hid me as a child, knows something of who I am. The way I can't get enough of the smell of lilacs in spring – the way I move in so close to them and try to own their smell so that soon I can hardly smell them at all – is a piece of who I am and how I live and how I love. The way I often park my car by backing it in, readying myself for what is to come at the same moment that I have just arrived, gives me hints about myself. We all have these bits of poetry in our lives, the drama of the ordinary that shapes us and proclaims who we are. We lean into these behaviors with nearly imperceptible ferocity, needing the way they mark and define us.

Why is it then, when we don our roles as therapists, we sometimes assume we do not come to know our clients in this same way, through their particular ways of behaving in response to the ordinary events of their lives? We speak of them as suicidal, resistant, passive, depressed, psychotic, belligerent, appropriate, inappropriate, compliant, malingering, disruptive, hyperactive, attention seeking, manipulative, engaged, expressive, limited, regressed, improving…and we miss the poetry of their lives. We miss the particulars of who they are, expressed quite intelligibly by the actions of their individual lives.

Attempting to understand clients

Attempts to understand our clients occur at multiple levels, ranging from broad theoretical understandings to consideration of cultural context, to the particular information gleaned from individual clients. It is important that understanding be approached from these multiple perspectives. Theoretical constructs provide us with objective distance, consideration of culture pushes us to recognize differing world views, and consideration of individual circumstances and behaviors brings empathy and humanity to our work with clients.

The focus in this text is on the specific contributions of an artistic perspective to understanding clients. When we endeavor to discern the poetry of our clients lives, as expressed through anecdotes about the client (told both by and about the individual) and by observing clients' behaviors, we are tuning into a means of understanding that is unique to the arts. The text and action stories of clients, their anecdotes and behaviors, provide the art

therapist with an avenue of understanding that is sympathetic to an artistic perspective. This is not to suggest that an art therapist ought to disregard other kinds of information, only that we might tune in to the textual and action stories relayed by clients as our particular areas of expertise. One of our contributions to the helping professions might be an acutely attuned sensitivity to the means of understanding clients offered by our aesthetic sensibilities.

Jenny, a student in my graduate art therapy class, raises her hand when I ask for a volunteer. I have laid out a few materials in the center of the room and tell her I simply want her to make art while we observe her. When I tell the other students what they are to do, they appear a little perplexed but also intrigued. I say that we will be practicing our clinical documentation skills while we observe Jenny. Only instead of writing standard clinical notes (and, in the process, observing and processing information in the way that such notes foster) we will be observing and documenting from the perspectives of different artistic sensibilities. I ask one student to observe Jenny as if watching a dance performance; another student is to listen to Jenny's activity as if it were a piece of music; still another is to observe Jenny's art making as if it were a drama unfolding; yet another is to view it as the makings of a poem; and finally, one student is to observe Jenny's art making process as a kinetic visual art piece. I tell them their documentation is to be done in the form of sketches, nonsense words, spontaneous poetry, narratives, musical notations, marks made on paper, or whatever else seems fitting.

The students gather paper, pens, and art materials and settle into the spots from which they will observe. I indicate it is time to start the "session" and to begin observing and documenting. I take on the role of the traditional clinician and compose a standard clinical note. While I write, I try to be faithful to the model of clinical documentation I learned from the hospital where I worked for many years, modified by the recent emphasis in psychiatric care on strengths rather than pathology. I try to write in a careful manner about the things I observe and to use qualifying terms when I am making inferences. I write:

> Client participated in and focused on art task for entire session. She engaged in the activity without hesitation, showing a clear capacity for creative thinking and inventive use of materials. Client did not involve in social interaction and appeared so focused on what she was doing as to be unaware of the activity around her. The only exception to this was when there was a loud, sharp noise in the room and she looked up briefly. She worked on an art piece that required a repetitive motion (winding string around a tube) and a moderate degree of eye–hand coordination. She demonstrated sustained attention to the task. Toward the end of the session she intermittently added beads to the string as she wound it, demonstrating an ability to be flexible and to modify her activity. At one point her string began to slip out of place and she used some glue to secure it, showing an ability to adapt and problem solve.

When fifteen minutes have elapsed, I thank Jenny for her willingness to be observed and tell the students it is now time to share with each other the things we have observed. I read my standard clinical notations first. Then I invite the students to read or show their documentation. This is what they say:

> At first I thought I would never be able to see her movement as a dance. She was moving so little; I thought she would be boring to watch. But then I started seeing the beauty of what she was doing and I wrote: "Curved over body, solidly set. A stillness at the base so her movements could wash over her again and again, like waves. And at the center of her curved body these motions accumulated, gathered together into the thing she was creating." She looked determined and protective then. And certainly not boring. I felt like I was watching something be born.

> It was really hard to listen to her as if she were a piece of music. She was hardly making any sounds at all. But they sounded something like a…like a shooshing sound, going sh, sh, sh, very rhythmically. I heard a little rattle once in a while and I realized it was coming from inside the tube. There was something inside it,

something hard like a stone, banging out this intermittent rhythm. I don't know what kind of music she would be…maybe jazz, experimental jazz but very quiet. Rhythmical, lulling, and then every once in a while this tiny jarring noise from inside her piece that made me wince.

I thought of her as someone like the princess in Rumpelstiltskin, trapped in the tower, spinning her flax into gold. Then I thought that everyone else in the room was in the drama also, so the story changed for me. This is what I wrote: "Once there was a woman who lived in a land of Yergs. She often wondered if she was really a Yerg, because she longed to wind and wrap string, which everyone knows, of course, is an activity of the Morgs. During the day she would paste a smile on her face and chatter with the Yergs around her as they all bent and crimped wire. But at night she would hurry off when no one was looking, gather up her stash of string and go to her secret place. There she would wind and wind and wrap and wrap to her heart's content, feeling the string as an extension of her fingers, feeling it fly out of her like whispers from her heart. Only unfamiliar noises from the woods around her would stop her motion. Then she would be alert, fearful. But as soon as she assured herself that there was no danger, she was back to her winding and wrapping, winding and wrapping. As she worked she remembered who she was. She remembered in the rhythm of her body, in the feel of the string running through her fingers, in the pleasure she felt when she looked at what she was creating. And she did not forget who she was, even in the light of day. She began to touch wire as if it were string, to bend and crimp it in a winding, wrapping kind of way. She remembered herself back into the life she was living."

I was supposed to pay attention to Jenny and write a poem about what she was doing. I'm not really a poet, but here's what I came up with:

gathering
hoarding?
string, tube, something held tightly in her hand (hidden)
she hovers over her possessions

the hand-held something disappears – where?
and quickly she settles into position
begins to wrap and wind around and around
moving away and toward this thing she holds in her lap
like an infant child being swaddled –
for birth or a funeral? –
a ritual of motion, a repetition
she seems lulled and then crack! someone drops something
loud
and she is yanked hard into the room around her
looking startled, alert, suspicious
and then it seems to be the motion of her arm, refusing to stop
that pulls her back to her self, her center
winding in and away, in and away, in and away
covering something over
in order to make something new
covering in order to reveal.

I didn't write any words. I just drew what I saw and heard. I was aware of the activity around her, the chattery noise and the people moving, going about their work. She became the focal point of my drawing, the still place. Only she wasn't really still; she was constantly moving her arms. But the way she looked so firmly planted really impressed me. And I found myself sitting like her while I drew, and echoing her movements in my drawing. It felt weird, but good, like I felt what it was like to be her for awhile.

We talk about the things we have shared, about what it is like to use our artistic sensibilities to observe another human being. Jenny talks about what it felt like to be observed. She discusses her reaction to hearing standard clinical notations about her read aloud, and how that was different from hearing or seeing what people noticed about her through the various artistic perspectives. Other students imagine themselves into Jenny's position as the one being observed and we discuss what this might be like for clients as well.

Not surprisingly, Jenny expresses a preference for being viewed from an artistic perspective; as poetry in motion, an improvisational dance, a song being released into the room. She talks about feeling emotionally moved by the artistic observers' reports. She says she felt understood when they shared their observations and even became aware of some things she had not previously noticed about herself.

We all talk about the differences between the standard clinical note and the observations based on artistic sensibilities. The students say the standard clinical note seems more detached or removed from the person, while the artistic observations seem more engaged and empathic. They also say the clinical note seems more pathology-driven and more judgmental, while the artistic observations seem more strengths-based and nonjudgmental. They feel this way even though I, as the writer of the standard clinical note, took great pains merely to make note of what I observed without passing judgment. We wonder aloud why we might experience clinical notes as having a critical tone. Have we learned to think of clinical notes this way, or is censorious scrutiny inherent in this type of documentation?

Our discussion also comes around to questioning the validity of observations made from the artistic perspectives. Some students say they felt like they were just making up stories when they wrote about what they were observing. They question whether their stories did not have more to do with themselves than their observations of Jenny. In response, Jenny says she felt understood by the dramatic stories, that the stories captured a truth the clinical notes completely missed.

One student wonders out loud if standard clinical notes might not also contain a great deal of subjectivity. We agree that this must be so, but admit it is easy to think of our documentation as factual. We talk about what it means that we accept as "right" the analytical, linear ways of thinking fostered by the medical model in therapy, yet question our artistic ways of knowing.

In the end, we acknowledge that standard clinical notes are helpful in that they allow us to observe someone from a more detached perspective. We talk about how they enable us to attempt a factual recounting of information, unencumbered by our emotional

responses. Several students complain that the content and style of clinical notes are dictated by the agencies where they are doing their practicums and ultimately by third-party payers. We all agree that standard clinical notes are a reality in the day-to-day practice of many, if not most, arts therapists.

Without disparaging standard clinical observations and documentation, I encourage the students to view observations made with our artistic sensibilities as additional, enriching ways of observing. I tell them artistic perspectives do not replace standard clinical observations but instead draw upon other innate capabilities we have for making sense of our world. Most significantly for arts therapists, I say, is that engaging our artistic sensibilities as an additional means for understanding our clients makes use of our particular skills and highlights a unique contribution of the arts therapies to clinical work.

When it is time for the class to end, the students talk about feeling inspired to view their clients in these artistic, poetic ways. One student timidly expresses some reservations, questioning the practicality of such observations. She says she barely has time to write the notes she is expected to write for the charts. I know she is expressing doubts that other students harbor as well. It is understandable that they would wonder about the practicality of these artistic ways of viewing clients when the short-term nature of treatment hardly allows time for thinking about clients at all. Jenny responds, "Even if I don't always have time to write it or draw it out, I'm going to practice thinking of my clients this way. It fits with what I do best as an art therapist. But more than that, I want my clients to feel the way I felt today – as if someone is really trying to understand them."

When I have conducted workshops or class sessions to explore these artistic ways of exercising our observational skills, the ensuing dialogue often runs a similar course. Participants express an intense interest in the use of aesthetic sensibilities as a way to try to understand clients, but also a concomitant suspicion that these forms of observation are not really valid or practical. When I encourage them to think of these forms of observation

not as replacements for, but rather additions to, the traditional processes of clinical observation and documentation, then their usefulness and value is more readily perceived. They are able to recognize valuable aspects of existing forms of documentation – such as fostering an objective view of treatment, aiding in reflection and treatment planning, and serving as a means of communication with other staff – as well as their limitations. They begin to see the addition of artistic perspectives as offering a richer, more complete picture of the client.

Discussion inevitably comes round to the idea that any observations, even those undertaken with the intention to recount "facts," have a subjective component. This aspect of documentation is often not empha-sized, perhaps because subjectivity is not highly valued in our society. In arts-based observations, subjectivity becomes more pronounced and its value as a means of understanding others more obvious. Our capacity for empathic connection is predicated on our ability to honor and perceive as valuable our subjective experience of the other person.

An artistic approach to observation and documentation can enrich our understanding of the clients with whom we work. Our passion for the arts can be channeled into our compassion for the people we serve. Through engaging our artistic sensibilities we can begin to appreciate the poetry of our clients' lives as it is presented through action and story.

Client Stories

I sit, along with a handful of gray-haired women, in the concrete block basement room of the nursing home. We fill the time with small talk as we wait for the other residents to arrive in wheelchairs or aided by walkers. As I begin to place some art materials on the table, Bessie and Margaret both inform me they are not artists. I sympathize with them, telling them it's also hard for me to do things that are unfamiliar to me. I reassure them that I am there to help them.

As I continue to set out art materials, their topic of conversation turns to swimming. Bessie says, "I never really had a chance to learn to swim until I was in my twenties. I had a beau then, name was Mac.

Now he wanted me to learn to swim. I was a little afraid and I didn't know if I'd be able to do it. But I'd always wanted to be able to swim. I was determined. So one day, when I went to the lake with Mac and some other friends, he showed me how to move my arms and kick my legs and I gave it a try. Once I had the basics down, I decided the only way to get over my fear would be to dive into the deep water. So I jumped off the dock." She chuckles quietly, and says, "I sputtered and fumbled, thought I'd been an utter fool. But then I got the hang of it and began paddling around the lake. My friends were standing on the shore, laughing and cheering for me."

Margaret responds to Bessie's story with one of her own. "Oh me, I was always afraid of the water. When I was nine years old my big brother decided it was time for me to learn to swim. He could be a little mean at times, you know. He and his buddy, Otis Simms, they snuck up on me and gave me a shove while I was peekin' over the edge of the back pond, lookin' at my reflection. I flopped over hard into that water. It was shallow enough so that I could stand in it, but it scared me anyway. I didn't like it one bit." Margaret sits up straight in her chair and lifts her chin up when she announces with what looks to be pride, "That was it for me. After that, I never tried to learn to swim, no matter how much anyone tried to talk me into it."

All of the sudden I think I get it. They are telling me what it is like for each of them to take risks, to try something new and unfamiliar. I think about these stories as hints for how best to approach each of them with these unfamiliar art materials and projects. I suspect that Bessie will need only to be provided with opportunity (space and materials), some rudimentary instructions, and my willingness to be nearby in order to offer tips or encouragement, as well as to celebrate successes. I suspected it might be much more difficult to persuade Margaret to engage in art making. Any move on my part might be interpreted as a "shove" and result in her need to maintain dignity by refusing to participate. I also hear in their stories the possibility that they might be unlikely but well-suited "swimming partners" in this art making adventure. Margaret's tendency to remain on the safe shores of non-involvement might temper Bessie's tendency to dive in before she is fully prepared, and Bessie's willingness to take risks and

try unfamiliar activities might inspire Margaret at least to wet her toes to see what is so inviting.

All clients do not enter their first art therapy session and supply the art therapist with a story so readily applicable to the task at hand. Many times I feel ill equipped to discern the clues I am given via the stories my clients tell. Just as I try to listen for the meaning the client assigns to artwork, I also listen for the meanings clients assign to their own narratives (White and Epston 1990). I wonder if I have really grasped the meaning consistent with the client's own experience of the story, or if I am merely creating my own fictions and asking the client to live them out.

I believe these questions and self-doubts are important. I have heard many professionals speak of clients as if they were puzzles to be solved rather than amazingly complex human beings who defy simple and reductionistic analysis. When I am privy to conversations among therapists in which interpretations of clients' behaviors or stories are treated as irrefutable facts, I become exasperated and dismayed. At times I've even overheard clinicians speaking as if they understood patients better than the patients understood themselves. The tragedy in this is that the client's "own text may well be so far removed from that of those who diagnose her as to render her unheard" (Jones 1997, p.73). Fortunately, the influence of postmodernism has given therapists permission to not be the all-knowing experts. Postmodern thinkers understand truth to be relative and dependent on social context. The therapist's perceptions of clients' stories are influenced by the therapist's own biases and subjectivity (Goldenberg and Goldenberg 2000). This way of thinking fosters a more collaborative approach to therapy where differing versions of reality are respected as representations of individual experience and social influence.

It is important to remember that our artistic perspectives offer us ways to *attempt* to understand clients, just as our analytical, logical abilities offer us ways to *attempt* to understand clients. Doubts that creep in when we are considering another human being from an artistic perspective are signals that the method we are using is legitimate and based in ethical discernment. We must work to "distinguish between a creative opening-out and an extravagant 'free association'" (Maclagan 1999, p.309) in our response to clients' stories, just as we would in our response to images. In both cases,

our ability to stay anchored in the specific aesthetic properties of the image or story, sticking faithfully to their tangible qualities and characteristics, helps to ground our interpretations (Maclagan 1999).

Doubt and humility ought to be our companions as we attempt to understand the stories and experiences of another. One advantage of viewing another human being from an artistic perspective is that aesthetic ways of knowing have not been perceived as revealing irrefutable truths, so we are likely to remain grounded in wondering, doubting, and questioning.

At times we may also become caught up in wondering about the truthfulness of the stories clients tell us. We may be unsure if the stories contain distortions, confabulations, or deliberate lies. When we worry about being manipulated or conned, our certainty is undermined and our confidence shaken.

A refreshing aspect of considering someone from an artistic perspective is that the literal truth of a story is often irrelevant. Aside from the particular times when factual information is needed to ensure safety, there is no need to be overly concerned with the factual accuracy of a story. What we need to be most concerned with is what a particular story, out of all the infinite possibilities for storytelling, is revealing about the truth of the storyteller's life at the moment of its telling. Fictions are "creative acts in and of themselves, and so are metaphoric portraits of the self, i.e., truths in their own right" (B. Moon 1994, p.63). The story a client tells may be wildly unbelievable at one level and profoundly truthful at another level. This is the difference between literal and poetic truths. Our job is to listen with the attentiveness of our artists' eyes and ears and hearts, attempting to hear the core of poetic truth being revealed.

In listening for the core truths held within a story, we are most interested in the particular phrases, details, and ways the story is told. For this reason, stories told *by* the client have a directness and authenticity not usually found in stories told *about* the client. In treatment settings, clinicians frequently use a form of shorthand that eclipses the most telling details of client stories. For example, I may hear that a client attempted to commit suicide. That may be all that is written on an admission note. I want to know more. I want to know the particular details of the client's attempt at suicide, not out of some morbid curiosity but out of a desire to understand what the story of his or her suicide attempt is expressing. The story may be

about someone who steps out in front of a train, passively and dramatically waiting to be run into the ground by something large, looming, and overpowering. The story may be of someone who quietly, secretly ingests a handful of pills while lying curled up on the floor of a dark apartment. The story may be of someone who readies a noose, planning to slip into something that will cut off the life supply in one sudden, greedy, gripping instant. These are very different kinds of stories, with their own particular truths about a person's experiences: of having felt overwhelmed, overpowered, and run down by life; of having felt slowly, darkly, secretly poisoned by what has been taken in during a lifetime; of having felt something suddenly grab hold and snatch away the very source of life.

In seeking out the particular details of a person's story, I am trying to tune into the unique poetic expressions revealed through story. The intent here is not to find hard-and-fast interpretive truths. Instead it is an attuned way of being with someone, a willingness to feel my way in the dark, to be fully attentive to what the person offers, and to respond with the sensitivity of my own empathic being.

Client behavior as expression

I hear the sound of voices and turn to see Eric, the psychiatric technician, leading four adults into the studio. I have never met any of them before. One of them, John, is being pushed in a wheelchair. He is quite large and it takes some effort on Eric's part to maneuver him into the room. I can hear both John and Eric breathing; they sound as if they are laboring to pull enough air into their lungs. John points to the table where he wishes to sit and, once there, thanks Eric and begins thumbing through a magazine he has brought with him. He is seated in front of a window, with his back to the room. He does not appear to be reading anything, only to be glancing at the pages, and I hear him humming softly between wheezing breaths of indrawn air. I introduce myself and announce that I am giving a tour of the studio for anyone who is there for the first time. John glances in my direction but then turns back around and continues leafing through the magazine.

This is my first impression of John. We have not spoken to each other and he has not yet begun to use any art materials. Yet he has already given me some clues about the poetry of his life. He has already expressed himself through his behavior and given me hints about points of access by which to draw near. As someone who has been inundated with the ways of the medical model, my first reaction might be to see his behavior in terms of pathology, as "resistance," or "passive dependence," or "passive aggressive acting out." I then might remind myself that his passivity could have a physiological origin, the result of clinical depression. I might also remind myself that he may have low self-esteem and therefore feel intimidated by the idea of having to make something with art materials, or that he is shy by nature and that it is his insecurity being expressed rather than resistance. At this point I have moved from a purely pathological perspective to a more humane and empathic perspective, but I am still missing the poetry this man is expressing through the way he has entered the room and engaged with the environment.

I begin to think in terms of poetry, but not poetry conceived of flowery waxing on the things I imagine about John's life. I try to focus my poetic intentions on the very specific behaviors John has shown in this brief encounter. I think in deliberate fragments, phrases, sparked by the threads of suggested meaning woven into the smallest gesture, the subtle expression, the words not spoken, the choices made. I hear these words drifting across my mind: pushed; breathless, breathy; partnered duet in breathing; audible taking in and pushing out; pointed desire; thick fingers in touch with delicate, paper-thin words, images; facing the light; backed up to us; glancing; pulling in air with effort, pushing out song; looking back, looking ahead; turning back to face us, looking away again; looking in, looking out.

At this point, my way of viewing John has shifted. I no longer view him in terms of pathological behaviors, nor do I see him merely in terms of physiology, mood, or personality traits that help me understand his behavior. Instead, I am caught up in the poetry of his presence. I find myself startled by the simplicity and poignancy of his "pointed desire." I am impressed with his ability to make song out of that which is taken in with such effort and struggle. I notice how others are pulled into relationship

with him (a duet of labored breathing) through struggle. I think how his being "backed up to us" allows us to see a side of him not readily visible in most social situations and I think how vulnerable a position that is. I am struck by the refrain of push/pull, taking in/pushing out, looking in/looking out that has repeated itself in this brief, wordless introduction.

While this way of perceiving another human being may seem strange to those who are accustomed to assessment and documentation fostered by the medical model, it must not be assumed that this is merely an "artsy" approach, lacking in professionalism and discipline. Our methods certainly can be undisciplined and even irrelevant if the poetic understandings are derived from flowery, imaginative projections of the poet/therapist rather than careful, attuned observations of the client's behavior. Inherent in this approach is the need to relax interpersonal boundaries so we can be more open to subtle nonverbal communications. At the same time, we have to remain firmly anchored by tangible, perceptual observations so our responses do not become merely an expression of our desire to merge with the client and experience vicarious release (Domash 1981). The discipline in an arts-based approach has to do with focusing on behavior as expression. This means that the first and most important step is carefully observing and noting behaviors, among them behaviors that normally would be taken for granted, go unnoticed, or be prematurely interpreted as having a specific meaning.

When I have worked with students or other professionals on developing this method of viewing clients through the poetry of their behavior, I begin by asking them to tell me as much as they can about the behaviors they have observed in a particular client. It is common to hear responses such as "he is manipulative" or "she is moody."

These are interpretations, not behaviors. As soon as we label someone "manipulative" or "moody" we are limiting our vision, closing off the potential to really see someone just as they are. In training people in this method I repeatedly ask, "What did he do? What did she do?" In the example above involving the client, John, if I had only seen him as resistant I doubt I would have noticed the contrast of his thick fingers moving the delicately thin paper images and words on the magazine. The discipline involved is one of attentive, nonjudgmental observation. When observing

behavior as expression, we attempt to recognize our bias and bracket it so that it does not distort our perceptions (Mohacsy 1995).

This way of perceiving another human being sets up a qualitatively different kind of interaction in the therapist–client relationship. It is a fundamental shift from the dominant paradigm in the helping professions where the therapist is the powerful expert and the client is the helpless, naïve one. The shift relates to minimizing the power differential in the therapeutic relationship. In addition, it adds a quality to this relationship that draws on our identities as arts therapists. If we view our clients in terms of the poetry of their lives, then our conception of the therapeutic relationship is firmly established as a co-creative venture. It becomes impossible to view our clients as persons in need of "fixing" according to our standards and values, just as we would not think to fix someone's poem, or painting, or dance according to our ideas about what is "right." Instead, our own poetic, aesthetic sensibilities are stirred in response to the poetic presence of another human being. We become interested, curious, touched, inspired. If the client is willing, client and therapist become artists together, working toward creative re-imaginings of problems and potentials.

Responding to poetic cues and clues

The ways we come to understand our clients influence the approaches we take when working with them. Recent art therapy literature has addressed the need to broaden our approaches beyond "reductive theoretical formulations" (Hogan 1997, p.20). Postmodernism (Alter-Muri 1998; Byrne 1995; Kapitan 2000), cultural analysis (Lupton 1997), feminist theory (Hogan 1997; Speert 1993), and narrative therapy (Riley 1997, 2000; Riley and Malchiodi 1994) are some of the perspectives offered as alternatives to the dominant, psychodynamically based understandings. Along with these enlightening perspectives from other philosophical and theoretical constructs, it seems natural for those of us in the arts therapies professions also to consider how understandings of the human experience gleaned from an artistic perspective can instruct us in the development of therapeutic approaches.

Ideally, the approach we employ in art therapy is not imposing or intrusive but instead is a means of drawing near to clients through the

points of access they make available to us. Attempting to understand clients through the poetry of their lives provides us with a way to discern these points of access. But what do we do with this information? How is it helpful in determining the directions treatment might take? How do we effectively respond to the poetic cues and clues our clients give us?

When we are considering what to do with a particular client in the first art therapy session, there are two basic considerations to make. First, we decide what art materials to offer the client. Our decisions may range from selecting only a few materials to making everything in the studio – clay, paint, wood, markers, pencils, yarn, and so on – available for use at the discretion of the individual client. Second, we decide how we will guide the client in the use of those materials. Again, our decisions may range from prescribing a directed task to promoting an open, nondirected use of materials.

It is sometimes erroneously assumed that a studio approach to art therapy implies the consistent use of a free-choice stance toward materials and a nondirective style in regard to the way those materials are used. This constitutes one kind of studio approach, relying on what has been called an "open studio" model (Allen 1995b; Luzatto 1997). Depending on the setting and available resources, along with the needs of the clients in the setting, this may be the best approach. However, it is not necessarily the best approach in all environments, or even with every given individual in a place well suited to this style of art therapy. Developing an appreciation for the range of applications possible in a studio approach to art therapy helps us to make sound clinical decisions that are in the best interests of our clients. For example, an open studio model would probably not work well in a program designed for children who are easily distracted and have problems with sustained attention. The unbounded availability of materials and the unlimited choices about what to do with those materials would likely be overwhelming and stimulate a chaotic environment rather than a healthy, creative one. The open studio approach might work well in a day treatment program for adults with psychiatric and emotional problems, but not necessarily for every individual in that program. For example, modifications might need to be made for an individual who experiences extreme mood swings and is currently behaving in an impulsive, hyperactive manner. This individual might be in need of more structure and contain-

ment than is provided by a wide-open studio approach. In other settings, the open studio model might not work because of restrictions imposed by the nature of the setting, such as in a prison where potentially dangerous art supplies must be monitored, or in a hospital where infection control necessitates the regulation of materials made available to patients.

In reality, even in a setting where an open studio approach is optimal, art therapists inevitably engage in making choices about materials and the way they are put to use. This occurs simply through the decisions we make about the materials we order and provide for clients. Even in the most lavishly supplied studios, every possible art material is not made available. Another subtle directive about material choices and uses is how we arrange our workspaces. Decisions about the placement of different materials – within easy reach, behind closed cupboard doors, or in the back room – as well as how invitingly certain media are displayed and the selection of art on exhibit, will subtly influence the clients' choices of materials and how they are put to use. As art therapists, our interests and expertise in particular art forms, and lack of interest or expertise in other art forms, will inevitably exert an influence on the kind of art making that occurs in the studio. In a more obvious way, we are involved in choices about the kinds and uses of materials because clients ask us for help. Sometimes their requests for assistance are communicated nonverbally. For example, a client may appear hesitant, unsure, and uncomfortable. To give no guidance to a person who is intimidated and insecure in the studio setting would be unkind at best and destructive to the therapeutic potential at worst. Clients may also ask for our involvement in a more direct manner, through requests for advice on technical matters, help with generating content ideas, or guidance in bringing intention and execution together in an art piece.

In any studio art therapy setting then, the question arises as to what art materials will be used and what will be done with them. In considering the poetic presence of a client, we are given clues about potential treatment directions or potential points of access to reach the client.

Typically, determinations about materials and possible thematic directions are made in treatment settings by identifying problems and then devising art therapy "interventions." Even when treatment plans are developed in cooperation with clients, the very language used can subtly suggest that it is not a collaborative effort after all. To intervene means to

come between by way of a hindrance or modification. In international affairs, an intervention is commonly carried out by force or threat of force (*Webster's New World Dictionary* 1988). Though it is likely that few therapists use the word "intervention" to signify such an interfering or controlling manner of relating to clients, it is important to consider the subtle effects of such language usage in a relationship that is inherently asymmetrical in terms of power (Spaniol and Catteneo 1994).

An alternative to thinking in terms of interventions is to think in terms of responsive actions. If we attune ourselves to what clients are doing and saying through their stories and behaviors, we may be given clues about the ways they prefer to be approached, the points of access they offer. Just as we might employ the meanings clients assign to their artwork as guides for determining the direction of therapy (Riley 1993, 1997), we can view client stories and behaviors as forms of art, as expressions of meaning that have the potential to serve as guides. Our actions then can become responses rather than interventions. We act with intention, fully cognizant of the influence of our role as therapists and working to temper the inherent imbalance in the relationship by respectfully conceding to the client's wishes and wisdom. If we are able to approach clients with this relational concept in mind, the potential for a true collaboration is enhanced.

The most difficult aspect of this relational approach is managing the tremendous amount of information gained by attentive listening to client stories and disciplined observation of client behaviors. We often have to "think on our feet" as therapists and have little time to consider methodically our understanding of clients and the resulting implications for treatment.

It is possible, however, to develop a way of thinking about clients and our responses to them that becomes, with practice, second nature. Few art therapists have the luxury of being able to apply this method thoughtfully and thoroughly to every therapeutic encounter. However, most of us can selectively apply it in a conscious way, adapting it to the realities of our circumstances for the sake of developing an arts-based way of seeing and thinking about clinical practice.

It is helpful initially to practice this model in a step-by-step manner. First, it is helpful to jot down the stories we've heard and the behaviors we've observed in regard to a particular client. Making these notations

helps us to see in concrete form what we visualize in our mind's eye. The discipline of writing may also help us take notice of behaviors or details of stories we would otherwise miss, often because they are deceptively obvious.

Once we have made these notations we can begin to consider what the stories and behaviors might be expressing about the person. Reflecting on the words we have written, we look for connections between the various behavioral and anecdotal expressions. We search for repeated themes. These are the clues that help us to map out a plan for working with the client. They help guide us in terms of materials and thematic direction.

In this process I view the client and the therapist as experts. The clients are experts in knowing themselves – their own strengths, struggles, perceptions, hopes, potentials, and so on. The art therapist is an expert in the use of art as a therapeutic aid for addressing problems and making use of potentials. Our task as art therapists is to be attentive to our clients' many ways of expressing self-knowing – through discursive language, anecdotal stories, and behavioral expression – and to take these expressions seriously. We then respond with the expertise we possess as art therapists by developing informed treatment plans for our art therapy sessions. The following examples will illustrate this model.

I have just finished my first art therapy session with Sue, a woman in her late twenties attending a psychiatric day treatment program. I have a few minutes before my next appointment and take the time to make some notations:

- moved in contained way, limbs pulled in close to her body

- when walking or talking to me head was curved downward, with chin almost touching her chest; looked up to find and use art materials

- made repeated motion of index finger flicking thumb on her right hand

- partially covered her mouth with her hand when talking

- talked softly, hard for me to hear

- told story of having been made to sit in her bedroom closet as punishment when she was a child

- told me she enjoys working in her flower garden, especially hoeing and weeding, though she feels bad about pulling out the weeds

- said her garden is the only thing that feels like it is truly hers

- initially slow in taking art materials, then seized them more quickly and with what seemed to be an intensity of purpose

- chose to create a collage picture of her garden

- delicately touched and gazed at materials for a time before using them

- ripped paper, bent wire, splintered wood for collage materials

- glued collage materials into a shoebox lid

- asked for a bag to put her piece in so she could carry it home

I pull out the notes I scribbled at the team meeting just before Sue was discharged from the inpatient unit. Most of the information came from the nursing staff:

> Frequently huddled in corner of room, writing or drawing in her journal. Seemed hesitant to ask for anything but then asked for things patients don't usually request – old boxes, surgical gloves, medicine cups. Used them in her art making. Visibly upset (tearful, pacing, breathing hard) when grounds crew removed a gangly-looking shrub from front of building. Unable to put words to what upset her, other than to say, "They didn't ask." On day of discharge, she presented nursing staff with collage made from natural materials (sticks, leaves, acorns, stones) depicting a cave-like environment. Presented it with no explanation other than to say it was a goodbye gift.

I place these remarks from the nursing staff inside a file folder, along with the notes I have made about my first outpatient session with

Sue. I put them inside my desk and get ready for my next appointment.

It is a few days later and I am due to have another session with Sue. I pull her file from my desk drawer and study the notes I made. I look for repeated themes. I notice many references to containment: body posture, covered mouth, closet, shoebox lid, bag, cave image. I am struck by her body rhythms that shift from slow, delicate, and reticent to quick and aggressive (flicking, hoeing, seizing, ripping, bending, splintering). The theme of not asking is something the nursing staff says about her and something she reportedly said about the grounds crew. I make mental note of the important role nature plays in her life, from her gardening to her use of natural materials in the artwork. I notice the theme of digging up and pulling out occurs in both her reference to weeding her garden and in the way she approaches art making. She expresses some ambivalence about this in relation to gardening but not in relation to art making. When she makes art, her behaviors of digging up and pulling out are followed by behaviors of securing and containing (gluing and putting in a box enclosure).

I begin to think about what direction I will take in my work with Sue. I think in very basic terms about what I will do with my tentative understandings of her. What materials might be helpful to her? What might she do with those materials to address her current interests and needs?

In terms of materials, she already seems to have a preference for found objects and things from nature. I see no reason to interfere with that. Perhaps I will also make available to her a range of objects that lend themselves to the theme of containment – boxes, bags, baskets, bottles, suitcases, purses, and the like. I imagine taking a walk with her on trash day, to do a little "digging up and pulling out" among the neighborhood discards. If I don't have the luxury of time with her, the found object cupboard in the studio will have to suffice as her resource for digging through.

I also want to make sure she has opportunities for both tender, delicate engagement with art materials and aggressive, "ripping, bending, splintering" use of materials. I make sure I have wire, wood,

hammers, nails, and pliers available, as well as a box of scrap paper that is clearly an acceptable target for ripping. I also think of clay because it is a natural material that can be successfully worked with in both slow, contained ways and active, aggressive ways. Since the action of securing seems to help her in regards to her ambivalence with digging up and pulling out, I think about making available to her not only white glue, but also twine, wire, and a glue gun.

I consider how I might present the materials to her. Since the theme of asking or not asking has surfaced in Sue's interactions, I think about not making everything too easily available to her, so she has the opportunity to ask for what she needs and so this theme has the potential to arise within the dynamics of the therapy sessions.

Now I also begin to think about what she might do with the materials I offer to her. Sue seems to be someone who works well without a lot of direction, as evident from her self-initiated art making on the inpatient unit. Again, I don't want to interfere with this. On the other hand, I don't want to totally abdicate my responsibility as a therapist and rely solely on her expertise in knowing herself and her needs. I remind myself that she is in therapy because doing this work on her own was insufficient.

I look again at the notations I have made about Sue and think about possible suggestions or directives I might give her in our art therapy sessions. At this point, I consider different options, some of them more directive and some more open. The most open option would be the nondirective approach, whereby Sue would decide what to do with the materials made available to her. If I want to provide her with some structure yet leave multiple possibilities open for her own creative process to take its course, I might ask her to make a container and to think about both what it looks like on the outside and what it contains on the inside. Other possible metaphoric themes, open enough to provide room for interpretation, would be: "digging up," or "a safe place," or "weeding out," or "holding on/letting go." I might simply suggest the metaphor of "the garden" as a theme, or I might use garden-related themes such as "pruning." A somewhat more directive approach would overtly link the theme to Sue, most likely resulting in her conscious awareness of

the connection between the art piece and herself. Rather than "the garden," the directive might be "depict yourself as a garden," or "make an art piece about the emotional 'digging up' you have been doing in your life." The least open, most pointedly directive approach would involve entirely doing away with the metaphor and asking Sue to "make an art piece that has to do with how you feel about asking and not asking," or "make an art piece about what you struggle to get rid of in your life," or "make an art piece about why your garden is so important to you." Art made from this kind of directive would tend to be both consciously connected to herself and reliant on her logical, analytical mind.

I decide that I will try an open approach with Sue. Since she has already demonstrated her ability to initiate her own art making, I think she may respond well to this way of working. I go into the art therapy studio and begin to pull materials from the cupboard. I create an inviting array on the table – an assortment of containers, objects from nature, scrap paper, clay, and a box of found objects. In this way, the materials will provide some subtle direction to her art making. I leave the necessary tools and bonding agents in the cupboards so she has the opportunity to go after what she needs, to make decisions about asking or not asking. If the open approach does not work and she seems to need more guidance, I will talk to her and help her develop a focus for her work. If she is unable to generate a theme on her own, I will make use of the clues she has given me and suggest a metaphoric theme to serve as a creative spark. Satisfied with my plan, I wait for Sue to arrive.

With practice, the process described above can occur in a matter of minutes. The therapist takes a few moments to jot down or make mental note of the client's behaviors and stories. Then consideration is given to common threads and repeated themes running through the notations. These serve as the guides for considering possible materials and directions for the session.

In group sessions, the task is obviously more complex. However, the process is similar. The therapist can consider the needs of the group-as-a-whole or the needs of each individual client, depending on whether the sessions are focused on individual or group dynamics. If the

group-as-a-whole is the focus, group behaviors and stories are used as the starting-point for developing a treatment plan. For example, Davis (1997) determined that wood scraps, the "remains of a destruction that has taken place both symbolically and literally," were the most sought-after and most fitting material for her work with women in an inner-city homeless shelter. The women could select which remnants to discard and make choices about how to transform the salvaged fragments into new, stronger structures.

Determinations made in regard to a directive versus nondirective approach to group work can also be guided by the behaviors and stories group members present. An arts-based model has the potential to address concerns that directives are used in group art therapy for controlling or coercive purposes (McNeilly 1983). By being attuned to the needs expressed by group members through their behaviors or stories, determinations for the most fitting approach can be guided by clients' rather than therapists' needs.

The development of treatment approaches invariably involves not only concern for the client's needs but also the influence of the therapist's preferences and personal style. It is important to be aware of our own preferred ways of working and to acknowledge them to ourselves. When we are clear about our strengths, limitations, likes, and dislikes we can be clear with clients about what we have to offer them. The way of working I describe in this text may need to be modified for the individual therapist. Some therapists require more structure and guidelines, while others can tolerate a great deal of ambiguity and are able to improvise as they go along. No matter the personal style of the therapist, it is possible to respond effectively and sensitively to the poetry of clients' self-presentations.

I have a preference for open directives, though not necessarily a totally nondirective approach. If someone comes to the art therapy session with a clear intention about what he or she feels impelled to make, I rarely interfere with that. I only intervene if the intention is potentially harmful to the individual or to others in the environment (for example, a child with poor impulse control who wants to burn the edges of their paper) or question the intention if I believe it to be counter-therapeutic (for example, a man with low self-esteem and no experience with woodcarving who wants to carve an ornate wooden boat during a two-week hospital stay, a project destined to fail). My aim is not to discourage persons from their

artistic intentions but to offer my expertise in helping shape their intentions toward art tasks that are both safe and therapeutic as well as true to the artist's vision.

I never assume that merely providing art materials and a studio space is enough for most people who seek therapy. Supplying guidance in terms of materials and themes gives the person a framework within which to work. If someone experiences the structure as safe, not confining, it will foster creative imagination and the use of art for expression. I have found the most helpful themes to be those that provide a spark rather than a set of directions. Themes that are metaphorical in nature tend to be sparks, providing some general parameters but allowing for a multitude of possibilities within those parameters. Themes that are overly direct and didactic in nature tend to make the person self-conscious about what they are creating and what it might convey about them, thus having an inhibiting effect. The process of discovering fitting metaphors – both material and thematic ones – engages the therapist in a poetic consideration of the client's life and in a therapeutic response engendered by this poetic understanding.

Another example will help illustrate this process of responding to the poetic cues and clues offered by our clients.

I hear about Tom from the staff on the adult unit before I ever meet him. Along with some basic information about age and diagnosis, I also hear that he emerged into the hall the night before clad only in his undershirt. Apparently, he caused quite a stir!

The nurses tell me he was looking for his favorite silk scarf. The story is that he owns many more than the twenty or so scarves he brought with him to the hospital. Tom comes with other stories as well. There is the one about his sleeping on the front porch of his mother's house in the middle of winter and of her inability to convince him to come in. There is the one about his having called the mayor's office to inform them of the pollution in town caused by the use of chemical agents by lawn-care companies. Apparently it was more of a telephone campaign, Tom having called the mayor's office 27 times in one day alone.

The nurses tell me Tom arrived at the unit speaking so rapidly the saliva was flying out of his mouth. He talked, among other things,

about the invisible and deadly gases in the air, about the Pope's error in not allowing married men to serve as priests, about the problem of cooking lasagna noodles too long, about the damaging effects of the disappearing ozone layer over the past thousand years, and about the proper technique for repairing a cracked tile floor.

I meet Tom on the third day of his hospital stay. He is assigned to the studio art therapy group, where the focus is on individual clients within a group atmosphere. The treatment team wants me to provide Tom with a structured environment where he can channel his expressions in a constructive manner.

I make some notations about Tom after the session is over.

— rapid speech, gait, hand gestures; rapid shifts of attention

— at times would pause, as if captivated, to watch the movement of his hands through the air

— surprisingly graceful hand gestures, like a dancer's

— heavy, shuffling walk

— talked to everyone in the studio, made suggestions to them about improving their pieces

— way of interacting with other people nearly the same, whether they responded to him or ignored him

— told me he owns a croquet set he won at a carnival when he was a child

— when he saw the box of scrap wood he said his grandfather and he used to make games with wood scraps

— when given the tour of the studio he touched nearly all of the materials

— when touching things, he seemed to slow down momentarily

— talked nearly nonstop on a variety of topics about which he seemed knowledgeable

When I sit down to think about a treatment plan for Tom, I am overwhelmed by the amount of input I have. Initially, it seems too vast,

too jumbled, too much to make sense of. I begin to look for recurring themes, possible points of access to what seems to be his hectic inner world. I make a list first, in an attempt to capture the essences of his stories and behaviors. I rearrange the words, clustering them according to the themes I see, and it turns into something almost like a poem:

- partly uncovered (no pants)
- partly covered (sleeping on porch in winter)
- persistent, rapid speech, gait, hands, attention
- spit flying
- heavy walk
- invisible, deadly gases
- Pope's errors
- cooked too long
- damaging effects
- repairing cracks
- suggestions for improving
- unaware of others' reactions?
- touching nearly everything
- silk scarves
- a croquet set won
- wood games with grandfather
- watching graceful hands, like dancer's
- slowed down with touching

I think about the themes I hear in this "poem." There is something about being both covered and uncovered at the same time. There is a contrast between Tom's intensity, persistence, and rapid pace, and the way he is slowed down by what he sees his hands do and what they

enable him to feel. There are tender contrasts between his heavy walk and his dancing hands, between his heavy concerns (deadly gases, errors, cracks, and so on) and his attraction for games and silk scarves. His concerns loom large and complicated while his attractions are simple and easily attainable.

When I think about materials for Tom, I think about the most obvious ones: scarves (or pieces of fabric) and wood. I think of honoring the complicated largeness of his concerns while enabling him to work in a way that is manageable for him and connects him to what he enjoys. If I offer him fabric, wood, and the means to bond these two materials, there is simplicity available to him. At the same time, fabric comes in a wide array of textures and wood scraps in a wide range of shapes and sizes. Within the simplicity of using only two materials he can explore variety and use his sensitive tactile abilities as a way to slow down and focus. The wood and fabric also echo the duality of heaviness and delicacy he expresses through his actions and stories.

When I think of themes for Tom, I am again tempted to work with what is most obvious. I think of working with him on inventing and constructing a game using fabric and wood. Since games often deal with overcoming obstacles, I think this has the potential to give him a structured way to express and deal with the things he is concerned about. I think about making not only a game, but a game box as well so that the metaphor of covering and uncovering is also addressed.

I am not sure if my plan will work with Tom. It is simply an idea. I may try it and it may be wildly unsuccessful. He may be disinterested in the idea of creating a game, or too disorganized to construct one. He may have his own ideas about the materials he would like to use or what he would like to make. For now, at least I have a plan. If need be, I can adapt it to his needs, ideas, and preferences. But I think it's important for me to provide some boundaries, albeit flexible ones, within which Tom can use his hands to give shape to his concerns.

Conclusions

I don't consider my ideas about materials and themes for either Tom or Sue to be the only "correct" therapeutic choices. Just as there is no one correct interpretation of a poem, there is no one correct interpretation of a person considered from a poetic or artistic perspective. However, I do believe that the attempt to find points of access to someone by considering the poetry of that person's life brings about a qualitatively different kind of interaction than would occur if I devised treatment interventions intended to "come between" a person and their pathology. Neither way is the "correct" way, but using a more poetic means of attempting to understand another person is consistent with an approach to therapy based in the arts. Using this method of attempting to understand a client gives art therapists a way of working that is firmly planted in an arts-based theory about treatment planning.

By first using our artistic sensibilities to observe, document, and attempt to understand the clients we work with, we add to and enrich traditional clinical processes. When we use the information we glean from this enriched perspective to determine our approach to treatment, therapy has the potential to become a co-creative venture. It becomes impossible to view clients as people in need of fixing. Instead, we are caught up in their poetic presence, stirred to empathic response. Our ability to be alert to the aesthetic qualities in not just our clients' productions, but in their very beings, creates an environment saturated with a keen awareness of creative potential.

A Relational Aesthetic

The reach of your compassion is the reach of your art (Joseph Campbell, as quoted in Fitzgerald 1996, p.105)

When Derek arrives home from school, his mother Sharon and I are sitting at the kitchen table. Christmas carols play on the tinny-sounding radio. Green tinsel garlands drape the window behind us. A cardboard cut-out of Santa Claus grins at us from the center of the table, extending its "Merry Christmas" wish in words printed on a scroll at its base.

"Okay, Cathy, what are we doing today?" Derek says as he plunks his bulky adolescent body down on a kitchen chair. Before I can answer, he is up again and heading for the refrigerator. He says we will have to excuse him; he is starving and has to get something to eat. He pulls out milk, mayonnaise, bologna, and some leftover macaroni and cheese. He places the leftovers in the microwave and begins to grab more food from the cupboards. Soon he is returning to the table with a glass of milk and a plate piled high with food. Before he sits down again he reaches across to his mother and tussles her hair. It is a playful gesture but the grin on his face is mean, twisted. Sharon swats at his hand, finding only empty air. "Derek, stop that!" she says in an annoyed voice. He laughs, says "Aw, I was just playin' with ya!"

I am not surprised at Derek's behavior. Last week he was talking excitedly about how good it was going to be to have all his family together for Christmas. Yesterday he learned that his mother would be spending her holidays in an inpatient psychiatric facility, to help

her deal with the recurring effects of childhood trauma. Now Derek is acting silly and mischievous. He says things to shock and perturb. He can't seem to sit still or get enough to eat. I think he is starving, but not for food. I think he is starving for emotional sustenance, for parenting that is consistent and predictable, for love that doesn't entice him near only to pull the emotional rug out from under him time and time again. These are things his parents have not been able to give him. His father abandoned him when he was an infant. His mother tries to be a good parent, but her substance abuse and psychiatric problems keep interfering.

I let Derek know his mother has told me of her upcoming hospitalization. He grunts in response and stuffs more food into his mouth. I acknowledge how hard this must be for him. He shrugs his shoulders, cocks his head to the side, and makes a sound that seems to express, "No big deal." But then he crams more food into his mouth. I wonder, what else is he stuffing in?

I tell them I have brought all kinds of found objects and art materials to work with today. I ask them if they have any ideas about what they need to do. Derek's mother suggests that we make gifts for each other, symbolic of our emotional gifts rather than the materialistic gifts typically given at Christmas. Derek readily agrees, but I see he has the mischievous grin on his face again.

Sharon and I work quietly, carefully selecting materials and constructing our gifts. Derek fidgets a bit and then plunges into the materials in what seems to be a haphazard way. Before Sharon and I have even completed one gift, Derek announces that he is finished with all three of his gifts. I find myself annoyed with him. I think he has just slapped some materials together with no forethought or intention.

When it comes time to share the gifts we have made, Derek shoves something in my direction. "Here," he says. "It's a heart." I pick it up. It is made from packing tape and a paper towel roll. It is crudely made and mangled in appearance. It looks vaguely like a heart shape. I watched him make it, so I know it only took him about three minutes to construct. I am disappointed; I know he is capable of more than this sloppy, haphazard stab at artistic creativity.

But I keep the piece of "art" he has given to me. I put it on the shelf in my studio with other hand-made gifts I have received from friends, clients, and students over the years. As the months go by I pick it up from time to time and turn it over in my hands. Sometimes I think of throwing it away, but then I put it back on the shelf. Is this art, I wonder? It certainly is not a well-crafted piece, and it did not appear that he made it with much care or attention. Yet, I can't shake the fact that the gift he gave me was his mangled heart. I think of throwing it away, but I can't bring myself to do it.

As art therapists, we have wrestled with locating our work within the broader context of art in Western society. There are those who claim that the practice of art therapy has little to do with fine arts and thus has no need for aesthetics (Riley 1996, p.410) and those who suggest that an emphasis on the aesthetic importance of the finished product in art therapy may be counter-therapeutic because it tends to undermine spontaneous, unconscious expression and the cathartic aspects of the creative process (Dalley *et al.* 1987, pp.5–6). Yet this relegation of art therapy art as "process art," distinct from the fine arts and unconcerned with aesthetics, has not seemed to provide a satisfactory resolution to our questions about where art therapy fits in relation to art and aesthetics. Perhaps this is because we have been attempting to fit art therapy into the paradigms of the established "art world" rather than envisioning how art therapy contributes to contemporary discourse on aesthetics and the role of art in society. Perhaps it is not that aesthetics has no relevance for art therapy, but that art therapy practice calls for a new understanding of aesthetics.

Toward a new understanding of art therapy aesthetics

The term "aesthetic" relates to sensory perceptions. As a branch of the philosophy of art, aesthetics historically has dealt with the question of what constitutes beauty in art. In this quest to define beauty, the traditional focus of the aesthetician has been on the formal aspects of the art object. Many art therapists, in attempts to distance themselves from the elitism and judgmental attitudes associated with this branch of philosophy, have largely ignored aesthetic considerations and instead have placed the

emphasis of their work on the artistic process. Knill, Barba, and Fuchs (1995) warn, however, that in "suppressing our aesthetic sense, we have thrown out the baby with the bathwater, so to speak – wasting one of our most valuable talents for engaging the healing power of the arts and for reaching depth in the psychotherapeutic relationship" (p.70).

Attempts have been made in art therapy literature to define aesthetics in terms relevant to the practice of our profession. Some of these definitions attempt to articulate an art therapy aesthetic concerned with the product of artistic activity, such as Wolf's (1990) description of aesthetics as a physical manifestation of what feels subjectively "right" on personal, cultural, and universal levels. Other writers articulate an aesthetic more focused on the process of art making. Arnheim (1980) asserts that aesthetic quality "is nothing but the means by which the artistic statement attains its goal" (p.250) and Robbins (1987) refers to aesthetics as "making the inanimate animate, giving form to diffuse energy or ideas, breathing life into sterile communication" (p.22). Maclagan (1995) distinguishes aesthetic concerns in art therapy from that of technical accomplishment or formal beauty, viewing aesthetics as "the full range of qualities in its *facture* or handling, whether they be subtle or obvious, rich or poor, and the psychological effects that are their inseparable accompaniment" (p.217).

The art therapy literature has also included the relationship between therapist and client as an aspect of developing an aesthetic relevant to art therapy. Aldridge, Brandt, and Wohler (1990) describe aesthetics as that which is made manifest in the art therapy relationship when clients are helped to articulate their inner realities coherently, with depth and richness, through external, visual forms (p.195). Case (1990, 1996) connects the aesthetic moment with the awe, wonder, at-oneness, and rapport that occurs between the viewer and any object, including people, nature, or artworks. She says "it is essentially through an aesthetic experience that the therapist with the client's permission can enter and share the client's world and that the client can make themselves known and found" (1990, p.20). Schaverien (1992) acknowledges that art made in art therapy sessions may not necessarily be considered successful according to the criteria of the art world. She argues, however, that art therapy art may elicit a comparable aesthetic response in the therapist as that evoked in a viewer of so-called "great art." In the case of art therapy art, she attributes this response to the

contextual qualities of the therapeutic relationship. Robbins (1987, 1988, 1992) has written extensively on what he refers to as "psychoaesthetics," the aesthetic qualities occurring simultaneously through the artistic modality and the patient-therapist relationship in arts therapy practice. He proposes an integrated approach that combines aesthetic awareness with psychodynamic understandings of client's communications. All of these authors address the idea that an aesthetic of art therapy must take into account the relationship between art therapist and client as a component of its definition.

The nature of the "aesthetic response" in art therapy has also been addressed. Aesthetic response has been described as a distinct sensory, sensual, and embodied response to what is perceived (Knill 1995; Maclagan 1999). Hillman (as quoted in Levine 1996) notes, "*aesthesis*...means at root 'taking in' and 'breathing in' – a 'gasp,' that primary aesthetic response." This gasp response, caused by perceiving something that "takes our breath away," can occur when confronted with the horrific as well as the beautiful. Thus, an aesthetic response can occur even when viewing client artwork that portrays such experiences as emotional or physical pain, traumatic events, loss, or outrage. An understanding of aesthetic response that is more active and participatory is Knill, Barba, and Fuchs (1995) description of aesthetic response as "characteristic ways of being in the presence of a creative act or work of art – ways that touch soul, evoke imagination, engage emotions and thought" (p.71). Thus, they suggest that an aesthetic response is not merely something evoked in us as viewers, but is something we can also actively engender by the ways we respond to and engage with an artwork. McNiff's (1981) understanding of "aesthetic consciousness" as something that heightens and strengthens the value of perception suggests that the sensual, bodily response is a capability that can be developed and fine-tuned over time. Carrying this notion of participation even further, Sarason (1990) proposes that engaging our own creativity as a part of aesthetic response results in our being changed or transformed in some way (p.123). Aesthetic response in art therapy, then, has the potential to include our embodied, visceral response to what we perceive, our intentional honing and development of that response, and a reciprocal effect on us as viewers that changes us in some way.

An expanded view of beauty

When we are challenged to view in aesthetic terms artworks that are impoverished, awkwardly executed, artistically undeveloped, or that contain unpleasant content, it becomes clear that traditional notions of beauty are not adequate in our field of work. Explorations in regard to the relevance of aesthetics to art therapy have led to questions concerning how beauty in art is defined. As art therapists we are well aware that the artworks of clients often depict the ugly and horrific aspects of life. This reality puts us at odds with the romantic notion equating art and beauty (C. Moon 1999) and challenges us to articulate a new understanding of beauty as it relates to what is created in the art therapy context. In art therapy practice "aesthetics involves coming to grips with the entire range of qualities...aesthetic appreciation is not confined to the obviously pleasant or simply enjoyable...but embraces all the various 'flavours' of an image" (Maclagan 1994, p.50).

A limited notion of beauty rests on qualities conventionally attributed to giving pleasure to the senses. By this limited standard, beauty does not challenge, provoke, unsettle, or disturb. Instead it provides superficial gratification. Certainly, contemporary art criticism has expanded beyond this view of beauty to include consideration of the formal elements of art and of the quality of craftsmanship in a work of art. Artists whose work is disturbing, provocative, or challenging to the established standards of the art world have forced contemporary art criticism to struggle with the validity of formerly accepted aesthetic criteria. This has led some people to the conclusion that any focus on artistic value is elitist (Felski 1995), others to question the effects of the social and historical contexts within which standards are set (Devereaux 1995), and still others to articulate the questions that must be addressed in developing new criteria for evaluating art (Lacy 1995).

Though less visible in the art market or the media, artwork produced in the context of art therapy has long demanded an expanded view of the concept of beauty in art. Art therapists and art therapy clients understand there is a need for "a standard of beauty that includes imperfection, pathos, and struggle" (McNiff 1998b, p.90), one that recognizes beauty as arising out of disorder (Robbins 1987, p.14). Such an understanding of beauty must be inclusive of a depth and range of experiences. The serene landscape

painted with painstaking care by a client attempting mastery of one aspect of his chaotic life; the huddled clay figure crudely sculpted by a client attempting to express her experience of aphasia; the disorganized assemblage created with nails and blood red paint made by a client expressing rage; all must find their place in an expanded concept of beauty in art.

To enlarge our perception of beauty, our understanding of it must be based on ways of knowing that encompass, but are not limited to, intellect. The intellectual constructs offered by formalist principles can be useful in assisting clients with creating art that is true to the artist/client's intentions. But if therapeutic responses to the potential beauty in a work of art are limited to these intellectual constructs, the effectiveness of the therapy will likely suffer. Stephen Levine (in Levine and Levine 1999) notes that effective artwork done in the context of therapy "is often jarring rather than soothing; it is an expression of suffering that strikes the witness to the core; it does not allow for the 'aesthetic distance' which one can take in the face of formally perfected work" (p.20). Our work demands that we include our emotional, perceptual, and spiritual (as well as our intellectual) capabilities in our repertoire of methods for comprehending beauty. When we are moved to tears by tender expressions of pain, in awe of the courage required for a client to transform internal experiences into tangible form, or witness a client giving artistic expression to something that could be articulated in no other way, we comprehend beauty in forms that deviate from conventional aesthetic standards.

Dissanayake (1988, 1992) offers an understanding of art that is relevant to this discussion of beauty in art therapy art. She considers art from an ethological perspective, as a behavior that has value for the survival of the species. Her studies of art as a behavior led her to identify the characteristic that distinguishes art making from other human behaviors. This characteristic is the activity of "making special." By this she means that human beings take the time and care to engage in embellishing, exaggerating, shaping, and transforming materials in order to imbue them with significance and import. "Special" implies that not only are we caught up in an object's striking appearance or intrigued by its uncommonness but also that "we make something special because doing so gives us a way of expressing its positive emotional valence for us, and the ways in which we accomplish this specialness not only reflect but give unusual or special grat-

ification and pleasure (i.e., are aesthetic)" (1992, p.54). This behavior of "making special" can be observed in art therapy even when the content of an artwork is about a traumatic or unpleasant experience. The behavior of making special sometimes occurs because an experience needs to be claimed and transformed through art, or because it needs to be ritually discarded (Schaverien 1992). "Making special" is not a trivial act, just as beauty in art is far more than a superficially pleasing quality.

Along with a need for an expanded notion of beauty, there is also the need for an understanding of beauty that is inclusive rather than elitist. Arnheim (1969) suggests that "aesthetic beauty is the isomorphic correspondence between what is said and how it is said" (p.255). This idea of beauty seems to resonate with Kramer's (1963) claim that quality in art is characterized, in part, by "inner consistency" (p.5). If beauty is understood in terms of authenticity or the consistency between intention and expression, then beauty in art may take an infinite variety of forms and is the domain of anyone willing to put forth the effort to achieve it. As art therapists, then, we become midwives of beauty by encouraging and facilitating formed expressions that are consistent with the inner intentions of the clients with whom we work.

An additional revisioning of the concept of beauty is suggested by those who propose that relationships – between artist and artwork, between artwork and viewer, between artistic intention and the effect of the artwork on society and the environment – are intrinsic to an understanding of beauty in art. Robbins (1992) asserts that "what is beautiful is what comes alive, whether in the artwork itself or in the transitional space between patient and therapist (p.177). Gablik (1995), considering art and beauty from a perspective encompassing all forms of socially responsible art making, calls for a more expanded notion of beauty to include art that is compassionate and healing, art that "reaches out to people who are normally left out of the process" (pp.441–2). These concepts of beauty are much more compatible with the practice of art therapy than are understandings of beauty in art that rely only on superficial pleasure, quality of craft, or adherence to formal criteria. The profession of art therapy is based in service and dedicated to the belief that art making has value in a relational context, where there is potential for art to be healing and life enhancing.

Art making within the context of relationship

Art therapists have commonly approached the subject of art therapy and aesthetics in one of three ways. Some have eschewed aesthetics altogether, attempting to distance themselves from the perceived product orientation of art education and the elitist, judgmental perspective of the art world. Others have operated from a subordinate position, conceding that most art therapy art is not "true art" but that it has merit and value in its process orientation. Still others have attempted to integrate aesthetic principles and therapeutic principles, engaging in a dialogue about the common ground as well as the differences between art therapy art and art created for other purposes. What is common in these approaches, particularly in the first and second approaches, is the reliance on criteria external to the field of art therapy for determining the relationship of art therapy to aesthetics. What would happen if, instead of turning to art educators, art critics, or the art market to determine aesthetic criteria for art therapy, we instead considered our own wealth of experiences as art therapists to be the basis upon which we developed aesthetic standards? What if we seriously considered our own particular and unique expertise in regard to aesthetics? We have something important to contribute to an understanding of aesthetics, particularly in light of the current postmodern climate where former standards have been called into question and the relevance of art to society is under critical review (Becker 1996; Felshin 1995; Gablik 1991; Lacy 1995). Perhaps we need not be so arrogant as to eschew aesthetics altogether, or so insecure as to consider ourselves second-class participants in the realm of artistic activity. Perhaps we can even move beyond synthesizing therapeutic and traditional aesthetic principles and begin to contribute to a new aesthetic, one that is inclusive rather than elitist and that is based in an ethic of care.

Key to this new understanding of aesthetics is the concept of art making as it occurs within the context of relationships. When art is viewed from a relational perspective it is no longer possible to rely solely on traditional aesthetic criteria, which is based on the formal properties of a work of art, an objective and "disinterested" viewer, and the work's pleasurable effects (Brand 1995). When the primary criteria for art making are based in connectedness – to oneself, to the object being created, to other people, to the environment – then traditional aesthetic criteria are seen in a new light.

Formal properties may be important only so far as they inform, support, and nurture these bonds. A disinterested perspective may be useful at times in order to gain a sense of objectivity, but a relationship-based aesthetic will also cultivate emotional, intimate, engaged involvement with artworks. There may be pleasurable effects to the art-making process or product, but non pleasure-producing art is equally valid and significant in an aesthetic focused on interconnectedness.

I use the term "relational aesthetic" to refer to an aesthetic concerned with the nature of artistic phenomena and aesthetic sensibilities within the context of relationships. Artworks are conceived as entities that not only are shaped by, but also shape, human perceptions and experiences. A relational aesthetic is characterized by a concern for the capacity of art to promote healthy interactions within and among people and the created world. This emphasis prompts different questions than does an aesthetic concerned with the formal elements of art and their pleasurable effects. The quality of art as determined by a relational aesthetic is based on questions such as the following:

> Is the art process healing and life enhancing for the artist?

> Is the art environment healing and life enhancing for those who work within it?

> Is the technical skill level of the artist sufficient to render intention into formed expression?

> Is the artwork true to its maker?

> Is there an authenticity, an "inner consistency," to what is expressed?

> Is there a relationship between the artist's personal and cultural history and the form the expression takes?

> Does the artist feel heard or understood by what he or she has communicated through artistic means?

> Has the artist invested the time, energy, and attention necessary to create work with authenticity and integrity?

Is the relationship between artist and art process based on a commitment to developing trust?

Is the artist able to be in a cooperative relationship with his or her art-in-progress, balancing the desire for mastery with openness to accident and happenstance?

Have the technical skills of the artist and a concern for the formal elements of art been used in service of authentic expression and the activity of "making special?"

Has the artist been able to work with a sense of dignity and purpose in spite of emotional, physical, or intellectual difficulties?

Does the art reflect a studio environment where diverse values, ideas, and sensibilities are respected and encouraged?

How are others affected by the presence of the artwork?

In the presence of the artwork, are people (including the identified artist) moved, affected, challenged, comforted, or provoked to action?

Does the artwork serve to deepen relationships…of the artist to the self, of the artist to others, of the artist to the environment, of viewers to one another, and so on?

Is the artwork relevant to concerns of the individual?

Is the artwork relevant to concerns of the larger community or world of which the artist is a part?

Are people changed in some way by the making or the viewing of the art?

Do the artistic environment, process, and product foster a sense of inclusion?

Is the art process and product accessible to diverse people?

Do people feel invited to be a part of the making and/or viewing of the art?

Are diverse ideas about the meaning of an artwork welcomed, with respect to the intentions of the artist?

Does the content of the work engender reflection, evoke response, or provoke life-affirming change in the artist and/or the viewer?

Does the artwork serve to change the world for the better, even if only in some small way?

These questions are not exhaustive of all the questions that might be asked when considering the merit of artworks from the perspective of a relational aesthetic. The questions are intended to inspire a way of thinking about art, art making, and art viewing whereby quality is centered in relational matters. The value of art, when considered from the perspective of a relational aesthetic, lies in its ability to foster and deepen quality in terms of connections. This does not make the formal qualities of art or a concern for finely crafted work irrelevant. However, from the perspective of a relational aesthetic, these qualities and concerns are viewed to be of importance insofar as they serve to foster and deepen bonds with oneself, others, or the larger community. They are important not from the perspective of art for art's sake, nor from the perspective of increasing market value, but from the perspective of fostering and deepening quality in relationships. An artwork that is carefully crafted may be valued because its handling reflects a desire to "make special," that is, to cultivate, deepen, and give honor to ties with the self, others, and the world. Concern with the formal qualities of an artwork may help the artist find the "just right" expression that leads to a deepening of relationships.

Each of the words, "relational" and "aesthetic," are key terms for the kind of arts-informed art therapy practice I am proposing. In terms of a therapeutic practice, the use of the term "relational" may seem merely to be stating the obvious since any type of therapy practice is based on relationships. It is only when this word is combined with the term "aesthetics" that a new kind of therapeutic relationship is suggested. Likewise, the term "aestthetics" is commonly linked to the topic of the visual arts. Less common from the perspective of the art world is the newer and more radical view of art as a practice informed by and primarily concerned with

relationships to ourselves, to other human beings, and to the created world (Becker 1994; Felshin 1995; Gablick 1991, 1995; Lacy 1995). For the profession of art therapy, art has served as a conduit for caring. But have we taken this idea far enough? Have we fostered the development of this art practice based in caring for others? Have we maintained a strong connection with our roots in the arts and allowed this to form the basis from which we attend to the world?

We have barely tapped into the potential for our profession to make a profound difference in the quality of individual people's lives and, consequently, in the quality of the world in which we live. In the quest for professional survival, we have often relinquished our capacity for meaningful relationships through the arts. Perhaps we have too readily accepted the definition of relationship that has come from the medical model and the definition of aesthetics that has come from the traditional art world. Instead, we might consider redefining these terms through the understandings that come from our own experiences as arts therapists. What happens to our understanding of aesthetics when it is shaped by the experiences we have with our clients in art therapy? Does the pursuit of beauty and the ideal form become irrelevant, or does it take on a profoundly new meaning? What happens to our understanding of relationships when our way of connecting is informed by our aesthetic sensibilities? Do we totally abandon a clinical model of interacting with clients and artworks, or do we re-invent the meaning of clinical from an arts-infused perspective? The difference for our profession in articulating these distinctions could mean the difference between merely surviving as a profession and thriving as a vital and contributing force in the cultural discourse about the role of art in our society.

Practical implications of a relational aesthetic

Practicing as an art therapist from the basis of a relational aesthetic has far-reaching implications. First, a relational aesthetic provides theoretical and philosophical grounding for the use of art and art making within a therapeutic or healing context. It provides a basis from which to articulate art therapy's place among other artistic practices, particularly those with humanitarian or social concerns. Second, a relational aesthetic forms the

basis for aesthetic criteria generated internally, from within the practice of art therapy. Thus, aesthetic criteria can be formulated that offer a valid and relevant means for addressing aesthetic questions arising from the practice of art therapy. Third, a relational aesthetic offers an arts-based model from which to consider the therapeutic relationship between client, therapist, artwork, and environment. Distinctions can thus be made about the unique aspects of the therapeutic relationship as conceived from within art therapy rather than as imposed by other professional models.

It is beyond the scope of this book to address all the nuances and possible implications of working from a relational aesthetic. Much of our collective wisdom in regard to this philosophical theory can be found in the day-to-day efforts of art therapists who shape and refine their under-standing of art therapy according to their experiences as practicing thera-pists. Questions about the nature of beauty, artistic phenomena, and the relationship of art therapy to aesthetic concerns arise naturally in art therapy practice and must be considered and addressed as they surface. It is my intent here to articulate some of the implications of a relational aesthetic in the hopes of inspiring further dialogue.

Response to beauty

There is a prevalent belief in art therapy that client artwork must be accepted unconditionally lest we therapists put ourselves in the position of judging the art as either good or bad and violating unconditional empathy toward our clients. At worst this belief leads to false praise, at best to a neutral, noncommittal response directed toward client artwork. The sus-pension of judgment is useful in fostering openness, attentiveness, and empathy toward what is being observed (Franklin 1990). However, sus-pension of judgment is sometimes perverted into repression of critical faculties. There is a place in our work for honest appraisals, for our authentic and discriminating responses as therapists. Hillman (1993) suggests that art therapists' discriminating appraisals are repressed due to our unexamined doctrines of empathy for clients. He cautions that suppres-sion of our spontaneous critical response may manifest instead in "subver-sively nasty interpretations." His understanding of criticism as an activity that sees potentials and invites higher attainment differs significantly from

the commonly held understanding of criticism (most notably, as practiced in critiques of student work at art schools or in art critics' published reviews of exhibits) as a review conducted in order to find fault, to make public note of flaws, and to stand in judgment.

If critical appraisal is viewed from the position of a relational aesthetic, then its purpose clearly is that of recognizing potential and fostering clarity, depth, and empathy in an artist's relationship to self, others, society, and the environment. From the basis of a relational aesthetic, we art therapists are interested in authentic relationships with clients, relationships in which our aesthetic sensibilities are important means of making connections. We engage in what I refer to as "loving criticism" and what David Henley (1992c) terms "empatheticism" (p.190). From this standpoint, the question of quality in artwork is centered in relational matters. The standards of beauty are wide and inclusive, not only making room for the quirky and unconventional but reveling in them when they occur as authentic attempts at connecting with self, others, or the world around. This does not mean that every artwork is accepted without question. It means, instead, that our critical appraisals occur in service to our clients. We don't merely consider the artwork as a discreet object, separate and distinct from its maker. The relationships between artist, art object, art process, and viewer are central to the critical appraisal. Under review is the relative success of the artwork toward enhancing the artist's connection to self, others, and environment. We conduct this review from an empathic position, remaining cognizant of the artist's intentions, aspirations, and limitations.

This empathic response does not, of course, eliminate our visceral reaction to an artwork. Upon viewing a work we may find ourselves repulsed, inspired, disinterested, delighted, bored, awestruck, or in a range of other reactive states. We may view the work as banal or become imme-diately excited by the originality and character of the work. We may strongly resonate with the work's content and the artist's use of materials, or we may find ourselves having a difficult time connecting with the work at any level. We may register immediate approval or immediate disapproval. We may react with a "like it" or "don't like it" judgment. All of these are natural, normal responses evoked by viewing artwork. These are not reactions to be eliminated but are glimpses of inner truth that can be used

with care and intention to further the quality of relationships in the art therapy context.

One aspect of the care that must be taken when incorporating these visceral reactions into our work with clients is caution about our own aesthetic bias. London (1992) warns that there is danger in applying our understanding of beauty to the art of other people due to differences in personal and cultural ideas about art. Cattaneo (1994) reminds us that we "must be alert to our culturally bound aesthetic values and tastes" (p.85). The ways we respond to particular artistic media, content, or style are shaped by our own cultural experiences and the messages we were given about the relative value or lack of value attributed to them. Sometimes our bias may present as an attitude of superiority, a belief that we are more educated, sophisticated, or otherwise equipped to distinguish "good" from "bad" art than are the clients we serve. Aesthetic bias, in whatever form it takes, exists in all of us. It comprises the aesthetic tastes, values, and preferences we have acquired by virtue of our cultural context. It is our responsibility to become aware of the antecedents of our aesthetic tastes and values so that we do not indiscriminately impose our aesthetic values on our clients. Reflecting on the kinds of art we were exposed to as children (including how our own homes were decorated), the attitudes about art that were conveyed to us by significant persons in our life, and the sources of our developing ideas about what constitutes "art" are all important avenues for gaining this awareness (Seiden 1997). The more we are able to appreciate our own sources of aesthetic tastes and values, the more likely we are to recognize and appreciate aesthetic sensibilities that differ from our own.

> Cara stops painting and looks up at me when I pass by. She smiles, but it seems like a nervous, appeasing smile. I glance at her watercolor painting. Faint, ambiguous, organic shapes are laid out in washes over the surface. The colors are pleasing enough, but the image does not engage me. I want to say something to her about her work, but no words come to me.
>
> I have no trouble responding with interest and enthusiasm to the work of the other clients in the studio. What is it that causes me to have so little interest in Cara's painting? It is as if there is nothing for me to grab on to – no intriguing details, no enticing, rich colors, no

engaging content. I find myself reacting with a judgmental attitude toward it, finding fault in the faint, tentative, vague character of it.

A memory comes to mind. I am in a painting class in college. I am nearly finished with a large oil painting of a dog, painted in pastel colors and whimsical in character. The professor, a man, informs me that as a woman artist I cannot get away with painting such images. I don't know with certainty the intent of his comment, but I do know the meaning I glean from it. It is this: As a woman, I can't paint soft, whimsical, pastel images or my art will not be taken seriously; in order to be taken seriously as a woman artist I have to paint powerful images that are bold in execution and rich in depth of color. I have to paint like a man.

I carry this message with me from my painting class and for decades to come. Is this what I bring to my encounter with Cara? Do I expect her to make art that is bold, richly colored, and powerful? At an intellectual level, I understand that characteristics associated with femininity are often denigrated. Have I internalized this oppressive message that tells me we can't be taken seriously as women if we work from a basis of feminine-identified qualities and character- istics? I look at Cara's image again. I think of the paradox of strength and gentleness. I think that working from a position of authenticity is a bold move for a woman.

From this perspective, I feel less judgmental toward her artwork. I see the potential in it. But I still find it hard to connect with, as if there is something held back that prevents me from resonating with the work. I wonder if this is true for Cara too, if she has trouble con- necting with herself or with others. I wonder if she holds back out of fear or caution, and then feels disconnected. I suggest we put her work on an easel to take a look at it, so we can be with it but at a distance. I don't ask her if she is fearful or disconnected. I don't say that she seems to be holding back. Instead we talk about her artwork. I ask her what she sees in it, what she hopes for. We talk about ways to make colors appear as if they are advancing or receding. When I want to point out a specific area of the painting, I ask if it is all right if I touch it. She says yes.

Over the next week or two, Cara's paintings change. They still appear fluid and organic, but there is more variation and definition in the forms. At least this is what I see. I think what is probably true is that the quality of Cara's painting style has shifted slightly, but my way of viewing her work has also shifted. By recognizing the cause of my aesthetic bias, it has lost its hold on me. Now when I look at Cara's work I feel more of a connection to it and to her.

Today I walk by Cara and she is standing back from her work, frowning in concentration. Her intense focus is compelling. It makes me want to move in closer. When I do, she begins to talk to me about what she likes and does not like about her work. Before I realize it has happened, I am hooked. I am her art partner, strategizing with her, becoming invested in her art process, working with her toward the realization of her artistic vision.

Our visceral reactions to artworks provide us with opportunities for empathic connection to clients and to their artworks. Immediate, internal reactions may hold more truth than do the bland, sanitized responses that come as a result of socialization and our training in therapeutic methods or aesthetic theory. These visceral reactions should not be used thoughtlessly or ruthlessly, but with care and intention. Attempting to understand the source of the truth of our reactions – whether it resides primarily in our aesthetic bias and aesthetic counter-transference (Schaverien 1995, ch.6) or also seems to express some truth within the relational context of therapist, client, and artwork – is an important aspect of the work we do. Self-awareness helps ensure that our response to beauty will be inclusive rather than elitist, and that our critical appraisals will be focused on nurturing potentials in our clients rather than reworking our own unresolved issues.

Response to clients and their artworks

If the aesthetic from which we work is a relational aesthetic, then the primary concern of our response toward client art is to further connections – of the client with the artwork, of our relationship with the client, of the client to a deepened sense of cultural identity, and so on. Lachman-Chapin

(2000) has suggested that as we became organized as a profession we "lost the simple focus on what it might mean for the client to do something he or she considers 'beautiful', i.e. coming close to expressing what is so important to his or her sense of being appreciated, being seen and heard" (p.13). This understanding of beauty is one that resonates with a relational aesthetic. Here the implication is that the efforts of the therapist are directed toward helping the client to connect authentically at an inward level and to externalize this authentic self through the form of artistic expression. Aesthetic quality is not derived from "a dogmatic demand for high aesthetic achievement as a value for its own sake but rather from the well-supported conviction that a person's best achievement bears therapeutic fruit, not obtainable from a lesser effort" (Arnheim 1980, p.250). Quality in the product of that expression is commensurate with the quality of relationship evoked. Quality is not measured in terms of technical proficiency, though technical proficiency may be an expression of the care and attention directed toward meaningful art making. How close the artwork comes to expressing the authentic intentions of the artist, how well it conveys these intentions to others, how well it fosters healing and health in relationships, are the kinds of concerns that form the basis for discerning quality.

The concept of a relational aesthetic engenders questions about how this philosophical perspective is applied in work with clients. Henley (1992a) proposes a therapeutic–aesthetic continuum whereby we can appreciate an artwork for its "existential authenticity while cautiously intervening to further that art maker's adjustment to this world" (p.154). He further advocates an empathic perspective, whereby the special needs and eccentricities of the client are taken into account, and where aesthetic concerns may be suspended when more pressing concerns such as establishment of basic trust are at issue (Henley 1992a, 1992b). Kramer's (1963) criteria for "true art," that is, "economy of means, inner consistency, and evocative power" (p.5), provide the beginning framework for the aesthetic component of the therapeutic–aesthetic continuum. Key to Henley's notion of a therapeutic–aesthetic continuum is the idea that aesthetic criteria must be continually expanded and refined according to experiences in the art therapy studio that challenge existing criteria.

Henley's style of therapeutic–aesthetic interventions can be contrasted with other models that apply aesthetic criteria but with a different perspective in regard to the role of the therapist. Lishinsky's (1972) approach to working with clients in a community mental health center was characterized by an "unwillingness to accept as art a pathological work – that is, a work that evinces symptoms of illness but is otherwise inexpressive" and instead "to demand clarity of form even if a patient's painting is *about* his illness or his miserable condition" (p.183). Lishinsky viewed this as a demand for a healthy form of nonverbal expression. Dr Janos Marten, who oversees The Living Museum in Queens, New York, relates to the people who come to this studio facility at Creedmore State Psychiatric Center as artists, rather than focusing on their identity as patients. He believes that the therapeutic potential lies in this change in identity. Marten views art as more than the so-called art product, but as what is happening within the artist and in the artist's life as a result of the act of making. In this way, he views the whole Living Museum as a conceptual art piece; not just what is made inside it but also how those acts of creation came about (Parouse and Yu 1997).

These various applications of what might be called art as therapy range in their mode and level of directed response toward clients. The approaches vary from an emphasis on the interrelationship between aesthetic and therapeutic interventions to an emphasis on aesthetic concerns *as* the therapeutic factor, to an emphasis on the therapeutic/aesthetic environment as an intervention-free zone. The common characteristic of all these approaches is a concern for aesthetics that is based in relational factors. Whether couched in terms of treatment, healing, or improving the experience of living, interest in the quality of connection to oneself and to the world remains central to the aesthetic philosophy.

Working from a relational aesthetic requires that attention be extended beyond a pure product focus. Robbins (1987) reminds us that, in the art therapy context, problems with aesthetics are not corrected through didactic means alone (pp.42–3). Addressing intrapersonal or interpersonal issues in art therapy may provide the impetus for aesthetic solutions to evolve naturally. However, a focus on aesthetics offers a way to address therapeutic issues in a language sympathetic to the art process. Knill (1995, 1999) and Knill, Barba, and Fuchs (1995) offer a model of "aesthetic

responsibility." They describe qualities that characterize responsible participation in the artistic process as it unfolds, ranging from committed attention and surrender to the ability to let go of work when it has been realized. Knill (1999) suggests that the arts therapist becomes a partner in such a process, engaging in "aesthetic probing" to serve the emerging work rather than engaging in probing that serves the fantasy of the therapist about what ought to arrive (p.48). The arts therapist works not only in service to the client's conscious intentions for the work, but also in service to the intentions of the work itself as it emerges. The therapist becomes a responsible participant in the artistic process, modeling a belief in the value of the process regardless of the beauty or beastliness of the "emergent" (Knill 1995, p.3).

A relational aesthetic forms the foundation for the aesthetic response in an art therapy context. The previous chapter addressed the way we can use our aesthetic sensibilities to attempt to understand and respond to client problems and potential. This same perspective can be extended to our attempts to understand and respond to clients' and our own artworks. If we look to artworks with attentiveness, openness, curiosity, a nonjudgmental attitude, and a sense of wonder, we are bound to enter into relationship with them in a qualitatively different way than if we approach them with the intention of finding hard-and-fast interpretive truths. We may sometimes have the unsettling feeling of having to feel our way in the dark, but the willingness to be in a position of not-knowing leaves the potential for discovery wide open. Through this attentive, open, curious, nonjudgmental, wonder-filled approach to artworks, we establish a co-creative venture with them. We are as ready to be affected *by* them as we are to have an effect upon them. We don't look to diagnose them any more than we expect them to diagnose us. We engage in a relationship with them. In the art therapy studio, we make our art and our art makes us.

I sit in my office and glance up at the clock. Fifteen minutes until group time. I think about the women who will soon arrive, about what they will bring with them to the session and how they will use it to reshape their lives. When my mind focuses on Tina, I experience that familiar sense of frustration. She has just returned from a visit to her parent's house and, by all reports, she is in bad shape. It is always

the same. She goes for weekend visits to her childhood home, time and time again, in spite of the recommendations of the treatment staff. Each time she returns, she is visibly shaky, has recurring nightmares, and cuts new marks on the insides of her forearms, stomach, and thighs. None of the staff members know for sure if her father still sexually abuses her. But everyone wonders.

I enter the art therapy room and Tina is already there, sitting in a chair. She looks up and says hello to me. I notice her hands shaking and her feet tapping. I feel a jolt of anger directed toward her. I want to shake her, tell her to stop making these trips home, tell her to stop subjecting herself to this abusive environment. I feel little empathy for her, mostly just exasperation.

When everyone else arrives, we talk a little about the thoughts and feelings we each bring in to the studio that day. I mention that I am feeling frustrated about things I have no power to change. Some of the group members nod as if they too know what this is like. When everyone has had a chance to share their thoughts, the group members decide they need to focus on "boundaries" as the theme for their artwork that day. A shuffling noise ensues as paper, pastels, paint, and clay are gathered. Each person finds their space to work and soon the only sounds to be heard are the faint rustling of paper, the shooshing sound of pastels being applied, the tapping of a brush on the side of a glass of rinse water. I work on my own drawing, frequently glancing around the room to observe the quiet activity of other artists at work. When we are all finished, we gather in a circle, artworks placed on the floor in front of us.

The atmosphere in the room feels heavy. No one looks at anyone else. I suggest we all take some time to look at what has been created. Everyone moves quietly around the circle, stopping briefly at each artwork. There is no easy banter among the group members today, no pats on the shoulders, no spontaneous remarks. When I ask if anyone would like to talk about her artwork, there is silence. "All right," I say, "it seems like a quiet day today. Let's do something quiet." I suggest that we each put a piece of paper beside our completed artwork. Then I encourage the women to move around to each of the artworks again. Only this time I ask them to write words

in response to what they see – single words or phrases, adjectives, words that describe. I ask them just to look and write without thinking too hard.

They move from one art piece to the next, jotting down words and phrases. When everyone is finished, we each take turns reading the words written about our own piece. When they are read out loud, they sound like poems.

Tina sits near her pastel drawing. The image is of a path bordered on either side by a wooden fence. The fence has been broken through in multiple places as if there has been a stampede. These are the words she reads: "bits and pieces / splintered / shattered / no one gets the message / ignored / disregarded/ in need of mending / can't hold in, can't hold back / useless protection / trampled." She looks up and in a small voice reads the last words on the page: "help me." In that instant, something shifts in me. I see the broken, splintered wood and I feel it inside, like something crashing through me, splintering my bones into bits and pieces. I feel the shock, the outrage, and the sense of total helplessness against this stampede. Momentarily, I feel lost and utterly powerless.

Then I look again at Tina's drawing and I am struck with a sense of wonder. It is such a simple drawing, and yet it conveys so much. I see in it Tina's story and the story of how women's boundaries are repeatedly and indiscriminately violated. I see in it my actions and the actions of the treatment team, forcing our ideas on Tina about how to "fix" her situation, rather than respecting her limits and asking for her ideas.

My response to the image is simple. I look at Tina and wince, hold my stomach, double over as if someone has kicked me in the stomach. Her eyes fill up with tears and so do mine. She quietly nods her head as if in confirmation. It looks as if she thinks I understand. And for the first time, I feel like I do.

Viewing artworks from a poetic rather than a pathological perspective offers clues about new ways of engaging and responding to artworks. Verbal "processing" after an artwork is completed, a model borrowed from word-based therapies, is but one avenue for engagement. It may be, but is

not necessarily, the method that best resonates with the artist's and the artwork's intentions. When we engage our aesthetic ways of seeing and knowing the person and the person's artwork, we become co-participants in the creative process. Aesthetic responses based on the needs of the client may occur at any point either during the art making process or after completion of the artwork. Responses can range from simple murmurs of encouragement, to painting side by side with someone as a form of gentle probing, to a spontaneous "interpretation" of a painting via found object percussion, to facilitating the dramatic enactments of group members in response to each other's works. The possibilities are endless. Other examples of ways to respond to artworks are presented in Chapter Seven, but the "just right" response to any artwork is found only through the trial and error that is an integral part of the creative process. Our roles as art therapists do not require us always to find the perfect response; rather, we are there to help our clients learn how to play with, approach, adjust, shift, take risks, modify, plunge forward, retreat, try out, and discover ways to creatively engage with their artworks. In essence, we help them engage in the process of trial and error so that they may find for themselves the "just right" way of expressing and transforming their experiences, thereby deepening relationships to self, others, and the world.

Conclusions

By and large, art therapy's relationship with the topic of aesthetics has been either reactive or adaptive in response to philosophical models offered by the art world. In practice, however, our cumulative experiences with art made in service to human potential have given us much to contribute to a new understanding of aesthetics. Our art-based practice is inclusive rather than elitist, based in an ethic of care, encompassing of a generous concept of beauty, and grounded in a concern for quality in relationships.

A relational aesthetic model provides a philosophical and theoretical grounding for the use of art and art making within a therapeutic context, as well as a basis for locating art therapy within socially concerned artistic practices. Working from a relational aesthetic provides the basis for aesthetic criteria that are generated internally, from within the profession of art therapy. It also offers an art-based model from which to consider the

therapeutic relationship in art therapy as it is distinguished from that of other professional models. Most importantly, however, the concept of a relational aesthetic leads to a valuing of art based on its ability to foster and deepen relationships to the self, the art object, other people, and the environment.

Influence of an Artistic Perspective on Therapeutic Work

This is what it means to be an artist — to seize this essence brooding everywhere in everything... (Frank Lloyd Wright quoted in Fitzgerald 1996, p.15)

"I can't draw," Will says to me after we are introduced. He glances nervously around the room, taking in the quiet bustle of activity as other adults set up easels, sort through the box of wood scraps, carry paper and oil sticks to the table, begin to construct stretcher frames, start to wedge clay. It is his first time in the art therapy studio. He looks back at me and smiles wryly "I can't even draw a straight line." I think to myself, how many times have I heard these words? Hundreds? Thousands? I want to brush his remarks aside. After all, I really don't have time for such nonsense. I have so many people to attend to and I am sure Will has the ability to draw; he has just lost touch with it. I want to tell him this. I want to give my "Rah! Rah! Go art!" cheerleader speech so we can get down to business.

Instead, I take a deep breath and let it out slowly. I remind myself of what I mean when I say I can't play softball. What I mean is that I'm not very good at it. I mean that somewhere back in my childhood I got the idea that I wasn't athletic so I avoided sports. And consequently, I didn't develop the skills it takes to play a good game of softball. When I was forced to play it in gym class I felt clumsy and foolish and embarrassed because I didn't know what to do or how to do it well. As I grew older, I made sure to avoid situations where my ineptitude would be exposed. If there was a softball game going on, I

steered clear. Consequently, I never developed the skills for playing the game. Now I sometimes play, but I may preface my play by saying "I can't play." And, as paradoxical as this may sound, it's true that I play but can't play. What I can do is be willing to risk feeling inadequate and foolish while my bat meets only air or I catch a ball but look around in a moment of confusion about where to throw it. For me, this is not play because the joy and spontaneity are missing. Instead, I am involved in facing my fears and taking a risk; it's hard work. "I can't play" also means that there are some aspects of softball I really can't do because I never developed the necessary skills. So when I say I can't play, even if I pick up a glove and start walking toward the outfield, I mean I can't play. For now, all I can do is work at it.

Remembering all this helps me in my response to Will. I ask him when he last recalled making any art. He laughs uncomfortably and tells me that it was probably in grade school. I acknowledge that it must be hard to think of taking it up again after so long, especially here, in a room full of strangers. I suggest we start with a tour of the studio just to get him acquainted with the materials available and to see what other people are doing. I assure him that I will help him if he decides he is willing to try making something.

As we move around the studio I greet other people who have come there to work. Stan has set up his easel and paints. After years as a psychiatric inpatient and years living in a halfway house, he has recently moved into his own apartment. His painting is for his living room. He has his preliminary sketch taped to the easel above his canvas. As usual, the connection between his preliminary sketch and his actual painting is an enigma to me. The sketch seems to provide some necessary structure for him, but it is a structure I do not grasp. His brain and my brain operate differently, so sometimes I have difficulty serving as his guide when he asks for help. Our mutual love for color and form, for the way images take shape on painted surfaces, provides the common ground between us. Our mutual respect for each other also gives us a solid base from which to work together. As Will and I pass him, Stan gives me a hearty greeting.

Lisa and Pam are sitting at the table with paper and pastels in front of them. Lisa tells me she doesn't know what to do today. Pam chimes in, "Let the image speak to you!" and then gives me a mischievous grin. "Oh, go ahead and make fun of me if you want!" I respond. We all laugh. I say, "Just let me finish giving Will the grand tour. Then I'll be back to help you get started, Lisa."

Ron passes by carrying brushes and a cup of water, his eyes focused downward as he shuffles along. He does not notice us until I greet him. He looks up and says hello, then heads toward the table where he always sits to work. Melinda has set up her easel in the corner of the room, a safe haven in which she is working intently. Out of the corner of my eye I see Miriam. She is loading up her arms with fabric, wood scraps, glitter, beads, hardware, and ceramic tiles. The last time she was here she had prepared a canvas to paint. I think I better check in with her as soon as I can, to see if she needs some help getting refocused.

When I have finished giving Will the tour, we sit down to talk for a few minutes. I tell him that the art therapy studio is a place where people use art to help them deal with the problems that have brought them to the hospital. I tell him it would be helpful if he could tell me a little bit about why he came to the hospital and what he hopes to get out of being there. He tells me that he had an accident at work eight months ago and has since been on disability pay, unable to return to work. He describes how over the months he has gradually lost interest in everybody and everything in his life. He says:

> And you know, the less I do, the less I feel like doing. The less I go out, the more excuses I come up with for why I shouldn't go out. And now, I feel like a big baby. I am afraid to go out, even to go to the grocery store. Sounds kinda crazy, I know. But what I want to get out of being at the hospital is to get my life back again. You know, just the simple things in life…going to the store, taking my kids fishing, working on my car. I just want my life back again.

I tell him that makes sense to me. I ask if there is anything he saw as we walked around the studio that piqued his interest; any ideas he

has about what he would like to make. "Oh, I don't know," he mutters. "I guess I'll try one of those tile things." He points to a mosaic on the wall, made by gluing tiles in a simple, geometric design. He sounds resigned, unenthusiastic. "Will," I ask, "are you sure that's what you want to do? You don't sound very convincing." He points at the wall again. "Well, I'd really like to do something like that painting there. That's real nice. But I could never do anything like that." I turn to look at the wall along with him and say, "Will, you said you want to get your life back again. It doesn't sound like it can be the same life you had before, since you won't be returning to your job. So maybe this is a good opportunity to consider what kind of life you want to get back. Will you be satisfied with a 'tile thing' kind of life, or would you rather get back the life you really want?" He turns to look at me, a smile barely playing on his lips. "Okay, you got me on that one! I'd like to make a painting, but I don't have a clue how to do it." I reassure him, "I'll help. Let me show you how to get started."

In any single "freeze-frame" of an art therapy session there are multiple opportunities to make use of the particular influences of an artistic perspective. This "artistic perspective" does not preclude the use of knowledge and skills gained through other perspectives, nor is it exclusively the domain of art therapists. The artistic perspective is, however, our unique contribution as arts therapists to the helping professions. It makes sense that we study, consider, cultivate, and work with intention from this perspective.

The influence of an artistic perspective on therapeutic work is potentially far-reaching. It can influence virtually everything we do with clients. Our perspective as artists affects how we respond to someone who believes they have no artistic abilities. It is played out in the atmosphere we create in the studio. It influences the kinds and qualities of relationships we have with our clients. When given attention, an artistic perspective helps to sharpen and clarify the particular form of therapeutic work we refer to as art therapy.

This chapter will focus on some – though certainly not all – of the influences of an artistic perspective on the work we do with clients. Brief, descriptive scenes from art therapy sessions will serve to give the "feel" of

the work while the exploration of concepts about an artistic therapeutic perspective are presented in order to give some theoretical grounding.

Relationship between art therapist and artist clients

I look around the studio, poking through the box of found objects I've been saving, pulling out some painted paper scraps. I want to be ready when Angela arrives, work-in-progress already happening. Maybe that will help give her a start, keep her from trying to work out every detail in her head before she dips her brush in the paint. I think the sound of hammer hitting nails, the smell of paint, the sight of materials laid out on the table might be an enticement to her to engage with her hands and her senses and her heart.

She walks in, averting her eyes, dragging her shoes on the wood floor as she makes her way to the table. She plops down and yawns, a sheepish grin on her face when she explains that soccer practice was cancelled and she just woke up from a nap. She doesn't even seem to notice the art materials displayed invitingly on the table. I put down my hammer and sit at the table with her. "Well…" she begins, and then launches into a lethargic-sounding report of the week's events. I am lulled by her sleepy voice. I think I could just listen to her for the entire hour we will be together. Maybe she just needs to talk today, I think. Maybe. Or maybe I am as leery as she of her making art that will connect her with her past. Too much pain there. She wants to remember, but she doesn't want to remember. And I am right there with her, wanting to hear her stories, not wanting to hear her stories.

I look at my own artwork-in-progress, an assembly of found wood scraps and twigs that form a box. It is patiently waiting for me to get to the heart of it, the insides. I think of how I have danced around the edges of it, preparing materials, arranging and rearranging found objects, setting it aside while I have given in to life's distractions. I remember what I have told Angela: "Your memories will come if and when it is time for you to remember. What we are doing by making art is creating nesting places for the memories to be born into when they are ready." I wonder, what are Angela and I afraid of?

Why do we keep dancing around the edges, giving in to life's distractions?

She is talking to me about her anxiety regarding the future. In a year she will graduate from high school and she has no idea what she wants to study in college. She spins out a tale of her future failings, all due to her present uncertainty. Before having taken a step, she has already foretold of her demise.

I pick up my palette knife and begin to mix a deep shade of blue. "What are you going to work on today, Angela?" I ask her. She shrugs her shoulders, walks over to the painting rack and pulls down the pieces of corrugated cardboard she has cut to make the cover of her oversized scrapbook. She lays them on the table and considers the painting she has begun on one of them. She doesn't mince words with her appraisal. "This looks really idiotic!" I reply, "The best thing about acrylic paint is that it's easy to paint over. What would you like to change about your painting?" She begins to think out loud, planning what she will paint, predicting how it will look, proposing ideas and nixing them one after the other. In no time she has predicted the total failure of her artwork.

I dip my brush into the blue paint I have mixed and begin to paint the interior of my box construction. "Sometimes," I say, "I have no idea where I am going with my art pieces. I just have to start working on them. Once I do something, I usually get an idea about what to do next. If I try to plan the whole thing out ahead of time, I get overwhelmed. But if I just take it one step at a time, each thing I do leads me to the next. And eventually I'll get to the point where I think it's finished. But at first, I just have to start doing the work, without knowing for sure where it will lead me." Angela sighs deeply and says, "I know, I know. Paint, paint. Don't think, just paint!"

As she mixes colors and applies them we talk about the possibility of Angela and her mother going to visit colleges this summer. We talk about what might help the figure in her painting stand out more from the background. We paint, take baby steps, work our way in and through…unsure of precisely how it will all turn out but going ahead in spite of our not knowing.

The relationship between the art therapist and the artist client is, as I have stated previously, a relationship between two people who contribute their various areas of expertise to the mix. As art therapists we contribute our expertise in the areas of art, human development, psychology, and counseling theory as well expertise derived from personal life experiences. Art therapy clients contribute from their own individual and unique areas of expertise. Among the areas of expertise held by clients is a first-hand knowledge of their needs, wishes, dreams, desires, insecurities, strengths, and so on.

An art-based model of art therapy places a high value on the artistic identity in both the art therapist and the client. This identity forms the nexus around which the relationship develops. In regard to this aspect of the relationship, each individual also contributes his or her expertise. As art therapists we contribute knowledge of art history and aesthetics; of art tools, media, and methods; of the psychology of art and the creative process. The clients we work with are likely to have at least some knowledge of art materials and techniques, and may or may not be knowledgeable about art history and aesthetics. The level of artistic experience and know-how will vary among individual clients. What each client will invariably contribute is a personal artistic vision, no matter how undeveloped, fragile, or insecure that vision may be. As art therapists we also bring our personal artistic vision to the relationship. It is at the crossroads of these visions that the artist client/art therapist relationship is born.

The interrelationship of these artistic visions is a delicate matter due to the unequal power inherent in therapy relationships. In most instances (though there are certainly exceptions), we art therapists will be more self-assured, confident, and passionate about our artistic visions than the clients who come to us for help. The client, as well as being in the more vulnerable position of the one who is in need of help, may feel incompetent and insecure when confronted with art materials and the expectation to make something from them. As art therapists, we strive to use our artistic visions in the service of our clients. This means we try to channel our enthusiasm and passion for art so that it becomes an inspiration for clients rather than a dominant force that overwhelms their tentative artistic intentions. At best, our sense of artistic vision provides a spark to ignite the dormant artistic sensibilities and passions of the clients with whom we

work. At worst, our artistic vision overwhelms and extinguishes the tentative flickers of artistic identity residing within clients.

Working from a position of authenticity is key to maintaining the necessary balance of a shared artistic vision in our relationships with clients. Robbins (1992) defines authenticity as "an experience in the patient of an inner availability on the part of the therapist, coexisting with respect for the bound area of treatment. Authenticity is thus bipolar also. It 'resides' in the therapist, but is experienced by the patient" (p.180). Robbins's definition nicely captures the relational quality of authenticity. I would add that this "inner availability" on the part of the therapist comes about as a result of the therapist's pursuit of truthfulness, the pursuit of a consistency between the therapist's internal being and external presentation. This is not a static achievement but rather a dynamic process of "checking in" that goes on between inner and outer experiences.

Refining one's sense of truthfulness means, to a large extent, becoming better at asking difficult questions of one's self. This questioning causes paradoxical experiences of being "off-balance" (full of questions) while at the same time being firmly grounded in one's core values and beliefs. Truthfulness is not measured by the full disclosure of intimate internal experiences. Instead, truthfulness is revealed primarily through actions, through the way one's life is lived. Art therapists who work from a position of authenticity and encourage clients to take risks in art making will inevitably question and challenge themselves as well in regard to their own risk-taking in art. The "inner availability" referred to by Robbins is experienced by the client because it is lived by the therapist.

Our authenticity as art therapists is most profoundly lived through commitment to our own meaningful, developed art making. There is no other way to know intimately and to genuinely communicate the nuances of the artistic process. Ironically, being committed to our own art making process enables us authentically to understand that *not making art* is sometimes an important aspect of the creative process. There are times when creative block signals a need for a change in artistic direction, when a hiatus from art making is needed so that new ideas may be generated, or when involvement in relationships that prohibit art making in the moment provide fuel for emerging work.

We also come to understand some of the other intricacies of the creative process. Our authenticity as art therapists is further enhanced if the art making we engage in is closely aligned with the kind of work we expect of our clients. If we ask our clients to engage in artwork for the purpose of self-exploration and self-expression, if we expect our clients to make art in a community studio setting, if we encourage clients to reflect on the meaning of completed works, then these are all important challenges to pursue in our own art making.

Resistance

To resist means to oppose or stand firm against the action or effect of something. At a social–political level, resistance is a strong stance taken against something that is perceived as detrimental to society. In therapy, "resistance" is a term used to refer to any unconscious psychic obstacle and corresponding behavior that interferes with the therapeutic process. From the political to the personal, resistance is a serious matter and is engaged in due to a perceived threat. Resistance is not something that occurs only in treatment settings, but instead is a normal response to change. It is an indication that change is beginning, that internal psychic processes have been alerted to the potential danger of a shift from the status quo. Since therapy is predicated on the need for some kind of change, resistance is a normal, common occurrence.

In our roles as therapists, when we recognize resistance behaviors in our clients we are provided with opportunities for engagement. In my experiences as a staff member and as a practicum supervisor in various mental health settings, I have observed that this opportunity for engagement frequently goes unrecognized. Resistance behaviors may be identified and labeled as defense mechanisms (leveling, seduction, avoidance, transference splitting, intellectualization, and so on) but not responded to accordingly, that is, they are not responded to as if they are indeed the acting out of unconscious psychic phenomena. Instead, resistance behaviors that cause discomfort or inconvenience for the staff are often interpreted as conscious phenomena and perceived to be hostile in nature. The response of staff thus tends to be moralistic and punitive. When the resistance

behaviors are less troublesome to staff, such as passive compliance, they are often unwittingly reinforced.

Considering resistance as an opportunity for engagement, as a point of access offered by a client, sets up an entirely different dynamic between client and therapist. Working from the perspective of a relational aesthetic makes this possible. We make use of our aesthetic sensibilities and attempt to "hear" what a client is expressing (unconsciously) through these behaviors. Bruce Moon (1998) suggests thinking about resistance behaviors as performance art so that we are "free to observe and reflect upon the meaning of the performance without becoming enmeshed in the drama" (p.115). Our empathic skills are stimulated through considering the poetry, rather than the pathology, of the person.

Responding effectively to resistance can be viewed in three steps: first, acknowledging the resistance; second, attempting to understand what is being communicated by the resistance behaviors; and third, engaging with the resistance at an empathic level. In the first step, acknowledging the resistance, the art therapist lets it be known to the client that the behaviors have been noticed. The client has been seen, felt, and heard.

Gerald's mother accompanies him into the art therapy studio. He appears sullen, every muscle in his thin, eleven-year-old body clenched tightly. He will not look at me and does not greet me. His mother whispers to me that Gerald is in revolt against all his therapies: psychotherapy, tutoring, social skills class, mobile therapy, therapeutic support services, and art therapy. He wants to ride his bike, play video games, have friends over after school; he wants nothing to do with all these therapy appointments. When she leaves the studio, Gerald follows her, saying he does not want to stay for his appointment. Once outside the building, he tries to get in her car, tries to hold onto the door handle as she pulls away from the curb. When these efforts fail, he resorts to simply not moving. He stands firm and resolute on the sidewalk outside the building, frozen in position, his silent protest.

I stand a bit apart from him, but within his line of sight. I tell him that I will stand still with him as long as he needs to be still, and that I will be ready to move inside and make art if and when he is ready.

Acknowledgement of resistance is simple and straightforward. It is a way of saying to the client, with words and/or with actions, "I hear you." It accords some measure of dignity to the client's expressions without passing judgment regarding the relative "goodness" or "badness" (appropriateness or inappropriateness) of the behaviors. It also gives us, as art therapists, the opportunity to do what my mentor, Don Jones, always advised: to respond rather than react. By taking the time (perhaps only a moment) to acknowledge the poetry of a person, we ourselves are forced to consider that poetry.

The natural follow-up to this acknowledgement is the second step in addressing resistance, an attempt to understand what the client may be expressing by particular behaviors.

As Gerald and I stand together, the sounds of trucks and cars on the busy street fill our ears. People on the sidewalk glance curiously in our direction as they pass by. I have to admire Gerald. I have the building to lean against, but he started his protest in the middle of the sidewalk and he hasn't budged an inch – not for me, not for all the tempting art supplies lying in wait for him inside, not even for the sake of his tired legs. I periodically remind him that I am there with him, that I will stay with him as long as he needs to stand still, that I am ready to move inside and make art if and when he is ready. I look at my watch from time to time – 5, 10, 15, 20, 25 minutes. His stamina is impressive. He doesn't even glance in my direction. I begin to doubt myself. "What," I wonder to myself, "just what the heck am I doing here with this kid!?" I have visions of his mother returning an hour later, finding us still standing outside on the sidewalk like statues. I don't think she'll be too impressed with our therapeutic progress! I don't think she will consider it money well spent.

Listen, I tell myself. Listen to what this child is telling you. So I try to listen. I "listen" to his frail body, swaying slightly with the effort of standing in one place for so long. I see the tense set of his jaw. Stuck, he looks stuck. He seems unable to relax, unable to move forward. I think of all the art materials inside my studio. He had told me in a previous session of his love for art, how he enjoyed the things we made together in the studio. So I look at him now and think maybe he is telling me about standing out of reach of the things he

loves, standing apart, stuck in an unfamiliar place while people pass him by. Maybe he is unable to go inside the building to get the good things, to take what is offered to him, what will nourish him. I wonder if he is also unable to go inside himself and get the things he needs to sustain himself. I think of how frightening this would be, to be so stuck. So I stay with him. I stay so he won't have to be stuck alone.

The third step in responding to resistance, following its acknowledgement and attempts to understand its message, involves engaging with the resistance behaviors at an empathic level. In essence, the therapist conveys to the client recognition of the message underlying the overt behavior. Just as the client communicates through metaphor, the therapist responds via metaphoric expressions (Rinsley 1980).

Limit setting can be a form of engagement, if carried out with a caring, compassionate intention rather than a punitive one. It is much easier to set limits in a caring manner if we also acknowledged the behavioral expression and attempt to understand it. Without these considerations, the tone of our limit setting is likely to be reprimanding and punitive. The message conveyed, though rarely so directly is: "Stop that! You are a bad (troublesome, frustrating, annoying, frightening, and so on) person for displaying such behaviors. You are unacceptable as you are and must be punished (restricted from desired objects or activities, publicly shamed, reminded of your lack of power in the situation, and so on) so that you will change your ways." If limit setting is approached as a way to engage with someone, then the implied tone of the message is very different. The message, again rarely stated so directly, goes something like this.

"I see that you are having a difficult time right now and that something is interfering with your ability to fully engage in what we are doing. What we are doing must be very hard (threatening, frightening, disconcerting) for you. I will try to help you become more engaged. However, if your behaviors are hurtful, or threaten to be hurtful to yourself or to other people, then I will work with you to contain or transform them. If you are not able to do this, I will do my best to serve as a temporary container so the harm is minimized. I believe in your ability to change, and I want to help you whenever you are ready and able."

It is sometimes necessary to set limits for reasons of emotional or physical safety before there has been time to try to understand or even to acknowledge resistance. Even so, it is possible to do this in a caring way, recognizing that the need for an immediate and intense response on the part of the therapist is most likely indicative of an immediate and intense need on the part of the client.

Engagement may take other forms in addition to limit setting. If the behaviors are not potentially harmful to the individual client or to the community environment, then the focus of engagement can be on some form of joining with the client. This doesn't mean that we engage at a superficial level in the same resistance behaviors as those of our clients, but rather that we join the clients at a deeper, empathic level. To think in metaphorical terms, resistance might be envisioned as the reluctance to enter an unfamiliar doorway. If we push and prod clients from behind as a way of trying to get them to go through the door, the normal response will be increased resistance to moving. So, too, if we stand at a distance and direct clients to move through the doorway it is likely that our directives will be looked upon as suspect and the clients' resistance to moving will increase. However, if *we* do the moving, if *we* join clients at the point of their resistance and demonstrate a willingness to simply be with them on their terms, then the threat of force is diminished and the need for resistance decreases. As clients develop trust in our empathic stance, we can model a willingness to move through the doorway. The clients are then free to choose whether they will stay put or move through the doorway as well.

Joining with clients can take many forms. There are no prescribed therapeutic maneuvers for empathically engaging with resistance behaviors. Instead, there is a willingness to be receptive and responsive to whatever clients offer through their behaviors. In art therapy, resistance often manifests through the art process. Behaviors such as claiming an inability to do art; using written language instead of making images; relying on trite or stereotypical imagery; creating vague and undefined imagery; making self-deprecating remarks about one's artistic skills; restricting use of materials; creating ambiguous, abstract imagery (Hanes 1998), or intellectualizing about one's own art may be (though are not necessarily) forms of resistance. When resistances become manifest through the art process, it is this very same art process that offers the most logical

access for engaging with that resistance. For example, if a client's use of writing in an art therapy group seems to serve as a way to maintain distance from self and others, I might "join" with the client by using writing as my medium of expression. I would begin with a writing style similar to that of the client's writings, and gradually allow my writing to become more deeply engaged, particularly in terms of my relationship with the client in question. Without ever saying anything, I would be acknowledging, attempting to understand, and engaging with the client within the idiosyncratic language of the client's resistance behaviors.

> After about thirty-five minutes of standing still, Gerald moves inside to the art studio. He spends the remainder of the session sitting at the table in the studio without looking at me or uttering a word. I sit with him. We don't make use of any visual art materials during the session. Mostly I am quiet, but I do acknowledge his ability to move inside. I tell him I am glad he was able to do this because I think it must have been tiring to stand still for so long. I remind him that I will be here again next week when he comes. And if he is ready, we will make art.

Some of the things I did as an art therapist to deal with Gerald's resistance behaviors were the very same things that someone trained as a counselor or social worker would do. To use the jargon of the mental health system, I set clear limits and I provided him with a consistent, nonthreatening therapeutic presence. But there were attitudes and actions I did not engage in that are commonplace in the domain of the mental health system. I did not conceive of his resistance behaviors as "inappropriate." (Frustrating yes, but not inappropriate.) I did not "prompt and redirect" him in an effort to get him to change his behavior.

What made it less likely for me to think of his behavior as inappropriate and to subsequently redirect him to alternative behaviors in order to facilitate change had to do, I believe, with my making intentional use of my artistic sensibilities. I attempted to perceive the poetry of his self-expression, to tune into the small wavering of his movements, the drama of his clenched expression, the story held firm in his entrenched position. Gerald was a bit of poetry set down in front of me, a subtle but eloquent performance art enactment of resistance gracing my life. How could he be

inappropriate? How could I feel impelled to prompt and redirect? To stomp out the poetry as if it were an inadvertent fire? To rudely pull the curtain as if his performance were wrong, not good enough? Instead, I was compelled to listen through his silence to that which he expressed without words. I became his audience. I waited for the invitation to join him. The invitation did come, with little fanfare, when he trod intently in front of me to enter the building, knowing full well I would follow.

Alliance

An alliance is a bond or connection made between individuals to further common interests. In therapy, the bond occurs between therapist and client in order to further the interests of the client's health or well-being. When art making is added to this mix, the bonding becomes more complex. Alliances occur between artists (clients or therapists) and their materials, between artists and their artworks, among artists working in a communal setting, and between artists and works of art created by others in the studio setting. In the communal or group studio setting, alliances occur between clients based on their common identity as art makers. As McNiff (1995) said, "the studio is an ecology of mutual influences" (p.181). It is important to consider how the relationship between artist client and art therapist can make best use of these mutual influences to further therapeutic progress.

In a studio-based approach to art therapy, artwork and the artistic process remain central in the relationship between therapist and client. This does not preclude talking with clients during sessions, nor does it preclude occasional sessions where talking predominates. It does, however, mean the therapeutic work is not anchored in discursive language but rather in the language of artistic expression.

What happens when the common interest between therapist and client is not art? This happens frequently in situations where clients are "pre-scribed" art therapy as a treatment modality but have little interest in art or art making. A woman with psychiatric disability (as quoted in Spaniol 1998), commenting on the subject of art therapy, said pointedly, "I don't know why they always seem to think we want to make art just because we're mental patients. I don't want to do art, so I shouldn't have to, just like anyone else" (p.33). One solution is the open studio model (see, for

example, McGraw 1995), where clients are free to come and go as they please, making as much or as little use of the art therapy studio as they wish. This model of art therapy is not always practical, nor is it a good fit for every setting. In an environment where clients are assigned to art therapy, the solution may be a flexible approach on the part of the art therapist. The therapist can invite involvement in art making but remain sensitive to the subtle levels on which it can occur and respectful of the client's right to choose. Allen (1983) discourages mandated participation in art therapy and advocates instead an acceptance of behaviors in clients ranging from observation to full participation. This approach underscores the expertise of clients relative to their needs and requirements for personal development. At the same time, it challenges the therapist to be open-minded about what constitutes the art-making process. For example, does the creative process begin only when the artist makes marks or shapes materials? Or does the creative process begin in a period of incubation, when consideration is given to both external and internal influences and raw materials? Some clients may never develop an interest or willingness to make art. However, it is within a flexible, accepting, and creatively fertile environment that the reluctant fledgling artist is most likely to become engaged in the process of making art.

Implicit in this flexible, accepting approach is respect for the autonomy of the client as artist. Art therapists contribute technical advice, examples, assistance, support, and guidance, as well as infectious enthusiasm and passion for art making. But it is the clients who determine the nature and content of their art-making processes, as well as the significance and meaning of their artworks. Art therapists defer to the client's sense of artistic vision, employing what Henley (1992c) describes as empatheticism, "whereby the intentions of the artist are approached without any preconceptions or expectations" (p. 190). It is an alliance of artistic interests, but one in which the therapist's artistic vision is employed in service to the relational aesthetic between therapist and client. The art therapist carefully looks and listens for the artistic intentions of the client and helps those intentions become manifest through art.

Respect for the autonomy of the client does not imply a totally uncritical, all-accepting approach on the part of the art therapist. There may be times when clients' behaviors interfere with the realization of their artistic

intentions. It is our role to help the client recognize unrealized intentions and develop ways of working that will lead to more satisfying results.

If art therapists have erred, it has been on the side of lacking a discriminating response toward clients' art products (Hillman 1993). Most art therapists have rejected the unnecessarily harsh critiques associated with art schools and art critics' reviews of exhibits. We have understood that this harshly critical approach can inhibit rather than inspire artistic development. However, there has been a tendency to take this rejection too far, not only blindly accepting any use of art materials by clients but also falsely praising clients' artistic efforts (Allen 1983; Spaniol 1998).

The development of a critical eye is crucial to the ability to bring intention to fruition. If our clients are to find satisfaction in their attempts at artistic expression, the critical perspective is an important ally in this process. The degree of intensity in constructive critiques can be modulated in response to the ego strength of the client, the level of trust in the therapeutic alliance, and, in a communal setting, the developmental level of the group. McNiff (1998c) makes a helpful distinction between the critical voice, which observes and comments from within the artistic process, and the judge, who is detached from the creative process and passes judgments according to a "set of standards that do not grow from the work" (p.194).

It is our task then to help our clients develop a critical voice, whereby they can realistically appraise their artworks based on the intentions for the work itself. Unrealistically bleak or unrealistically optimistic appraisals are equally detrimental to the realization of artistic intentions. What is most helpful is the development of a lovingly critical eye, a perspective that recognizes problems and potentials in the artistic process so that problems can be resolved and potentials can be actualized. Our ability to help our clients develop this lovingly critical eye toward their own work will naturally evolve from our ability to cultivate this perspective within ourselves, both in relation to our own work and to the work of our clients.

Relationship between artist and art process

One of the best sources for understanding the relationship between people and the artistic process is our relationships with our own art making. If this understanding is used prudently, by recognizing that our own experiences

will not be unerringly duplicated in the people we work with, it can help us remain grounded in what the artistic process has to offer our clients. Absurd as it may be, there are times when we expect clients to make art under conditions that would stifle our own creative process. For example, we sometimes ask clients to create art on demand, under extreme time constraints, with poor quality materials, and in response to a theme that evokes cognition rather than imagination. Furthermore, we sometimes ascribe pathology to normal aspects of the creative process. For example, when a client does not make art in a session we might label them as resistant rather than as in need of time to allow creative ideas to germinate. Remaining intimately aware of our own artistic process provides a basis for challenging these expectations and assumptions.

Understanding our own artistic process, important as it is, is not enough. We also have to continually remind ourselves of the varieties of experience that constitute and impact the creative process in different people. It is essential to remain sensitive to the varying needs among clients for fostering and supporting artistic activity and to be flexible enough in approach to accommodate these needs.

Opportunities and obstacles

Bayles's and Orland's (1993) book, *Art and Fear*, begins with the sentence, "Making art is difficult" (p. 1). Those of us who are active as artists (as well as many who no longer are making art) recognize this as an irrefutable truth. We can easily relate to the evidence Bayles and Orland cite: difficulty finishing works, feeling as if the work is not authentic, experiencing the fits and starts of the creative process, frustration that the reality of our creations do not match the imagined ideal, and so on. Yet we sometimes forget this when we are working with clients. We forget what a difficult endeavor we are asking clients to undertake. To add to the difficulty, clients are typically in therapy because their lives are already on shaky ground. Then we ask them (many of whom have no confidence in their artistic abilities and for whom the idea of being observed making art strikes terror in their hearts) to do something that we, in our most healthy moments, find difficult. It seems only fair that we try to foster an environment for our clients where

opportunities for art making are generous and obstacles to creative expression are minimized.

There are many contributing factors to the experiencing of obstacles and opportunities in artistic pursuits. In Chapter Four I discussed in detail the studio space and its potential to contribute to the creative ambiance. Other factors contribute (or detract) as well, including: the context within which art making occurs, the time allotted for art making, the materials provided, and the ways in which artworks are handled, displayed, and discussed.

The first factor that affects the relationship between the artist client and his or her art process is the context within which art making occurs. The context for a studio approach to art therapy is created when art is considered to be "the way" rather than a tool used to illustrate or stimulate verbal expression (Wix 1995, p.175). When an atmosphere is set up where clients understand they are free to either discuss or refrain from discussing the meaning of their artwork, and when clients understand they will not be subjected to unwanted interpretations of their artwork, freedom of artistic expression is fostered. For some clients, discussing the significance of the artworks they make is an important element in the therapeutic process. Other clients may choose to never say anything about the things they make.

The distinction can be made between creative arts experiences and expressive arts experiences. In creative arts experiences the focus is on the art-making process as a way to channel feelings, adjust to new circumstances, or come up with creative solutions for problems. In expressive arts experiences the focus is on making and discussing art as a way to reveal thoughts and feelings (Feder and Feder 1998; McGraw 1995). A studio art therapy approach can be flexible enough to respond to different needs. Opportunities can be provided for discussion of artworks, both on a one-to-one basis with the therapist and in a communal way, without imposing this as an expectation.

In most instances, the *expectation* to provide or be subjected to the interpretation of an artwork interferes with the artistic process. It imposes a foreign meaning system – verbal language – on the primarily nonverbal process of art making. As those of us who make art are well aware, the ability to put words to our imagery is often difficult and is inexact at best.

We sometimes have to live with the artwork for a while before the meaning surfaces (Malchiodi and Catteneo 1988). On the other hand, the *opportunity* to discuss the meaning of a work may foster artistic expression for some clients. They may be reassured that their expressions will be managed through the container of the therapeutic relationship and that they will have the opportunity for deepening their understanding of their art. Exploring the meaning of art through verbal language may, for some people, stimulate creative expression.

Time allotted for art making is a second factor that can either promote or inhibit artistic expression and affect the atmosphere of the art therapy studio. It is also one of the most frustrating realities for art therapists working in today's healthcare field, where the emphasis on short-term treatment results in decreases in both the length and the number of sessions. As Malchiodi (1999b) reminds us, "trying to reduce the complex process of art making into a 50-minute therapeutic session will not be enough" (p.3). Yet time constraints for group and individual sessions are often an inflexible part of art therapists' jobs. Where possible, allowing a generous amount of time for art making is ideal. When this is not possible, other creative solutions may need to be explored. We can take heart from the fact that there are many people in our society who continue to be dedicated artists in spite of the lack of societal support or financial remuneration. People manage to make meaningful, heartfelt, and well-crafted art, in spite of having to squeeze art making in between the demands of work, childcare, relationships, and other responsibilities. As art therapists, we are among those who make art in spite of many other demands on our time. In this sense, art therapy sessions may mirror the reality clients will face upon discharge and we can offer ourselves as healthy role models for continued art making.

Time constraints can easily be viewed as obstacles to meaningful art making. It is crucial, therefore, to create and/or to recognize opportunities for art making that exist within or in spite of time constraints. We can be advocates of the clients at our places of employment, championing the cause of adequate time for studio art therapy sessions. We can also encourage clients to engage in creative thinking and resourcefulness in order to get their art making needs met, in the hopes that this creativity and resourcefulness will carry over post-discharge. We can help them explore

what is possible. Are there ways for art to be made outside designated art therapy session times? Can we help our clients develop a focus for "homework" to be done between sessions, using simple materials? What about encouraging the use of a journal, not only for writing but also for artwork? A journal provides a potential artistic outlet that has few inherent restrictions in regards to convenience; it is portable, private, can accommodate a variety of media, and does not require large amounts of time to use.

What about the possibility of an open studio during down time, when other groups or individual sessions are not scheduled? Does the open studio session have to be dependent on the art therapist's availability? Would it be possible for the session to be monitored by another staff member or an artist volunteer? Would it be feasible for the session to be client run? Could the "open studio" occur not in the art therapy studio but in a common area where simple art materials are made available on a regular basis? Could artists, student artists, or student art therapists serve as artists-in-residence to inspire art making during these open studio times? This kind of questioning serves to challenge the status quo and to realistically assess the existing opportunities and obstacles in terms of providing adequate time for art making.

Due to the awareness of time limitations, an important component for any short-term treatment is a focus on follow-up care. In the art therapy studio we can provide clients with information about resources in the community for continued art making. This may mean providing them with the names of art therapists in private practice, and it may mean providing them with information about cultural art centers, art classes, art cooperatives, museums and galleries, art workshops, art supply catalogs, art tutors, and so on. It is helpful to be familiar with the philosophies and methods employed by these service providers so that the needs of clients – ranging from technical assistance to support of personal expression – can be matched with the services provided at various sites.

The third factor that can either provide opportunities or present obstacles in the art therapy studio is the supply of art materials made available. In a studio approach, where developed art making is emphasized, materials of adequate quality are a must. Poor-quality art materials may even be anti-therapeutic, establishing conditions where satisfying, successful experiences in art making are impossible. In the ideal art therapy studio,

a wide range of art media and tools, all of good quality and in ample supply, are available. In reality, few art therapists have an unlimited budget for art materials. Surviving on a meager budget requires focusing on a limited range of materials that are of adequate quality, emphasizing proper care of materials (such as thoroughly washing paint brushes), and being resourceful in acquiring donated or "found" materials. Just as limited time for art making in art therapy reflects a reality clients are likely to experience in their everyday lives, so too a limited budget for art materials will be a reality for many clients once they are no longer in therapy. While offering a generously stocked art studio to clients provides a nourishing oasis from everyday life, an adequately stocked art studio where resourcefulness must be cultivated may actually be more helpful in developing art skills that will last beyond the life of the therapy.

The fourth factor to be considered relative to obstacles and opportunities in the art therapy studio is the way in which artworks are treated – how they are handled, displayed, and talked about. In general, it is helpful to rephrase the old adage, "treat others as you would have them treat you" as a guideline to apply to the treatment of artwork: treat others' artwork as you would have them treat your artwork. Following this guideline will likely mean that there will be adequate, safe storage for artworks-in-progress; that there will be a general expectation in the studio milieu of mutual respect for artworks; and that artwork will not be displayed (not for a case conference, not to decorate the building, and so on) without the permission of the artist. I also advocate "not talking about the artwork behind its back." Although clients initially think this is a rather strange idea, if they try to follow this advice they find it encourages a different kind of relationship with their art-making process, one of a cooperative and respectful nature rather than one where the artwork has to "prove" itself to the artist lest it be talked about in disparaging terms. More will be said about this in the following section on the relationship with the art process/ product.

Motivation

The creation of artwork requires sufficient internal and/or external motivation. There is great variety among people as to what stimulates creative imagination. Our job then, as art therapists, is to provide our clients with a

range of potential stimuli for inspiring artistic vision, in the hopes of providing a fitting "spark" for each individual client. We have to be flexible enough to support and nurture along the idiosyncratic motivations presented by individual clients, even when they are foreign to our way of initiating art making.

Materials provide the source of inspiration in art making for some people. Having a range of materials available that offers different qualities, such as ease of control, fluidity, resistance, malleability, softness, rigidity, massiveness, delicacy, containment, expansiveness, cleanliness, messiness, and so on, may be all that is necessary to ensure a "good fit" and sufficient motivation for some clients. Some cautions have been given regarding offering too many art materials to clients. Kramer (1961) warns that the use of unorthodox materials can cause resourcefulness to be perverted into a search for novelty and a superficial acquaintance with techniques (p.9). Similarly, Lachman (in Kramer *et al.* 1974) believes that offering a wide array of art materials may diffuse creative expression (p.16). For some clients, having so many choices may be overwhelming.

These cautions merit serious attention but should not be taken to mean that offering a wide range of materials cannot be effective in art therapy. A rich assortment of found objects may prove to be too much stimulation for one person, while the same objects provide the spark that launches another person into serious and committed art making. As art therapists, it is our responsibility to gauge the number and type of materials we provide in various circumstances, and to assist each client in finding and focusing on the most suitable materials with which to bring artistic intentions to life. We do not need to limit ourselves to traditional materials in art therapy – drawing and painting supplies, clay, collage materials, and so on – but can expand to include whatever is effective.

Art therapists have worked with materials as diverse as glass (Somer and Somer 2000), environmental found object sculpture (Davis 1999), performance art (Boegal and Marissing 1991) and film making (Arnott and Gushin 1976; Horovitz 1999). A traditional material can be adapted to meet contemporary needs, as in Vick's (1999) use of pre-structured collage materials to provide a stimulus in short-term therapy. A commonly used material can take on new dimensions in art therapy when presented by an

art therapist who has a depth of understanding and experience in using that material (for example, see a discussion of art in boxes, Kaufman 1996).

The motivations for clients to use particular art materials are undoubtedly influenced by the personal preferences of art therapists in regard to materials. Even when we do not make art during sessions with clients, our preferences are evident in the materials we make available, in our knowledge or lack of knowledge regarding particular media and tools, and in the subtle (and probably unconscious) ways we express approval or disapproval of clients' choices of materials. Owning our biases for particular materials is probably the most effective way to keep our coercive potentials in check. Our love for certain materials, if acknowledged rather than repressed, may lead some clients to follow our lead and work with the same materials, but it will also inspire other clients to be curious about the qualities of materials in general and to be seduced by the potentials inherent in materials to which they are attracted.

Another common motivator for art making is exposure to the artworks and the art-making processes of other people. Alter-Muri (1996) describes the success of incorporating museum and gallery visits, slide presentations of artists' works, and discussions of the artists' ways of working, as a source of inspiration in a variety of art therapy settings. Allen's (1985) use of "art lectures," slide shows and discussions of artwork done by both clients and famous artists, was found to enhance the involvement of patients in art therapy groups. Art posters, art exhibits, art books, and art magazines, along with the display of client works-in-progress or finished artworks, also can stimulate creative ideas for art making. I encourage clients and students to try out any technique or style to which they are attracted. Ideas for art making do not materialize from thin air; we borrow and build upon and remake ideas from looking at the world around us, including the work of other artists.

It is important to have art examples available to which the clients we are working with can relate. Many art therapy clients have had a limited exposure to the various forms and styles that the word "art" encompasses. If they are to make informed choices about their own art making, they must be given the opportunity to explore what is possible in art. Providing a range of examples from sources as varied as photo-realism, impressionism, cubism, surrealism, dadaism, folk art, and outsider art helps clients expand

ideas about what qualifies as "art," sharpen discriminating tastes, and discover styles with which they can identify. These examples might take the form of art books, art posters, photographic slides, as well as actual art objects. Along with providing examples of art that reflect diverse artistic styles, examples of artworks that affirm aspects of cultural identity such as race, ethnicity, age, religion, gender, and sexual orientation should also be available. Including examples of artists who have psychiatric or physical disabilities can be inspiring to clients who themselves have disabilities. This sensitivity to cultural diversity is reflected both in examples of work done by artists from diverse cultural backgrounds and in artworks that deal with culture as subject matter.

A third common motivator for art making is exposure to a visually rich environment. This visual richness comes, in part, from the display of materials and art examples in the studio environment. It also comes from the aesthetics of the physical space and surrounding environment. In addition, it is common in any art studio to have visual references at hand for art making. These can include standard items, such as poseable mannequins or plastic skeletons for use in depicting the human figure, or fruit bowls and vases for still life works. Visual references might also include a collection of objects from nature, a fish tank teeming with colorful creatures, a collection of books and magazines with good color photographs, an assortment of auto parts and other interesting objects set up like a still life, and so on. Some of these references may be on display, and some may be stored when not in use so that the environment does not become too chaotic. A visually rich environment is not achieved by accumulating the greatest possible number of objects! Visual stimulation has to be balanced with visually "quiet" places where what is seen can be fully absorbed and where ideas for art making are given the opportunity to germinate.

Along with the three sources of motivation already mentioned — materials, art examples, and visual references — there are innumerable additional sources of inspiration used by artists. Other art forms, such as music, movement, poetry, or story can provide motivation for visual art. A simple word or phrase may provide all that is needed to spark the imagination. Some people begin with clear, conscious intent and need to "talk out" their idea before they can begin to give it form. Others have too many competing ideas and have trouble knowing how to start. Many people have

absolutely no idea how to begin making something called "art." As art therapists, it is our role to be well versed in the varieties of artistic motivation, to have available the materials and methods needed to stimulate artistic expression, and to be flexible in our approach so that we help each individual find what works best for him or her.

Expression and containment

Art making is an activity that is both expressive and containing at the same time. One quality may be more dominant than the other at any given time during the process of making a work of art. None the less, art making always involves the externalization of thoughts, feelings, or ideas (expression) and their transformation into form (containment). Kramer (1961) has described the extreme versions of these opposing forces of art as "primeval chaos and stereotyped order" (p.7) and the goal of art to be a synthesis of emotional freedom and structured expression. The extreme of expression in the art process is uninhibited cathartic release through the use of art materials, without any consideration for the conscious, aesthetic decision making involved in giving form to expression. The extreme of containment in the art process is absorption in external, technical processes, resulting in the squelching of internal impulses.

In the past, with some exceptions (most notably Edith Kramer), there has been a tendency for art therapists to emphasize the process of making art and to downplay the importance of the art product. A desire to distinguish art therapy from the work of crafts instructors, art teachers, and occupational therapists likely influenced this emphasis. A process focus was identified primarily with the use of art as a means of self-expression and was held in counterpoint to a focus on the aesthetic characteristics of the thing being made, the product. Ostensibly, this reflected a concern for the person rather than the object being made. Fortunately, this perspective is changing (Henley 1992a; Maclagan 1982; McNiff 1992; B. Moon 1994; Schaverien 1992) as art therapists recognize the false nature of this dichotomy. All art making involves both expression and containment. The process of making art is not entirely focused on expression; it also is intimately involved with a concern for what is being formed, with how that expression is contained in form. Even in seemingly spontaneous art

processes, numerous and ongoing decisions must be made about what color of paint to fling, which area of chalk to smudge, or where to pierce and gouge the clay.

The recognition of this paradoxical capacity in art making is important because it is a recognition of one of the unique characteristics of art therapy, that is, its ability to simultaneously address the need for expression and the need for containment. One of the most important ways to become well versed in these paradoxical characteristics of the art process is to explore them in our own art making. For those whose tendency is to labor intensively over the technical aspects of artworks, the challenge may be to explore creating art that is loose and spontaneous. For those whose tendency is to produce quick, emotionally cathartic works, the challenge may be to explore making well-crafted pieces.

In reality, the synthesis of emotional freedom and structured expression to which Kramer refers is not so much a goal that is reached as a dynamic process a person is willing to explore through art making. Achieving a balance between discipline and spontaneity in the process of making one piece of art does not guarantee this balance will be maintained in subsequent attempts at making art. However, our willingness to engage in the dynamic process of exploring this balance between the expressive and containing potentials of art will help us to better serve our clients.

If we are familiar with the paradoxical qualities of the artistic process and do not rely on a false dichotomy between expressive potential and concern for technique, we are better equipped to apply our knowledge with more discernment in our art therapy practices. A concern with craft is "not opposed to creative expression, it is the means by which private expression becomes the object of public empathies" (London 1989, p.100). Just as we may need to work at bringing our capacity for spontaneity and discipline into a healthy balance, our clients will undoubtedly have similar needs. A need for cathartic release may later evolve into a need for refined expression. A rigid adherence to artistic techniques may interfere with capacity for self-expression. The more familiar and comfortable we are with our own shifting needs for expression and containment, the more discriminating we will be in responding to the needs of our clients in art therapy.

Ebb and flow

The dynamic process of expression and containment is but one aspect of the ebb and flow of the artistic process. Our relationship to our art-making process is not a static entity. Our interest, desire, enthusiasm, and even our proficiency for art making do not follow a predictable progression but are instead characterized by dips and surges, fits and starts, inspirational epiphanies and grinding-to-a-dead-stop creative blocks. Like it or not, this is the nature of the artistic process.

Our own willingness to keep doing the work, to keep making art, in spite of the unpredictable nature of the creative process, is the best thing we can do for our clients. Then we are able to encourage their art making (in spite of lacks in motivation, confidence, or inspiration) with authenticity. Slogging through our own unmotivated, self-doubting, uninspired periods and continuing the effort to engage in art making gives us the *right* to encourage this in other people. It also gives us a great deal more empathy for the tenacity and courage it takes at times to make art.

Our own willingness to keep making art through the ebb and flow of the creative process is also helpful in preventing us from ascribing to pathology what may be normal, natural aspects of art making. For example, the creation of stereotypical art might be interpreted as defensiveness. In truth, it is not always easy to distinguish between "form that is a living container of ideas and form that has frozen into a shell which stifles and hides content" (Kramer 1967, p.152). Repetition of stereotypical forms may be the most forceful and articulate way for an artist to give form to artistic intentions. Repetition of familiar forms can also be a healthy, normal and useful way of getting one's bearings in art making prior to delving into less familiar, more risky imagery.

Creative block is another normal aspect of the creative process that can be erroneously attributed to pathology. Clients who do not make art may be labeled "resistant." It is worth considering, however, that the client may be experiencing creative block, perhaps caused by preoccupation with internal or external concerns, physical discomfort, an inability to focus, a lack of uninterrupted time, or a need for time to research and develop ideas. Not making art is not necessarily connected to any diagnostic indicators but may just be what happens from time to time to those of us who make art. As Crosson (1982) reminds us, "the productive client who comes to a halt in

creative activity or produces a stereotype may be reflecting an inevitable aspect of the creative process rather than an emotional problem or a defense mechanism" (p.261). Responding to the ebb and flow of clients' artistic processes with sensitivity and empathy, rather than interpreting behaviors as pathological, will likely do more to foster clients' ongoing engagement in meaningful art making.

Effects and impact

Franklin (1992) states: "creating art is hard work that takes courage. The shadow of failure always accompanies one along the way – there are no guarantees" (p.83–4). So why engage in art making at all? Why encourage clients to do the same? What are the beneficial effects of engaging in a relationship where we sometimes flounder around and don't know where to start, where we encounter daunting obstacles, and where we experience frequent bouts of frustration? Are the highs – the moments of blazing inspiration, the surprisingly successful "accidents," and the deep satisfaction of a "just right" refinement – enough to justify the difficulty and uncertainty of the artistic process? Is this enough for the clients with whom we work?

We don't really know, with certainty, the beneficial effects of engaging in the artistic process. Research in our field has focused largely on the art product rather than on the process of artistic expression or on the questions of how or even if art making is healing (Malchiodi 1995a, 1999b; McNiff 1998a). We have not pinpointed the precise healing factor or therapeutic agent. What we do know is that people have been engaging in art as a behavior for at least the last 250,000 years. From an ethological perspective, the persistence of art-making behaviors over time, their ubiquitous nature, the fact that they have been and continue to be an integral part of most human societies, and their association with pleasure, all point to the notion that art must have survival value for our species (Dissanayake 1988). While this ethological understanding provides a solid foundation on which to base the practice of art therapy, it does little to predict the effects of the artistic process on any single individual.

We attempt to understand the effects of the artistic process in art therapy by extending theories about the ability of the artistic process to

connect internal and external reality, to bring order out of chaos (Ulman 1975), to foster empowerment and self-esteem (Franklin 1992), to give form to that which cannot be verbally articulated, and to facilitate the process of letting go (Feen-Calligan 1995), among other things. We test these theories out by engaging in research that is sympathetic to the artistic process (Bloomgarden 1998; Junge and Linesch 1992, 1993; Kapitan 1998; McNiff 1998a).

At the same time, a postmodern perspective reminds us of the subjective and contextual nature of our theories. If we want to know the truth of how, and when, and if art making has a positive effect on an individual client, we have to collaborate with our clients, exploring how theory and individual meaning intersect or diverge. While art therapists have often posited the importance of art making as a means to connect with and express uncon-scious material, the value in the client's experience may lie in art making as a means to direct attention away from the self and thereby decrease anxiety (Beard 1979) or in art making as a way to manage emotions and maintain self-control (Spaniol 1998). If we are open to discovering the multiple effects of the artistic process through the experiences of our clients, we become co-learners, ever broadening our understandings of the relation-ship between people and the process of art making.

Relationship between artists and art process/product

The past emphasis in art therapy on process and the tendency to eschew concern for the appearance of the product (other than for its value as a diag-nostic tool) has given way to an acknowledgment of the interrelationship between process and product (Schaverien 1992). In actual practice, "process is product in a state of transformation, whereas product is process suspended" (Yon 1993). This acknowledgement of the relational nature of process and product has led to a qualitatively different way of engaging with artworks. There is greater understanding that the product of art making is intimately and irrevocably connected to the process of its making. This realization calls into question the tendency to see art products as objects to be reviewed and analyzed, independent of both the person who made them and of any connection to the process of their making. Instead, the relationship between the artist, the art process, and the formed

object are considered to be fundamental to an understanding of what occurs in art therapy.

Different ways of conceiving of the "product" aspect of art making have been proposed. Hilllman (1975), in discussing dream imagery, posits that images have an inherent intelligibility that exists autonomously from the dreamers' ideas about meaning. He considers images to be visitors or visitations to our psychic life that have the potential to surprise and inform us if we are not too quick to assign meaning to them. McNiff (1991, 1998b), influenced by Hillman's ideas about dream imagery, acknowledges that artistic products may reveal something of their creators, but also appreciates their autonomous nature. He proposes that artistic creations be viewed as offspring, related to the "parent" creators, but also transcending the artist creators and having lives of their own. If the product is viewed as process suspended, as Yon (1993) proposes, then it may be considered to be a resting place in the artistic process, a time to contemplate what has come before and to gather energy for plunging into the creative process with effort and energy once again.

What is common among these different ways of conceiving of imagery and artworks is a respect for the inherent intelligibility, the purposefulness, and the significance of the products of our imaginations. I try to foster a respectful relationship between client artists and their artworks by advising clients to "not talk behind the art's back." In essence, I tell them, this means to focus on having a relationship *with* the artwork, rather than on talking *about* it. I suggest that when they do talk about their art, they try to do so in a respectful manner. I tell them I know it sounds silly but ask them to try to humor me. Once they get to know me they will often poke fun, in a good-natured way, at my advice. But in this playful way a respectful relationship is established between the client artists and their art. The clients begin to think of their artwork as something that comes from them, but also has a distinct and separate presence. Typically, deprecating remarks directed toward the artwork diminish because the self-consciousness associated with viewing art purely as a reflection or production of the self is lessened. Instead, the artwork is viewed as an entity that can surprise, disturb, educate, offer insight, reflect back, inspire, or please. In short, the artwork is viewed as something with which to engage in relationship.

The question arises, however, whether all mark-making or form-making in the name of art is equally intelligible, equally purposeful, and equally significant. If there is an interrelationship between process and product, does a lack of effort and investment in the process yield a product with less to "say," a product with less import and significance? Do factors that inhibit the process of making art (lack of skill, lack of confidence in one's artistic abilities, lack of a sense of emotional safety, and so on) lead to a diminishment of the significance and import of the product? If so, what implications does this have for art therapy practice?

Qualities of process/product

This question about the relationship between process and product has been partially addressed by those who have made efforts to distinguish qualitatively different types of art making. London (1989) identifies the objective of art to be not the representation of what happens to us but rather the process of discovery itself (p.39). Yet it is common in art therapy to encounter clients who use art as a means for representing or illustrating thoughts, feelings, or experiences. Deco (1998) identifies this type of descriptive or diagrammatic art making as corresponding to the surface level of communication that occurs in open studio groups. She identifies three additional layers, each representing increased depth in communication: imagery made through playful activity; imagery made through intense, involved, and sensually connected activity; and imagery expressed through pre-verbal, archaic language (p.103).

Schaverien (1987, 1992) writes extensively about a distinction between what she terms "diagrammatic" and "embodied" imagery. Diagrammatic imagery is that which arises from a preconceived mental image and is motivated by a desire to illustrate something consciously known or experienced. Diagrammatic images tend to be controlled in execution and specific in content. Embodied images, on the other hand, are akin to London's description of the objective of art in that they embody the process of discovery rather than point to or describe what is already known. In the process of creating an embodied image, the artist either has no preconceived image in mind or relinquishes the need to control the outcome. Instead, the artist becomes absorbed in the physical act of making

something, allowing the artwork to develop in unexpected ways. The embodied image transcends what is consciously known and is not immediately amenable to being articulated in words.

These distinctions between different characteristics of the art process/product help us to consider how different attitudes and abilities on the part of artist/clients and different circumstances in the art therapy studio might foster or hinder therapeutic outcomes. It is easy to understand how a client who puts forth less energy and investment in the creative process may very well end up with a product to which little import or significance is attached. This is not to say that such an artwork lacks relevance or significance. Some unconscious content may find its way into any created object, regardless of the level of investment demonstrated by the artist. However, the richness of the artwork – in terms of visual appeal, depth, and complexity of unconscious content, and significance for the artist – is likely to suffer when there is less investment in the process.

It is easy to make a connection between an art process lacking in energy or investment and an impoverished art product. It is not quite as easy or comfortable to say that an artist who lacks artistic skills, talent, confidence, or freedom will likely create products lacking in intelligibility, purpose, and significance. This sort of statement runs counter to a basic belief underlying art therapy, that is, a belief in the equitable nature of the healing potential of the arts. We work with clients who have little experience, few skills, and shaky confidence in art making because we believe it possible to create meaningful art in spite of these obstacles.

In a studio approach to art therapy we *do* help clients gain experience, increase skills, and shore up confidence in art making in order to enhance the therapeutic potentials available to them. In general, we *do* encourage embodied art making, where the artistic process is an experience of being fully alive, not merely reporting through imagery but instead experiencing and discovering through the process of creating. We *do not*, however, determine the efficacy of the therapy solely by the quality of the art product. Nor do we automatically discount, disregard, or perceive as inadequate art that is tentative, emotionally bereft, stereotypical, or lacking in technical proficiency.

Our approach to art is based in a relational aesthetic, meaning we are concerned with the product as it relates to the process of art making, to the

person who made it, to that person's artistic intentions, and to the effect it has upon those who view it. We are interested in developing our sense perceptions and those of our clients so that we are more keenly aware and better able to nurture the "potentials" lying in wait within each individual person's creative process. We help clients become clearer about their artistic as well as therapeutic intentions, and we help them develop the necessary abilities for giving form to those intentions.

While the general emphasis in a studio approach is toward embodied art making, it is understood that art making of a more diagrammatic or illustrative nature is also a normal and natural part of artistic development and may, at times, be the best expression of an individual artist's intentions. From a developmental perspective, creating stereotypical forms is a normal aspect of evolving capabilities in artistic expression. From a psychological perspective, creating stereotypical or diagrammatic forms may be a normal step in the process of developing trust – with the therapist, other clients, and the artistic process. It can be a way of maintaining a sense of control while emotional and physical safety are being established, and a step toward working with the art materials in a more fully engaged way. From an aesthetic perspective, tightly controlled rendering of familiar forms may provide the "just right" touch to a work of art. It may provide a decorative border or, in another instance, be central to the content implications of being "scared stiff." In either situation it may provide a perfect fit with the artist's intentions.

These qualities of process/product cannot simply be categorized as "good art" or "bad art." From the standpoint of a relational aesthetic, the quality of the therapeutic activity of making art must be evaluated with a multifaceted approach, taking into account the rich and complex aspects of beauty to be found in the relationships between people, art process, art product, viewers, and the surrounding environment.

From interpretation to engagement

Remaining connected to our identities as artists has implications for how we approach client artwork. When we are committed to nurturing the relationship we have with our own art process/products, we are likely to be interested in fostering such relationships with the artwork of our clients.

Our task is to be responsive to the artistic productions of our clients, "not necessarily in terms of providing the correct interpretation... Rather, we need to stay *engaged* with the images ourselves, to allow them to come inside and to provide a response which fosters their forward movement" (Levine 1995, p.15). By remaining connected to our aesthetic sensibilities, we are less likely to view an artwork as something to be figured out and more likely to approach it with curiosity, awe, and a healthy dose of not knowing. When we encounter an image we might ask ourselves if we are "relating rationally, seeking to define it, or imaginally, opening ourselves to what it might reveal" (Lanham 1998, p.50).

This does not mean we never interpret artworks. When we encounter an art object, unless we choose to disregard it completely, we cannot help but attempt to make sense of it. This "making sense" is a form of interpretation. In viewing an artwork we are affected, not only intellectually but also in our sensing bodies, by what we see, smell, feel, and hear. Our "understanding of what is 'seen' is already a creative act of interpretation, rather than an objective observation" (Maclagan 1999, p.307).

Questions concerning the topic of interpretation have been a part of art therapy since its inception. It has long been recognized that verbal interpretation of visual art should be approached with caution because "the art form has its own validity and to translate from one language to another is bound to bring loss or error" (Champernowne 1971, p.141). Current trends in the field seem to be leaning toward respecting the multiple potentials for meaning in any single artwork and respecting clients' rights to discover and name the significance of their own artworks. These values are challenged when professional colleagues expect art therapists to provide simplistic interpretations of complex, multidimensional artworks. On the one hand are those who view any interpretation of artworks to be "imagicide" (B. Moon 1990, 1992, 1997a) and on the other hand are those who are cautious about interpretation but also believe it necessary to be able to translate our understandings of artwork into the context and jargon of other health professionals (Horovitz 1999).

A postmodern perspective supports the notion that meaning and truth reside within the individual person rather than in the theories and views of so-called experts. From this perspective, art therapists are co-creators of

meaning via dialogue (verbal or nonverbal) about the shared reality of the artwork (Alter-Muri 1998; Byrne 1995).

While a belief in the subjective, contextual nature of meaning lends itself to a respectful approach both to clients and their artworks, if taken to the extreme this relativist position suggests that interpretation is completely limitless and unbounded. Franklin and Politsky (1992) remind us that from a practical perspective "the multiplicity and openness of the work of art is limited simply because not everything belongs to it" (p.171). Even though an artwork can have multiple meanings, no single artwork encompasses *all* possible meanings. We are left with the question of how to balance openness to the potential multiple meanings inherent in artworks with our responsibility to serve as guides to our clients. How do we remain open to what "belongs" to the image while trying to help the client discern what "does not belong?"

A balance between openness and discernment is difficult to maintain. It is tempting to veer off to a position of extreme relativism whereby we deny our expertise and responsibility as guides and, in the name of openness, abandon clients to their own search for meaning. It is equally tempting to veer off to a position of extreme authoritarianism whereby we overextend our guiding role, in the name of expertise, and behave as if we are more knowledgeable and capable than clients in regard to discovering and naming the meaning of their artworks.

The question of how to engage with artworks in a way that is respectful of both the artist and the inherent intelligibility of the artwork itself has been a topic addressed by numerous authors. London (1989) cautions against judging or interpreting an artwork within a rigid theoretical frame but instead urges the viewer to subjectively describe his or her personal encounter with a work of art (p.60–6). Betensky (1995) advocates a phenomenological approach whereby the therapist, without any predetermined meanings in mind, guides clients to discover the inner experience that led to the art product's creation. Linesch (1994) proposes a hermeneutic approach whereby interpretation is conceptualized as the intersubjective creation of the client and therapist in dialogue. Franklin and Politsky (1992) propose a five-step approach informed by various interpretive strategies used in literary criticism. They propose that the art therapist contemplate the work while suspending judgment, carefully

observe the formal qualities of the artwork, consider contributing factors that affect the individual's artistic process and product, form hypotheses based on philosophical frameworks, and develop informed, educated impressions that lead to flexible conclusions. Hillman, in an interview with McNiff (1986a), recommends three steps to discovering meaning in an image: first, withhold interpretations; second, recognize the multiplicity of potential meanings; third, determine which meaning is most authentic and fecund. Hillman suggests, "the response that is as imaginative as the image is an adequate response" (p.104). McNiff (1992) defines interpretation as "another phase of the creative process during which we respond to the art of picture making through a creative discourse that has the freedom to follow diverse aesthetic, psychological, and spiritual possibilities" (p.97). He encourages participants in his workshops to engage in interpretive responses ranging from "speaking meditations," to dialogues *with* (as opposed to *about*) images, to performance art enactments. Bruce Moon (1999) extends this idea in his clinical work, where he creates art in response to the artwork of his clients, and clients, in turn, create art in response to his artistic response pieces, engaging in what he refers to as "an imaginative interpretive dialogue" (p.81).

There are countless ways to engage with the process/product of art making. Responses can range from intellectual, detached, and analytical encounters to affective, involved, and empathic engagement. Ideally, as studio art therapists we harness our creative capacities in service to our clients and engage with their artworks in ways that are most sympathetic to the intentions of the work and most beneficial to the client. This requires flexibility in approach. The "just right" method of engaging with the artwork of one client may be a total disaster with another client. It is crucial to try to suspend our own judgments and preconceived notions so that we are as open as possible to discovering what that "just right" method might be in any particular instance.

I have found some general guidelines helpful in determining what might be the most suitable approach to engaging with clients and their artworks.

First, I find it helpful to use the cues clients give me. As the experts in who they are and what they need, it makes sense to seriously consider their accumulated wisdom. Their words and behaviors are like bits of bread-

crumbs dropped to mark the path we need to travel together. I have to be attentive to notice the cues and then respond in the moment, following these fleeting crumbs of wisdom before the moment is lost. For example, I initially interpreted a 13-year-old boy's mute participation in our final session as avoidance of termination issues. Fortunately, I eventually followed his lead, allowing our last session to be focused on working together side by side. As the session came to a close and he was getting ready to leave, he tapped me on the shoulder. When he had my full attention, he used his own brand of sign language to convey his simple message: "I love you." I was stunned by his eloquence in bringing our work to a close. This was no avoidance maneuver. In his wisdom, he understood that what was most important about our time together was not what was said but what was communicated through action.

Second, I find it helpful to remain connected to the artwork as a guiding force for what happens in the session. When I am unsure about what to do, I pay attention not only to what the client is telling me but also to my own aesthetic response to the artwork. What is the kind of response for which the artwork seems to be asking? The artwork provides a helpful grounding point for me to return to if I feel lost or uncertain. I make use of my intuitive response to the work but also to a very concrete, literal acknowledgment of the work. For example, simple statements about how a certain drawing appears "ragged around the edges," or how a figure in a painting is "cut off" (by the edge of the canvas) may bypass the client's intellectual understanding of the image and tap into a deeper connection with its meaning and significance. This use of metaphoric language is a way of acknowledging what the image presents without making interpretive leaps that take us far from the actual artwork in front of us.

Third, I remember there are no "correct" interpretations of artworks. There are only intuitive responses, informed impressions, and educated guesses. I respect clients' rights to assign meaning to their own artworks, but at times also encourage their exploration of the potential for multiple interpretations. As Maclagan (1989) suggests, sometimes my task as a therapist is to help "loosen up and release the image from its rational captivity: the point being, not to deny the consciously intended meanings, but to encourage tolerance for other, co-existent meanings which may not always converge with the authorised version" (p.12).

Fourth, I remember that finding a suitable approach to engaging with an artwork is most likely to occur if I am firmly situated in a position of not-knowing. This humble position leaves lots of room for surprise, wonder, and discovery. Sometimes I share this "not knowing" with my clients, telling them that I'm not sure how to respond to an artwork. While this ambiguity may be a bit unnerving for both of us, it also opens up endless possibilities for discovering meaning. It is preferable to a stance of bluff certainty that threatens to shut down meaningful exploration. Rather than the client relying on me to be the all-knowing guide, we both become explorers (albeit explorers with differing levels of experience) who turn to the artwork itself to serve as our guide. The aspects of the artwork that intrigue, startle, disturb, or evoke curiosity provide starting-points for our exploration.

Fifth, I try to make equal use of my knowledge base and my intuition. As an "explorer" with years of experience in traversing the wilds of artistic expression, it would be foolish and irresponsible of me to act as if I had no knowledge of the territory. My formal education and, more importantly, the education I have gained through my experience as an art therapist have given me a certain level of facility, comfort and know-how when it comes to engaging with images. Yet, no matter how many years of experience I have, it is never enough. Each encounter with a client and his or her artwork brings its own surprises. I have to rely on my intuition to help me make use of the idiosyncratic – sometimes delightful, sometimes unsettling – encounters with individual artists and their creations.

Sixth, I try to engage with artworks in ways that are sympathetic to and consistent with the "language" of visual expression. I am interested in responding to works of art through the unique ways of knowing and experiencing the world that characterize artistic experiences. Art therapists who have explored artistic expression as the medium for engaging with artworks (Franklin *et al.* 1998, 2000; McNiff 1992; Moon 1999) have furthered our understanding of finding an intrinsic language for engaging with art. Communicating through words, while the most common method, may not always be the most suitable method of exploring and responding to artworks. Alternate means of engaging with artworks will be explored in more depth in Chapter Nine.

Just as there are multiple meanings contained within any single artwork, there is also a multiplicity of potential responses to that artwork. McNiff (1993) asserts that "spontaneous and imaginative expression is considered fundamental to the making of art, but these principles have not guided our treatment of artworks once they have arrived" (p.3). Calling upon our identities as artists and responding with imagination to the artworks of our clients is a way of honoring the intelligibility of images.

Artistic responses are an attempt to "speak the same language" so less is lost in the translation. Artistic responses can include various forms of dramatic enactment, vocal sounds or music, video productions, instrumental music, dance or movement, performance art, and visual art. When words are used as the means of exploring and responding to images, the use of poetic responses, storytelling, or creative writing may be more fitting than the traditional forms of dialogue used in therapy. The range of potential responses is limited only by our imaginations; however, the most wildly imaginative and outlandish response is not necessarily the best or most fitting. Engaging with an artwork in a way that is sympathetic to and consistent with the language of that artwork may be as simple as placing a hand over one's heart and letting out a deep, heartfelt sigh. It may be as simple as moving close to a drawing of fire and holding one's hands near it to enact being warmed or being singed. It may be as simple as speaking out loud, with expression, the words scribbled across a client's drawing.

Conclusions

An artistic perspective influences virtually every aspect of the work we do with clients. An art-based approach has implications for the relationship between therapist and artist client, including how we understand and respond to resistance and our ability to develop a therapeutic alliance based on respect for the client's identity as artist. An artistic perspective also influences our understanding of the relationship between artist clients and their artistic processes. It helps us to examine critically such aspects of the relationship as obstacles and aids to expression, motivational factors, the dialectic of expression and containment, and the normal ebb and flow of the creative process. Additionally, an art-based perspective sharpens and clarifies our understanding of the relationship between client artists and the

objects they make. Sensitivity to the qualities of artworks in their process and product forms, and the ways in which we respond to, interpret and engage with artworks leads to increased sophistication in therapeutic practice.

This chapter has offered only a glimpse of the many ways in which an artistic perspective influences practical applications in our work with clients. I hope it has provided a base from which ongoing explorations can be carried out. The artistic process involves both opening up to possibilities and engaging in deliberate actions, a dialectic that is as intrinsic to the therapy we practice as it is to the art we make.

Role of the Therapist as Artist

In therapy, patients and therapists alike are engaged in finding the artists within themselves (Robbins 1987, p.21)

I still wonder about Dan, after all these years. I wonder about the secrets he held inside his brooding silences. I wonder if they are still there, hanging over him like the heavy, dark, agitated sky of his painting. Do they trip him up like the piles of rocks he depicted in his art? Do they, like the red-painted ground he described as "too hot to walk on" burn through the soles of his shoes even when he tries to walk right past them, right over them? I wonder if they cause him pain, if he feels broken like the tree he painted on the red ground, snapped in two at its base.

I am curious now about his silences because I was curious then, when I met with him some years ago for four months of outpatient art therapy. He was referred by his psychiatrist and complained of symptoms of depression that prohibited him from being able to function as a student in medical school. He said little to me with words, and those he did say were in such small parcels and so lacking in detail that they only left me wondering more intensely. I suspected there was some significant drama being played out between us in these near silent exchanges, but I never felt sure of the story line, nor of the part I played. He told me he experienced anger, bouts of crying, disturbing memories, and agitation, but he never told me the source of his anger, the trigger for his crying spells, the memories he had, or what sparked his agitated states. He did let me know he remembered things he was not yet ready to tell me. He arrived at one

197

session with a plastic hospital bracelet on his wrist. I happened to notice it falling below the cuff of his sleeve and asked about it. Only then did he reveal that he was currently hospitalized, out on a pass to attend our therapy session. If I had not noticed and asked, I would never have known.

Dan's silences were a challenge to me, leaving me feeling off-balance and unsure of the direction the therapy should take. One day I decided to do a painting about our relationship. I depicted us as two birds standing in a windy, rainy landscape (Figure 8.1). He is a big, blue bird, easy to see. He appears exhausted, as if he has collapsed against the rock in front of him. I, on the other hand, am a small red bird, difficult to distinguish from the surrounding landscape. I stand more toward the foreground, behind a small rock. I appear to be looking at the blue bird but I don't think he sees me. Perhaps he is too exhausted to look; perhaps I am too difficult to see;

Figure 8.1

perhaps I don't want to be seen. I told Dan I felt like the red bird looked – cautious, unsure if I should come closer. Dan responded to the painting, acknowledging that the distance between us seemed accurate. Some weeks later he referred back to the painting, asking if I saw our relationship any differently at that point. It was one of the few times Dan ever asked me for anything. Somehow, this painting had provided a tentative connection to Dan, more than my words ever seemed to provide.

It was only in looking back at this painting, years after having met with Dan for art therapy sessions, that I recognized my own part in this silent drama. I was the one hidden from view in my painting, not Dan. He may not have said much with words, but his behaviors and his paintings were eloquently articulate expressions. I was the one who cowered, watching him but not responding to his obvious need. I erred on the side of caution, waiting for words that never came. I was arrogant to think he would eventually speak in the language of my choosing and that I could afford to wait for this to happen. But it never did. After about four months of therapy Dan decided to return to medical school and abruptly quit treatment. I never saw him again, though I still wonder about him.

Clients like Dan, the ones who seldom say anything, have provided some of my greatest challenges as an art therapist. They also have been some of my greatest teachers. They have pushed me to develop my ideas about an art-based approach to art therapy by giving me no other options. These clients have offered me grunts, snarls, arms crossed over chests, pained expressions, shaking hands, furtive glances, bits of color on paper, marks made in clay, and perhaps a mumble or two in explanation. Sometimes they have tossed a few words in my direction. I have been guilty of hungrily taking them in as if they were mine to own, causing both the clients and me to feel more lost than found. I have tried to make the word clues mine, to own them, to be the one who knows the way. Or rather, the one who likes to think she knows the way. At times, this has been preferable to being the one who wonders, discovers, is in awe, is curious, and experiences small epiphanies in the grunts, snarls, arm-crossed chests, colors, marks, and

mumbles. Sometimes I have resisted being temporarily lost, forgetting that lost-ness is a necessary prerequisite for finding one's way.

These clients who seldom talk have been instrumental in helping me experience "lost-ness" because they effectively do away with the potential for using the verbal, discursive language by which I navigate through much of the rest of my life. Stripped bare of the common parlance, I have been left to grapple with what then I have to offer…not just art as an alternative means of expression and communication, but art as *the* medium of expression and communication. When the client offers few or no words, the practice becomes art-based out of necessity. Experiencing being lost, unable to rely on the use of discursive verbal language, has sharpened the focus on critical questions about my role as an art therapist. In particular, I question how I can make best use of my own art making within the context of the therapeutic relationship. These questions, and the ideas they evoke, inevitably are what help me find my way once again.

Therapist art making during sessions

When I have given professional presentations for audiences of art therapists or art therapy students I have often been questioned about my own art making during sessions with clients. These questions arise even when my own art making has not been the topic of the presentation but merely an aside. The questions seem to arise for two reasons. First, many art therapists have not been trained to make art alongside clients and some have been actively discouraged from doing so. Many art therapy graduate students are not exposed to this way of working as one of their options in the clinical setting and this predisposes them not to consider it a viable option during their professional career as art therapists. So the topic is of art therapists making art during sessions is, for many people, an unfamiliar topic. Second, there seems to be a genuine curiosity or interest in the idea of making art alongside clients. For some art therapists and art therapy students this curiosity arises out of not having been exposed to the idea. For other art therapists whose practices have naturally evolved over time to include their own art making, there is an interest in deepening their understanding of how to make effective use of this practice. They also are often looking for affirmation, since non-involvement in art making has historically been the

more generally acceptable practice. For those art therapists firmly rooted in the belief that art therapists should not make art in sessions with clients, there is an interest in engaging in healthy debate about the issue.

Bruce Moon (1999), in discussing art therapy with adolescents, describes the therapist's art making as a logical outgrowth of viewing art as "the anchor, the heart, the taproot of the work" and he maintains that art therapists must make art with clients (p.78). Allen (1992) is equally as forceful in her assertion that "art therapists have a right and even a responsibility to make art at their placements during training and subsequently at their jobs" (p.26).

These contemporary viewpoints are undoubtedly influenced by earlier efforts to articulate the role of therapist art making in sessions with clients. Don Jones's (1983) sensitive portraits of patients in a state mental health facility demonstrated the use of art for empathic connection. His commitment to using his art to engage directly with clients continued in his work at the Menniger Foundation Clinic in Topeka, Kansas and later at the Harding Hospital in Worthington, Ohio. Millie Lachman-Chapin began doing art along with her clients in the early 1970s and presented her ideas at the 1974 American Art Therapy Association conference (personal communication, February 2001). She developed an art interactive technique whereby she and her clients worked on separate but simultaneous artworks. She used her art to reflect and support the clients' feelings as well as to respond and offer comment to them (Lachman-Chapin 1983a). Frances Kaplan (1983) worked together with her clients on the same art piece as a way for the client to experience healthy merging. Martha Haeseler (1989) articulated some of the different ways and corresponding rationales for the use of her own art making in sessions with clients.

My own position on the topic of art therapists making art in sessions with clients is that it ought to remain a lively, open question in the minds of art therapists working from an art-based model of art therapy. While I understand some of the problems identified with this way of practicing art therapy, it has not made sense to me to view total non-involvement in art making during sessions as a reasonable solution. We offer art making to our clients as a means for self-expression and communication. It makes little sense to eschew the use of art making by the therapist as a means for communicating with those very same clients. It would be akin to a German

teacher refusing to speak in the German language during class sessions. On the other hand, if the German teacher *always* speaks in German to an introductory language class the effect will also be detrimental for the students. Just like the German teacher, the art therapist must consider and make informed decisions about what modes of expression and communication will be used in various situations with clients. Skaife (1995) asks, "If the art therapist only talks and does not paint, what sort of unconscious message is she giving? If she paints, how does she model authentic expression of deep feeling without shifting the attention in the therapy onto herself?" (p.7). It is important to consider what is most helpful for the person being served. In the case of art therapy, the decision of the art therapist to engage or not engage in art making during sessions requires thoughtful consideration of the clinical implications in each particular situation.

I am aware of three common arguments against art therapists making art in session with clients: the inherent narcissism of artistic activity in the visual arts, the potential distraction from attending responsibly to the client, and the potential for the therapist's artistic skill level to be an intimidating factor for the client. In order to make sound clinical decisions about making art during sessions with clients, these arguments need to be thoughtfully addressed.

Narcissism

One of the most common reasons given for art therapists to refrain from personal art making during sessions with clients is the narcissistic nature of the visual art process. The concern is that the therapist will become so absorbed in the art making that attention to the client will be diminished. Certain aspects of the creative process, such as formulating the initial idea for a piece or accessing deep emotional connections to the work-in-progress, do require a certain amount of absorption in the work at hand. There are also technical procedures in art making that require focused attention. Many artists enjoy working in solitude and the indulgence of focus on self and artwork that this solitude affords. It is clear that this kind of solitary art making on the part of the art therapist could be detrimental to clients in a clinical setting. As Kramer (in McMahan 1989) asserts, one needs to be less narcissistic as an art therapist than as an artist.

While the narcissistic potential in art making is cause for caution when art therapists make art along with their clients, there are also perspectives that call into question whether narcissism is an inherent ingredient of art making. First, it is important to remember that the solitary nature of contemporary art making has not *always* been the hallmark of visual art. Ellen Dissanayake (1988), in her ethological approach to understanding the purpose of art making as it relates to the survival of the human species, observes that in most human societies the arts are integral to many activities of life. She remarks, "perhaps the most outstanding feature of art in primitive societies is that it is inseparable from daily life" (p.44). She goes on to suggest that "what the arts were for, an embodiment and reinforcement of socially shared significances, is what we crave and are perishing for today" (p.200). Indeed, this idea is supported by contemporary writings from the art world. Suzi Gablik (1991) has called for an art that is more responsive to the needs of the world. She writes, "when art is rooted in the responsive heart, rather than the disembodied eye, it may even come to be seen, not as the solitary process it has been since the Renaissance, but as *something we do with others*" (p.106).

It is possible to engage in art making with clients that is not tied to narcissistic distraction. Instead, the focus can be on art making in a mutual context that facilitates empathy and deepens relationships (Franklin 1990; Haeseler 1989; Jones 1983; F. Kaplan 1983; Lachman-Chapin 1983a; B. Moon 1999). By selectively engaging in artistic techniques and aspects of the creative process that do not demand a self- or art-absorbed stance, it is possible for art therapists to become a part of the art-making process in therapy.

There may be aspects of the artistic process not suitable for the art therapist in a clinical setting. For example, when I am developing the initial idea for an artwork I sometimes need quiet, uninterrupted time to bring together the mix of images, sensations, feelings, and thoughts that are sparking my creative energies. This is a part of my artistic process that may not be suitable to incorporate into my sessions with clients. I may be working with clients who are emotionally tender, potentially self-harmful, and unfamiliar with art media and processes. It simply would not be possible for me to attend to their needs and authentically engage in this aspect of my creative process at the same time. I may also avoid engaging in

certain artistic processes because they demand a level of focused attention that compromises my ability to be attentive and responsive to the needs of clients. For example, if I am working on an acrylic painting and desire to work a section of the canvas using a wet-on-wet technique, it may be best to save this work for my own personal studio time where I can work quickly and without interruption to achieve the desired effect. Another consideration when selecting artwork to be done by the therapist in session with clients is emotional content. If the subject of my painting is fraught with intense emotion, and particularly if it deals with something that still feels emotionally raw to me, again it may be best to save this work for my own personal studio time.

There remain many and varied aspects of the artistic process that *are* potentially suitable for the art therapist to incorporate into a therapy session without having to be overly concerned about artistic narcissism. In fact, it is possible to develop suitable ways of working in community with others while remaining firmly grounded in the responsibilities and ethics of being an art therapist. I may use my personal studio time to manage the intense demands of beginning a painting and then, once I have a sense of direction for the piece, work on it during sessions with clients. Or I may decide it is important for me to be willing to struggle with starting a painting in the midst of all the distractions of the art therapy studio (for this is what clients are expected to do), so I push myself to develop a way to do this that does not compromise my responsibilities as a therapist. In another instance, I may decide the subject matter of a painting is too ridden with conflict and unresolved for me to work on the piece in the clinical setting, yet the process of painting it may bring me to a point of resolution where it not only seems fitting but beneficial to share the work-in-progress with clients. I make decisions about selective transparency in my art, just as I would do in regard to the things I say to clients. In yet another instance, an artistic technique that demands my focused attention may be suitable to incorporate into an art therapy session if I use it to engage clients in the same technique, in a parallel process way of working.

With thoughtful intention, our way of incorporating our own art making in therapy sessions need not be ruled by narcissism. It is possible to engage in art making in an authentic manner – that is, to make art that is genuinely, personally meaningful and selectively self-revealing – and, at

the same time, to not only responsibly fulfill our roles as art therapists but also to add to the enrichment of the artistic experience for all persons in the art therapy studio.

Distraction from responsibility to clients

A second common reason given for the belief that art therapists should refrain from art making during sessions has to do with the importance placed on attentiveness to clients. The assumption is that any activity in which the therapist is engaged during a session, including artistic activity, will serve as a distraction from the encounter with the client.

The basis of this position lies in an emphasis on service to the client. Therapists refrain from taking phone calls, writing clinical notes, or filling out a work order during client sessions. It is understood that the therapy session is a time set apart from the rest of life, a time when the focus is on the client and the needs of the client. Clearly, it is not a time for the therapist to engage in art making of a purely self-serving nature. Clients may perceive therapists' art making as taking time and attention away from them and the problems they are in therapy to address.

On the other hand, does the therapist's art making during sessions always serve as a distraction? Is it possible for the therapist to engage in art making that sharpens his or her observational skills, enhances empathy for the client, and sheds light on the dynamics of the therapeutic relationship? If we intend to work from an art-based model of art therapy then these possibilities need to be seriously considered.

There may be art therapists who find it impossible to work on their own art and simultaneously attend to the needs of the client. Every individual has a unique personality style and a distinct way of assimilating and responding to information. Some therapists may work best with a single-minded focus and need to refrain from art making in order to observe the process of the client and to respond with sensitivity. However, to categorically eliminate therapist's art making from the repertoire of the art therapist on the basis of its being a distraction underestimates both the art-making process and the capacity for art therapists to operate from what Gardner (1993) identifies as multiple intelligences. Some people listen and observe with greater acuity when they are actively involved in a

complementary task that engages their bodies as well as their minds. For some art therapists this means that engaging in art making alongside their clients can be a tool to increase perceptual awareness and processing of observations. As McNiff (1986b) suggests, "the power of art to heighten and focus consciousness through varied forms of communication suggests many possibilities for a cooperative relationship between *artistic* and *clinical* skills" (p.189).

Artistic intimidation

A third common reason given for art therapists to refrain from art making during sessions is derived from the belief that the therapist's art making will have an intimidating effect on clients' art making. Art therapists work with many clients who have received little training in the use of art materials and techniques, do not consider themselves to be artists, have low self-esteem, and lack confidence in their artistic skills. The argument is made that being in the presence of an art therapist who displays confidence and skillful execution in art making can have an inhibiting influence on the client. In addition, the question has been asked whether either making or presenting to clients one's own "intense, emotional, as well as artistically formed" artwork will have an intimidating effect (Allen 1995b, p.162).

It is important to consider seriously the potentially intimidating effect of the therapist engaging in art making during the session. The power differential is a factor in all therapist–client relationships due to the nature of the relationship between the "expert" helper and the client who comes seeking help. Culture and class issues also contribute to the power dynamics of the relationship (Pinderhughes 1989). The practice of therapists making art during sessions adds another potential arena where the dynamics of power may be played out. Artistic skills may be subtly wielded in a "power over" maneuver whereby the therapist reinforces a position of power over the less skilled client who must remain in the dependent role. The therapist may subtly flaunt artistic and expressive skills as a way to mask vulnerabilities or lack of competence in other areas. The art therapist may use personal art making as a way to influence the art of the client, subtly manipulating the client to make art in harmony with the therapist's biases about what constitutes "good" art or "good" client behavior. In effect,

the therapist may groom the client to be an artistic protégé whose own ideas about art are devalued while the therapist's sense of power is increased. Agell (1986) posits an additional challenging question to art therapists: "...do we – because we are Sunday painters, in some sense failed artists – establish conditions and environments for our patients so they too will fail where we have not succeeded?" (p.52).

These and other manifestations of the misuse of power must be guarded against. Pinderhughes (1989) suggests that "understanding one's own experiences, feelings, attitudes, and behavior related to having or lacking power is an important step in the attainment of such vigilance" (p.111). For those of us who are art therapists this understanding must extend to our experiences, feelings, attitudes, and behavior related to art and art making. Wadeson (1986) urges us to be mindful of transference and counter-transference dynamics that may be more pronounced in art therapy due to the nature of our work. Roles such as the provider, critic, approving parent, or envious sibling can all be exacerbated by the concrete presence of art materials as symbols of nurturance. Exploring our personal history in relation to art and art making, and exploring our "culturally bound aesthetic values and tastes" (Cattaneo 1994, p.185) are essential. Only when we attempt to be aware of and to understand our own relationship to both art and power can we guard against using our art in an intimidating way.

Undoubtedly, there are circumstances in which the therapist's art making can be intimidating. It is important to consider intimidation as a possible effect of incorporating therapist art making into art therapy practice. Factors to be taken into account when considering this effect include the client's developmental level, physical abilities, previous experiences with art making, artistic skill level, self-esteem issues, and intra- and interpersonal dynamics.

For example, a client's developmental level may preclude the possibility of achieving the artistic skill level possessed by the therapist. In addition to this the client may have little self-esteem and have a tendency toward interpersonal dynamics characterized by competitiveness or a perceived failure to measure up. These factors indicate that therapist's engagement in art making during sessions might be perceived by the client as intimidating and, at least initially, be counter-therapeutic. A second example is that of a

client who is a practicing artist who has recently suffered a debilitating physical condition. If the condition seriously compromises former art skills and abilities, the client may perceive the therapist's art making only as a reminder of physical capabilities now lost. The effect may thus be one of intimidation and prove to be counter-productive in therapy sessions.

It is important to remember that art making is a form of self-disclosure. Ideally, the therapist who makes art in sessions with clients uses selective transparency not only in relation to the content of the work but also in relation to its style. The therapist's modulation of the level of artistic skill revealed in different situations with clients is one aspect of a sensitive use of artistic self-disclosure, particularly in regard to the potential dynamic of intimidation. Just as a therapist makes choices about what and how much information to share with a client through words, the art therapist uses discrimination in deciding what to expose in regard to artistic proficiency. The goal is to retain authenticity in art making, but not necessarily to reveal the full range of authentic artistic prowess in every given situation.

Along with the potential for intimidation, art therapists' art making during sessions can have the opposite effect. It can lead to clients feeling affirmed, inspired, and at ease with their own art making. Haeseler (1989) found that attending seriously to her own artwork afforded clients some privacy, made them more comfortable in their artistic pursuits, and caused them to consider their work meaningful as well. Michael Franklin (1996) discussed his observations of an open studio for "psychiatric survivors" in New Zealand where those hired to lend emotional or technical assistance also engaged in their own art making. He described the participants in this studio environment as rarely appearing "intimidated by the art making of their tutors. Instead, they seemed to be inspired by watching them manifest the possibilities inherent in a wide range of materials" (p.129). Perdoux (1996), an art therapist who created artwork alongside clients with serious mental illness, wrote, "I have never felt that my own artistic process permanently intimidates clients. In fact, I find that my participation gradually encourages people to create within the noncompetitive arena of the art studio" (p.287). Cheney (1993), in discussing an art therapy studio at a state hospital, asserted that clinicians who "sit aside aloof from the creative and expressive activities" contribute to "an artificial and impeding sense of isolation among residents" while active participation of staff

fosters "a spirit of discovery in which the creative and therapeutic processes are afforded much respect" (pp.234–5).

Even more compelling are the comments of persons with psychiatric disabilities who have experienced art therapy. Spaniol (1998) interviewed people with psychiatric disabilities regarding "their experiences of art therapy, and how they wished to experience art therapy" (p.33). Some of their responses call into question the idea that therapist's art making is intimidating. Spaniol reported that one respondent urged art therapists to join clients in making art so people with psychiatric disability could learn not only from our knowledge and skills, but also from our emotions (p.34).

The active involvement of the therapist as artist within the therapeutic process may actually diminish the potential for intimidation. When the therapist is involved in the art process, clients are not as likely to experience themselves as being "watched" and may thus feel less self-conscious. If art therapists guard against using art making as a means for the misuse of power, then therapist participation can also work to diminish the power differential in the therapeutic relationship. A more equal "playing field" can be created, where therapist and client are simultaneously involved in the struggles and rewards of the creative process. If art therapists demonstrate through art making a willingness to be vulnerable, to take creative risks, to persevere through setbacks, to make use of "mistakes," to seek feedback or help when needed, to be flexible enough to make modifications, and to be committed enough to see an idea through to its fruition, then their presence in the art therapy studio is less likely to be intimidating than it is to be reassuring and inspiring.

A continuum of roles

In cultivating our identities as artists within the profession of art therapy it makes sense to explore the many different manifestations of this identity in the clinical setting. As has already been discussed, our artist identity can be integrated into every aspect of our work and it can have a profound impact on everything we do as part of our professional lives. The focal point of our work occurs in the art therapy setting, in our interactions with those who come to us for help. Some of the aspects of our artist identity, such as how we conceive of the work and how we attempt to understand our clients, will

inevitably affect these interactions. The use of post-session art making as a way to address counter-transference has been addressed in the art therapy literature (Fish 1989; Kielo 1991; Lavery 1994; Wadeson, Geiser and Ramseyer 1990). At this juncture, however, it is critical to examine when, how, and why we might make use of our own art making activities within the context of the art therapy session.

If some of the arguments against therapists making art during sessions are considered precautionary notes rather than prohibitions, then it is possible to explore diverse ways that art therapists might use art making during sessions. The possibilities do not have to be limited to the polarities of *never* making art in the presence of clients or *always* making art with clients. As art therapists, we can make sound clinical judgments about whether or not, when, and how we engage in art making during sessions.

Kramer's (1986) ideas about the use of what she refers to as the art therapist's Third Hand are helpful in elucidating the role of the art therapist as artist. She defines the Third Hand as "a hand that helps the creative process along without being intrusive, without distorting meaning or imposing pictorial ideas or preferences alien to the client" (p.71). She includes in this description some activities of the therapist that do not involve art making, such as setting up an environment conducive to art making, caring for the art supplies, offering the needed art tool or material at the right time, or providing "rescue actions" when the integrity of a client's artwork is threatened. In discussing Third Hand activities that *do* rely on the art therapist's own art making, she advocates that these activities be employed in the empathic service of others, based on a "full command of the artistic medium...combined with therapeutic integrity and self-awareness" (p.71). Her clinical examples reflect a thoughtful, intentional use of the therapist's own art making in ways that are respectfully and sensitively responsive to the clients' artistic styles. She also describes failures of Third Hand interventions caused by the imposition of therapists' artistic styles or preferences in ways that disregard clients' visual language. In these stories of work done with clients, we are given examples of how we might, as art therapists, make careful and care-filled clinical judgments regarding the use of our own art making during sessions.

Other art therapists have written about the use of the therapist's own art making during client sessions and about the potential pitfalls of such an

approach. Gantt (1985) warned that "boredom, self-consciousness, or feeling at a loss for something to do while the client draws are *not* reasons for the therapist to draw" (p.125). De Knegt (1978), in writing about her work as a student intern, acknowledged her own use of drawing with a client as both a way to gain understanding and connection with the client and a way to withdraw "from a tense situation into a protected enclosure" (p.94). Wadeson (1980) cited a tendency to become absorbed in her own artwork, the potential for intimidation, and a concern that discussing her art would take valuable time away from the client as reasons for not participating in art making during sessions. Gilroy (1989) abandoned making art alongside clients because she believed it detracted from her attention to the client and because the setting was inappropriate for working through of the unconscious material that would inevitably surface and become conscious through the art-making process. Haeseler (1989) named client's responses such as boundary disturbance, fear, or jealousy of the therapist's works as reasons for refraining from art making. She also identified complicating factors, such as the therapist's lack of confidence in artistic skills, frustration with not being able to complete works, and difficulty with modulating expression so as to not be too personally revealing. In order to make sound clinical decisions regarding the use of our own artwork in sessions with clients, a high level of self-awareness as well as sensitivity to the needs of clients is required. Training, supervision, and personal therapy, along with commitment to personal art making on our own time, are all invaluable aids for recognizing when and how to use our own art making in sessions with clients.

We are better able to make sound clinical determinations about the use of our own art if we consider the full repertoire of roles available to us. It is helpful to consider these roles of the artist as therapist along a continuum that ranges from being a detached observer to being something akin to a colleague with the client. The roles, described below, I have named the analyst, the witness, the collaborator, the role model, and the peer. In examining these roles I describe how they might become manifest in the activities of the art therapist interested in the therapeutic potential of making art alongside clients.

Analyst and peer

The analyst and the peer are located at the two opposite ends of the continuum of therapeutic roles. The role of the analyst is the most circumscribed of the roles, with a clear separation between the activities of the therapist and the activities of the client. The role of the peer, on the other hand, has very fluid boundaries, making it impossible to distinguish who is the therapist and who is the client. These two roles are described primarily as a means to establish the outside edges of what may be considered the role of the art therapist, from the most circumscribed and opaque to the most fluid and transparent.

The role of the analyst is one who studies, assesses or diagnoses. In this role the art therapist attempts to be as unobtrusive as possible, allowing clients to fill the space and time of therapy sessions without interference. The art therapist carefully and objectively observes, studies, assesses, and documents client behaviors. The position of the therapist is one of detachment, in an attempt to be a neutral presence in the setting. Though in practical reality it is impossible to be present in the therapy setting without having some influence, the attempt is made to have as little impact as possible. In this role there is no potential for the art therapist to make art, since any art making would compromise the intended position of therapeutic neutrality.

At the opposite end of the continuum is a peer, one who is of equal standing with another. In peer counseling, the hierarchical roles of counselor and counselee or therapist and client are abandoned. Two peer counselors enter into an agreement to help each other as companions in their quest toward health and wholeness. In this capacity, the art therapist relinquishes the role of therapist and actively engages in art making as a way to both make personal gains and to respond to or assist a peer who engages in similar endeavors. There is no distinction between the roles of the two people involved in peer counseling. Instead, the parties involved enter into a mutual relationship of art making for personal and interpersonal problem solving and enrichment.

Neither of these roles is explored in depth in this text. They serve to establish what may be considered the outer edges of the role of the art therapist. The role of the analyst, as I have described it, is in evidence in much of art therapy literature dealing with assessment and diagnosis. It can

also be discerned in some art therapy literature describing therapeutic practice. On the other hand, the peer counseling model has not, to my knowledge, been a subject broached in art therapy literature. There are accounts of art therapists using their own art making to deal with personal issues, but no account that I am aware of where this is done by an art therapist in a relationship of art making with another person. Our published literature is one expression of our communally accepted scope of practice, suggesting that it has been more acceptable as an art therapist to work from the detached and more powerful position of the analyst than it has been to abandon the power position inherent in the therapist–client relationship in order to function as a peer.

It is not my intent here to be a proponent of either end of this continuum of roles. However, I believe it to be healthy to explore the edges of our professional identities and to challenge and question ourselves about the roles we assume. Why, for example, has it been widely acceptable for us to adopt a role as art therapist wherein our own art making has no place or function? Why would we be more likely to question the role of the peer counselor, where engagement in art making occurs at the level of one human being trying to be open to and vulnerable with another? Do we need to redress this imbalance in acceptable roles for art therapists?

The following descriptions of three roles – the witness, the collaborator, and the role model – offer some alternative models for art therapists wishing to make full use of their artist identities in working with clients. All fall along the continuum between the role of analyst and the role of peer. None of these roles precludes the adoption of other roles as the therapist sees fit. In other words, in one situation the most fitting role for the therapist might be that of the analyst, while in another situation the client might best be served by the therapist adopting the role of the collaborator. Role flexibility comes from sensitively responding to the needs of clients while remaining anchored in one's sense of self. The ability to shift roles with ease comes about with practice and experience.

Witness

The role of the witness is to be attentive, to see (or sense) for oneself, to take note of, and then to attest to what has been observed through reflecting

back or "bearing witness." This role for the art therapist has been described as a mirroring response (Lachman-Chapin 1979), as a reflection of individual patient behavior or group mood (Gantt 1979), and as receiving the testimony of the client's experiences (Learmonth 1994). Wolf (1985) discusses the use of his own art making as a way to receive, contain, and synthesize client's projections. In the role of the witness, however, the focus is primarily on the receiving aspect. The witness does not interpret, evaluate, or judge but attempts to put aside any personal agenda and to engage in being fully present with the other person (Allen 1995a).

Art therapists commonly offer this attentive presence by silently bearing witness to clients' art making. It is also possible for art therapists to use their own art making as a way to reflect back their experience of the client.

In the role of witness, the use of the therapist's art making can serve several different purposes. First, witnessing can be a way to affirm clients. By therapists reflecting back to clients what has been sensed or observed, clients may experience being recognized, acknowledged, or understood. This is helpful in the establishment of a therapeutic alliance and in offering ongoing support. Second, witnessing has the potential to foster empathy in therapists. Therapists must adopt an empathic stance in order to be fully attentive and to give themselves over to the experience of another. Witnessing demands full sensory attention on the part of the therapist. Only through this empathic stance is it possible to gain the depth of understanding necessary for authentically reflecting back one's experience of another person. Third, therapists who act as witnesses offer clients a kind of "mirror" by which to become more self-aware. Clients are given the chance to come to understand themselves as another human being perceives them.

There are different ways art therapists can use their own art making as a vehicle for witnessing. One of the most straightforward ways to witness another person is through portraiture. This has been described by art therapists as both a way to build a therapeutic alliance and as a process of empathic connection (Costello-Du Bois 1989; Franklin 1990; Jones 1983; McGraw 1995; McNeil 1983). I sometimes draw portraits of clients who refuse to engage with me or with the art materials. I let them know of my intentions, asking them to let me know if they have any objections. Rarely do they object, though I may only be able to draw the backs of their heads

and arms as they slump over the table with their faces turned away. Drawing them is a way to bear witness to their behavior and to get the feel, through my own fingers, of their slumped-ness, their turned away-ness. Instead of feeling frustrated with their resistance, my art making helps me to be with them just as they are. At some point, perhaps only motivated by curiosity, they look to see what I have done. They see themselves as I have seen them and perhaps feel acknowledged rather than judged for their behavior. I have received their turning away behavior as an opportunity for empathic connection. If nothing else, they are usually curious about this unexpected turn of events. Often they respond with some softening of their resistant stance. In general, taking the time to do someone's portrait is perceived as taking the time to notice and, at some level, to care.

Portraits of clients can also be symbolic, an attempt to mirror the client's internal experiences rather than external appearance (Figure 8.2). When I am making a symbolic portrait of a client I find it serves to sharpen, organize, and clarify my perceptions. It is a discipline of articulating

Figure 8.2

through imagery what begins with vague impressions and unformed ideas. When I share such artwork with clients I present it as my own perceptions. I don't claim to have knowledge of other people's inner experiences but I do offer my humble and tentative attempts to understand the experiences of the people I work with in therapy. In this way my bearing witness "may reflect a restricted range, but its truths are unshakable" (London 1989, p.85) because I am reflecting back *my* experience of the client.

In addition to literal or symbolic portraits, art therapists can use art making as a vehicle for witnessing their clients by mirroring clients' ways of using media, style of artwork, themes, or subject matter. This has been identified as a way for therapists to use their art making post-session (Kielo 1991) but also offers possibilities for art made during sessions. When I have presented this idea to students they have often questioned whether this might not be perceived by the client as mimicry and misunderstood to be a form of "making fun" or ridiculing. While this is possible, I think it is unlikely if the therapist engages in this behavior with the clear intention of bearing witness to the client. The attentiveness and empathy connected to the role of the witness make it unlikely that the therapists' motivations will be misconstrued.

None the less, sensitivity is called for. It is possible to work alongside someone and to subtly mirror behaviors without the client being cognizant of it. For example, I may be aware of how hard a client presses on the oil pastels as she uses a circular motion to fill in areas of color. I may work alongside her on my own image but attempt to mirror this hard-pressing, circular motion. As we work side by side without speaking, the sound of our mark making may begin to create a cooperative rhythm. After awhile I may start to feel an ache in the muscles of my arm from all the pressure and repetition. Is this what it is like for the client, I wonder? Does she ache from all the pressure, from going around in circles? As the client fills her page with thick, sticky color, I do the same. By the time we are finished I have a film of sweat over the top of my lip and I notice she does as well. We have worked side by side, sweated together, exerted ourselves. Is she aware of my mirroring? Perhaps not initially, or perhaps she is never aware to the degree that she thinks to herself, "Oh, my therapist is pressing hard and making circular motions with the oil pastels just like I am doing." At another level,

however, it is likely that she experiences an affirming presence, a sense that she is not alone as she labors and sweats.

Collaborator

To collaborate is to work jointly or cooperatively with others. When the therapist is working as a collaborator with the client, then therapy is viewed as a kind of partnership. "This does not mean to model in some behavioral sense what we want our clients to do; rather collaboration means a genuine investment in the art as a part of the shared task of therapy" (Phillips 1992). Each partner has areas of expertise to contribute to the collaboration; the therapist offers expertise in art therapy and the client offers expertise regarding the self. Ideally, client and therapist work together toward a common goal or outcome.

There are many ways an art therapist can engage in art making as part of this collaborative relationship. The most obvious and straightforward collaborative ventures in art therapy occur when the therapist and client are working on the same art piece. Franklin (1981) describes his use of a collaborative art piece as a "common ground" where he and each of the emotionally disturbed children he worked with could explore feelings about termination. The use of "pictorial dialogues" to enhance trust and communication with persons who have serious mental illness (Boenheim and Stone 1969; Landgarten 1981) and the use of collaborative art making as a means to satisfy the wish to merge (F. Kaplan 1983) have also been described.

The art therapist can also function as a collaborator in a group setting. I was hired to work with a group of junior and senior high school students who were first or second generation Americans from Latin American countries. The purpose of the project was to create a community art piece intended to increase awareness of their cultural identity. I offered my expertise in group dynamics and group work, in working with adolescents, in drawing and painting techniques, and in basic construction techniques. They offered their expertise in cultural values, tastes, symbols, history, and pride, along with their knowledge of art and their personal preferences. The resulting mural was the product of a collaborative effort. I worked alongside them. They needed the expertise I had to offer them in order to

carry out their ideas, and I was absolutely dependent on them for their expertise regarding their cultural identity.

Another type of collaboration occurs when the therapist is willing to take a subordinate position in the creative endeavor, working as the client's assistant. The client may lack the physical abilities necessary to execute the artwork unaided, or there may be emotional reasons to support the client in this way. There are numerous examples of situations in which clients are physically unable to carry out their intentions due to illness, injury, or disability. In these instances, the art therapist attempts to serve as a tool – a hand to steady, a pair of eyes to see, a serviceable amount of energy for the work at hand, a physically able body to execute the artwork – in order to fill in for areas of weakness or disability in the client (Kern-Pilch 1980; Rosner 1982; Simon 1982). This work is carried out by the art therapist with an effort to remain true to the client's intentions and to support the client's exercise of choice and control over the artistic process.

Work done with clients at an emotional level offers many instances when the fitting response is for the therapist to serve as the client's assistant. A couple of examples will help to clarify this role. In one instance, I had worked with Gina, a 24-year-old woman with a history of sexual abuse, for several years. She was a member of an outpatient art therapy group. One night she arrived for the group session only to find out that the other group members had called to cancel. I told her she had the option to cancel as well or, if she preferred, to have an individual session. She chose to meet with me individually if I would be willing to help her draw her rape by a neighbor that had occurred just two weeks earlier. She had pressed charges and had been asked many questions by the police. She wanted to convey her experience through imagery but could not tolerate the emotional stress of executing the drawing herself. She described in great detail the picture held within her memory and I served as her "third hand", drawing, asking questions, drawing some more, and modifying the drawing when I had not gotten it quite right. This enabled her to externalize her imagery in way that did not threaten her emotional stability.

In another instance, a 13-year-old client I had worked with for nine months decided that he wanted to carve a piece of driftwood into a boat shape. I was concerned that he was attempting a task beyond his abilities and attention span, as was often the case. I expressed my concern, but he

was convinced he could do it if I would be willing to help him. I agreed. He enlisted my help, instructing me about what areas of wood to carve away and the quality of surface texture he desired. I worked alongside him, carving one area of the boat while he worked on another area. He was like the foreman; I worked for him and with him. After many weeks, the boat was completed. He experienced success through a collaborative relationship, a success that he would not have likely experienced had he worked alone on his project.

Bruce Moon (1997b, 1999) has described a third type of collaborative work as responsive art making. He defines this as "a process that involves the artist-therapist in creating artworks as a form of therapeutic intervention" (1999, p.78) in response to the artworks made by clients. Of particular relevance to this section on collaborative art making is the use of art to respond in a reciprocal fashion to art made by clients, to engage in what Moon describes as imaginative, interpretive dialogue. I also think of responsive artwork as occurring in response not only to the client's artwork but also to the client and the relationship between client and therapist. The vignette at the beginning of this chapter describes art made in response to the relationship between Dan, a client, and myself as therapist. In another instance, I made a series of small collages in response to the things a client was dealing with in therapy. Her attempt to pull together and articulate the fragmented pieces of her life seemed naturally to lead to my making art in response by using a collage technique. My images, in turn, led to her further exploration, through word and image, of her fragmented life.

A fourth type of collaborative work in art therapy involves the therapist working alongside the client in a parallel process. In this case the art therapist makes art that relates to the client's themes, media, or style but does not attempt to replicate them as the therapist does when working in the role of witness. Instead, the intent is to work alongside the client, to collaborate in the sense of a shared workspace and shared focus. As an example, I cite the therapeutic stance I took with Rena, a 45-year-old female who used the art therapy session to prepare for a family vacation. She shared her fear that she would become caught up in taking care of the family and in being the mediator for her husband and teenage daughter, rather than allowing herself a true vacation. I suggested that she make an artwork about her vision of a "true vacation." While she worked on her

drawing, I also made an image of how I imagined she would look if she were experiencing a genuine respite from her life struggles. She depicted herself in a hammock in a tropical setting while I depicted her on a raft in a lake cove. I collaborated with her on envisioning herself as truly being on vacation. She commented on the similarities in the images and seemed pleased by this. It seemed to affirm her belief that she deserved a vacation. She was able to begin to articulate how she might integrate these idyllic images into the reality of her vacation scenario.

Another example of the art therapist and client co-laboring alongside each other occurred in the 1999 "Creative Dialog: A Shared Will to Create" exhibit in Chicago. In this public exhibit, graduate art therapy students from the School of the Art Institute of Chicago and the clients they worked with at their internship sites collaborated to display their works. As the title suggests, the emphasis of the exhibit was on the common will to create rather than on pathology or disability. Their collaborative efforts manifested in a variety of forms, reflecting the unique creative decisions made within each of the student–client partnerships (Vick 2000).

A fifth type of collaborative role for the art therapist is that of the artist-in-residence who attempts to make art expressive of the community identity. In this role as collaborator the art therapist works within a group setting or in a communal space. Typically, the artwork is created over a period of time and the clients, staff, and/or visitors are able to view the work in progress. The artist may execute the artwork independently or may work cooperatively with clients to create the art piece. What makes the work collaborative in nature does not rely on the execution alone but on the cooperative development of ideas and content. For example, I once found a wooden chair sitting at the curb on trash day. The caning in the seat of the chair was all broken out. I brought the chair back to the art therapy studio and replaced the caning with a padded, canvas-covered seat. Then I told the participants in the group art therapy studio, "This is our chair. It is about the things people sit on…emotionally sit on, I mean. I will paint it, but I need you to help me by giving me ideas about what should go on it." "Anger," said one. "Deepest fears," said another. "Other people…to control them," another group member chimed in. Day by day, as I worked on the chair, other people would give me ideas that I would incorporate into the work.

Figure 8.3

Figure 8.4

The seat of the chair came to be filled with animals, birds, and fish, all symbolic of the life that is squelched when we "sit on" our feelings, as well as what threatens to snap back at us when we try to squelch it. The seat also has a ring of straight pins painted around the edge, a tribute to the saying, "sitting on pins and needles." At the top of the backrest in front there are words that read, "Put it all behind you," a common piece of ill-considered advice given to persons with mental illness. Directly behind, on the other side of the backrest, are the words, "the unspeakable, the unspoken" to remind the viewer of the reality behind the saying (Figures 8.3 and 8.4).

A sixth type of collaborative work the art therapist might engage in is to use art making as a means of dialogue and communication with the client. While all artwork may be seen as a form of communication, what I am referring to here is artwork created in dialogue fashion, with either client or therapist initiating and then continuing in a back-and-forth way. Each person in this collaborative relationship embellishes, elaborates, supports, adds to, changes, deletes, or in other ways responds to that which is expressed by the other through artistic means. This has some similarity to responsive art making but has a quicker pace to it, more akin to conversation, progressive storytelling, or the enactment of a drama.

As an example, Jake, a 16-year-old client, and his grandmother (his primary caregiver) were discussing a conflict situation at home. I recognized a familiar dynamic in their relationship in the way they were relating in response to the conflict. However, they were so caught up in the specifics of the disagreement they were unable to see the larger pattern that had developed in their way of relating. I asked Jake to depict in clay how he was feeling at that moment. He initially balked at this idea, saying he was unable to envision what "upset" would look like. But by asking him questions about the shape and texture of "upset" he was able to create a roughly- textured, hard-edged cube. I then asked the grandmother to do the same. Jake quickly jumped in, saying her shape should be like a wave. Whether or not this seemed right to her, she acquiesced to his wishes but professed an inability to make a wave. I stepped in to be her assistant, helping her to articulate and shape the kind of wave she wanted to create.

At that point we began to communicate, not with words but with the "speech" of the clay figures. I placed the cube and the wave in close proximity. Jake began to forcefully advance on the wave, knocking into it.

Then he folded the wave over so that it appeared to wash over the cube and envelop it. The grandmother giggled nervously and joined in, following her grandson's gestures. With what appeared to be enthusiasm she made the wave advance and retreat, enveloping the cube each time she did so.

I then enacted a scenario where the cube did not directly charge the wave but instead passed close by it. With my other hand I moved the wave, but in a gentler way that did not threaten to overwhelm the cube. The grandmother then attempted to model my action with the wave, though Jake kept charging at the wave with his hard-edged cube.

Following this use of art as communication both Jake and his grandmother were able to engage in a fruitful discussion about their mutual desires for control of the other, Jake through aggressive actions and his grandmother through smothering actions, and the difficulties they were having with the changing nature of their relationship as Jake grew older. There were things they did not talk about with words – the grandmother's acquiescence to Jake's demands, how quickly attempts at connection became hurtful actions between them. I trusted their judgment in overtly addressing the issues they felt capable of dealing with at a verbal level and leaving other issues to the symbolic intelligibility of the artistic language. Our art making together served to communicate the subtleties of their relationship in a way they were not able to do with words.

Role model

To be a role model is to be a person who demonstrates a socially expected behavior and provides an example worthy of imitation or emulation. Art therapists who serve as role models create art about their own lives in order to demonstrate how art can be used to deal with life as it is, in all its painful, challenging, and rewarding moments. Art therapists in this role are present as fellow struggling human beings, working alongside clients as guides and companions. They are artists-in-residence, creating their own paintings, drawings, and sculptures while at the same time helping clients to develop and give form to artistic intentions. This use of the artist-in-residence style of engaging with clients differs from that of the art therapist working as a collaborator. Instead of the art being made in service of the community

identity, the art therapist who is working as a role model makes artwork that arises from personal motivations.

The engagement with both problems and potentials can be modeled through the art-making process itself, where there are inevitably encounters with failure as well as success. Clients are given the opportunity to observe art therapists as artists who struggle with the frustration of color combinations that don't look "right," with clay pieces that break apart in the kiln, with not knowing what to do next with a piece of art-in-process. They also see how art therapists resolve these frustrations...by asking other artists (clients or other therapists in the art therapy studio) for their opinions about the color needed, by incorporating the broken clay shards into a new artwork, by putting a work aside for awhile so it might be viewed afresh at another time.

Art therapists may also model engagement with problems and potentials through the use of selective transparency in regard to the content and significance of their own artworks. This requires an ability to discern when sharing explicit information about artwork is likely to enhance the positive impact of the role model, and when the sharing of explicit information is likely to have no benefit or to interfere with the client's ability to make use of the therapy.

When working as a role model, two guidelines are helpful in deciding what to share about artwork made in sessions with clients. One guideline is to remember that emotional content can be shared without having to share all the specific details concerning those emotions. For example, I might create an artwork about my anger within a group art therapy session. I may decide against sharing the situational details and refrain from disclosing that my anger was in response to some flippant remark made by a co-worker. However, this does not prevent me from sharing the emotional content in the image by articulating the color, shape, texture, and experience of my anger. In this way I model the use of art as a safe way to grapple with and express angry feelings.

The second guideline relevant to selective transparency is never to share something likely to be a burden to the client. This requires that art therapists make clinical judgments based on self-knowledge and sensitivity toward clients' issues and needs. Sharing explicit content with clients is generally contraindicated if the content of the artwork is experienced by

the art therapist as emotionally raw and unresolved. When in doubt, it is better to err on the side of caution.

The question of authenticity often arises in relation to art therapists withholding information about their personal artworks created in sessions with clients. If, the argument goes, we expect clients to reveal the intention and meanings of their artworks, then is it right for us to withhold the meanings of our works from clients? Won't clients sense our insincerity and doubt our genuineness as therapists and as human beings? It is important to remember that authenticity neither requires nor is equivalent to complete personal revelation. This is true for both clients and therapists. Art therapist Elinor Ulman's maxim to tell the truth, nothing but the truth, but not necessarily the whole truth, holds some wisdom for therapists negotiating the treacherous waters of self-disclosure. Withholding information may, in fact, be more authentic than blindly revealing everything. Refraining from self-disclosure may be based on an authentic need and desire for privacy and personal boundaries. The therapist's intentional use of selective transparency, rather than an uninhibited baring of the soul, provides healthy role modeling for clients who must make these same delicate decisions about the timing, content, and recipients of their self-revelations.

The personal disclosure inherent in the function of the art therapist as role model – whether it be disclosure of the process or the content of art making – intensifies the importance of the therapist's self-awareness and self-monitoring. Supervision is invaluable for helping the art therapist sort through questions of disclosure so the best interests of the client are kept in the forefront. An astute supervisor can help the art therapist identify pertinent issues and make sound clinical judgments in regard to selective transparency.

It is also important for art therapists to maintain clarity about the function of the role model, that is, to use personal artistic expression in service of others. Key to maintaining this clarity is an active involvement in one's own personal art making outside the therapy setting. This is not to suggest that experiencing enjoyment or fulfillment from personal art making carried out in the context of work with clients is "wrong." On the contrary, authentically experiencing and conveying a sense of passionate involvement with art is one of the most important aspects of the art therapist as role model. The potential for this to become problematic exists

if the artwork created during client sessions is the *only* source of artistic ful-fillment for the art therapist. Then the art therapist is in danger of using client sessions to fulfill his or her own unmet needs (Lanham 1989) rather than engaging in personal artistic expression in service of others.

Some examples of my artwork made with the intention of serving a role-modeling function and created within the context of therapy may help to clarify the process of selective transparency. Some of the works I describe were executed exclusively during therapy sessions. More often, however, I worked on the pieces over time, both during and outside the framework of client sessions. The examples shown in this text are the finished works. It is important to remember that clients saw not only the finished works but also the works-in-progress, when they were sketchy, messy, unresolved. Some clients only had a single exposure to my way of working, a snapshot example of working with inner experiences and external materials to make something concrete out of them. Other clients saw work evolve over time; they saw how sometimes I worked and reworked an image, how I embel-lished or painted over, how I tried different ideas until something "worked."

Along with the examples provided by my visual art pieces, I also make occasional comments about my internal process as it evolves. At times this involves asking for feedback or ideas; at other times I "talk to myself" while I work so that other people within earshot can be privy to my thought process regarding content or technique; sometimes I engage in dialogue with a client about our ways of experiencing the artistic process; still other times I exclaim aloud my frustration or delight in response to the way the work is proceeding. These glimpses into the internal workings of the creative process are an important aspect of the art therapist's function as role model. We are modeling not simply the making of external art products but also the ongoing remaking of our inner being.

Some of the artwork I do is inspired by my work as an art therapist. *I Remember Every Single One of You* (Figure 8.5) (also discussed in C. Moon 2001) was made in response to the overwhelming number of clients with a history of abuse admitted to the hospital where I was working at the time. It reflected the paradoxical duality in me of naïve disbelief and profound, knowing grief. The title refers both to the impossibility of ever remem-bering all the individual faces and names, and the impossibility, at some

Figure 8.5

level, of ever forgetting a single one of them. I made this piece, for the most part, while doing a solo retreat at a friend's cabin in the woods. I needed to be alone to allow time and room for the intense emotions to come out. They were too large, too raw, too threatening inside me to release in the context of a therapy group with clients. I would not have been able to do my own internal work with the images and attend to the clients at the same time.

When I returned to work I brought the piece with me and made the finishing touches on it during studio art therapy sessions. I believed it was an important piece to share with the clients. Many of them struggled with the same thing I struggled with, that is, what to do with all the stories of abuse to which they were exposed. This was particularly true for those who were dealing with their own abusive pasts as well. They knew how important it was to tell these stories and how important it was to be listened to in a nonjudgmental way. At the same time, they became worn down and retraumatized by hearing about other clients' traumatic pasts. This caused a

double bind for them. They wanted both to be accepting listeners and to close their ears to what they were hearing.

My artwork presented them with a model for how to deal with these feelings. I let the clients know that I had made the piece during a personal retreat. In this way I let them know of my own paradoxical need to both retreat from and connect with the feelings stirred up by all these trauma stories. I let them know that sometimes I had to back away, say I had had enough, and take care of myself. I believed these to be important stances to model for women whose experiences had made it difficult for them to set personal boundaries.

As is typical in my work, I took cues from them about how much to disclose concerning the significance of the work. Some clients took little interest in the piece and went about the business of doing their own artwork. Other clients expressed curiosity and interest. Not surprisingly, they were the ones who themselves had a history of abuse. They didn't want to talk about it for a long time, but they looked and listened intently as I responded to their comments and questions. Then they too went about making their own art pieces.

Another example of art inspired by my work as an art therapist is *Something About Brokenness* (Figure 8.6). This piece came about without my having any clear sense of its meaning. I played around with it, painting and

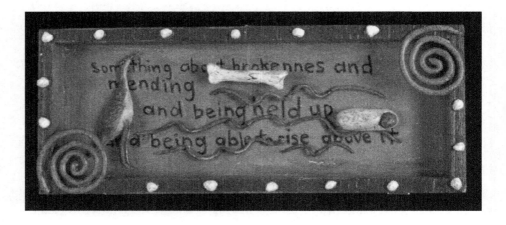

Figure 8.6

shaping, arranging and rearranging. The words came to mind as part of this playful creative process: "Something about brokenness and mending and being held up and being able to rise above it." When I painted these words on the piece I connected with my sense of awe for the clients I worked with, for the hope they manifested in spite of all they had endured in their broken lives. This work was created in its entirety during sessions with clients. I modeled engaging in art making by allowing the process to lead me. I let the clients know about my different ways of "finding" images to work with. I did not feel the need to explain the meaning of the work, nor did the clients express a need for an explanation. We simply lived with the piece, allowing it to tell its many and varied stories to all who cared to look and "listen."

There are times when I have used my art to deal with the institutional aspects of my work as an art therapist. During the period of time when the hospital I was working at was undergoing downsizing of both staff and facilities, I was deeply affected by these changes. The stability I had come to take for granted was shaken. This was true for some of the clients as well, particularly those who had been associated with the hospital over a long period of time and had come to view it as a safe haven in times of need. An art piece I made during this time, *Grieving* (Figure 8.7), was in response to these unsettling times. I combined images of bones, a tombstone, flowers, and a figure with her head tilted back and arms upraised. On the right side of the paper were the words, "They're tearing down the greenhouse." The artwork was a response to the powerful metaphor I recognized in the gradual "downsizing" of the horticulture therapy areas and landscaping of the hospital grounds. Each rose bush torn out, each garden pond plowed under, each reduction in size of the vegetable garden reverberated in the other acts of tearing and plowing under and reducing that were taking place at the hospital. Sometimes the attempts of the staff to maintain "good" boundaries around their own emotional responses to the changes at the hospital resulted in the clients feeling as if the topic were taboo. By making this artwork I modeled a healthy way to give expression to the grief and outrage that are a normal response to such losses. The clients responded with what seemed like a sense of relief, relating their fears and anger and sense of impending abandonment.

Figure 8.7

The areas of overlap in my personal and professional lives sometimes inspire the artwork I make. Such was the case with *Rantings and Ravings* (Figure 8.8). This piece was begun with some painted "doodling" as Janet, a 16-year-old client, talked to me about her fears of dating boys. Having been sexually abused by her father when she was a small child, Janet questioned how she could trust any boy and his intentions. Later, as I reflected on our session, I began to think also of my own 16-year-old daughter. I knew I would be able to protect neither Janet nor my daughter from the boys who would ask them out. I had no way of knowing for sure whether the boys could be trusted. I dealt with my own fears by allowing them to reach frenetic proportions in my artwork, blending genuine concern and alarm with a sense of humor. Wild-looking creatures and humans form the center of the image. The half of a boy's face that appears on the front of the artwork is sweet and innocent, while around the edge of the painted piece of wood lurks the other, more malevolent side of his face, with crooked grin and evil eyes. Textual "rantings and ravings" include words such as these: "How can I trust you with my daughter? You seem nice enough, sure. But I hear Charles Manson did too…seemed nice enough I mean. How will she really know? Of course she won't until it's too late, until you have her alone

on some dark road and then…" The words are written all around the wide border of the piece, undulating in curved lines like the clay snakes that slither around them. The beginnings of this piece came from and during sessions with a client. At some point, however, I needed to work on this alone. I needed to be able to express my wildest fears without worrying that I would burden or unnecessarily alarm Janet, who already had fears of her own with which to deal.

Figure 8.8

Sometimes my artwork deals with larger social issues, such as *In the Land of Plenty* (Figure 8.9), a piece about the existence of poverty within our wealthy nation. In making art about such themes I role model awareness and concern about issues outside the art therapy studio. There may be times when such a focus may be burdensome to a client already overwhelmed with intrapersonal issues. In general, however, examining, critiquing, and challenging the socio-cultural context is an important part of therapeutic practice. At times, therapy "practices may actually work to individualize

social and economic disadvantage by focusing the person's problems at the level of her personal biography and personality" (Lupton 1997, p.1). Presenting socio-cultural issues through therapists' artwork is one way to widen the lens of therapy beyond the insularity of the therapist–client relationship. This acknowledges the interrelated nature of the personal and the political and gives clients implicit permission to examine critically the impact of the socio-cultural context on the problems they are addressing in therapy. It also offers clients a wider perspective by which to view health and healing, so that socially responsible activities may become part of the therapeutic process.

At times my artwork also pertains to specific personal issues I am dealing with. These issues may be primarily intrapersonal in nature, as in *Two Selves* (Figure 8.10), a piece depicting the cold, calculating part of me in

Figure 8.9

interaction with the sensitive, vulnerable part of me. Another piece, *Me and My Shadow* (Figure 8.11) portrays my reluctance to deal with my "shadow" even though it stubbornly demands my attention. Both of these pastel drawings were created in group art therapy sessions (though I later worked on the images to deepen the colors) where everyone was working from a common theme and art making was followed by discussion of the images created. In each case, I briefly discussed the emotional content of the drawing without divulging the specific personal issues I was dealing with. In this way I did not burden the clients with my issues, but I allowed the group members to "borrow" my images as a way to explore their contradictory aspects and to imagine what it would be like to engage with the shadow parts of themselves.

Figure 8.10

Figure 8.11

At times the content of the artwork may be interpersonal in nature. I created *What the Bird Knows* (Figure 8.12) about trying to have a relationship with my father who had Alzheimer's Disease. I did not begin the piece with that intention. The piece started with a spontaneous image and I later saw it as a portrait of my relationship with my father. This piece was made within the context of a studio art therapy group where each person worked individually within the group setting. The meaning of my artwork was sufficiently ambiguous for no one to know the significance to me unless they asked. The clients saw my work-in-progress and made comments about it, but none of them ever asked just who the figures represented. Since they did not ask, I had no reason to tell them. We left the artwork open to the multiplicity of potential interpretations.

Figure 8.12

It's About Love (Figure 8.13), on the other hand, had significance immedi-
ately known to some of the clients. This piece was made as a memorial to
Debra DeBrular, an art therapist and close friend, who died tragically in an
airplane crash. At the time of her death she was not working at the hospital
where I was employed, but she had done so in the recent past. Many of the
clients in the day treatment program knew her and knew that she and I had
been close friends. I began this mixed media piece in my own studio. I
needed the time alone with it as part of my process of working through and
grieving her death. At some point it also seemed important to bring it into
the context of the art therapy studio. There was no choice to keep my grief
over her death private. The circumstances of her death made it immediate
public knowledge as it was published in the local papers and aired on local
news. Though the clients did not have the kind of relationship with her that
I had, they too were grieving her death. They recognized the loss of a
caring human being, and the loss of her was echoed in the losses they expe-
rienced through the hospital's downsizing process. By working on this
piece in the art therapy studio, I served as a role model for using art to deal
with profound grief and loss. I also let my art become "our" art, so together
we could grieve the loss of Deb and the loss of so many others.

Figure 8.13

I think one of the characteristics of much of my work is a sense of "consola-tion through festivity" (Lippard 1990, p.81). Even in artwork that has to do with tremendous grief, as in my memorial piece for my friend Deb, there is a certain delight I take in using the materials in a festive way. The broken shards of ceramic tiles can express my sense of emotional brokenness at the same time that they celebrate color and life and my good fortune to have had such a friend. This is an important aspect of my role modeling function, to be able to bring these paradoxes of life together, to be able to find conso-lation even in the midst of pain. I think it is as important to have humor and shared laughter be a part of an art therapy studio as it is to have the oppor-tunity to express emotional pain and difficulties. At times I create art that is celebratory in nature, work that lays claim to the good in life. This aspect is important for art therapists in service as role models, for along with working through problems we also want our clients to lay claim to the good

in their lives. *Marketplace* (Figure 8.14) and *Woman with Painted Toenails* (Figure 8.15) are two examples of such celebratory works. Both were created in a spontaneous manner, allowing the energy of the image to carry the creative process, without a need to understand what was being created. They are a celebration of art making as much as they are a celebration of any particular content. If these kinds of images were all I ever created in the art therapy studio, then their celebratory nature might seem to be dissonant with the clients' experiences. As one perspective amidst a wide range of emotional content expressed, they serve to articulate the hope within me and to role model the potential for art to be a bastion of hope in the midst of suffering.

Figure 8.14

Conclusions

The active use of our own art making as an aspect of our work with clients is a critical component of a studio approach to art therapy. Though there are good reasons for the therapist to refrain from art making in specific circumstances, the use of our own art making in sessions ought to be cultivated as one of our most significant and potentially effective contributions to thera-

peutic work. Careful examination of traditional arguments against therapists making art alongside clients, and the development of sophisticated understandings of the many applications of therapist's art making, lead to making sound clinical decisions about when and how we use our art making in sessions with clients.

If we offer art to our clients as a medium of expression, it makes sense that we respond and relate to them using that same artistic language. In so doing, art becomes not merely the *alternative* but the *primary* mode of expression in the art therapy studio.

Figure 8.15

Communicating with Others about the Work We Do

Talking and pictures participate in making each other (Goodman, as quoted in Tomson 1997, p.102)

When my daughter was born, I saw her squirming little body and was suddenly overcome with the realization of how much I had hoped for a little girl. I'm not sure if I said it or just felt it, but the words that bubbled up in me were, "I have a daughter!" At another time in my life, when I had confided in my friend Deb about what a mess I had made of several relationships, I remember her green eyes brimming with tears as she said tenderly, "Isn't love always a little crazy?" At my father's funeral, the priest began his eulogy by stepping down from the pulpit and walking over to stand in front of my mother. His first word, "Marge," directed with compassion toward my grieving mother, was the only word from his eulogy I remember. It cut straight to the bone, touching my own grief and soothing it all at once.

Still, when Marianne showed up for the art therapy group with her dyed black hair covering her eyes and her slashing red marks covering her paper, I expected her to tell me in great detail about her image. I got irritated when time and again she made provocative drawings and then would not tell me or the other women in the group what they meant to her. I probed and prodded, but she maintained her stony, glaring silence.

I could use the excuse that Marianne arrived at a period of time in my professional life when I was still young and inexperienced. But, on the other hand, why didn't I already know that the most significant experiences in life are not apprehended or communicated through lengthy verbal articulation? My own experiences had taught me that glances, shrieks, grasps, gasps, mumbles, embraces, shudders, chuckles, and the like were often the most articulate forms of expression. The rule of thumb for conveying something of profound significance seemed to be to use no more words than could fit in a sentence or two, or to use no words at all. Somehow I forgot all that when it came to my relationship with Marianne.

Just last week an art therapy supervisee spoke to me of her self-doubts about her work with an adolescent boy who would not talk, though he came to sessions regularly and made art every single time. While I now have a good deal more experience behind me than I did when I worked with Marianne, I could still empathize with the supervisee's struggle. I still wonder sometimes if I am effective as an art therapist when I get little in the way of verbal confirmation from a client. My faith in the healing power of art is still sometimes on shaky ground.

I've learned to forgive myself again and again for my lapses in faith. It is no wonder faith in art is difficult to maintain. Believing in the inherent intelligibility of the arts, believing in the power of the arts to apprehend, convey, memorialize, and even transform experience, is a continual struggle when the prevailing social attitudes disregard or discount art as a mere "frill." In a society where value is placed on verbal language characterized by linear, discursive thinking, the arts are relegated to an inferior position. When words are used, there is subtle, covert pressure to conform to the sound, style, syntax, and word meanings of the dominant culture. Thus, the language habits of persons who are marginalized on the basis of race, class, ethnicity, gender, occupation, or other cultural characteristics are not considered "standard" or acceptable. The poetic basis of language, its capacity for subtly conveying authentic identity and experience, is thus stripped in favor of a more sanitized version.

The systems and institutions within which art therapists work are microcosms of the larger social system where language is used to confer dominance on some and to exclude others. Thus, we are not exempt from the influences of this oppressive system. We have the opportunity to offer the arts as an alternative language to clients who experience themselves as marginalized and misrepresented by the language of the dominant culture. We also have the opportunity, when communicating with clients or colleagues, to use means that honor the poetic basis of language. In order to do this, we have to resist the tremendous (though subtle) pressure to conform to the language habits of the dominant culture and instead to become more articulate in the particulars of a language inherent to art and the arts therapies.

To claim and articulate a language true to art therapy necessitates challenging the dominant culture at several levels. First, art therapy practice must be based on a deep respect for, and faith in, the value of the nonverbal characteristics of communication through the arts. While this may seem an obvious and fundamental aspect of the practice of art therapy, there is tremendous pressure to "translate" art into verbal explanations, and art therapists are subtly rewarded for doing so. Awareness of a hierarchy within the medical community that values verbal over nonverbal expressions has been in evidence since the early years of our profession (Ulman 1966) and is something with which we still must contend. Talk will always be a part of the practice of art therapy, but there is also "a door opened to a kind of communication with yourself and others that is, indeed, nonverbal and is symbolic and need not necessarily be translated into words" (Kramer, as quoted in Koodrin, Caulfield, and McGarr 1994, p.181). Becoming more articulate in a language true to art therapy requires the development of skills in responding and relating to clients and their artworks through artistic, nonverbal means.

Second, claiming and articulating a language true to art therapy necessitates an examination of the way we use words in the practice of our profession. We rely on verbal communication when we speak to our clients, document our work in client records, tell colleagues about what occurred during an art therapy session, explain to interested persons our ways of viewing artworks, speak about art therapy through lectures or workshops, and write for professional publications. In each instance, we make choices

about how much we conform to the language of the dominant culture and how much we use words in ways that more closely represent the aesthetic, relational basis of our work in art therapy. If the process of self-naming and self-definition is a political act (Becker 1996; Aldridge 1993), a potential danger of complete conformity is the disavowal of our own identity in the process.

Being multilingual

Our ability to use a form of communication intrinsic to the practice of art therapy requires that we be, to some degree, multilingual. In addition to the requirement that we have skills in both verbal and nonverbal communications, we must also know how to speak in other "languages," often straddling seemingly contradictory terminology and value systems. We have the sometimes difficult, sometimes exciting, but always challenging task of navigating through the intersecting languages of truth and fiction; artistic language and the language of therapy; words and enactments; and universality, cultural context, and idiosyncratic expression.

Truth and fiction

One of the false beliefs about words is that they convey specific and fixed meanings. In truth, both art and words are symbol systems whose meanings are dynamic (changing over time) and relative (varying with individual circumstances). Both images and words are powerful social instruments that not only reflect the rich and varied nuances of experience but also shape how we think, feel, and act. In the realm of words, "truth" is considered in a fairly circumscribed and limited way. When we say something, we are considered either to be telling the truth or to be telling a lie. The exception to this is when language is used in such forms as poetry, creative writing, or drama. In the realm of art, there seems to be a much wider acceptance of the way a symbol system can convey truth through fleeting ideas, vague memories, subtle sensations, glimpses, notions, anecdotes, embellishments, repetition, intuition, fantasy, and fabrication.

As art therapists we must sometimes operate in the realm of words that seek factual truths. For example, we may need to enquire of an elderly male

client who speaks about suicidal thoughts whether he has a specific plan of action to keep safe and alive until the next art therapy session. But we also have the unique opportunity to engage with him on the level of poetic truths, that is truths conveyed through what may appear on the surface to be lies. We may straddle truth and fiction when dealing with his image of a tombstone at the crest of a hill in an otherwise empty landscape. The image, along with his facial expression, demeanor, and quality of relating, may alert us to possible suicidal intent. But if the story he tells us is of memories of his homeland in Russia, where family members were buried near the site of their birth, we may be clued in to other truths he is conveying through his image. These truths may be about preparing to die, a sense of connection with his past, an understanding of the circular nature of life and death, a love for the land of his birth, a desire to be reunited with those he has left behind. If we happen to know that he was born and raised in New York City, does this alter the truth of his image and his story? We may revert to a logical interpretation, seek factual truths, and assume he is either lying, confused, or psychotic. But we can also attend to the truth of his image, the subtle and specific truths revealed through the particular metaphors of his image and words. "The concept of the world without imagination is euphemistically referred to as 'reality'; but as the poet Wallace Stevens said, 'the absence of imagination has itself to be imagined'…the method for dissolving the paradox is to enter into it" (Sexson 1992, p.69). Art offers a way for us to enter into this paradox, where imagination forms reality and fiction reveals truth.

Artistic language and the language of therapy

At the same time that we are attempting to find and articulate an authentic language for art therapy experiences, we also often must be versed in the medical, diagnostic, administrative, clinical, and financial terminology of our workplaces. The common language is often "therapese," a term coined by Ulman (1962) to refer to language used by therapists to "conceal poverty of ideas behind a smokescreen of pseudo-science, pseudo-intellectuality, pseudo-elegance" (p.77). Terminology related to art is often a foreign language to all staff but the art therapist. Although most art therapists are bilingual in both the language of the arts and the language of psychother-

apy, there is often no forum within our work environments where we can engage in discussions about art (Semekoski 1998). Being in the minority position places a burden on art therapists. In order to "prove" parity with the majority, we have to be able to engage in the discourse that is considered standard and acceptable. At the same time, in order to maintain a sense of professional identity and integrity, we must use language that arises from the true quality and character of our work as art therapists. Thus we are con-tinually engaged in "combining the word language of the scientist on the one hand with the poet's reconstruction of reality on the other" (Lachman-Chapin 1983b, p.49).

If we have erred in our balance between speaking the language of the dominant culture of therapy and speaking our own authentic truths, it has tended to be on the side of conformity to the dominant culture. Bouchard (1998) questions the validity of saying we must use the language of psychopathology in order to communicate with other professionals and suggests that one motivation to do so is derived from a desire to link ourselves with those we perceive as powerful among mental health pro-fessionals. He asks, "What would happen were we to begin to use a language more intrinsic to art therapy? What if we could envision diagnosis in such terms as 'disorders of the imagination,' for example, or 'blocked creative will'?" (p.161). Another perspective is offered by the recovery paradigm, where the symptom and disease focus of the medical model is replaced by an emphasis on human potential and the consequences of illness (Spaniol 2000). From this perspective, the development of a visual language for art therapy practice comes from collaboration with clients-as-experts. This collaborative effort is essential if the development of an art therapy language is to be true to the experiences of clients as well as therapists and is to avoid the pitfall of the more powerful group (art ther-apists) imposing a language on the group holding less power (clients).

The development and use in our professional encounters of a language consistent with the experiences of art therapists and art therapy clients is likely to require concerted effort. It involves stepping outside the bound-aries of what may be considered appropriate and acceptable by the larger professional community. A willingness sometimes to feel awkward, uncom-fortable, or foolish may be necessary as we struggle to find words that accurately convey what happens in art therapy (C. Moon 1988, 1997a).

Courage might also be a requirement when we dare to communicate clinical information to our colleagues through gestures, word pictures, bits of poetry, or images in lieu of words. At times we may need to engage in tactful and perhaps gentle confrontation when other professionals use language that equates art with pathology or otherwise misrepresents and undermines clients or the art therapy process. At the same time, we have to be both patient and tenacious in our own use of language so that we do not sacrifice clarity or precision for the sake of freedom of expression. A language that accurately reflects the relational and aesthetic basis of our work is likely to be a work-in-progress for some time.

Words and enactments

A common scenario in art therapy practice occurs when a client makes a piece of art and then therapist and client engage in a discussion about the finished work. We frequently use words to get at the meaning of art, in spite of our awareness that "we are using art to get at meaning that evades words" (Goodman *et al.* 1998, p.39). This format for a session may be helpful and meaningful for clients when used with sensitivity and respect for the clients' roles as experts. However, the potential of art therapy is severely limited when discussion of the product becomes the only option for relating to artworks. In working with children, not only may they not have the words to describe their experiences, but also it is not necessarily in their best interest to break down effective imaginative defenses they have established as a means of coping (Klorer 2000). As a consistent practice, this way of structuring art therapy sessions runs the risk of treating art as the "means to an end of insight into a problem the client is having" (Allen 1992, p.22). The potentials of art to serve as an embodiment of significant experience, a symbol of transformation, a process of making special, a vehicle for gaining a sense of mastery, and/or an object of personal significance and import are all diminished when the art product is treated solely as a piece of evidence to be examined.

Cohen and Cox (1995) identify process, structure, and content levels as elements of art that must be considered when attempting to discern meaning. The process level encompasses both the making of an artwork and discussion about it; the structure level comprises the various techniques

of pictorial composition that characterize its style; and the content level refers to the subject matter, theme, story, or, in abstract work, the dynamic interrelationship of the structural elements. While process, structure, and content levels are widely recognized as elements of art made in art therapy, the focus of relating to artworks has tended to be on the content level. In spite of the common ethos in art therapy that emphasizes the process of art making over the art object as product (Spaniol 1998), our most common method for engaging with artworks – talking about them – seems to emphasize their qualities as objects or products. As art therapists, we believe in the importance of so-called process art – the dynamic, action-oriented, experiential, relational understanding of the significance of art – and this distinguishes our practices from those of art education or the art world. Yet we often seem to lose our understanding of art as an action language when it comes time to help clients find meaning in relation to their artworks. We frequently revert to the common practices of the talking therapies and lose the opportunity to involve in a relationship with art on its own terms, in its own language.

Relying solely on verbal "processing" of artworks fails to make full use of the unique skills of the arts therapist. It disregards the potential for art therapists to respond in kind to the artworks of clients, to respond with heightened aesthetic sensitivity through artistic means. When the therapist relies on verbal discussion as the basis for relating to the client's image, there is a tendency for clients to relate to their own artwork in this way as well. In groups, the discussion can easily lapse into labeling, interpreting, judging, and advice giving. This is caused, at least in part, by the fact that *discussion* of art is distinctly removed from the *experience* of art. Aldridge, Brandt, and Wohler (1990), in addressing the need for a common language in the creative arts therapies, refer to the "grammar" of the arts as being based on verbs or active doing, as distinguished from psychology and other talking-based therapies where the focus "is always several steps removed from the actual activity in which we partake" (p.193). When discussion in art therapy sessions occurs through discursive language, this distancing factor is emphasized and the unique, action-oriented, here-and-now language of the arts is relinquished.

Engaging with art in kind, on its own terms, in its own language means responding to art either through language based in poetic sensibilities or

through enactment. Enactment refers to the intentional use of artistic actions as a means of connecting with the art at a resonant level. Artistic enactments include making visual art in response to a client's artwork, as well as other art forms such as movement, drama, dance, music, sound, poetry, or story.

There is some irony in addressing in written form a means of communication that is action oriented. It would be much easier and more effective to demonstrate enactments in response to client artworks than to write about them. Adding to the difficulty of conveying the concept of enactment in the context of therapy is the fact that there are no cookbook-style prescriptions for what to do in any single session. Attempting to find the artistic response that best resonates with a client and his or her artwork is all about attending to the particulars of the client, artwork, and contextual factors as presented in the here-and-now. None the less, the following is an attempt to convey, through presenting a sampler of ideas and examples, how we might stretch ourselves as art therapists to engage with artworks not only through discussion but also through the action oriented languages of the arts. It is my hope that these examples serve to stimulate other ideas about how to engage with clients and their artworks. At its most basic level, aesthetic response requires the use of our perceptual and expressive abilities – touch, sight, hearing, taste, smell, movement, sound making, visual expression, drama, poetic language – employed in the service of relationships. The ideas and examples I give are simple ones, in part because the simple response is often the most effective, and in part because I want this list to generate a sense of possibilities rather than a sense of exclusion. While an art therapist's ability to sing arias, quote Shakespeare, do the Lindy Hop, or rival Marcel Marceau in miming skills, may come in handy from time to time, it is certainly not necessary and might even have a counter-productive, intimidating effect! The kinds of perceptive and expressive abilities required to respond in kind to artworks are those abilities that are commonly available to all, therapists and clients alike.

1. Darcy draws a picture of herself curled up awkwardly on a chair in the corner of a room. She expresses frustration that the figure she has drawn "does not look right" and is not what she wants to convey. I place a chair in the corner of the room and attempt

to position myself as the figure in the picture is positioned. I invite Darcy to do the same. Together we explore what in particular is "right" or "not right" about the position. Groans and sighs and "ugh" sounds that arise naturally create accompanying "music" by which to engage with the picture.

2. A friend of mine, Debra DeBrular (1993), would sometimes bake bread as part of her adolescent girls' art therapy group. The aroma of the baking bread, the feel of the warm bread just out of the oven, the sight of it as big hunks were broken off, the taste of it in their mouths, all contributed sensory experiences that addressed their hunger, their sense of brokenness, their ability to nurture one another and to change themselves from the inside out. At a purely experiential level, the themes they were addressing through their artwork were deepened through engaging with the metaphors of the bread.

3. A student I was supervising was working with adults who were developmentally disabled. They engaged enthusiastically in the art making but her attempts to have them discuss the images fell flat time and time again. She decided to try something new. One day, when the clients had completed their artworks, she invited each of them to become the "director" for a live-action portrayal of his or her own artwork. Each "director," in turn, assigned roles to the other group members based on the elements portrayed in the drawing (for example, boy, dog, sun, pond, fish, wind, grass). Each cast member was instructed where to position themselves, if and how to move, and what kind of noise to make. In this way, the images came alive and the clients were actively engaged in deepening their relationships to each other and to the artworks.

4. I attended a workshop at Marywood University led by author and art therapist Pat Allen. She instructed us in a way of engaging with images she called "witness writing." Before making art, we each wrote an intention having to do with our art making. After completing the art, we spent quiet time engaged in witness writing. This involved simply writing in

response to the art or the art process. Some people wrote *about* the artwork, some people wrote *to* the artwork, some people wrote *from the perspective of* the artwork, and others wrote *a dialogue between* themselves and the artworks. We were then given the option to read our witness writing out loud to the other workshop participants. We were asked to listen to others' readings without comment, creating a criticism-free, praise-free environment where the focus became attending to rather than evaluating one another's artworks.

5. I am working with a group of adolescents on a mural project. One of the boys is very physically active. He has a hard time staying focused for extended periods of time, and is distracting to the other adolescents. From time to time, he spontaneously expels his excess energy through using objects in the room as percussion instruments. Out of necessity, I set limits on some of his behaviors and make an effort to help him focus on painting. However, I consider his spontaneous creation of percussive sounds to be an aspect of his artistic expression. So I help him channel his disruptive drumming episodes into a productive outlet by charging him with the task of leading our found-object drumming ritual at the close of the session. By providing him with a new context for his behavior, he is able to contribute to the sense of community in our group and to experience his actions as empowering and affirming.

6. Clara comes into the art therapy group humming a song. The group members are chatting easily. Paul asks her what she is singing. She says she doesn't know the name of the song but the words say something about singing over the bones. After some discussion, the group members decide this should be their theme for the session, "Singing over the Bones." They quickly become engrossed in making their art. Someone taps tiny nails into a piece of wood. Another person wraps twine around and around a cardboard tube she has filled with buttons and shells. Several people draw. One person glues velvet material inside a box. No one talks. When everyone has finished working, we

gather in a circle again. The mood of the group seems to have changed. It feels more somber, as if the funereal reference has shifted them all into more solemn and reflective frames of mind. I ask if anyone wants to speak about his or her art piece, but am met with silence. We sit that way for a while, just being quiet. I am not sure what to do, though it seems like something needs to be done. I ask the group members what they think these artworks need. Paul mumbles in his gruff voice, "A proper burial." "Hmm," I reply. I pull down a box of fabric and begin rooting around in it while the other group members scatter to find and fashion resting places for their artworks. When we have all finished, we place them in a grouping and form a circle around them. Even now, this does not seem like enough. It seems like something else needs to be done. I think of our theme and know what is missing. I am not very confident in my singing voice, but I begin to hum quietly. After a few moments, another voice joins in and then another until we are a chorus of voices, singing over the bones we have lain to rest.

7. Tanya, an adolescent girl I am seeing in outpatient art therapy, completes a painting she has been working on for six sessions. It is a picture of a door slightly ajar, with a beam of light coming through. She tells me she feels good about how it turned out, but she is bothered that she does not understand its meaning. I ask her to give the painting a title. She thinks for a minute, and then says, "Hope Peeking Through." I suggest she write a story by that title that begins with, "Once upon a time…"

8. Today the women's group has decided they need to focus on the theme of "sensitive spots." Not surprisingly, these women, who have all experienced some sort of trauma during their lives, depict images that look too raw to touch. I tell them the room looks like it is full of wounds. They nod their heads in agreement. One woman says, "This is hard to look at. I am not sure I am ready to hear about so much pain." Other group members nod. They look at me as if to see what I will do with

all these wounds. I think of a time when I was young and stepped on a piece of glass. I tell them the story of what happened, of how I went to the hospital to get stitches, of how the wound got hot and full of puss a few days later, of how I had to go back to the doctor and have the wound re-opened and cleaned out. I said I did not remember much about how it felt to get stitches, but I still remembered how painful it was to have the wound re-opened. They begin to tell stories about their own or their children's experiences with cuts and stitches and broken bones. After listening for awhile, I remark, "We women sure know a lot about wounds, don't we?" They nod their heads, looking somewhat resigned to this dubious distinction. "But," I say, "this also means we know a lot about caring for wounds, doesn't it?" They look up at me and one woman says, "We sure do!" "Then," I suggest, "let's use that knowledge right now. Let's make something to care for the wounds in this room." I make a sweeping gesture that takes in the artworks we have made. One woman asks, "What do you mean? Make what? What do we use?" "I'm not sure," I say as I stand up and begin to look around the room, picking up a jar of paint, fingering a piece of fabric, shaking a box of beads, "but I think we'll be able to figure it out." I give her a small smile and remind her, "We women are resourceful too." Another woman jumps up and walks over to the first-aid kit hanging on the wall. With a mischievous grin she says, "Can we use what's in here?" I smile back at her, "Sure, why not!" Inside I think, sometimes healing is subversive. Sometimes it involves claiming what we've been told we cannot have. As I think this, I notice the room has suddenly come alive. The women no longer look fragile or resigned. They look strong as they go about claiming and fashioning what they need to care for their wounds.

9. I am doing an art therapy group on the adult inpatient unit of the hospital. The room feels hot and stuffy. I receive shoulder shrugs, sighs, and one-word answers in response to my question about what thoughts or feelings each person brings to the

session that day. They don't look at one another or talk to one another, and they can't seem to focus enough to come up with a common theme among them. I begin to feel as sluggish as they look. I can't think of a theme either. One woman, probably more out of anxiety than inspiration, breaks the silence and suggests we draw how we are feeling that day. For lack of any other ideas to work with, I affirm her suggestion. The clients respond lethargically and make quick, diagrammatic-looking sketches. When given a chance to talk about their images, they merely label them. "Depressed." "Hopeless." "Worthless." "Numb." Inside, I feel like I am sinking with them, becoming hopeless, depressed. I know we all need rescue and sense that something needs to happen at a body level. I stand up and pull a box of scissors out of the cupboard. Already, I feel a little better myself just getting up and moving. As I pass out the scissors, I tell them a little bit about collage as an art technique. I tell them that if they don't mind cutting out the images in their drawings we will use them in a group collage. I give them the option to cut out something from a magazine instead, if they don't want to cut up their drawings. All of them cut out what they have drawn, perhaps for no other reason than this takes less energy. I tear off a four-foot length of brown butcher paper and ask several of the group members to help me tape it to the wall. Once it is up, I ask each person to glue his or her cutout picture somewhere on the paper. Not surprisingly, the images are scattered and isolated on the page. "Let's stand back and look at it," I suggest. "What do you think it needs?" One man in the group is shaken from his lethargy by what he seems to perceive as my inane question. He rolls his eyes and says, "It needs a lot." "Like what?" I ask. "Well, it's just a bunch of pictures that look like some two-year-olds made them." He looks around apologetically, "Sorry if I'm offending anyone, but this is pretty lame." The smiles and quiet chuckles assure him that they are all in agreement. "But," I say, "you're talking about what's already there. You're saying there are some lame pictures that look like they were drawn by a two-year-old. So what does

this picture need? What's *not* there?" I look around at everyone. One woman timidly ventures a comment, "Some more color." Another person points out that it needs some background. "Here," I say, as I pull oil pastels and chalk, paint and magazines, scissors and glue out of the cupboards. "Let's give this picture color and a background." The pace of the work is slow and the marks are initially tentative. But the group members have to stand up and move in order to work on the picture. They either have to take turns or bump and nudge the person next to them. The finished artwork is not visually stunning and the group members still poke fun at their lack of artistic skills, but it is an image of interrelated parts that touch one another and share a mutual context.

10. Maria brings a drawing she has done at home to our individual art therapy session. "Here," she says as she hands it to me. "I can't talk about this." I take it from her hands and say it is okay not to talk about it. She quickly blurts, "But I *need* to let you hear about it. I've been holding it in too long!" The look in her eyes appears desperate. Momentarily, I feel stuck. Does she want me to encourage her to talk? Does she want me to respect her right to silence? Then I think again about what she has said. She said she can't talk about it, but she needs to let me hear about it. I turn to her and suggest we try to give the drawing a "voice" through sounds. I tell her she can make vocal sounds or find objects to use to make the sounds. I pick up a drawing I have made and demonstrate some of the sounds I "hear" in my own drawing. I tell her I am willing to be her assistant if there are sounds she would like me to help her make. She begins tentatively, and then becomes more daring and inventive. She decides to make not just isolated sounds, but a cohesive musical piece to tell the story of the picture. She experiments with different sounds and instructs me in what she wants me to do. She explains how quiet or loud, how fast or slow, and in what order the sounds are to come. In the end, we perform the piece together. It is simple and crude and hauntingly beautiful. I don't

know what the literal content of the story is about, but still I "hear" it. When the session comes to a close, she appears more relaxed. She smiles at me and says she feels relieved that she has finally been able to tell someone her story.

Universality, cultural context, and idiosyncratic expression

The arts are sometimes referred to as a universal language. Well meaning in intention, this type of pronouncement promotes artistic expression as a means of communication that easily crosses cultural barriers. Catteneo (1994) warns us to be cautious in making such statements and to examine critically what we mean by "universal" lest it be defined through the lens of the dominant culture. Though well intentioned, an emphasis on the universal nature of artistic expression runs the risk of denying real differences in culturally conditioned artistic styles and forms as well as culture-specific meanings for colors, symbols, or images. When sameness is emphasized, there is the potential for distortion, misunderstanding, and misrepresentation (Pinderhughes 1989). Lippard (1990) suggests that the immense challenge of authentically representing oneself and one's cultural identity without the support to do so can lead to apathy and a denial of difference. "Brainwashed by the notion that 'art speaks for itself' artists of all races have often been silenced, abdicating responsibility, doing little to resist the decontextualization of their works (and thus themselves)" (p.8). As art therapists, it is our responsibility to develop knowledge, awareness, and sensitivity in regard to the multicultural language of art so that we do not misunderstand or ignore the context for our clients' work, and thereby distort its meaning and significance. If art is to have the potential for providing an alternative language for clients who have experienced marginalization, then differences in its "linguistics" must be recognized and honored.

At the same time, there may be some kernel of truth to the statement that art is a universal language. Respecting and appreciating difference does not mean that commonalities and a sense of connectedness have to be denied. Perhaps art's shared meaning does not reside so much in common understandings of specific styles, forms, or symbols as it does in a common recognition of the human proclivity toward making art as a means of

expressing what can't be conveyed in any other way. Perhaps the universality resides in the behavior, not in the product of that behavior (Dissanayake 1988, 1992).

If there is a universal language of art, it is a base language that has many diverse and dissimilar dialects and contextual nuances. It would be conceivable (though not necessarily desirable) to have an art therapy group session in which each person spoke a different verbal language. Art offers some kind of common denominator in terms of shared meaning, even if it is only an appreciation of our frail human attempts at conveying meaning. At some level, we all seem to appreciate the ubiquitous and powerful nature of art, even while we may struggle to explain exactly what it is about art that connects us.

As art therapists, we serve our clients best when we are attentive to the various levels at which the language of art is communicated. An appreciation for both commonalities and differences in artistic expression is imperative. This appreciation comes from recognizing and valuing our own idiosyncratic and culturally influenced style and form, along with exposing ourselves to a wide range of artistic expressions different from our own. In regard to diversity, being multilingual means that we appreciate the universal quality of art as a mode of expression, are sensitive to the diverse cultural languages of the arts, and are respectful of the idiosyncratic nature of artistic expression as it is filtered through the lens of individual experience.

Professional integrity and the use of words

In spite of art therapists' recognition that it is extremely difficult, if not impossible, to convert the meaning of an artwork or the art process into words (Goodman *et al.* 1998; Tinnin 1990), verbal language is an integral part of the practice of art therapy. How and when and why we use words are – or ought to be – our everyday concerns as art therapists. Language is a powerful social instrument that not only reflects but also shapes experience. Using words with care and intention comes from recognition of the potential for harm as well as for good that can come from the ways we use language.

Arnheim (in M. B. Franklin 1994) distinguishes three modes of language usage that reflect differing orientations: practical or pragmatic, scientific or purely conceptual, and poetic. Practical or pragmatic language is used to navigate the ordinary responsibilities and events of our everyday lives. Scientific or conceptual language is used to categorize, label, and organize abstract ideas and contributes to developing theory. Poetic use of language emphasizes the "sensuous tangibility of words" (p.263) whereby words embody or are fused with their meanings. Art therapists employ all three modes of language in their work and each serves an important function. My emphasis here, however, is on the poetic use of language in art therapy. As with other areas of enquiry in this book, my interest is in cultivating an understanding of the unique contributions we make to the helping professions from our positions as artists.

Since words are the common medium through which information and ideas are exchanged, we use them in all aspects of our professional lives. We use them in our interactions with clients; in such descriptions and discussions of therapy sessions as occur through written documentation, supervision, and treatment team meetings; and in our presentation of art therapy to the outside world through presentations and published writings. In all of these areas, the words we use will have an impact on both reflecting and shaping art therapy as we know it.

Words and our work with clients

Ann tapes a large sheet of butcher paper to the wall and immediately begins to work on a drawing. She uses soft pastels that make dense, intense color on her paper. She has been in the group for weeks now and no matter what theme the group members choose, her imagery is similar each time. Swirling vortices of color fill her paper. By the time she has finished there is a coating of dust over her arms and on the floor below her drawing. When we take time to reflect on what we have drawn, Ann attempts to put words to her image. Inevitably though, she cannot find the words. She apologizes to the group members, as if she is not doing her part in the group. But they do not seem to take offense. No one seems to doubt that Ann would put

words to her images if she could. They don't seem to view her behavior as rebellious or withholding, and no one even tries, out of impatience or anxiety, to speak for her. They just reassure her with small words and nods of their heads.

Today, there is something new in her drawing. It is an arrow, black and pointy with sharply drawn lines up and down its shaft, perhaps indicating feathers. Something about the way it is drawn gives it a sense of animation, as if it is moving or is about to take flight. I can't pinpoint why I feel this way, but the presence of the arrow disturbs me. I look at Ann and think I detect fear and confusion in her eyes, the way an animal looks when it is suddenly caught in the headlights of an oncoming car and does not know what to do. But then, I am not certain. The look is so subtle.

I want to help her understand her image, to be her guide. I try to say words that will invite her to engage imaginatively with the picture she has drawn. "I wonder what it would be like to enter this picture, as if it were a landscape a person could walk right into. I wonder what it would feel like underfoot, what it would sound like, how it would look up close."

Ann turns back toward her drawing and looks at it intently, but after a few moments she turns back around with a helpless look on her face. She shrugs her shoulders and says, "I... I can't."

"You look like this is really hard for you," I say. She nods her head. "But I'm not sure why. You don't seem to know much about these pictures you draw." I gesture toward her image. "I don't even know if this would seem like a good place or a not-so-good place for you to enter."

Ann sighs and says to me, "I think it's a not-so-good place, but I don't know why I think that."

"If you don't mind, I would like to try to get a sense of how close it would be safe for me to get. If it's okay with you, I'll just move my hand in slowly toward your drawing and you can tell me when I should stop." I look to her for permission.

"Okay," she says and she watches my hand as I slowly move it along the wall, beginning from about three feet away. My fingers are pointed toward her picture and I check in with her as I move my

hand, periodically making sure she is still all right with my proximity. When I notice her hands clench, I halt my progress and ask her if I should stop or keep going. "Stop," she says. My fingertips are a foot from the edge of her paper.

I notice her hands are still clenched and the muscles in her jaw look tight. I say, "I wonder if I should even back up a little. I wonder if I'm still a little too close." She tells me it would be better if I backed up a little. When I do, she visibly relaxes.

"Okay, I'm stopping here. I won't go any closer." I want to reassure her, let her know that I am respecting her boundaries. When I say it to her, I know it is a message delivered to the other group members as well.

She smiles sadly when she looks at me. She still appears confused and afraid. "I wish I could tell you more, but I – I – I don't know why I didn't want you to get any closer."

"It's okay, Ann. It's seems like right now your picture needs lots of breathing space around it, and it isn't ready for many words yet. That's something that seems clear right now."

"Yes," she says, as if she is surprised that anything could be clear. "Yes."

The use of words in our work with clients is delicate business. Words have the potential to aid in moving art toward its full expression and disclosing its full meaning, if the words used are sympathetic to the language of particular artwork. However, words also have the power to contain, constrain, or even silence the emerging meaning in an artwork. The choice of words used, the tone and voice inflection, the timing of when something is said, the quantity of words used, and the understanding of when silence is a better option, all contribute to a skilled and sensitive use of words in art therapy practice.

There is always interplay between words and images in art therapy and it is difficult to find the "just right" relationship between the two. In some situations, the resolution of the pull between words and images is satisfied by working from an open studio model, where the emphasis is on art making in recognition of the fact that words can sometimes be too confrontational (McGraw 1995, p.168). During art making, a therapist's

speech can have an intrusive, disruptive effect and silence may be the better alternative for enhancing the client's immersion in the art process (Clarkson and Geller 1996, p.316). An emphasis on art as the primary language in art therapy may also arise from a recognition of the potential it has as an "alternate" language, one not as systematically entrenched in power differentials as is verbal language. As Jones (1997) points out, art's strength may lie in its "otherness." Allowing the image to speak for itself reduces the possibility that the artist will be "spoken over" (p.75). For some clients, however, the opportunity to deepen understanding of their images through words is a significant aspect of what they experience as helpful in art therapy.

Given how integral the spoken word is to the practice of art therapy, the subject of how we use language in art therapy practice has received comparatively little attention in the literature. When the subject has been addressed, it has sometimes been approached from perspectives common to all forms of therapy, such as developing verbal counseling skills (Andrus 1990), engaging in question–answer dialogues with clients (Bloomgarden 2000), and critically examining bias and language usage in regard to power in the therapeutic relationship (Joyce 1997; Spaniol and Catteneo 1994).

Art therapy techniques that offer guidelines for helping clients to identify and name the meanings of their own artworks through a phenomenological approach have made significant contributions to our field (Betensky 1987; Nucho 1987). These approaches have provided us with highly structured ways to respectfully engage with clients' images without imposing our own interpretations. They thus form a solid basis for further developments in practice. The profession seems to be moving toward a respect for clients' rights as meaning makers and away from interpretive methods that intrude on this right (Betensky 1995; Cheney 1993; Goodman et al. 1998). Maintaining this respectful attitude is critical, even as we approach language from a less structured, more imaginative perspective.

There are indications of dissatisfaction with the language we have inherited from the medical and psychiatric professions. The process of identifying and developing a language indigenous to art therapy begins, of necessity, with questions that challenge the bias inherent in the language of the dominant culture. Spaniol and Catteneo (1994) encourage us to

examine our language usage not only for evidence of bias in the common discourse of the medical model, but also for assumptions we may have inherited from the common discourse of the art world, where what is considered normative is based on Eurocentric standards. They recognize the need for an alternative language, one that embraces imagination as a core component of empathy, honors the authority of clients' experiences, and gives credibility to the accuracy and specificity of poetic language.

Some art therapists have offered theoretical or practical models for developing an art therapy language that is congruent with the artistic base of our knowledge and skills. Knill's (1994) practice of intermodal expressive therapy is based on crystallization theory that "finds interpretation and meaning phenomenologically, through artistic differentiation in a poiesis indigenous to art – that is, in words that are imaginative, particular and precise" (p.322). This theory is built on the assumption that meaning making occurs within the context of relationships. The task of the art therapist is to assist the client in nurturing the "seeds" of artistic expression toward full fruition. Knill believes this is possible only through engaging with artwork in its own language, a poetic language.

Wix (1995, 1997) advocates for art therapy practice in which art remains the focus and core of the verbal exchange through "therapist and patient listening for metaphors and stories in and around the image" (1995, p.176). This use of words is distinguished from using art as a tool, where the focus is on problems and the discussion departs from the image. Wix employs an archetypal approach to working with images, attempting to use a poetic, descriptive language and engaging clients in the same. She acknowledges that the most challenging aspect of this approach occurs not in post-session reflection but in thinking and speaking poetically within the context of the therapy session (Wix 1997).

Thomson (1997), in viewing dialogue with the unconscious as what is valued in art therapy, suggests that words ought to resonate with the original interaction that occurred between artist and artwork. She believes such a use of words "does not overvalue the picture but values, rather, the life that has brought it into being and which is mirrored therein" (p.103).

Riley (Riley and Malchiodi 1994), influenced by ideas from narrative therapy, has also addressed the use of language in art therapy practice. She emphasizes the need to adapt our language to the artistic style of the client,

according to whether the art expression is more symbolic or more pragmatic in nature. Speaking in the stylistic language of clients requires making use of their visual metaphors, providing the therapist with "a dictionary that mirrors their unique way of perceiving the world and understanding events" (p.49).

These models suggest ways of using words in art therapy that are specific to the unique character of an art-based approach to therapy. The task of the art therapist is to use a poetic language responsive to the verbal and visual metaphors of the client, with the intention of supporting and encouraging the emergence of form and meaning intrinsic to the client's artistic expression. The very quality and character of this manner of using words makes it difficult to convey adequately how this type of language usage manifests in practice. There is no blueprint for the therapeutic encounter when it is approached imaginatively and when an attempt is made to respond poetically to the metaphoric language of the client. However, there are some guidelines that might be of help in developing these skills.

1. Devote time outside the therapeutic session to developing facility with poetic language. Practicing creative writing, especially creative non-fiction or poetry about our work with clients, is a way of "exercising" our poetic imaginations. Reading other people's poetry is helpful as well, particularly when read out loud. Reading aloud enables us to become attuned not just to the literal meaning of words but also to the poet's meaning as conveyed through nuances of sound. The more comfortable and skilled we become using poetic language *outside* of sessions, the more at ease and articulate we are likely to be when we use it *in* sessions.

2. If you give directives to clients, try to present them in metaphoric terms. This fosters an imaginative encounter with art making and will tend to facilitate a more poetic use of words in response to the artwork. For example, rather than saying, "Draw a picture about a problem you are having and what you can do to resolve it," try to present the same concept through metaphor. You might say, "Imagine you are walking down a path through a

dense, thorny wood. You come across an obstacle in your path. How do you get past it?" Or you might leave the directive more open by giving a theme such as "Obstacles and Openings." Stories and poems are other sources for presenting a theme metaphorically. A selected excerpt or story or poem can be read or it can be read as a way to inspire art making.

3. Make use of the clients' metaphors as much as possible, both in guiding their artistic process and in guiding their exploration of the art product. Hoffman (as quoted in Riley 1997) states that "the reason for using metaphor is...because metaphor hardly ever implies that people are doing something wrong. Advice or problem solving almost always does" (p.283). For example, a family tells you in great detail how they have been going through all the closets in their house, trying to impose some order. They express frustration about not having enough room in their tiny apartment; they tell you about the arguments over what will be saved and what will be discarded. This story is rich in metaphoric themes that have great potential for artistic and therapeutic exploration. The elements of their story – boxes, containers, doors, and an assortment of objects – can become the elements of their artwork. The action in their story – sorting, imposing order, saving, discarding – can become the actions in their artwork. The themes in their story – exploring what's been hidden or is out of sight, bringing things out in the open, holding on and letting go, finding a "good fit" for everyone – can become the themes explored in therapy. Thus, they might be guided in art making that uses these elements and actions to address the themes of their story. For example, they might work together to create an assemblage of found objects inside a box. Through the process of exploring, examining, deciding what is to be included or not included, imposing order, and arranging objects they become actively engaged in the here-and-now with the metaphors of their own story. As they talk about what they are doing, it is important to listen for the particular words they use to describe their experiences and to

adopt these words as the language by which to help them deepen understanding.

4. When you do engage with a client around an image, try to avoid asking questions. While some queries may be necessary, questions are not the best way to invite imaginative dialogue in response to an artwork (B. Moon 1994). Think instead of making poetic commentary that invites the client to participate with the artwork in deepening relationship or amplifying meaning. Statements beginning with "I wonder…" or comments making note of an aspect of the artwork that stirs curiosity in you are ways to indicate interest in hearing more, without presenting it as a demand for information. Honest comments about the effect an artwork has on you may facilitate the client's own honest commentary. Statements about the literal qualities of the artwork, such as, "I notice that the tree's roots are cut off at the bottom of the page," may elicit elaboration by the client if presented not as analysis but as statements of wonder, curiosity, or interest. Simple descriptive words or phrases uttered in authentic response to the image may also inspire the client's imaginative engagement with the artwork. Open-ended statements that invite clients' imaginative responses are another way to help clients deepen their relationships with their artworks. Clients can also be encouraged to tell a story or spontaneous poem about their artwork. Though asking questions may seem like the most expedient means to gain understanding of artworks, questions can be experienced by clients as intrusive rather than inviting. It makes sense to develop other ways of using words, ways that are more compatible with an invitation to explore creatively and deepen relationships with artworks.

5. When doing group work, it is important to establish norms and to set the desired tone for how clients give and receive verbal commentary to each other. I have found it helpful to tell clients that responding to someone else's artwork is like allowing that person to borrow their eyes for a while, to see the artwork

through another pair of eyes. This reinforces the idea that there are many different ways of perceiving a piece of art. I also encourage clients to think of feedback like they would think of clothes someone has loaned them. When they "try on" comments from another group member, the words may feel like a good fit, that is, feel right at a physical and emotional level. In other instances the fit of the words may be all wrong, like clothes that are too constricting, too roomy, or not their style. I encourage them to take the time to "try on" the words though, to get a feel for them, rather than to reject them outright. I model these behaviors as well. I try to convey that my way of viewing an artwork is just one perspective among many in the group. Together, our vision is stronger, richer. When someone gives me feedback about one of my artworks, I try to consider it honestly and to let them know I am doing so, whether or not I particularly like the perspective it affords me.

6. Pay attention not only to the words you use, but how you deliver them. Tone of voice, volume level, consistency between words and facial expression or body language, pace of speech, vocal rhythm, use of silence, and timing are all important aspects of how words are conveyed and received. These qualities and characteristics are important elements of poetic speech, as is evident when we listen to someone recite poetry, read a story, or speak the part of a character in a dramatic enactment. If we use poetic language in our work, then it is important to develop an appreciation for the effective delivery of words. This "effective delivery" comes from developing the subtleties of our vocal expressive capabilities. It also comes from our learning to "speak from our hearts," that is, to speak from a position of authenticity and sincerity.

Using words to communicate with colleagues

It is late afternoon. The clients have all gone home for the day. I sit at the conference table in the sunny day room along with the other staff

members. We are discussing Ann and her treatment progress. I think of the swirling vortices of color in her drawings, of the difficulty she has with saying anything about them. I think of how her images have been evolving over time.

I fidget in my chair as I listen to everyone talk about how well she is doing. Ann is easy to like. She is pleasant and cooperative; she takes an active part in the community and is supportive of other clients. It is not that I disagree with my colleagues and their assessment of Ann's progress. It's that I think there is something missing in what they say. I'm not sure they will want to hear about this missing part. We are all weary here, from the trauma stories the clients tell, brain chemistry that won't respond to medications, cuts and burns that appear on forearms, the never-ending litany of suicidal thoughts shared, the clients who are discharged only to return in a month, two months. So Ann is a bright spot in our midst. In some ways, she is doing well.

I know I need to speak up. I cough to clear my throat. "I'd like to talk about what Ann is doing in the art therapy group. I see a different side of her in there and I'm concerned that she may be heading into some rough times ahead."

The other staff members turn to look at me. Roger, a social worker, jokes with me. "So now you can predict the future through art, huh Cathy?" We all laugh uneasily. I don't think any of us wants to hear what I am going to say, including me.

"No, no crystal ball, just some drawings that are starting to change. I've told you before how immersed she seems to become in her drawings while she's doing them. It's like the swirling colors are a part of her that pours out onto the paper. And then, when we take time at the end of the group to reflect on the artwork, she is nearly mute. She can't find any words to put to them. It's not like she can't find the right words; it's more like there are no words."

Bobbi, the program coordinator interrupts. "So it sounds like she is using the group as a non-verbal outlet. Isn't that what it's for? Why are you concerned?" I know Bobbi is warning me to get to the point. She is our timekeeper and we have a lot of clients to discuss. I collect my thoughts for a moment, trying to think how I can convey what I have seen and what I have experienced being in the group with Ann.

"I don't have any problem with how Ann is using the group. She works hard in there. But her imagery is slowly shifting. It's like a drama unfolding on paper, and I don't think it's going to be a very pleasant story. As I've told you before, for weeks she has been filling her paper with vivid, swirling colors that fill the page and create vortex-like forms. That imagery has seemed intense, but not threatening. In the past two weeks this same kind of imagery has been appearing, but with new characters added."

"What do you mean, Cathy," interjects Roger, "when you say the imagery has been 'appearing'? It almost sounds like she's not the one in charge of making the drawings. Sounds a little spooky."

"No," I reassure him, "it's not spooky. But it does seem like her imagery is coming from a part of herself of which she has no conscious awareness. A lot of people in the group think about and plan their artwork. For Ann, I think it just comes. In the past two weeks, what has been coming – along with the intense, swirling colors – are arrows and splatters of red that look like blood. First the arrows appeared as random objects. Then she began to draw them as if they were piercing the swirling background and made red marks around the points of the arrows. The red reminded me of blood, but I wasn't sure what significance it had for her since she couldn't put words to it. But today there was a new character in the drawing. It was a baby drawn at the center of the swirling colors, with an arrow piercing it and red splatters of color coming from the pierced place. Like I said, I'm not sure what story is emerging here, but I don't think it is a pleasant one."

"Just to play the devil's advocate here," said Bobbi, "what if Ann is getting scared and she's drawing this disturbing imagery to let us know that she's not ready to leave treatment? Or what if this is her way of expressing the anger she is not so good at expressing directly? Maybe she is angry that she's getting better."

I wish I had Ann's drawings with me, but she always rolls them up and takes them with her after the session is over. But even if I had them, I know they would not convey the whole story. "It's... I...oh, I don't know how to tell you what I need to say!" I throw my hands up in exasperation. I take a deep breath and try again. "Bobbi, I can't

tell you exactly what Ann's pictures mean. She can't even begin to say what they mean. But I can tell you what it feels like inside me when I am with her in that room. I see her pressing the chalk so hard on the paper that a cloud of dust forms around her. She works…furiously! Like some kind of gate is tripped open inside her and she is set free. So I feel a sense of relief for her but I'm also uneasy because I don't know what's getting cut loose. And then, when she is finished and she turns around I see something else on her face. She looks like something has worked its way out of her and she is fatigued, maybe somewhat relieved…but I also see what looks like terror on her face. Maybe terror is too strong a word because it's not the kind of look that comes when people are faced with a monster, or an impending car crash, or something else that is immediately terrifying. It's more vague than that, like the kind of terror that comes when people sense something bad is about to happen but they have no idea what it is or when it will come. I look at her and my stomach churns with anxiety. I am afraid for her. And I can't tell you why."

I stop talking and the room is unusually quiet. I realize that my voice became more intense as I talked. I didn't maintain the usual cool, professional tone reserved for occasions like this. I wonder what the other staff members are thinking. Do they think I've become a little too emotionally involved with Ann? Do they think I'm getting a little too weird and "out there" with my art therapy group? I'm not sure that I really said what I needed to say either. I didn't want to give them the idea that I could tell what Ann's drawings meant to her. I was just trying to tell them how I experienced her and her artwork. I have my doubts about the adequacy of my words, but I also am breathing clear and easy. I know I told the truth of my experience as best I could. I didn't couch what I had to say in psychiatric jargon to impress them and I didn't pretend to be able to interpret the meaning of Ann's drawings. I just told them what I saw, what I felt, what it was like to be there.

Hillman (1972) advocates that those who deal with the psyche employ speech "that leads to participation…in and with the thing spoken of, a speech of stories and insights which evoke, in the other who listens, new

stories and new insights, the way one poem and one tune ignite another verse and another song" (p.206). His concern for the language of psychotherapy is that it has come to be viewed with mistrust, an outcome of our societal distrust of words. He calls for a restoration of words to their function as emissaries or message-bearers (Hillman 1975, p.9). When we report to colleagues at our workplaces about what has occurred in art therapy sessions – whether that is through written documentation, casual conversation, or formal meetings – it is our responsibility to evoke, through word pictures, a representation of that experience that is as accurate as possible.

In order to "lead our colleagues to participation," we have to engage them in words not only at an intellectual level but also at an emotional and empathic level. The characteristic idiom of professional healthcare, rife as it is with jargon, has a tendency to distance us from experience rather than lead us to participate in it. It is perhaps even more dissonant in relation to describing our experiences in the arts therapies than in other healthcare professions, due to the poetic, dynamic basis of the work we do. Language that has the potential to convey more accurately the experience of art therapy is that developed from a poetic basis. However, the pressure to conform to the acceptable language of the work setting or institution can make the use of poetic language awkward and uncomfortable. The question becomes, then, how do we remain fluent in the terminology of the dominant culture within our workplaces without sacrificing our own language in the process?

I have suggested that the ability to effectively "art-iculate" the nature of our work comes from a firm grounding in our identities as arts therapists, an ongoing commitment continually to deepening our understanding of the work we do, and a willingness to sound foolish at times (C. Moon 1997a). The experience of feeling a little foolish is a natural outgrowth of trying to speak in a language not yet fully developed or mastered. Stumbling over words from time to time, having difficulty finding the "right words" to convey an experience, feeling awkward, fearing being perceived as unprofessional or lacking in knowledge, all are natural outgrowths of speaking in a new language, particularly one that does not conform to that of the dominant culture. Why then, it might be asked, bother to develop a language more consistent with art therapy experience? Some might argue

for the importance of speaking the language of those in power in order to gain or maintain respect and credibility for art therapy. There are those who understand the need for a poetic, dynamic language in the context of art therapy sessions, but who question the usefulness of this language in our discourse with other professionals.

There are at least three reasons to develop a language for talking about art therapy practice that is congruent with the nature of that practice. First, naming our own experiences is a critical aspect of our developing identity as a profession. Succumbing to pressure to speak the acceptable language of the dominant discourse in healthcare does not ensure respect and credibility for art therapy but instead ensures a subservient position. "Naming is the active tense of identity, the outward aspect of the self-representation process, acknowledging all the circumstances through which it must elbow its way" (Lippard 1990, p.19). When we name what it is that we do, in our own words, with our own emphasis, from our own perspective, we are claiming our right to exist. This is a political act (Aldridge 1993; Aldridge, Brandt and Wohler 1990). Since language not only reflects but also shapes experience, how we use language will not only shape how others view us but also how we perceive ourselves and how we practice our profession.

Second, reporting art therapy practice in a language congruent with that practice is important because we are accountable to represent accurately the clients we serve. It is our responsibility to portray them and their experiences of art therapy in a language that is respectful, empathic, and as accurate as possible. While we may be concerned about how we are viewed by colleagues if our language usage is not polished and refined, we should be equally concerned about speaking in slick, jargon-filled "therapese." A little uncertainty, a little humility, is called for as we attempt to articulate our clients' experiences of art therapy. "In any discussion utilizing a language system where assumptions are made about others which may be distinct from the way those individuals see themselves, these assumptions require ongoing consideration" (Wiener 1998, p.168). Questioning, wondering, challenging, rethinking, attempting, adjusting, and trying again are all healthy activities of ongoing language development.

Third, developing a congruent language for reporting art therapy experiences is important because the pathology-oriented and paternalistic nature of healthcare linguistics is in need of a humanizing influence. The

arts have the potential to offer such an influence. A language based in poetics is not satisfied with jargon or rhetoric. An artistic language seeks expression that is specific and evocative. Its reliance on metaphor as the conduit for meaning fosters an appreciation for the potential of multiple levels of meaning and truth, a healthy perspective for attempting to understand human beings, and one that provides a counter-balance for the reductive tendencies of the medical model. A poetic-based language engages not only our intellect but our aesthetic sensibilities as well, calling forth our capacities for understanding based at an empathic, experiential level. Poetic language draws the listener in, inviting empathic participation in that which is being described, and inviting authentic response. These qualities of poetic language offer potential antidotes for the problematic characteristics of the dominant discourse in medical and mental health, and a balancing effect for the medical model's detached, diagnostic language for interpreting human behavior.

Developing a congruent language to describe art therapy is not a feat but an ongoing process. It involves raising conscious awareness about language usage and its effects, and then trying out some new, alternate ways of speaking that are more consistent with the experience of art therapy. The following are some suggestions for entering into this process of developing a language true to art therapy.

1. Take advantage of opportunities to be exposed to poetic language. Take "poetry breaks" at work, read a few pages of a novel before you fall asleep at night, treat yourself to attending a play, jot down words or phrases you hear that catch your interest, listen to the way certain words sound together and say them quietly to yourself just for the pure pleasure of it. In short, try to allow these poetic musings into the nooks and crannies of your life, as the opportunity presents. If you do this you will come to experience first hand a love for the way words sound when they are put together, an appreciation for the turn of a phrase that invites you to see in a new way, the power of word pictures to evoke experience, and the way a few words can get at the heart of a matter. The limitations of a language based on linear, logical constructs become apparent as an appreciation for

poetic language is developed. At the same time, recognition of the legitimacy and value of poetic language is fostered.

2. Be well versed in the common, acceptable language of your workplace. You can make accurate judgments about the strengths and problematic characteristics of a language system only if you are familiar with it. You can be instrumental in introducing alternative or complementary ways of speaking or writing only if you are able to first find a common language with which to communicate.

3. Once you are well versed with the common language of your workplace, begin to question it. Ask yourself if the words you are asked to use, the reports you are asked to give, and the forms you are asked to fill out accurately reflect and positively shape art therapy experience. For example, Kramer (1996) questions the requirement to state treatment goals when therapy just begins, citing this as antithetical to the flexible, inventive, open to the unexpected, inner-directed characteristics of the creative process. The same kind of questioning can occur in relation to everything from the format for written assessments to the casual remarks made about clients by staff.

4. When attempting to risk the use of a more descriptive, poetic, humane language in a context where it is viewed as outside the norm, start small. Try just an occasional descriptive word, phrase, or sentence that deviates from the acceptable language of the work environment. Gradually introduce a more developed poetic language. The idea here is not to dazzle, shame, or intimidate our colleagues in the helping professions with our creatively proficient use of words, but to introduce a language for speaking about clients and their art that is humane, accurate, empathic, and true to the nature of what occurs in art therapy.

5. When possible, use the clients' own words to describe their experiences in art therapy. Spaniol and Cattaneo (1994) suggest considering clients as potential consultants for corroborating or correcting written reports (p.269).

6. Be humble about the limitations of language – even poetic
 language – to authentically convey experience. When you have
 clients' permission to show their work to other staff in the work
 setting, don't forget to leave a few moments of silent reflection
 so the artwork can "speak for itself." When you do use words to
 describe artwork or what happened in sessions, be clear in
 presenting it accurately as an observation, a hunch, an
 interpretive guess, a personal reaction, or a rephrasing of
 something a client has said. Be aware that the pronouncements
 of specialists are often heard by others as "fact." Make the
 context of your statements clear.

7. As often as possible, try to describe what occurs in a session
 rather than interpret it through a theoretical perspective foreign
 to the arts. Descriptive words tend to remain more closely
 connected to the actual experiences of the therapeutic session
 than do labels or theoretical concepts that serve as a shorthand
 for communicating about clients. Aldridge, Brandt, and Wohler
 (1990) identify two levels of reporting about arts therapy
 sessions. The first level, description, involves using the terms of
 our artistic disciplines to describe what happens in a way that is
 relatively objective and verifiable. The second level,
 interpretation, involves explaining what happens according to
 another system (for example, academic psychology) or in
 relation to the process of healing. Description is one step
 removed from the actual experience, while interpretation is
 several steps removed (pp.193–4).

8. Remember to rely on other arts therapists or sympathetic
 colleagues in attempting to develop a language that accurately
 represents your experiences as an art therapist. We can help each
 other become clearer and clearer.

9. Remember it is not our job to speak *for* clients or their artworks
 but to attempt to be conduits for them, allowing them to speak
 through us.

Public presentations and published writings

It is a year after Ann has been discharged from the day treatment program. I am sorting through my mail at work and find a postcard from her among the memos, forms, and art supply catalogs. I smile. It is always good to hear from her. I think back over the time I have known her. The images she drew in art therapy eventually led the way to memories of childhood abuse, which she put into words mostly in individual therapy sessions with her psychiatrist. Since leaving the day treatment program, she has continued in individual outpatient therapy and periodically drops by or writes a note to let me and the other staff members know how she is doing. Thankfully, she is doing well. The last I heard from her she had a part-time job, was doing some volunteer work, and was involved in an intimate relationship that she felt very positive about.

This time her note says she was excited to see my painting at the fine arts exhibit at the state fair. She is referring to a painting titled *We Can't Have Any More Babies* (Figure 9.1). She writes about the positive effect it had on her to see how I use my art to deal with my life. I don't know if she is referring only to this painting or also to the many artworks she saw me make during the time she was in treatment at the hospital.

Figure 9.1

Her words are so simple, yet they inspire in me a new way of viewing my participation in public exhibits of my artwork. I begin to see exhibiting my art as an extension of the work I do in the studio setting with clients. In both the studio and the gallery, art, as my friend Michael Franklin has said, "is a fine antidote to this insanity" of living. Art gives me a place of release, provokes me when I need a little provoking, and soothes me when I've had enough. I know that my work sometimes inspires clients to find release, provokes responses in them, or soothes them as well. I consider this an important aspect of my work as an art therapist, to be a participant guide. What Ann's note makes me realize is that it is possible for me to be a participant guide in the community that exists outside the therapy setting as well. My role as a therapist does not stop at the edge of the hospital grounds.

This same idea – about being a participant guide – sneaks into the way I view public presentations and lectures. Six years after Ann is discharged I do a performance art piece for the American Art Therapy Association national conference. It is a spoken word piece titled *Making Art from the Bits and Pieces of Lives Discarded*. I weave together text about recycling, found object art, my friend Deb's death, my work with clients, and the idea of reclaiming our lives from whatever has been handed to us. I don't give Ann credit for inspiring this piece, but she deserves some credit. She helped me to understand the interplay between word and image, between client and therapist, between public and private. I now understand there are no immutable borders to this work I do, only boundaries that bind together at the same time they make distinct. As I write this book, Ann's postcard sits on the desktop beside me. It is a reminder to me that even the writing of this text is but one more facet of the work I do as an art therapist.

Public presentations and published writings about art therapy not only are a way to present our profession to the community-at-large but also are an opportunity to extend the effects of our work as art therapists. Since language not only reflects but also shapes experience, we have an obligation to be thoughtful and responsible in how we use words to convey

the theory and practice of art therapy. When we speak publicly or publish our writings, we represent our own individual thoughts, experiences, and beliefs and we also serve as representatives of the art therapy profession. In addition, we represent the experiences of our clients, who have far fewer opportunities to speak for themselves through public forums or published literature. Furthermore, the content of our presentations, concerned as it often is with the use of art as a means of emotional, psychological, and spiritual healing, has the potential to significantly and profoundly affect members of our audience. Through our presentations and writings we have the potential to influence people's perceptions of persons who are mentally ill, physically disabled, or medically compromised, and we have the potential to affect the general public's understanding of the role of art relative to health, healing, and recovery.

Just as we need to attend to our use of words in our work settings, it is important to develop a language for public speaking or published writings about art therapy that is congruent with the nature of art therapy practice. When public modes of communication are used, words have the potential for increased levels of power and influence. The words we use and the words we leave out have wide implications for how we are perceived, how we view ourselves, and how we practice our profession. When we choose to use words that do not simply conform to the dominant language but are authentic to our own experiences, our writings and presentations become political acts. We "are modeling behavior and demonstrating values with which others may identify" (Sandel 1987, p.112). We begin to shape ourselves from the inside out, to influence as well as to be influenced by the social context around us.

This increased visibility demands increased responsibility. Our goal is to be "accurate in our message and precise in our language" (Gantt *et al.* 1997, p.48). At the same time, we can't afford to be too cautious or con-stricted in our use of language. As feminist scholars have helped us under-stand, it is no easy task to accurately articulate experience. Our current language may be inadequate to the task (Surrey 1991). The "accuracy" and "precision" of our words may only come about as the result of a good bit of trial and error, a good bit of fumbling around in the dark.

As we address a wider audience, as we attempt to name and describe who we are and what we do, it is imperative that we challenge the

limitations of male-dominated, linear, scientific paradigms of scholarship, research, and professional identity (Burt 1996; C. Moon 2000; Talbott-Green 1989; Wadeson 1989). As I have suggested elsewhere (C. Moon 2000), "a feminist aesthetic paradigm of professionalism values such qualities as flexibility, creativity, inclusion, openness to interdisciplinary pursuits, being in relationship, engagement with ordinary daily life, emotionality, and artistic sensibilities" (p.9). If these qualities are to be embraced as essential to our identities, they must find their way into our writings and oral presentations. Accurate and precise communications in art therapy may sometimes become manifest in a story rather than a clinical vignette, in personal revelation rather than detached analysis, in description rather than diagnosis, in a poem about a client rather than a case study. These alternate manifestations of professional language can function as mirrors to reflect back, affirm, and legitimize the validity of our experiences as art therapists.

Conclusions

In attempting to develop a language consistent with our practice as art therapists, we are challenged on many levels. In effect, we need to be multilingual, conversant if not fluent in the many "languages" our work demands of us. These languages include truth and fiction; the language of art and the language of therapy; words and enactments; and expression that ranges from universal to culture specific to idiosyncratic. In spite of our deep respect for, and faith in, the value of nonverbal expression through art, we must also frequently relate through words. In our work with clients, our communications with colleagues, our public presentations, and our published writings we do art therapy justice when we seek to speak in a language sympathetic to its basis in the arts.

The task of negotiating the many modes of communication we encounter in art therapy and developing a verbal language consistent with our experiences is no easy task. In this endeavor, I take inspiration from my son. When he was seven or eight years old, I found these words he had scrawled in a notebook: "to write with her toes and then write sloppy with her hands." I have no idea why he wrote them or what they meant to him. But they serve to remind me that finding an accurate and acceptable language sometimes requires us to take what we have always known and

apply it in a totally new, unconventional way. His words help me to remember that play, experimentation, and having a sense of humor are important aspects of any attempt to authentically translate art therapy experiences into effective communication.

Art Therapy and Social Responsibility

Let's start whispering into the ear of the public: The art that's best for you – now and in the future – is not a commodity but an inspiration (Kuryluk 1994, p.19)

"So, what is this supposed to be about? I don't get it," says Joseph. Seven pairs of eyes turn in my direction. We are sitting around an old, Formica-topped table in the back room of the community art gallery. We have come here to work on the schedule of exhibitions for the coming year.

I wonder if Joseph really doesn't "get it" or if his question is a challenge to me because he does not like what I am doing. I respond as if the former is true, that he really doesn't understand. "I'm working with people from the Diversity Coalition, the African American Arts Alliance, and the United Cultures Community Council. The focus of the exhibition is 'diversity.' In the spirit of the theme, we're thinking in an inclusive way about what might be considered art – not just so-called fine arts, but also woodworking, needlecrafts, traditional folk arts and other handicrafts. We want to reach beyond the typical gallery artists and audience. We want to include work done by people who might not even consider themselves artists."

Joseph's head snaps up. His long, black ponytail swings around and his dark eyes shine with a piercing intensity. He asks aggressively, "So I can't be part of this?" I look back at him, trying to gauge whether he is serious or just trying to stir things up. I'm not sure.

Doug, one of the other committee members, jokes, "Sure you can! You're ethnic!" Rob laughs along with him. I feel a wave of exasperation come over me. They are kidding around with Joseph about being a native of Portugal. But the humor has a serious side to it as well. The joke effectively situates Joseph in the position of the "other" while Doug and Rob, two white men, remain in the center, the norm against which "diversity" is defined. They are good friends with Joseph and I know they are not intending to be mean. Their humor likely belies their discomfort with the whole theme. I am exasperated because I expect more from this community of artists. I expect more awareness, sensitivity, openness, and understanding. Inside myself, I sigh deep and long.

Then I attempt an answer. "We are all ethnic," I say quietly but deliberately. I notice Mimi, a native of France, nodding her head in agreement. I direct my attention to Joseph. "Yes, Joseph, you are welcome to submit art to this exhibition. Our idea is not to exclude anyone but to be as inclusive as possible. We want to be welcoming of everyone, including people who would not ordinarily even come into an art gallery. Does that make sense?"

"Not really," Joseph replies. But he shrugs his shoulders as if in resignation. The discussion moves on to other topics. It is a meeting and we have much we need to accomplish.

On the way home I think about what happened. I suspect Joseph's question and Doug's joke only hint at the deeper issues aroused by the exhibition. In addition to questions about who will be included, I am pretty sure there are also unspoken questions about what will be included. For a nonprofit, community arts organization that has struggled to be taken seriously by the artists' community, I know this exhibition threatens our fragile hold on art world elitism. I think to myself that I don't want this to be an elitist organization anyway. But I have to admit, even I cringe at the thought of what might show up to be displayed in the exhibition – crocheted toilet paper roll covers, painted ceramic statuettes made from molds, paint-by-number landscapes, who knows!

I want to see myself as superior to Doug. I am passionate about the need for an inclusive society, one that respects difference and

promotes tolerance. I want to be outraged by Doug's joke (he who is not only an artist but a well-educated professional!) and incensed by his lack of awareness and lack of sensitivity. I *am* outraged and incensed. But I don't feel particularly superior. It is too easy for me to think of what has spurred my own passion for addressing diversity issues – the times I have been shocked into an awareness of my own insensitivity, my own covert racism and internalized oppression. So my outrage is tempered by empathy. In forgiving myself, I can forgive Doug as well. But I don't use this as an excuse to do nothing. My outrage also fuels my action.

That evening, when I arrive home, I sit down at the computer and begin to compose an article about the exhibition. I realize it is not enough just to hold the exhibition. In spite of good intentions, it might only serve to further entrench elitist attitudes about art and the divisions that exist between people of differing cultural groups. The article is for the gallery's newsletter. I write and rewrite, attempting to articulate the issues provoked by the exhibition without doing so in a way that will engender defensiveness in the reader. I want to raise awareness, stimulate thought, perhaps spark dialogue about our cultural identities and a more inclusive view of art. This is a tall order. Writing the few paragraphs is exhausting. But, paradoxically, when I am finished I feel renewed. It feels good to be doing something, even if it is a small something.

I have no illusions about the exhibition or the article I have written. Neither is likely to dramatically change elitist attitudes toward art or the tendency to relegate to the margins of society those who are considered "other." At the same time, it's likely to stimulate at least a few people to think about their own attitudes toward diversity. It is likely to offer the experience of being seen and "heard" to some of the people who are effectively silenced in our society. It is bound to shake things up at least a little bit in this conservative community where I live. Who knows what the ripple effects might be. For me, the small part I play in this quietly political act is infinitely preferable to doing nothing.

In our role as art therapists we are involved in a service profession that often ministers to the most vulnerable members of society. We offer art as a means of empowering those who have little power, soothing those who are in pain, and helping those who feel lost to reclaim their hold on life. It is easy, however, to view our work as that which occurs exclusively within the walls of our studios or offices. Therapy practice has historically focused on the individual in isolation or within the family or small group. In reality, however, "individuality is determined, not in isolated particularity but in relationship to one's membership within the human community and within history" (Becker 1996, p.89). Social and political forces shape and influence the context within which therapy occurs. Indeed, both client and therapist are inextricably bound to a historical time and cultural situation (Junge 1999; Wadeson 1987). There is danger in ignoring this reality. If we do so, we run the risk of individualizing problems that are more appropriately addressed at social or political levels than at the level of personal biography and personality (Lupton 1997).

Currently, both in the fields of art and psychology, a challenge is being extended to those of us involved in these activities to become more engaged with the world, to become more socially responsible. Hillman and Ventura (1992) have questioned the individualistic, detached, internal focus of psychotherapy. They argue that an exclusive focus on saving the individual adds to the culture of denial about the state of a world badly in need of saving. While they don't dismiss the need for personal therapy, they suggest that interpreting clients' concerns about the world as symbolic of personal problems, and ignoring the reality base of these concerns, implicates psychology as part of the problem rather than part of the solution. Gablik (1995) has challenged the art world in a similar manner. She believes that "like therapy, art too has fashioned its practice on the paradigm of separation, detachment and autonomy. It may be no accident that both disciplines traditionally are carried on in rooms whose doors are closed" (p.178). She is critical of art done for art's sake and the commodification of art, calling instead for an art practice based in an ethic of care and intimately connected with the world. In a similar vein of thinking, Levine (1992) warns that "the healing power of art is lost as artists lose their connection with a living community" (p.12).

As art therapists, our art practice *is* relational in nature and *does* operate out of an ethic of care. We tend not to view art as a commodity but as means for salvaging and enriching lives. Yet, we are influenced by the practices of psychology and the trends of the art world. In general, we still tend to view art making as a solitary pursuit carried out in the relative isolation of personal studios or art therapy practice spaces. Our work with clients tends to focus on the amelioration of symptoms and the fostering of adaptation to individual life circumstances. Junge (Junge *et al.* 1993) suggests that our art therapy training encourages us to support and appreciate clients' art-making efforts and to aid them in exploring intrapsychic landscapes, but that this very training impedes us from seeing our roles as "pro-activist, co-creators engaged together with our clients in their struggle, which is ultimately also our own" (p.150). If we ignore clients' social and cultural contexts, we may place an undue burden on them to change that which is beyond their sphere of influence, thus setting up unrealistic, and potentially damaging, goals for therapy.

In becoming more socially responsive and responsible in our practice of art therapy, it is not necessary to totally abandon a focus on the individual needs and concerns of our clients. There is much support for the notion that care of the self and care of the world are inextricably interrelated. A tension exists for the artist who desires solace in the studio and also seeks to transform social ills. These desires need not be incompatible; an inward focus may be part of the necessary preparation for action in the world (Kapitan 1997; Kumar 1995). There may even be some intrinsic social value in the tradition of the artist working in isolation, as this enables the artist to serve from the vantage-point of outside observer (Lacy 1995, p.184), social critic, and articulator of an anti-collectivist spirit (Kuryluk 1994). Indeed, one of the important contributions of feminism has been the idea that the personal is political; that is, individual, subjective experience has far-reaching social and political implications. Not only is personal experience relevant when addressing issues of social responsibility, but also, some would even argue, it is impossible to change the world without first engaging in change within the self. Majozo (1995) asserts that concerns about militarism, oppression, toxic waste, racism, sexism, and the like cannot be "taken on unless they are examined, acknowledged, and con-

fronted within the inner territory of the self, the earth that, in fact, we are" (p.88).

The cultivation of inner awareness, a significant aspect of work in art therapy, has the potential to be consistent with socially responsible and responsive practice if it is understood within the context of a dynamic relationship between the individual and society. For the client, working with content from his or her own life can be a step toward liberation (Cohen-Cruz 1995). For the art therapist, coming to know intimately the stories of our own lives through our art making enables us to have empathy for the stories of others. We experience first-hand the potential for art to be empowering. If our art making and art therapy practice occur in a socially engaged way, there is no distinct division between the personal and the political. Our most personal revelations are given meaning within the context of our social reality. Our greatest social and political achievements have their beginnings in personal integrity and commitment, in our willingness to change the landscape of our personal lives.

The question is not whether this cultivation of inner awareness is faulty, but whether it is enough. What does it mean to be socially responsible as an art therapist? Kramer (1971) attributed the rise of art therapy as a profession to the unfulfilled need for art in our society. But she saw problems in these social conditions as well, acknowledging that "when the creative capacities of the ordinary citizen no longer have a legitimate function beyond the confines of the therapeutic milieu, it is hard to make art therapy a living experience" (p.4). What is our responsibility to make art therapy a living experience, to address the larger social conditions that either support or act as a detriment to meaningful art making within society? Is it ethical to practice our work in a vacuum, ignorant about or disconnected from the social context within which we practice? Or is it our responsibility to advocate for a better world, one free of poverty, injustice, and violence? How does this interplay between the personal and political occur in art therapy practice? These are some of the questions that must be addressed in considering art therapy from the perspective of social responsibility.

Art therapy education

Two students displayed posters about handicapped parking to engender awareness and dialogue. One of their classmates engaged people in spontaneous performance art pieces to elicit awareness of occupation and class issues. A fourth student brought together young Latino children and Caucasian adolescents to work together on making pop-up books about their cultural identity. Still another made a poster that bluntly challenged common biases about people on welfare. And two more classmates worked together on a painting depicting anonymous figures with numbers on their chests to denote diagnostic labels. They displayed it along with information about the importance of using "people first" language rather than identifying people by their illnesses.

Today they share their projects with one another, along with the rest of the students in the class I am teaching. The course is Multicultural Issues in Art Therapy. It is near the end of the semester and we are all tired. Not just from the usual end-of-the-semester crunch, but from our heightened awareness of racism and oppression. It is so easy to become overwhelmed by all the damage we have done to each other as human beings and to lose hope in the possibility for change. I survey the faces in the room to see how they are responding to each other's presentations. I want them to remember that they can make a difference. I want them to have hope.

At the end of class, we each share what we are taking from the course that day. There is more of a positive, upbeat tone to what people are saying than has sometimes been the case at the end of other class sessions. Still, one student remarks that she wonders if what we are doing will ever be enough. I respond with a story.

As most of you know, I live outside the city, in the mountains. Unfortunately, everyone who lives out there with me is not particularly respectful of the environment. One of the things I've made a commitment to do is to pick up litter on my road when I'm on the way back from my morning run. It's a never-ending job. New beer bottles, pop cans, cigarette wrappers and other junk appear all the time, taking the place of whatever I clear away.

It's an especially big job right now. Since the snow has melted, all the accumulated trash from the winter is visible. Some days, it feels like an overwhelming job and I wonder why I bother. But I keep working at it, little by little.

Two days ago I was walking back home, picking up trash along the way, when someone who was driving by stopped to tell me thank you. This was the first time, in all the years I have been doing this, that anyone has ever thanked me. He told me he would come by later with his truck to pick up the bag of trash I had collected. I thanked him and when I had collected enough trash to fill my bag, I left it by the side of the road.

The next day, I saw that not only did he pick up the bag of litter I had collected, but he also did more. He cleaned up a wooded area by the roadside that had become a dumping ground for old furniture and other large trash items. It now looks beautiful.

I felt really good when I saw what he had done. It's what I'd always hoped would happen. That's how I think it works, one person at a time. I do my part. And maybe what I do gets somebody else thinking. And maybe it gives them a little hope, makes them realize they're not alone. So maybe they do their part too. You know what I mean?

I looked over at the student who had wondered aloud if we would ever be able to do enough. She smiled at me and nodded her head.

Developing awareness about the relationship between art therapy as care of the individual and art therapy as care of the world is a crucial concern for professional education. The student whose art therapy training is embedded in socially responsible practice is more likely to integrate this mindset and way of working into his or her professional life. Three facets of art therapy education are important in cultivating social responsibility. First, it is important that the student gain an understanding of the roots of our profession in the social application of studio arts. Second, if service is to be the ethos of our professional practice it must also be the grounding of professional education. Third, new paradigms of education must be

developed not only in response to the shifting milieu of the marketplace but to the shifting milieu of societal need.

Roots in social application of studio arts

The purpose of learning about history is to develop an understanding of how we came to this time and place, who our guides were along the way, and how our current lives intersect with history. If a historical perspective is to be instructive, we must come to see ourselves as a continuation of the story being told.

If we are to understand clearly the potential we have as art therapists to address the injustices of this world, we have to understand the roots of our profession in the social application of the arts. Too often, there is a simplistic viewpoint directed toward history, seeing it as interesting but antiquated or otherwise irrelevant information. This viewpoint enables the reader of history to disengage from it rather than consider how he or she might responsibly engage in participating in the ongoing story. What our art therapy history has to offer us is a firm grounding in a profession driven by passionate dedication to art making as a means for personal and communal healing. Maintaining a connection to these roots is a way to maintain a connection with the service-related values on which our profession was established. This connection helps us to avoid becoming unnecessarily distracted by pressures of the marketplace and to continue the ongoing story of art therapy as a practice grounded in service.

An overly simplistic reading of art therapy history can lead to the dismissal of studio-based practices as lacking relevance within the current healthcare market. An alternate reading of history is possible with what one of my professors in graduate school termed "a lovingly critical stance". This stance encourages empathy for the particular circumstances of time and place within which the historical events occurred. When history is read with empathy, attuned to the way it intersects with our lives, it is much more difficult to dismiss outright its relevance to the contemporary context. A lovingly critical stance enables us to be more discerning about those aspects of our history that constitute foundational values, those that have become outdated practices, and those that inform ongoing development of our profession. Instead of dismissing studio-based practice outright, we can

evaluate how it worked in the past, how we might adapt it to existing circumstances, and how we might advocate for change so a studio-based approach can continue to have relevance in the current context.

There have been significant contributions to the development of studio-based approaches to art therapy made by artists, art educators, and art therapists such as Cane, Kramer, Huntoon, and Jones in the United States (Junge and Asawa 1994; Wix 2000) and Hill, Petrie, and Adamson in the United Kingdom (Adamson 1984; Waller 1991). Coming to know their stories of art-based art therapy practices and interests in social concerns gives us a sense of the foundation upon which we now stand as art therapists. For example, Don Jones's beginnings as an art therapist grew out of his work done as a conscientious objector at a state hospital during the Second World War (Jones 1983). When we understand where we came from as socially responsible art therapists, we gain a sense of historical continuity and a clearer sense of vision about the hope we hold for the future of our profession.

As in any history, there are also missing voices. Little has been written about the work of pioneering art therapists of color, such as African-American art therapists Lucille Venture, Georgette Powell, Sarah McGee, and Cliff Joseph (Boston and Short 1998; Riley-Hiscox 1997). Many art therapists, busy working with clients or doing organizational tasks for the development of art therapy associations, had little time to write about what they were doing. Perhaps most significantly, the voices of art therapy clients are largely missing from the literature. As we engage with our sense of historicity as socially responsible art therapists, it is important to fill in these missing voices when we are able to do so, and leave space to acknowledge their silent contributions when the opportunity to recover their wisdom has been lost.

Service

In addition to offering a solid historical foundation, art therapy education must be grounded in service-oriented practice if service is to remain the ethos of our profession. To be of service means to assist, to be of use in such a way that one contributes to the welfare of others. It is easy to lose sight of this orientation when there are numerous other demands made on the

student or practicing therapist. The high cost of education and the pressure to pay back student loans, licensure and registration requirements, demands for mastering an ever-increasing amount of information at a graduate level of education, and the competition for practicum placements (and ultimately jobs), all function as distractions from the service orientation of our work. Yet, a service orientation is crucial during the student's education, when patterns of practice are established that will influence the professional for a lifetime.

A service orientation is based in humility. It presumes that we each have abilities and limitations. We offer our skills, abilities, and passions with the intention of contributing to the greater good. We give what we can and trust that others will do the same. In this way, our limitations are offset by others' strengths. Ideally, we give without attachment, that is, without attempting to manipulate others' reception of what we have to offer and without expecting repayment in kind. We "engage in compassionate and humanitarian acts given without personal ownership, professional identity or authority" (Malchiodi 2000, p.159).

Offering oneself to others at the expense of personal well-being is not consistent with a service orientation since it is a denial of personal limitations. Therefore, expecting to earn a decent, livable wage does not compromise a service orientation. However, the desire for power, recognition, prestige, and control can certainly distract from and confuse an orientation toward service.

Maintaining a service orientation, in spite of all the distractions and complications of life, is fostered by an intentional focus during art therapy education on who and what we are serving. In order to effectively address the needs of society, students must view it from a wider vantage point, one that takes into account how the strengths of art therapy intersect with the needs of the world. Hillman (1995), in recognizing the problems inherent in art's service to individualism and commodification, posits that the important question for art may not be what it should do, but rather how we find what it should serve. Feen-Calligan (2000) suggests that a similar shift in thinking needs to occur in art therapy education, where students often become so concerned with what technique or experiential they will *do* with clients that they forget to think about the purpose of what they are doing, about what greater good is being served.

It is likely that students will best maintain grounding in art therapy's service orientation through experiences that challenge them to consider how art can intersect with society in order to create healing potentials. Feen-Calligan (2000) recommends the development of two types of competencies through graduate art therapy education – contextual competence and adaptive competence. Contextual competence has to do with understanding "the broad social, economic, and cultural setting"(p.85) within which art therapy takes place. Adaptive competence has to do with anticipating and adjusting to new conditions in a rapidly shifting society. The development of adaptive competence is fostered when the student has an awareness of personal skills and interests and understands how to apply them in new situations. Vick's (1996) Dimensions of Service model offers students a means for examining how best to bridge the gap between the wished-for ideal and the practical reality in professional practice. Students can develop cultural and adaptive competencies through experiences that invite them to identify areas of social need and to make use of personal and professional skills to address those needs through art.

An example of such experiential learning occurred in an undergraduate introductory arts therapy course I taught. The class comprised students from a variety of undergraduate majors. For their major class project they were to identify a social issue and to engage with that issue through some form of socially responsible art activity. One of the students (not an art or art therapy major) contacted Habitat for Humanity and was given a family to work with. The family was very large, consisting of a mother, father and twelve children. Rather than help with the construction of their house, she talked with the family members about what kind of art they would like to have in the home they were currently building. After coming to understand their wishes, she organized students from the art department to donate artwork or to help with a mural painted directly on a wall in the house. This experience gave her the opportunity to address social, economic, and class issues; to engage in an empathic rather than an elitist dialogue about the role art plays in the lives of ordinary people; and to organize a community of artists in an activist manner. It also gave her ample opportunity to develop her adaptive competence when artists failed to follow through with commitments, family members changed their minds about what they wanted, and local media became involved!

Another effective way to keep art therapy education focused on whom and what art therapy serves is to invite clients to be guest lecturers in class, or collaborators in developing community arts initiatives. According to Spaniol (2000), "by shifting the asymmetry of power, people with disabilities become the experts with much to teach students about their conditions and their use of art" (p.79). In my experience, inviting clients to participate as experts in student education has positive ramifications all around. Students have a chance to learn about art therapy and be sensitized to issues and experiences from a "consumer's" perspective. Clients, who are often in the position of the one being helped, take on the role of helper and expert, which may be experienced as empowering.

New paradigms for art therapy education

If art therapy is to do more than survive as a profession, models of education must be as responsive to the shifting needs of the society we serve as to the demands of professionalism and the marketplace. A thriving profession, strong in its purpose and dedicated to its mission, will arise from education models developed in recognition of the unique attributes of art therapy and in response to the pressing needs of the social milieu.

If we are to be clear about what we have to offer as art therapists to this ailing world, our theoretical constructs in art therapy education must articulate with increasing clarity what makes the therapeutic use of art distinct from other types of therapy models. This can happen only if we do not "separate the aesthetic acumen developed in the studio from the more linear intelligence cultivated in the classroom" (Becker 1996, p.29). If this aesthetic/didactic integration is to occur, serious engagement in studio artwork cannot be relegated to undergraduate education alone. The student who continues to cultivate the integration of an artist identity and an artistic way of conceptualizing therapeutic practice throughout the course of graduate studies will be much more likely to practice in a similar manner. An art-based model of education requires that the art part of graduate art therapy education be viewed as more than adding art experiences to didactic coursework. Instead, the structure of the curriculum revolves around an artistic perspective so that understanding theory and practical

applications develop naturally from the practice of making and responding to art.

Concerns have been expressed about the loss of focus on art and art making in graduate art therapy education (Agell 1994; Allen 1992; Cahn 2000; McNiff 1986b; Semekoski 1998; Wix 1995, 1996) and new models of education have been formulated to redress this loss of focus. Allen (1992) has recommended that educational programs seek internship sites where art making plays a central role and where students can function in the role of artists-in-residence, an alternative to traditional models of art therapy practice. Wix (1995) has proposed the intern studio, a weekly studio arts experience for art therapy interns, as a means of recentralizing art's role in the educational experience and helping students connect their own art making with that of their peers and the clients they serve.

Cahn (2000) has offered a new paradigm for studio-based art therapy education that borrows from the format used in architectural education. In her model, the primary educational structure is the studio, a sort of home base wherein diverse theories, methods, and techniques are taught in an integrated fashion. Some of the material formerly taught in separate courses is combined in a sequence of four- to six-credit courses where the concepts of art and clinical expertise are understood in an ongoing and comprehensive way, taking full advantage of the classroom as a laboratory. This paradigm takes a transformative, rather than an additive approach to education (Banks 1997), so that the art becomes the central component of everything that occurs in the educational milieu. The intent of Cahn's (2000) model is to "help students integrate the art process into their entire professional life" (p.181).

The question of where, with whom, and how this art-based approach to therapy is applied is most effective when the lens through which we make these considerations is inclusive of individuals, groups, community, and society at large. Graduate education provides an opportunity for students to be challenged to consider who they are and what they have to contribute in relation to the social context. This is true whether the student's practicum experiences take place within the context of individual therapy sessions or community-based art projects. Everyone exists within a social context, so cultural issues such as power, race, ethnicity, class, gender, and lifestyle are central to our work. How we can most effectively address

these issues through art is an ongoing challenge for our profession. When we help students ask critical questions in regard to this challenge and support their exploration of art therapy applications that extend beyond traditional pathology-focused models, we are preparing them to contribute to the ever-developing body of knowledge in our field.

Semekoski (1998) addresses the importance not only of the artist identity of the art therapy student but also the importance of understanding this identity in light of current practices in the art world that are directed toward collaboration with the community. She advocates for a more expansive vision of our profession, one where there is the potential to work collaboratively with artists "to shape a different future for the arts and society" (p.240). She suggests that postmodern approaches to therapy be taught in order to build a bridge to community-oriented work in which a pathology-focused approach is not valued. She recommends that students be encouraged to read literature outside the field of art therapy, not only pertaining to other therapy approaches but also pertaining to contemporary community-based art practices, and such topics as ecopsychology, spiritual practices of other cultures, and contemporary art history. In this way students can become aware of their own cultural context and sensitive to the cultural lens through which others see the world.

When education moves beyond the confines of the institution, students are given the opportunity to view the larger world as the learning environment. A shift in perspective occurs when students are involved in practicum or internship experiences. As valuable as these learning experiences are, however, the shift in perspective may be only a shift from one institution to another. The view may still be microscopic relative to the larger society. It is important that art therapy education effectively challenges students to see and think at a macroscopic level, to recognize significant social issues and to take actions to help solve them. Learning opportunities that involve collaborative efforts with social agencies, consumers of art therapy services, arts organizations, people from diverse cultural groups, and activist organizations, enable art therapy students to experience first hand the relationship of our work to the larger community.

Students can also be encouraged to develop their own initiatives for socially responsible and responsive art therapy activities. Helping students to recognize that even small, seemingly insignificant efforts contribute to

the greater good is an important lesson. With these kinds of educational experiences, life-long attitudes toward art therapy and social responsibility are cultivated.

Art therapy practice

Art therapy education has the potential to provide a strong foundation for a service-orientation and socially minded awareness. However, the learning does not stop at graduation. The development of a socially responsible art therapy practice is an ongoing process. Viewing clients as experts, recognizing art therapy's subversive potential, and enlarging our understanding of the activism in art therapy are key elements in this process.

Clients as experts

I pull into the parking lot near the lake. I am behind the wheel of an old school bus, repainted and now affectionately called Old Blue. I open the door and everyone files out. I button up my coat and pull my hood over my head before I exit.

This is our community outing for the adult psychiatric day treatment program where I work. Earlier in the week, on a balmy spring day, the clients had made the decision that this park would be our destination. But the weather changed its mind last night, decided it wasn't quite finished with winter yet. Frank, my supervisor, had insisted that we stick with the original plan none the less. He told me the clients too easily abandon their plans when the weather is the least bit challenging. He said it's good for us all to be outdoors.

In principle, I agree. Being outdoors and being active does seem to have a positive effect on most of us. I know it often makes me feel more energetic. But I didn't like the way Frank came to his decision about going to the park in spite of the bitterly cold weather. He ignored protests from some of the clients, asserting his authority as he announced, "Time to go! Let's board the bus!" It seemed disrespectful, as if he thought he knew better than the clients themselves what was best for them.

I walk along the grass at the edge of the water, my hands thrust deep into my pockets, the wind whipping around my face. I chat with the clients and we feed the seagulls some old bread we have brought along. The time seems to pass slowly. I try to make the best of a lousy day, but my teeth won't stop chattering. When it is time to leave, I eagerly board the bus again.

Everyone is quiet on the way back. When we arrive at the hospital, we gather in the community room, huddled in our coats and rubbing our hands together. We sit around the large table and talk about how our day went, what plans we have for the weekend. I am feeling a little disgruntled and decide that sometime soon I will try to talk to Frank about the decision-making process for our community outings.

A week later, Ellen, one of the clients at the day treatment program, gives me a slip of paper. On it is a poem she has written about our trip to the lake. It is titled "Grace." I read the poem and don't know what to say. It is so beautiful. But there is more to my reaction than aesthetic appreciation. It takes me a while to grasp what it is.

I come to realize the title is right – grace. The poem is a free gift, undeserved, unearned. The gift feels like a lesson.

Ellen's words acknowledge the dismal nature of the community trip, the questionable benefits of this "recreational" outing. Her words echo my feelings. But the poem articulates an understanding beyond my own. She writes about a man turned away from the group, tossing bread balls to the seagulls. She tells how we become a community around him, "oohing" and "ahing" as the bread and wings fill the air around us. I think about who the man is, whether he represents a client or one of the staff. It seems right that I can't figure it out.

Ellen is able to give her experience of our community trip meaning, drawing from it her own understanding and transforming the experience in the process. Her ability to see the poetry embedded in the afternoon is an inspiration to me. It reminds me of what my work is all about: helping people transform their experiences;

becoming a community in the midst of nearly impossible circum-stances so that together we can find new versions of hope.

If our art therapy practices are to be socially responsible, they must be grounded in relationships with clients that are based on respect and dignity. The willingness to question our own assumptions about treatment and to view clients as experts is critical to this grounding. Colli (1994) warns of the dangers of art therapists' unquestioning conformity to the institutions that employ us. When clients' needs become subordinate to the expecta-tions of the institution, art therapy may be used to foster adaptive behavior in clients. Colli asserts that "patients do not become normal because they lose or deny the potential vitality that is contained within their madness, but because they are able to give it a meaning and assume responsibility for bringing out and transforming that meaning, letting it take its chance in real involvement with the external world" (p.111).

Taking on the role of collaborators with clients challenges the old hierarchical models of the therapist/client relationship. Gerrity (2000) suggests that our natures as artists – interested in viewing things from different perspectives; intrigued by various textures, colors, and forms; able to appreciate the relationship of parts to the whole – can provide the basis for an appreciation of diversity and a collaboration with clients.

In my experience, it has also been my clients' artistic natures that have been instructional for me. They have helped me to better understand the "process by which people develop personal and community power through the shared act of creating knowledge out of their own experience" (Ciornai 1983, p.65). Like Ellen, they have been able to use their art as a way to transform experience, create community, and give form to even the smallest bits of hope.

Art therapy as subversive activity

One of the characteristics of art that makes the arts therapies particularly suited to addressing social concerns is its subversive potential. Art can function as a transformative agent, sometimes subtly and sometimes dra-matically overturning social ideologies at a foundational level. The very act of creating serves to challenge the notions of disability, helplessness, and

dependence often ascribed to clients in therapy. Furthermore, clients often challenge the secrecy of social taboos – sexual and physical abuse, poverty, domestic violence, family secrets, disabilities, neglect, death, loss – by using art to transform secrets into something seen, heard, and discussed openly (Aldridge 1998, p.9). The ultimate subversive activity occurs when the issues society seeks to deny are overturned, the invisible transformed into the visible. In effect, art empowers clients to claim and refine the self that has been denied. This process of self-definition is a political act.

In understanding art therapy's subversive potential, it is also important to be sensitive to how this potential can be distorted. Just as artists and art students sometimes misconstrue the relationship between freedom of expression and social responsibility, so too art therapists and art therapy clients are vulnerable to this same confusion. Becker (1994, 1996) has addressed the naïve notion of freedom that permeates the art world, whereby artists are unable to reconcile the need for uninhibited and uncensored personal expression and the need to make careful decisions about the contexts within which art is made and shown. She contends that this idea of freedom signifies "the right to do whatever one wants, however one wants, whenever and wherever one wants without consideration of consequence" (1996, p.31) and results in a lonely position for the artist, cut off from an ongoing dialogue with the larger world. She also argues that this definition of freedom perpetuates an infantalized notion of artists, as not responsible for their actions.

We do a disservice to our clients if we promote uninhibited artistic expression without concern for its social effects or impact. Such an emphasis does not prepare clients for the reception of either their art or themselves in the real world. In the case of clients with psychiatric disability, it also threatens to reinforce a damaging stereotype that portrays the mentally ill as childlike and not to be held responsible for their actions.

Haeseler (1987) addresses the delicate balance between freedom of expression and social responsibility as a dynamic in art therapy. She distinquishes between art made privately and art made in the contexts of groups. She believes "patients can learn to understand their artwork not only in terms of its relevance to themselves, but also in terms of its likely reception by and meaning to others" (p.11). Henley (1995b, 1997a) makes a similar distinction between "an artist's right to create and the privilege to

exhibit" (1995b, p.65). In his work with children and adolescents, he attempts to make sensitive clinical decisions about how to handle disturbing artwork, taking into consideration the artist's intentions as well as the needs of the students or clients who will view it. He believes "it is not enough to shield exploitational art from others while the offending artist remains oppressed and required to work in isolation. Interventions must attempt to develop the artist's maturity and consciousness beyond mere provocation" (1997a, p.45). The artist is helped to understand the relationship between artistic license and social responsibility. Censorship is balanced with empowerment.

It is perhaps true that public art of a disturbing or offensive nature is a phenomenon of cultural healing that has "grown out of a need to restore psychic balance and equality through social, political, racial and religious protest" (Politsky 1995, p.115). It is equally possible, however, that such art can alienate those it seeks to engage in discourse and harm those it seeks to help. In my experience of working with adults with a history of childhood abuse, the creation of disturbing or offensive art sometimes is an aspect of healing, giving the client a chance to exert some control over intrusive memories and mental imagery. When created in a group context, however, the art that can be helpful to its maker is sometimes simultaneously perceived as disturbing or psychologically harmful to those who view it. The dilemma for group participants parallels some of the dynamics of trauma. If images are censored, this may be experienced as a replication of messages about keeping the abuse secret. If the disturbing artworks are tolerated, in spite of their damaging effects, this may be experienced as a re-enactment of the powerlessness felt in relation to the abuser. There is no simple solution to this dilemma. I have found it most helpful to engage group participants in grappling with the issue of freedom of expression versus social responsibility. This has the effect of transforming the dynamics to a healthy, open forum wherein the complex nature of the effects of trauma is acknowledged. Group members are given the opportunity to come to their own solution in regard to the dialectic of containment and expression, and in the process to experience empowerment.

If one of the dangers linked with art is exploitation of its subversive potential, then the opposite, denial of this potential, is also a danger. Skaife (1995) warns art therapists of the forces against our remaining in touch

with the subversive potential of our profession. She cites the tendency in Western culture toward a valuing of materialism above personal and communal relationships; a philosophy of individualism that promotes competition rather than collective activity; and economic pressures that compromise the ability to remain focused on clients' needs. She believes "it is imperative for the integrity of our profession that we are alert to the ways in which art therapy is pulled and pushed to conform to an ideology at odds with our own" (p.2).

If we are to stay connected to the subversive potential of art, we have to be not only alert to the institutional, professional, and social forces that shape our identities, but also willing to challenge, question, and engage in dialogue with these same forces. In the face of a society characterized by materialism and individualism, we have to hold firm to our commitment to service and our belief in the democratic, ubiquitous nature of art's healing potential, without overly romanticizing these concepts. Remaining connected to the subversive potential of art therapy is enacted through our roles as activists.

Activism in art therapy

In one sense, all art therapy practice is activist because it addresses social ills. In the belief that "liberation begins with us, at home, internally" (Escobar 1994, p.52) we art therapists address social change, one person at a time, through the work we do within ourselves and through assisting those who come to us for help. For some art therapists, it has also been important to address the implications of our work from the perspective of a wider socio-cultural context and to consider our roles as activists.

The notion of activist art is sometimes confused with the idea of political art. In activist art the intention is not merely to make a statement, but to be concerned with the comprehension and participation of those who view it (Felshin 1995). Activist art doesn't seek to shock or mystify viewers but to engage them in a process of transformation. Thus, an activist approach is in sympathy with the ethos of art therapy, where art is made in a relational context with the intention of fostering and realizing change. Suzanne Lacy (1995) offers a helpful model by which to consider activism

in art on a continuum from private to public acts. She discusses four levels: artist as experiencer, artist as reporter, artist as analyst, and artist as activist.

In the first level, that of experiencer, the artist attempts to empathically reflect and document the experiences of a social group through making art based on compassionate subjectivity. The potential for art therapists to function in the role of experiencer is exemplified by Don Jones's (1983) series of portraits depicting his subjective reactions to patients at the Marlboro State Hospital in New Jersey. Painted in the 1940s, they are sensitive and haunting images of the suffering experienced by patients in a state mental health system that provided little more than custodial care at that time.

Art therapists are particularly well situated to engage in activist art at this level, since empathically reflecting the experiences of our clients is an essential feature of the work we do. The question of bringing our artwork to the level of public viewing has received some attention in regard to both public art exhibitions (Fleming 1993, 1998; Franklin 1993; Lachman-Chapin 1993a, 1993b) and performance art (Henley 1993, 1998; McComas and McComas 1996, 1998; B. Moon 1995, 1996; C. Moon 1997b; Moon and Schoenholtz 1998). These exhibits and performances have given viewers an opportunity to look with a new and perhaps more empathic perspective at the experiences of people who have been treated as social outcasts, such as people with serious mental illness or people with AIDS. The question of audience is important here. Do we present these artworks only to those already sensitized to the issues (for example, to an audience of art therapists) or do we challenge ourselves to present them to viewers who are less sympathetic or less aware?

In the second level of activism, the artist as reporter, the aim is not merely to reflect what exists in society, but to report it more intentionally and selectively, oftentimes with the intention of interpreting and persuading. Taking on the role of the artist as reporter moves the activist role one step beyond merely reflecting interior experience. If "the creation and public sharing of art is essential to any practice of freedom" (Hooks 1995, p.4), then the role of the artist as reporter makes intentional use of this freedom by selectively presenting art that has social or political implications. "Creative Dialog: A Shared Will to Create," a collaborative exhibit featuring the work of graduate art therapy students and their clients (Vick

2000), is an example of the artist as reporter. In this case, the hierarchical posturing about whose viewpoint is most valued was called into question. The client, who is typically made the subject of reports – through such venues as clinical documentation, case conferences, and therapist's professional presentations or writings – became an equal partner in the reporting of experience, as client and therapist exhibited side by side. The viewer, in turn, was challenged to reconsider the helpless role typically ascribed to clients and to consider instead the clients' abilities, creativity, will to create, and expertise in regard to the therapeutic relationship. Spaniol (1998) also has challenged the traditional hierarchy of the client–therapist relationship by engaging people with psychiatric disabilities as partners in a research project. Her written report of the project includes clients' views on art making and art therapy that challenge some of the assumptions, values, and practices common to the profession of art therapy.

In the third level of activism – the artist as analyst – the receptive, observational, intuitive, and experiential positions of the artist give way to more intellectually oriented work. The artist analyzes, theorizes, and develops provocative commentary about the social situation. Writers who critically examine the response of art therapy to significant social issues assume the role of analyst. The artists' response to issues such as violence (Kapitan 1997), the AIDS epidemic (Franklin 1993; Junge 1999; Weiser 1989), and the ecological crisis (Kellen-Taylor 1998) are examples of issues that have been analyzed and examined, particularly in light of art therapy's responsibility and accountability. Social issues more particular to art therapy, such as examining the effects of displaying client art (Alter-Muri 1994; Edwards 1993; Knowles 1996; Spaniol 1990a, 1990b, 1994) or analyzing the impact on art therapy of the public's fascination with Outsider Art (Esman 1988; Haeseler 1988; Martin 1988; Parsons 1986; Rubin 1986; Sweig and Cohen 1998) have also been addressed. The analysis provided by these writings raises awareness of critical issues and prompts the reader to wrestle with difficult questions concerning art therapy's role and responsibility in the social milieu.

The final level, artist as activist, is characterized by work done in collaboration with the public and situated within the context of the local, national, or global issue being addressed. In this role the artist does not

stand outside an issue to document, interpret, or comment upon it. Instead, the artist addresses the issue from the inside out, in partnership with members of the community for whom the issue is a lived reality. Art therapists are particularly well situated to engage with the public as arts activists, given our history of fostering art making by people with no formal art training. Extending this belief in people's inherent capacity for artistic expression to the activist level happens when the art therapist addresses concerns of the local, national, or global community. Art making, then, is no longer detached or insulated from the issues being addressed but takes place within the community of people who are intimately affected.

Examples of art therapists who have taken on the role of activists include Timm-Botos (1995), whose community-based Artstreet project empowers residents of a homeless shelter and serves to decrease the gap created by class issues; Vance and Clark (1995), whose *Peace Bridge Project* helps children find creative, nonviolent solutions to the problems they encounter in society; Ault's (1988) use of art making with people in business organizations in order to promote a humanizing influence; and Speert's (1989) proactive use of art as a means to address the fears and concerns of children confronted with the existence of nuclear weapons.

As we continue to explore the relationship of art therapy practice to the larger social milieu, it may be helpful to keep Lacy's (1995) model in mind. Activism can take many forms, requiring different levels of involvement. Stereotypical versions of activism are characterized as direct, volatile, and ephemeral demonstrations, but activism can also be quiet, restrained, intimate, and prolonged (Phillips 1995). It can be based on empathy and be enacted through gradually evolving commitments to social issues. As the examples mentioned attest to, we have a history of activism in our profession on which to build. Our ongoing challenge will be to continue to apply our skills, passions, and commitments to the ever-changing needs of the society to which we belong.

Expanding our vision of art therapy

I am in my car, driving home after a session with Corrine. I find myself sighing as I think about the time we spent together. Her usual

litany of physical and emotional ailments has worn me down. She is only in her early fifties, but I have a hard time remembering this. She seems much older.

There are things I wish for Corrine: a part-time job, an identity separate from that of caregiver and victim of her alcoholic husband, a driver's license, some pleasure in her life. I have told her what I know of local Al-anon groups and she has nodded her head as I have talked, saying that it would be good for her to go to a meeting. But she has never gone. She has always lacked a ride, or been afraid to go by herself, or had something unexpected come up. She has, however, developed a friendship with a woman in the neighborhood whose ex-husband is an alcoholic. Sometimes they have coffee together and talk about their lives.

When she makes art, she apologizes for her lack of skill. She makes self-deprecating remarks, saying her art looks like that of a two-year-old. She is sure what she does is no good. But something keeps her coming back. I provide things like paint and glue, scissors and thread, so she can rework her life bit by bit. For now, this has to be enough.

I want liberation for her. I want her to demand that her husband go into a substance abuse treatment program or move out of the house. I want her to build a life for herself in which she feels proud and capable. But the reality is that she is financially and emotionally dependent on her husband. She never finished high school, has a limited work history, and is part of a loving but chaotic extended family. There aren't many options for a woman in her situation. If I were to insist that she separate from her husband, the results could be devastating. I try to listen to what she wants and feels able to do. I try to remember that a bit of art making and coffee with a friend may be her first steps toward liberation.

Tomorrow night I will go to the women's group to which I belong. We'll share food and stories, laughter and vulnerability. I won't talk about Corrine, but I'll think of her when I'm with these women. We all make things together – art, coffee, conversation, space for listening, time to hear each other into speaking – and in this way honor our mundane but courageous acts of liberation.

What is an expanded vision of art therapy as it relates to social responsibility? Is my work with Corrine socially responsible work? Or is it too limited, too focused on the personal? If it can be validated as a socially responsible practice, is it enough? Shouldn't I be doing more? Maybe I should help Corrine get her graduate equivalency degree, join a women's group, or get a volunteer job. Maybe I should do some volunteer work with a literacy group, so I can help other women like Corrine become more self-confident and capable, more employable. Maybe I should offer to integrate art making into the literacy group as a way to enhance self-esteem and visual discernment. Or maybe I should incorporate all these ideas by starting a program for women, based in the arts and directed toward increasing competence, self-esteem, and self-determination. Would this be enough? Would I then be socially responsible as an art therapist? What does it *mean* to be a socially responsible art therapist?

Fortunately, I think the answer to the last question is that being a socially responsible art therapist can mean many things. There is no requirement to engage in heroic, monumental efforts toward social change. At its most fundamental level, social responsibility involves being aware of the effects of the socio-political context on people's lives and attempting to address problems at the level at which they occur, from the private to the public, from the individual to the cultural, from the personal to the political.

A continuum of social action

Majozo (1995), in discussing the artist as activist, views the blues form in music from African-American culture as a fitting metaphor for art and its potential. In this form of music the first line is the call, the second line is the response, and the third line is the release that sets the listener free. In art, she says, "the call is incited by the experiences we have within the world, by the human conditions and predicaments within our terrain that arouse our interest or consciousness" (p.91). The response is enacted through artistic creations that attempt to name, acknowledge, and spur change. The release is the ongoing process inspired by the artistic creation, the ways in which the art takes on a life of its own in the responses of the viewing, participating public.

This metaphor is an apt one for art therapists as we try to elucidate how social responsibility might play itself out in our lives and work. The initial motivations for action come from experiences in regard to the human condition that arouse interest or raise awareness in us. Since our experiences are so varied, so too will our responses be diverse. Our responses are shaped not only by what motivates us, but also by the particular circumstances of our lives. These circumstances include such characteristics as our skills, abilities, resources (physical, emotional, financial, communal, and spiritual), and commitments. Individual circumstances might lead one art therapist working with the homeless to create sensitive portraits of shelter residents as a way to acknowledge their dignity and humanity. In the same situation, another art therapist with different life circumstances might respond by organizing a coalition of community arts organizations, with the goal of empowering shelter residents as artists and challenging the boundaries between elitist and grass-roots art. Neither one of these is a better or a "correct" response. They are just different responses, evolving from the circumstances of individual lives.

One way to conceive of the possibilities for social action in art therapy is to think in terms of a continuum that ranges from individual- to community-focused activities. A circular continuum, rather than a linear one, where there is no end or beginning point probably captures the nature of social action best. Most of us move about on the continuum, shifting from personal to public efforts in response to different internal needs and changing external events.

On one point of the continuum are the ways we work within ourselves, tending our inner landscapes, sensitizing ourselves to the effects of our environments, cultivating our awareness, receiving emotional sustenance, and preparing ourselves for action in the world. For art therapists, this inner work may take many forms, but certainly personal art making is likely to be a primary one.

Next along the continuum are activities of an intimate nature. In response to being called to action, the art therapist engages interpersonally, through art-based relationships with one other person or a small group of people. This intimate interpersonal activity characterizes much of the work done by art therapists. When such work is carried out with sensitivity to the

interplay of personal and social dynamics, it becomes a form of socially responsible practice.

At another point along the continuum are activities that engage us in interactions at an organizational or communal level. We may become involved in our professional organizations at a state or national level as an act of service (Minar *et al.* 1997). Our efforts may take us in other directions as well. For example, we might work with national arts-and-healing organizations, mental health advocacy groups, or local nonprofit arts organizations. Published writings, performance art, or art exhibitions also may be forms of social action that connect us with the larger community. We can participate directly by publishing, performing or exhibiting our own work, or we can be advocates and organizers, working on behalf of presenting other people's work to the public.

If we are motivated and able, we might push our organizational involvement farther. We might be instrumental in establishing organizations to address social issues about which we are passionate. Or we might work to focus our energies on bringing together existing organizations so they can function in a complementary and collaborative manner.

The thread that runs through the entire continuum is a commitment to social awareness and social action, no matter how it is enacted. When we are called to compassionate action by the ills of the world, our most authentic and generous response may be that generated through our identities as artists. But art is not a panacea, able to address every need that arises in society. Gomez-Pena (1995) warns that sometimes we have to step outside the safety of the art arena and "fine-tune our multiple roles as intercultural diplomats, border philosophers, chroniclers, and activists…we must practice, promote, and demand access, tolerance, dialogue, and reform" (p.103). Our response to the call for social action may be enacted through artistic creations, but if these creations are insulated from the lives of the people we are purportedly trying to help, or disconnected from the wider efforts of all cultural workers, we are not likely to be effective in instigating change.

Becker (1996), in remarking on a trip to South Africa, noted that artists were not identified as politically active based solely on the content of their artwork. "Rather, they were evaluated, like everyone else, on the quality of their life's commitments" (p.103). As art therapists attempting to respond

with compassion to the needs of the society around us, we too would do well to keep this concept in mind. When our passion and compassion are linked, our art becomes more than what we make or do. It infiltrates every corner and crevice of our being, giving expression through how we live our lives.

Our unique contributions

It has been a recurrent theme in this book to underscore the unique contributions we make as art therapists to the helping professions. My intention in doing this is not to set art therapists apart, but rather to help us come to know more clearly what we have to offer that will contribute to the greater good. My belief is that in knowing and appreciating our own gifts, we are better able to recognize and appreciate the gifts of others.

The specific contributions we make in terms of our profession also have wider implications. The field of art therapy is predicated on the belief that the "creative process involved in the making of art is healing and life-enhancing" (AATA Mission Statement 2000). Certainly we cannot own or control this healing, life enhancing potential; all we can do is intentionally and devotedly participate in it. Thus, we constitute one among many groups of people who recognize and make use of the restorative power of art. Arnheim (1990) has suggested, "The function of the arts in therapy can serve as an effective reminder of what is the true and wholesome motivation of art quite in general" (p.4). At our best, we effectively serve this purpose. At the same time, being at our best means we are also continually open to learning more about the artistic process. Our learning can come from dialogue with other organizations involved in the arts and healing (for example, The Society for the Arts in Healthcare), with consumer arts organizations (for example, Altered States of the Arts), with socially minded arts organizations, with clients, and with other artists (Hannah 1992; Lachman-Chapin 1998). Malchiodi (2000) asserts, "In becoming advocates for the therapeutic potential of the visual arts and dedicating ourselves to service through that therapeutic potential, we may find that recognition of art therapists' expertise emerges naturally from a commitment to advocacy and compassionate service to others" (p.159).

Conclusions

Art therapists have much to offer the larger community. When our professional identities are oriented toward a model of service and attuned to our potential for socially responsible action, we enhance our position as contributing members of society. In collaboration with others and in response to the needs of the community, we can become strong advocates for the therapeutic potential of the arts.

With this in mind, I would like to suggest some of the contributions we might make to the society of which we are part.

We might be instrumental in what Lippard (1995b) terms "visual consciousness raising", that is, the shift in vision that allows us to "see *all* the arts of making as equal products of a creative impulse that is as socially determined as it is personally necessary" (p.138). We do this first by engaging in an inner dialogue, between the part of us that makes art alone in our studios and the part of us that works with clients in art therapy. If we are reluctant to identify ourselves as artists, why is that? Is it due to a lack of confidence in artistic skills, to a rejection of the elitist notions connected with being an artist, or to a combination of these two reasons? Does this reluctance disguise an internalization of art elitism? Or do we identify ourselves as artists but conceive of this identity as distinct from our identities as art therapists? If we do make this distinction, is it an expression of a hierarchical viewing of artistic activity? By challenging ourselves with these difficult questions, we engage in our own visual consciousness raising. In so doing, we position ourselves to be champions of a nonhierarchical, anti-elitist view of art.

We also can contribute to an understanding of art as compassionate action in relationship and response to oneself, others, and the social and physical environment. We can work "at a grass-roots level to listen and mobilize and construct a kind of foundation for art that powerful art institutions cannot now build" (Brenson 1995). Because of the nature of our work, we are in a position from which to offer a more humane, less commodity-oriented, more relationship-minded view of art. We can honor the role of art in allowing for individual expression while also challenging the idea that art is a solitary act, recognizing that individual expression

occurs within the dynamic relationship between the artist and society. As our experience demonstrates, art is an essential ingredient to the life that sustains us, helps us recognize our common humanity, and can serve to transform individuals and communities.

Finally, we can help expand the vision of what constitutes "art." Together with other artists we can redefine art as: concerned not with object making but with the process of making meaningful; involved in issues directly relevant to people's lives; concocted from both traditional and nontraditional media; based in an aesthetic that conceives of beauty in terms of the quality of relationships; made and displayed in everyday places by ordinary people; valuable apart from the economic market; an agent of change; accessible, inclusive, and potentially empowering; a means to cultivate empathy; and, at least for some people if not for society at large, essential to survival.

Epilogue

I imagine myself sitting on the beach. The sand is still warm from the sun, but the sky is beginning to flaunt its evening coat of colors. I see something bobbing out in the water. I shield my eyes from the setting sun and peer out to see what it is. Only the buoys, I realize, as they lazily rise and fall with the faint stirrings of the water. "Hm," I think to myself, "maybe I should jump in the water, see if I can swim out to them." I try to judge how far away they are. They don't seem too far, maybe I could even swim past them. I start to get up, but then change my mind. I settle back on the sand, dig my toes in so they disappear. For now, I am content to be still, listen to the rhythm of the water, and watch the sun glint off the buoys as they bob about in the water.

Tomorrow, I can go swimming.

As I bring this book to its end, I think again of the metaphor introduced in the opening chapter, of images as buoys bobbing to the surface, to mark off territory or invite exploration. It is my hope that this book has succeeded in doing both.

The territory I have attempted to mark off has been that of a studio approach to art therapy. I have considered the implications of an art-centered theory of therapy as applied to conceptual understandings, attempts to understand clients, creation of the therapeutic space, development of treatment methods, interactions with clients, communications that occur in relation to the work, and social responsibility. Along with the ideas I have presented, I have also given concrete examples in order to make the theory understandable and practical.

Yet, this is no cookbook text. I have presented models for concept-ualizing the work of art therapy, but these models leave much room for creative thinking and practical exploration when it comes to applying them in our encounters with clients. That is, I believe, as it should be. An art-based practice is characterized by finely attuned perceptions, keen sensitivity to the many versions of beauty made manifest in relationships, and the use of our aesthetic sensibilities in service of empathy. Art therapy is indeed an art, and as such it cannot be whittled down to a set of rules or directions to follow.

I hope my ideas about art therapy are instrumental in stimulating further dialogue. Perhaps they have, in some small measure, helped to define a territory we might call "home" for our profession. But just as importantly, I hope they have motivated you, the reader, to continue to push at the edges of what the arts therapies might become. After all, this is merely a book. It requires you to make it come alive.

References

AATA Mission Statement (2000) *American Art Therapy Association Newsletter 33*, fall, 3.

Abbenante, J. (1994) "Commencement address at Vermont College of Norwich University, August 1993." *American Journal of Art Therapy 32*, 3, 83–4.

Adamson, E. (1984) *Art as Healing.* London: Coventure.

Addison, D. (1996) "Message of acceptance: 'Gay-friendly' art therapy for homosexual clients." *Art Therapy: Journal of the American Art Therapy Association 13*, 1, 54–6.

Agell, G. (1986) "Comment." *American Journal of Art Therapy 25*, 2, 51–2.

Agell, G. (1994) "Art therapy: The future." *Art Therapy: Journal of the American Art Therapy Association 11*, 1, 28–9.

Agell, G., Levick, M., Rhyne, J.L., Robbins, A., Rubin, J.A., Ulman, E., Wang, C.W, and Wilson, L. (1981) "Transference and countertransference in art therapy." *American Journal of Art Therapy 21,* 1, 3–24.

Aldridge, D. (1993) "Artists or psychotherapists?" *The Arts in Psychotherapy 20*, 3, 199–200.

Aldridge, F. (1998) "Chocolate or shit: Aesthetics and cultural poverty in art therapy with children." *Inscape: Journal of the British Art Therapy Association 3,* 1, 2–9.

Aldridge, D., Brandt, G. and Wohler, D. (1990) "Toward a common language among the creative art therapies." *The Arts in Psychotherapy 17*, 3, 189–95.

Allen, P.B. (1983) "Group art therapy in short-term hospital settings." *American Journal of Art Therapy 22,* 93–5.

Allen, P.B. (1985) "Integrating art therapy into an alcoholism treatment program." *American Journal of Art Therapy 24*, 1, 10–12.

Allen, P.B. (1992) "Artist-in-residence: An alternative to 'clinification' for art therapists." *Art Therapy: Journal of the American Art Therapy Association 9*, 1, 22–9.

Allen, P.B. (1995a) *Art is a way of knowing: A guide to self-knowledge and spiritual fulfillment through creativity.* Boston: Shambhala.

Allen, P.B. (1995b) "Coyote comes in from the cold: The evolution of the open studio concept." *Art Therapy: Journal of the American Art Therapy Association 12*, 3,161–6.

Alter-Muri, S.B. (1994) "Psychopathology of expression and the therapeutic value of exhibiting chronic clients" art: A case study." *Art Therapy: Journal of the American Art Therapy Association11*, 3, 219–24.

Alter-Muri, S.B. (1996) "Dali to Beuys: Incorporating art history into art therapy treatment plans." *Art Therapy: Journal of the American Art Therapy Association 3*, 2, 102–7.

Alter-Muri, S.B. (1998). "Texture in the melting pot: Postmodernist art and art therapy." *Art Therapy: Journal of the American Art Therapy Association 15*, 4, 245–51.

Andrus, L. (1990) "Art therapy education: A tool for developing verbal skills." *Art Therapy: Journal of the American Art Therapy Association 7*, 1, 29–38.

Arnheim, R. (1969) *Visual Thinking.* Berkeley, CA: University of California Press.

Arnheim, R. (1980) 'Art as therapy'. *The Arts in Psychotherapy 7*, 4, 247–51.

Arnheim, R. (1990) 'The artist as healer'. *The Arts in Psychotherapy 17,* 1, 1–4.

Arnheim, R. (1992) "Why aesthetics is needed." *The Arts in Psychotherapy 19,* 3, 149–51.

Arnott, B. and Gushin, J. (1976) "Film making as a therapeutic tool." *American Journal of Art Therapy 16,* 1, 29–33.

Atkins, R. (1990) *Art speak.* New York: Abbeville Press.

Audette, A. H. (1993) *The blank canvas: Inviting the muse.* Boston: Shambhala.

Ault, R.E. (1977) "Are you an artist or a therapist – A professional dilemma of art therapists. In R. Shoemaker and S. Gonick-Barris (eds) *Proceedings of the 7th Annual American Art Therapy Association Conference,* 55–56. Baltimore, MD: AATA.

Ault, R. E. (1988) "Art therapy in the great American wasteland; Implications for business and industry and the economic structures of society." In R. E. Ault, G. C. Barlow, M. Junge, and B. Moon, "Social applications of the arts." *Art Therapy: Journal of the American Art Therapy Association 5,* 1, 10–21.

Ault, R.E. (1989) "Art therapy with the unidentified patient." In H. Wadeson, J. Durkin and D. Perach (eds) *Advances in Art Therapy.* New York: John Wiley and Sons.

Ault, R.E. (1994) "How will the profession of art therapy change in the next 25 years? Responses by past award winners: In search of a vision." *Art Therapy: Journal of the American Art Therapy Association 11,* 4, 251–3.

Bachelard, G. (1958) *The Poetics of Space.* Boston: Beacon Press.

Banks, J. (1997) *Educating Citizens in a Multicultural Society.* NY: Teacher"s College Press.

Bayles, D. and Orland, T. (1993) *Art and fear: Observations on the perils (and rewards) of artmaking.* Santa Barbara, CA: Capra Press.

Beard, F. (1979) "One man"s treat is another man"s treatment." *American Journal of Art Therapy 18,* 2, 59–60.

Becker, C. (ed.) (1994) *The subversive imagination: Artists, society, and social responsibility.* London: Routledge.

Becker, C. (1996) *Zones of contention: Essays on art, institutions, gender, and anxiety.* New York: State University of New York Press.

Betensky, M. (1973) *Self-Discovery Through Self-Expression.* Springfield, IL: Charles C. Thomas.

Betensky, M. (1987) "Phenomenology of therapeutic art expression and art therapy." In J. Rubin (ed.) *Approaches to art therapy; Theory and technique.* New York: Brunner/Mazel.

Betensky, M. (1995) *What Do You See? Phenomenology of Therapeutic Art Expression.* London: Jessica Kingsley Publishers.

Bloomgarden, J. (1998) "Validating art therapists" tacit knowing: The heuristic experience." *Art Therapy: Journal of the American Art Therapy Association 15,* 1, 51–4.

Bloomgarden, J. (2000) "Drawing on questions." *Art Therapy: Journal of the American Art Therapy Association 17,* 3,183–87.

Boegel, K. and Marissing, L. V. (1991) "The healing qualities of art." *Art Therapy: Journal of the American Art Therapy Association 8,* 1, 12–5.

Boenheim, C. and Stone, B. (1969) "Pictorial dialogues: Notes on a technique." *Bulletin of Art Therapy 8,* 2, 67–9.

Boston, C.G. and Short, G.M. (1998) "Art therapy: An Afrocentric approach." In A.R. Hiscox and A.C. Calisch (eds) *Tapestry of Cultural Issues in Art Therapy.* London: Jessica Kingsley Publishers.

Bouchard, R. (1998) "Art therapy and its shadow: A Jungian perspective on professional identity and community." *Art Therapy: Journal of the American Art Therapy Association 15*, 3, 158–64.

Brand, P. Z. (1995) "Revising the aesthetic-nonaesthetic distinction: The aesthetic value of activist art." In P. Z. Brand and C. Korsmeyer (eds) *Feminism and Tradition in Aesthetics.* University Park, PA: The Pennsylvania State University Press.

Brederode, A. (1999) "Layer upon layer: A healing experience in the art studio." In S.K. Levine and E.G. Levine (eds) *Foundations of Expressive Arts Therapy: Theoretical and Clinical Perspectives.* London: Jessica Kingsley Publishers.

Brenson, M. (1995) "Where do we go from here? Securing a place for the artist in society." In C. Becker and A. Wiens (eds) *The Artist in Society: Rights, Roles, and Responsibilities.* Chicago: New Art Examiner Press.

Burt, H. (1996) "Beyond practice: A postmodern feminist perspective on art therapy research." *Art Therapy: Journal of the American Art Therapy Association 13*, 1, 12–19.

Byrne, P. (1995) "From the depths to the surface: Art therapy as a discursive practice in the post-modern era." *The Arts in Psychotherapy 22*, 3, 235–9.

Cahn, E. (2000) "Proposal for a studio-based art therapy education." *Art Therapy: Journal of the American Art Therapy Association 17,* 3, 177–182.

Cane, F. (1983) *The Artist in Each of Us.* (Rev. ed.), Craftsbury Common, VT: Art Therapy Publications.

Case, C. (1990) "The triangular relationship (3): Heart forms – the image as mediator." *Inscape: Journal of the British Art Therapy Association,* winter, 20–6.

Case, C. (1996) "On the aesthetic moment in the transference." *Inscape: Journal of the British Art Therapy Association 1,* 2, 39–45.

Case, C. and Dalley, T. (1992) *The Handbook of Art Therapy.* London: Routledge.

Cassou, M. and Cubley, S. (1995) *Life, Paint and Passion: Reclaiming the Magic of Spontaneous Expression.* New York: G. P. Putnam's Sons.

Cather, W. (1943) *The Song of the Lark.* Boston: Houghton Mifflin.

Cattaneo, M. (1994) "Addressing culture and values in the training of art therapists." *Art Therapy, Journal of the American Art Therapy Association 11,* 3, 184–6.

Champernowne, H. I. (1971) "Art and therapy: An uneasy partnership." *American Journal of Art Therapy 10,* 3, 131–44.

Cheney, J. (1993) "The development of Camarillo State Hospital's art therapy / fine arts discovery studio." In E. Virshup (ed.) *California Art Therapy Trends.* Chicago: Magnolia Street Publishers.

Chicago, J. (1975). *Through the Flower: My Struggle as a Woman Artist.* New York: Penguin Books.

Ciornai, S. (1983) "Art therapy with working class Latino women." *Arts in Psychotherapy 10,* 2, 63–76.

Clarkson, G. and Geller, J. D. (1996) "The Bonny Method from a psychoanalytic perspective: insights from working with a psychoanalytic psychotherapist in a guided imagery and music series." *The Arts in Psychotherapy 23,* 4, 311–9.

Cohen, B.M. and Cox, C. T. (1995) *Telling Without Talking: Art as a Window into the World of Multiple Personality.* New York: W. W. Norton & Company.

Cohen-Cruz, J. (1995) "The American festival project: Performing difference, discovering common ground." In N. Felshin (ed.) *But is it Art? The Spirit of Art as Activism.* Seattle: Bay Press.

Colli, L. M. (1994) "Aims in therapy and directives in society: Observations on individuation and adaptation." *The Arts in Psychotherapy 21,* 2, 107–12.

Costello-Du Bois, J. (1989) "Drawing out the unique beauty: Portraits." *Art Therapy: Journal of the American Art Therapy Association 6,* 2, 67–70.

Crosson, C. W. (1982) "Creative block: A brief inquiry." *Arts in Psychotherapy 9, 4,* 259–62.

Dalley, T., Case, C., Schaverien, J., Weir, F., Halliday, D., Hall, P. N., and Waller, D. (1987) *Images of Art Therapy; New Developments in Theory and Practice.* London: Routledge.

Davis, J. (1997) "Building from the scraps: Art therapy within a homeless community." *Art Therapy: Journal of the American Art Therapy Association 14,* 3, 210–3.

Davis, J. (1999) "Environmental art therapy – metaphors in the field." *The Arts in Psychotherapy 26,* 1, 45–49.

DeBrular, D. (1993) "Nest building: Children recovering themselves through art." *Proceedings of the America Art Therapy Association 24th Annual Conference,* 63. Mundelein, IL: American Art Therapy Association.

Deco, S. (1998) "Return to the open studio group: Art therapy groups in acute psychiatry." In S. Skaife and V. Huet (eds) *Art Psychotherapy Groups: Between Pictures and Words.* London: Routledge.

de Knegt, H. (1978) "The evolution of an art therapy intern's view of therapeutic process." *American Journal of Art Therapy 17,* 3, 91–7.

Devereaux, M. (1995) "Oppressive texts, resisting readers, and the gendered spectator: The new aesthetics." In P.Z. Brand and C. Korsmeyer (eds) *Feminism and Tradition in Aesthetics.* University Park, PA: The Pennsylvania State University.

Dissanayake, E. (1988) *What is Art For?* Seattle, WA: University of Washington Press.

Dissanayake, E. (1992) *Homoaestheticus: Where Art Comes From and Why.* New York: The Free Press.

Domash, L. (1981) "Facilitating the creativity of the psychotherapist." *The Arts in Psychotherapy 8,* 3/4, 157–163.

Dougherty, C. A. (1974) "Group art therapy: A Jungian approach." *American Journal of Art Therapy 13,* 3, 229–36.

Durkin, J., Perach, D., Ramseyer, J., and Sontag, E. (1989) "A model for art therapy supervision enhanced through art making and journal writing." In H. Wadeson, J. Durkin and D. Perach (eds) *Advances in Art Therapy.* New York: John Wiley & Sons.

Edwards, D. (1992) "Certainty and uncertainty in art therapy practice." *Inscape: Journal of the British Art Therapy Association,* spring, 2–7.

Edwards, D. (1993) "Putting principles into practice." *Inscape: Journal of the British Art Therapy Association,* winter, 15–23.

Edwards, M. (1987) "Jungian analytic art therapy." In J. Rubin (ed.), *Approaches to Art Therapy.* New York: Brunner / Mazel.

Escobar, E. (1994) "The heuristic power of art." In C. Becker (ed.) *The Subversive Imagination: Artists, Society & Social Responsibility.* London: Routledge.

Esman, A. H. (1988) "Art and psychopathology: The message of outsider art." *American Journal of Art Therapy 27,* 1, 13–21.

Feder, B. and Feder, E. (1998) *The Art and Science of Evaluation in the Arts Therapies: How Do You Know What's Working?* Springfield, IL: Charles C. Thomas.

Feen-Calligan, H. (1995) "The use of art therapy in treatment programs to promote spiritual recovery from addiction." *Art Therapy: Journal of the American Art Therapy Association 12*, 1, 46–50.

Feen-Calligan, H. (2000) "Professing the creative process while striving to maintain ideals." *Art Therapy: Journal of the American Art Therapy Association 17*, 2, 82–86.

Feen-Calligan, H. and Sands-Goldstein, M. (1996) "A picture of our beginnings: The artwork of art therapy pioneers." *American Journal of Art Therapy 35*, 2, 43–53.

Felshin, N. (ed.) (1995) *But is it Art? The Spirit of Art as Activism.* Seattle, WA: Bay Press.

Felski, R. (1995) "Why feminism doesn't need an aesthetic (and why it can't ignore aesthetics)." In P.Z. Brand and C. Korsmeyer (eds) *Feminism and Tradition in Aesthetics.* University Park, PA: The Pennsylvania State University.

Fish, B. (1989) "Addressing countertransference through image making." In H. Wadeson, J. Durkin, and D. Perach (eds) *Advances in Art Therapy.* New York: John Wiley & Sons.

Fitzgerald, A. (1996) *An Artist's Book of Inspiration: A Collection of Thoughts on Art, Artists, and Creativity.* Hudson, NY: Lindisfarne Press.

Fleming, M. M. (1993) "From clinician to artist; From artist to clinician, part I: A personal account." *American Journal of Art Therapy 31*, 3, 70–75.

Fleming, M. M. (1998) "Exhibiting your artwork." In M. Lachman-Chapin, D. L. Jones, T. L. Sweig, B. M. Cohen, S. S. Semekoski, and M. M. Fleming "Connecting with the art world: Expanding beyond the mental health world.' *Art Therapy: Journal of the American Art Therapy Association 15*, 4, 241–243.

Franklin, M. (1981) "Terminating art therapy with emotionally disturbed children." *American Journal of Art Therapy 20*, 2, 55–57.

Franklin, M. (1990) "The esthetic attitude and empathy: A point of convergence." *The American Journal of Art Therapy 29*, 2, 42–47.

Franklin, M. (1992) "Art therapy and self-esteem." *Art Therapy: Journal of the American Art Therapy Association 9, 2,* 78–84.

Franklin, M. (1993) "AIDS iconography and cultural transformation: Visual and artistic responses to the AIDS crisis." *The Arts in Psychotherapy 20*, 4, 299–316.

Franklin, M. (1996) "A place to stand: Maori culture-tradition in a contemporary art studio." *Art Therapy: Journal of the American Art Therapy Association 13*, 2, 126–30.

Franklin, M., Farelly-Hansen, M., Marek, B., Swan-Foster, N., and Wallingsford, S. (2000). "Transpersonal art therapy education." *Art Therapy: Journal of the American Art Therapy Association 17*, 2, 101–10.

Franklin, M., Moon, C., Vance, L., and Vick, R. (1998) "Something offered, something received: An artistic exchange." *Proceedings of the American Art Therapy Association 29th Annual Conference,* 174. Mundelein, IL: American Art Therapy Association.

Franklin, M., Moon, C., Vance, L., and Vick, R. (2000) 'In transit: A continuing exchange.' *Proceedings of the American Art Therapy Association 31st Annual Conference,* 159. Mundelein, IL: American Art Therapy Association.

Franklin, M., and Politsky, R. (1992) "The problem of interpretation: Implications and strategies for the field of art therapy." *Arts in Psychotherapy 19*, 3, 163–75.

Franklin, M. B. (1994) 'A feeling for words: Arnheim on language.' *The Arts in Psychotherapy 21*, 4, 261–7.

Gablik, S. (1991) *The Reenchantment of Art*. New York: Thames & Hudson.

Gablik, S. (1995) *Conversations Before the End of Time: Dialogues on Art, Life and Spiritual Renewal*. New York: Thames & Hudson.

Gantt, L. (1979) "The other side of art therapy." *American Journal of Art Therapy 19*, 1, 11–18.

Gantt, L. (1985) "Comment." *American Journal of Art Therapy 23*, 4, 125.

Gantt, L., Goodman, R. F., Williams, K., and Agell, G. (1997) "Prescriptions for the future." *American Journal of Art Therapy 36*, 2, 31–48.

Gardner, H. (1993) *Multiple Intelligences: The Theory in Practice*. New York: Basic Books.

Gerrity, L. (2000) "The subversive art therapist: Embracing cultural diversity in the art room." *Art Therapy: Journal of the American Art Therapy Association 17*, 3, 202–6.

Gilroy, A. (1989) "On occasionally being able to paint." *Inscape: Journal of the British Art Therapy Association*, spring, 2–9.

Gold, A. (1998) *Painting from the Source: Awakening the Artist's Soul in Everyone*. New York: Harper Collins.

Goldenberg, I. and Goldenberg, H. (2000) *Family Therapy: An Overview*. (5th ed), Belmont, CA: Wadsworth.

Gomez-Pena, G. (1995) "From art-mageddon to gringostroika: A manifesto against censorship." In S. Lacy (ed.) *Mapping the Terrain: New Genre Public Art*. Seattle, WA: Bay Press.

Good, D. A. (1994) "How will the profession of art therapy change in the next 25 years? Responses of past award winners: Art therapy and changing times." *Art Therapy: Journal of the American Art Therapy Association 11*, 4, 256–7.

Goodman, N. (1981) *Languages of Art: An Approach to a Theory of Symbols*.

Goodman, R., Williams, K., Agell, G., and Gantt, L. (1998) "Talk, talk, talk, when do we draw?" *American Journal of Art Therapy 37*, 2, 39–65.

Haeseler, M.P. (1987) "Censorship or intervention: But you said we could draw whatever we wanted!" *American Journal of Art Therapy 26*, 1, 11–20.

Haeseler, M.P. (1988) "Outsider art: A point of view." *American Journal of Art Therapy, 26*, 3, 83–8.

Haeseler, M.P. (1989) 'Should art therapists create artwork alongside their clients?" *American Journal of Art Therapy 27*, 3, 70–9.

Hall, N. (1999) "Letter to the editor." *Art Therapy: Journal of the American Art Therapy Association, 16*, 1, 4–5.

Hanes, M. J. (1998) "Abstract imagery in art therapy : What does it mean?" *Art Therapy: Journal of the American Art Therapy Association 15*, 3, 185–90.

Hannah, C.M. (1992) 'Healing arts: A mural on mental illness and wellness." *American Journal of Art Therapy 31*, 2, 34–9.

Henley, D. (1992a) "Aesthetics in art therapy: Theory into practice." *The Arts in Psychotherapy 19*, 3, 153–61.

Henley, D. (1992b) *Exceptional Children Exceptional Art: Teaching Art to Special Needs*. Worcester, MA: Davis Publications.

Henley, D. (1992c) "Facilitating artistic expression in captive mammals: Implications for art therapy and art empathicism." *Art Therapy: Journal of the American Art Therapy Association 9*, 4, 178–92.

Henley, D. (1993) "Mu!: Four prose poems on Zen in art therapy." *Proceedings of the American Art Therapy Association 24th Annual Conference,* 108. Mundelein, IL: American Art Therapy Association.

Henley, D. (1995a) "A consideration of the studio as therapeutic intervention." *Art Therapy 12,* 3, 188–90.

Henley, D. (1995b) "Political correctness in the artroom: Pushing the limits of artistic license." *Art Education,* 57–66.

Henley, D. (1997a) "Art of disturbation: Provocation and censorship in art education." *Art Education,* September, 39–45.

Henley, D. (1997b) "Expressive art therapy as alternative education: Devising a therapeutic curriculum." *Art Therapy: Journal of the American Art Therapy Association 14,* 1, 15–22.

Henley, D. (1998) "The child as art therapist: Poetic rantings on the descent into madness and healing." *Proceedings of the American Art Therapy Association 29th Annual Conference,* 137. Mundelein, IL: American Art Therapy Association.

Hillman, J. (1972) *The Myth of Analysis.* New York: Harper Perennial.

Hillman, J. (1975) *Re-visioning Psychology.* New York: Harper & Row.

Hillman, J. (Speaker) (1993) *It Ain't Broke, and Besides You Can't Fix It.* (Cassette Recording No. 45–143) Mundelein, IL: American Art Therapy Association.

Hillman, J. (1995) "When you're healed, send me a postcard." In S. Gablik (ed.) *Conversations Before the End of Time: Dialogues on Art, Life & Spiritual Renewal.* London: Thames & Hudson.

Hillman, J. and Ventura, M. (1992) *We've Had a Hundred Years of Psychotherapy and the World's Getting Worse.* San Francisco: Harper Collins.

Hogan, S. (ed.) (1997) *Feminist Approaches to Art Therapy.* London: Routledge.

Hooks, B. (1995) *Art on My Mind: Visual Politics.* New York: The New Press.

Horovitz, E. G. (1999) *A Leap of Faith: The Call to Art.* Springfield, IL: Charles C. Thomas.

Jones, D. (1983) "An art therapist's personal record." *Art Therapy: Journal of the American Art Therapy Association 1,* 1, 22–5.

Jones, M. (1997) "Alice, Dora and Constance from the eve of history." In S. Hogan (ed.), *Feminist Approaches to Art Therapy.* London: Routledge.

Jordan, J. V. (1991) "Empathy and self boundaries." In J.V. Jordan, A.G. Kaplan, J.B. Miller, I.P. Stiver, and J.L. Surrey, *Women's Growth in Connection.* New York: Guilford Press.

Joyce, S. (1997) "Feminist-perspective art therapy: An option for women's mental health – an Australian perspective." In S. Hogan (ed.) *Feminist Approaches to Art Therapy.* London: Routledge.

Julliard, K.N. and Van Den Heuvel, G. (1999) "Susan K. Langer and the foundations of art therapy." *Art Therapy: Journal of the American Art Therapy Association 16,* 3, 112–20

Junge, M.B. (1988) "An inquiry into women and creativity including two case studies of the artists Frida Kahlo and Diane Arbus." *Art Therapy: Journal of the American Art Therapy Association 5,* 3, 79–93.

Junge, M.B. (1999) "Mourning, memory and life itself: The AIDS quilt and the Vietnam veterans' memorial wall." *The Arts in Psychotherapy 26,* 3, 195–203.

Junge, M.B., Alvarez, J.F., Kellogg, A., and Volker, C. (1993) "The art therapist as social activist: Reflections and visions." *Art Therapy: Journal of the American Art Therapy Association 10,* 3, 148–55.

Junge, M.B. and Asawa, P.P. (1994) *A History of Art Therapy in the United States.* Mundelein, IL: American Art Therapy Association.

Junge, M.B. and Linesch, D. (1992). "Art therapists' ways of knowing: Toward creativity and new paradigms for art therapy research." In H. Wadeson (ed.) *A Guide to Conducting Art Therapy Research.* Mundelein, IL: The American Art Therapy Association.

Junge, M.B. and Linesch, D. (1993) "Our own voices: New paradigms for art therapy research." *The Arts in Psychotherapy 20,* 1, 61–7.

Kapitan, L. (1997) "Making or breaking: Art therapy in the shifting tides of a violent culture." *Art Therapy: Journal of the American Art Therapy Association 14,* 4, 255–60.

Kapitan, L. (1998) "In pursuit of the irresistible: Art therapy research in the hunting tradition." *Art Therapy: Journal of the American Art Therapy Association 15,* 1, 22–8.

Kapitan, L. (2000) "Playing chaos into coherence: Educating the postmodern art therapist." *Art Therapy: Journal of the American Art Therapy Association 17,* 2, 111–7.

Kaplan, F.F. (1983) "Drawing together: Therapeutic use of the wish to merge." *American Journal of Art Therapy 22,* 3, 79–85.

Kaplan, M. (1983) "A woman's view of DSMIII." *American Psychologist 38,* 786–92.

Kaufman, A. B. (1996) "Art in boxes: An exploration of meanings." *The Arts in Psychotherapy 23,* 3, 237–47.

Kellen-Taylor, M. (1998) "Imagination and the world: A call for ecological expressive therapies. *The Arts in Psychotherapy 25,* 5, 303–11.

Kern-Pilch, K. (1980) "Anne: An illustrated case of art therapy with a terminally ill patient." *American Journal of Art Therapy 20,* 1, 3–11.

Keyes, M.F. (1974) *Inward Journey: Art as Therapy.* Millbrae, CA: Celestial Arts.

Kielo, J. (1991) "Art therapists' countertransference and post-session imagery." *Art Therapy: Journal of the American Art Therapy Association 8,* 2, 14–19.

Klorer, P.G. (2000) *Expressive Therapy with Troubled Children.* Northvale, NJ: Jason Aronson. *American Journal of Art Therapy 17,* 3, 91–7.

Knill, P.J. (1994) "Multiplicity as a tradition: Theories for interdisciplinary arts therapies – an overview." *The Arts in Psychotherapy 21,* 5, 319–28.

Knill, P.J. (1995) "The place of beauty in therapy and the arts." *The Arts in Psychotherapy 22,* 1, 1–7.

Knill, P.J. (1999) "Soul nourishment, or the intermodal language of imagination." In S.K. Levine, and E.G. Levine (eds) *Foundations of Expressive Arts Therapy.* London: Jessica Kingsley.

Knill, P.J., Barba, H.N., and Fuchs, M.N. (1995) *Minstrels of Soul: Intermodal Expressive Therapy.* Toronto, Canada: Palmerston Press.

Knowles, L.P. (1996) "Art therapists exhibiting children's art: When, where, and why. *Art Therapy: Journal of the American Art Therapy Association 13,* 3, 205–7.

Koodrin, B., Caulfield, G., and McGarr, A. (1994) "An informal interview with Edith Kramer." *Art Therapy: Journal of the American Art Therapy Association 11,* 3, 180–3.

Kramer, E. (1958) *Art Therapy in a Children's Community.* Springfield, IL: Charles C Thomas.

Kramer, E. (1961) "Art and emptiness: New problems in art education and art therapy." *Bulletin of Art Therapy 1,* 1, 7–16.

Kramer, E. (1963) "The problem of quality in art." *Bulletin of Art Therapy 3,* 1, 3–19.

Kramer, E. (1967). "The problem of quality in art II: Stereotypes." *Bulletin of Art Therapy 6,* 4, 151–71.

Kramer, E. (1971) *Art as Therapy with Children.* New York: Schocken Books.

Kramer, E. (1979) *Childhood and Art Therapy.* New York: Schocken Books.

Kramer, E. (1986) "The art therapist's third hand: Reflections on art, art therapy, and society at large." *American Journal of Art Therapy 24*, 3, 71–86.

Kramer, E. (1994) "How will the profession of art therapy change in the next 25 years? Responses by past award winners: We cannot look into the future without considering the past and present." *Art therapy: Journal of the American Art Therapy Association 11*, 2, 91–2.

Kramer, E. (1996) "Commencement address to the August, 1996, graduates of the master's of arts in art therapy program, Vermont College of Norwich University." *American Journal of Art Therapy 35*, 2, 39–41.

Kramer, E., Kwiatkowska, H., Lachman, M., Levy, B.I., Rhyne, J. and Ulman, E. (1974) "Symposium: Integration of divergent points of view in art therapy." *American Journal of Art Therapy 14*, 1, 13–17.

Kumar, S. (1995) "Ten thousand artists, not one master." In S. Gablik (ed.) *Conversations Before the End of Time: Dialogues on Art, Life & Spiritual Renewal.* New York: Thames and Hudson.

Kuryluk, E. (1994) "A plea for irresponsibility." In C. Becker (ed.) *The Subversive Imagination: Artists, Society, & Social Responsibility.* London: Routledge.

Lachman-Chapin, M. (1979). "Kohut's theories on narcissism: Implications for art therapy." *American Journal of Art Therapy 19*, 1, 3–9.

Lachman-Chapin, M. (1983a) "The artist as clinician: An interactive technique. *American Journal of Art Therapy 23*, 1, 13–25.

Lachman-Chapin, M. (1983b) Making verbal the nonverbal: A commentary. *Art Therapy: Journal of the American Art Therapy Association 1*, 1, 47–9.

Lachman-Chapin, M. (1985) "Ericksonian hypnosis and art therapy." *American Journal of Art Therapy 23*, 4, 115–124.

Lachman-Chapin, M. (1987) "A self-psychology approach to art therapy." In J. Rubin (ed.) *Approaches to Art Therapy: Theory and Techniques.* New York: Brunner/Mazel.

Lachman-Chapin, M. (1993a) "The art therapist as exhibiting artist: Messages from Joseph Beuys, Suzi Gablik, and Donald Kuspit." *Art Therapy: Journal of the American Art Therapy Association 10*, 3, 141–7.

Lachman-Chapin, M. (1993b) "From clinician to artist: From artist to clinician part II: Another perspective." *American Journal of Art Therapy 31*, 3, 76–80.

Lachman-Chapin, M. (1998) "Connecting with the art world: Exploring beyond the mental health world." *Art Therapy: Journal of the American Art Therapy Association 15*, 4, 233–244.

Lachman-Chapin, M. (2000). Is art therapy a profession or an idea? *Art Therapy: Journal of the American Art Therapy Association 17*, 11–13.

Lacy, S. (ed.) (1995) *Mapping the Terrain: New Genre Public Art.* Seattle, WA: Bay Press.

Landgarten, H. (1981) *Clinical Art Therapy: A Comprehensive Guide.* New York: Brunner/Mazel.

Lanham, R. (1989) "Is it art or art therapy?" *Inscape: Journal of the British Art Therapy Association,* spring, 18–22.

Lanham, R. (1998) "The life and soul of the image." *Inscape: Journal of the British Art Therapy Association 3*, 2, 48–55.

Lavery, T.P. (1994) "Culture shock: Adventuring into the inner city through post- session imagery. *American Journal of Art Therapy 33*, 1, 14–20.

Learmonth, M. (1994) "Witness and witnessing in art therapy." *Inscape: Journal of the British Art Therapy Association 1*, 19–22.

Levine, E.G. (1989) "Women and creativity: Art in relationship." *American Journal of Art Therapy 16*, 4, 309–25.

Levine, E.G. (1995) *Tending the Fire: Studies in Art, Therapy, and Creativity.* Toronto, Canada: Palmerston Press.

Levine, S.K. (1992) *Poiesis: The Language of Psychology and the Speech of the Soul.* "Toronto, Canada: Palmerston Press.

Levine, S.K. (1996). "Expressive arts therapy: A call for dialogue." *The Arts in Psychotherapy 23*, 5, 431–4.

Levine, S.K. and Levine, E.G. (1999) *Foundations of Expressive Arts Therapy: Theoretical and Clinical Perspectives.* London: Jessica Kingsley Publishers.

Linesch, D. (1994) "Interpretation in art therapy research and practice: The hermeneutic circle." *The Arts in Psychotherapy 21*, 3, 185–95.

Lippard, L.R. (1990) *Mixed Blessings: New Art in Multicultural America.* New York: Pantheon Books.

Lippard, L.R. (1995a) "Looking around: Where we are, where we could be." In S. Lacy (ed.) *Mapping the Terrain: New Genre Public Art.* Seattle: Bay Press.

Lippard, L.R. (1995b) *The Pink Glass Swan: Selected Feminist Essays on Art.* New York: The New Press.

Lippard, L.R. (1997) *The Lure of the Local: Senses of Place in a Multicentered Society.* New York: The New Press.

Lishinsky, S. (1972) "Rehabilitative use of art in a community mental health center." *America Journal of Art Therapy 11*, 4, 173–83.

London, P. (1989) *No More Secondhand Art: Awakening the Artist Within.* Boston: Shambhala.

London, P. (1992) "Art as transformation." *Art Education,* May, 8–15.

Lupton, D. (1997) "Foreword." In Hogan, S. (ed.) *Feminist Approaches to Art Therapy.* London: Routledge.

Lusebrink, V.B. (1990) *Imagery and Visual Expression in Therapy.* New York: Plenum Publishing.

Luzzatto, P. (1997) "Short-term art therapy on the acute psychiatric ward: The open session as a psychodynamic development of the studio-based approach." *Inscape: Journal of the British Art Therapy Association 2,* 1, 2–10.

Maclagan, D. (1982). "Creativity – cultivated and wild." *Inscape: Journal of the British Art Therapy Association,* May, 10–13.

Maclagan, D. (1989). "The aesthetic dimension of art therapy: Luxury or necessity?" *Inscape: Journal of the British Art Therapy Association,* Spring, 10–13.

Maclagan, D. (1994) "Between the aesthetic and the psychological." *Inscape: Journal of the British Art Therapy Association 2,* 49–51.

Maclagan, D. (1995) "Fantasy and the aesthetic: Have they become the uninvited guests at art therapy's feast?" *The Arts in Psychotherapy 22,* 3, 217–21.

Maclagan, D. (1999) "Getting the feel: Problems of research in the fields of psychological aesthetics and art therapy." *The Arts in Psychotherapy 26,* 5, 303–11.

Majozo, E. C. (1995) "To search for the good and make it matter." In S. Lacy (ed.) *Mapping the Terrain: New Genre Public Art.* Seattle, WA: Bay Press.

Malchiodi, C.A. (1994) "How will the profession of art therapy change in the next 25 years? Responses by past award winners: Looking ahead." *Art Therapy: Journal of the American Art Therapy Association 1,* 4, 257–9.

Malchiodi, C.A. (1995a) "Does a lack of art therapy research hold us back?" *Art Therapy: Journal of the American Art Therapy Association 12*, 4, 218–19.

Malchiodi, C.A. (1995b) "Studio approaches to art therapy." *Art Therapy: Journal of the American Art Therapy Association 12*, 3, 154–6.

Malchiodi, C.A. (1998) *The Art Therapy Sourcebook.* Los Angeles: Lowell House.

Malchiodi, C.A. (1999a) "Artists and clinicians: Can we be both?" *Art Therapy: Journal of the American Art Therapy Association 16*, 3, 110–11.

Malchiodi, C.A. (1999b) "The artist's way: Is it the art therapist's way?" *Art Therapy: Journal of the American Art Therapy Association 16*, 1, 2–3.

Malchiodi, C.A. (2000) "Authority or advocacy: Art therapy in service of self or others?" *Art Therapy: Journal of the American Art Therapy Association 17*, 3, 158–9.

Malchiodi, C.A. and Catteneo, M.K. (1988) "Creative process / therapeutic process: Parallels and interfaces." *Art Therapy: Journal of the American Art Therapy Association 5*, 2, 52–8.

Malchiodi, C.A. and Riley, S. (1996) *Supervision and Related Issues: A Handbook for Professionals.* Chicago: Magnolia Street Publishers.

Martin, S. A. (1988) "Martin Ramirez: Psychological hero." *The Arts in Psychotherapy 15*, 3, 189–205.

McComas, C. K. and McComas, P. (1996) "Now I know my ABCs – dramatization of adolescent-onset schizophrenia." *Proceedings of the American Art Therapy Association 27th Annual Conference,* 216. Mundelein, IL: American Art Therapy Association.

McComas, C. K. and McComas, P. (1998) "Unplugged: Near-death, new life and the art of healing." *Proceedings of the American Art Therapy Association 29th Annual Conference,* 161. Mundelein, IL: American Art Therapy Association.

McGraw, M. (1995) "The art studio: a studio based art therapy program." *Art Therapy: Journal of the American Art Therapy Association 12*, 3, 167–74.

McMahan, J. (1989) "An interview with Edith Kramer." *American Journal of Art Therapy 27*, 4, 107–114.

McNeil, E. (1983). "Viewpoint." *Art Therapy: Journal of the American Art Therapy Association 1*, 1, 52.

McNeilly, G. (1983) "Directive and nondirective approaches to art therapy." *The Arts in Psychotherapy 10*, 4, 211–219.

McNiff, S. (1981) *The Arts and Psychotherapy.* Springfield, IL: Charles C. Thomas.

McNiff, S. (1986a) "A dialogue with James Hillman." *Art Therapy: Journal of the American Art Therapy Association 3*, 3, 99–110.

McNiff, S. (1986b) *Educating the Creative Arts Therapist: A Profile of the Profession.* Springfield, IL: Charles C Thomas.

McNiff, S. (1991) "Ethics and the autonomy of images." *The Arts in psychotherapy 18*, 4, 277–83.

McNiff, S. (1992) *Art as Medicine: Creating a Therapy of the Imagination.* Boston: Shambhala.

McNiff, S. (1993) "The authority of experience." *The Arts in Psychotherapy 20*, 1, 3- 9.

McNiff, S. (1995) "Keeping the studio." *Art Therapy: Journal of the American Art Therapy Association 12*, 3, 179–83.

McNiff, S. (1998a) *Art-Based Research.* London: Jessica Kingsley Publishers.

McNiff, S. (1998b). "Enlarging the vision of art therapy research." *Art Therapy 15*, 2, 86–92.

McNiff, S. (1998c) *Trust the Process: An Artist's Guide to Letting Go.* Boston: Shambhala.

Minar, V., Gantt, L., Gussak, D., Rauch, T.M. and Vick, R. (1997). "Commitment to service: A professional responsibility." *Proceedings of the 28th Annual Conference of the American Art Therapy Association,* 146. Mundelein, IL: AATA.

Mitchell, J. (1970) "Big yellow taxi. "On *Ladies of the Canyon* [CD]. New York: Warner Brothers (1987)

Mohacsy, I. (1995) "Nonverbal communication and its place in the therapy session." *The Arts in Psychotherapy 22,* 1, 31–8.

Moon, B.L. (1990) *Existential Art Therapy: The Canvas Mirror.* Springfield, IL: Charles C. Thomas.

Moon, B.L. (1992) *Essentials of Art Therapy Training and Practice.* Springfield, IL: Charles C. Thomas.

Moon, B.L. (1994) *Introduction to Art Therapy: Faith in the Product.* Springfield, IL: Charles C. Thomas.

Moon, B. L. (1995) "Four lives: A folk musical." *Proceedings of the American Art Therapy Association 26th Annual Conference,* 150. Mundelein, IL: American Art Therapy Association.

Moon, B. L. (1996) "A razor in his heart." *Proceedings of the American Art Therapy Association 27th Annual Conference,* 190. Mundelein, IL: American Art Therapy Association.

Moon, B. L. (1997a) *Art and Soul: Reflections on an Artistic Psychology.* Springfield, IL: Charles C. Thomas.

Moon, B. L. (1997b) "Welcome to the studio: The role of responsive art making in art therapy." Unpublished doctoral dissertation, Union Institute, Cincinnati, Ohio.

Moon, B.L. (1998) *The Dynamics of Art as Therapy with Adolescents.* Springfield, IL: Charles C. Thomas.

Moon, B. L. (1999). "The tears make me paint: The role of responsive artmaking in adolescent art therapy." *Art Therapy: Journal of the American Art Therapy Association 16,* 2, 78–82.

Moon, B. L. and Schoenholtz, B. (1998) "Songs from the studio: A responsive art performance." *Proceedings of the American Art Therapy Association 29th Annual Conference,* 180. Mundelein, IL: American Art Therapy Association.

Moon, C. (1988) "Words beyond words: Articulation of the art therapy experience." *Proceedings of the American Art Therapy Association 19th Annual Conference.* Mundelein, IL: American Art Therapy Association.

Moon, C. (1997a). "Art therapy: Creating the space we will live in." *Arts in Psychotherapy 24,* 1, 45–50.

Moon, C. (1997b) "Making art from the bits and pieces of lives discarded." *Proceedings of the American Art Therapy Association 28th Annual Conference,* 174. Mundelein, IL: American Art Therapy Association.

Moon, C. (1999) Book review of *An artist's book of inspiration: A collection of thoughts on art, artists, and creativity. Art Therapy: Journal of the American Art Therapy Association 16,* 3, 150–151.

Moon, C. (2000) "Art therapy, profession or idea? A feminist aesthetic perspective." *Art Therapy: Journal of the American Art Therapy Association 17,* 1, 7–10.

Moon, C. (2001) "Prayer, sacrament, and grace." In M. Farelly-Hansen (ed.) *Spirituality and Art Therapy: Living the Connection.* London: Jessica Kingsley Publishers.

Moustakas, C.E. (1995) *Being-In, Being-For, Being-With.* Northvale, NJ: Jason Aronson.

Museum of Contemporary Art, Chicago (1992) *Art at the Armory: Occupied Territory.* Chicago: Museum of Contemporary Art.

Museum of Contemporary Art, Chicago (1997) *Performance Anxiety.* Chicago: Museum of Contemporary Art.

Museum of Contemporary Art, San Diego (1997) *Blurring the Boundaries: Installation Art 1969–1996.* La Jolla, CA: Museum of Contemporary Art.

Naumburg, M. (1950) *Schizophrenic Art: Its Meaning in Psychotherapy.* New York: Grune & Stratton.

Naumburg, M. (1953) *Psychoneurotic Art: Its function in Psychotherapy.* New York: Grune & Stratton.

Nucho, A. (1987) *The Psychocybernetic Model of Art Therapy.* Springfield, IL: Charles C. Thomas.

O'Doherty, B. (1976) "Inside the white cube: Notes on the gallery space, part I." March, *Artforum.*

Olsen, T. (1965) *Silences.* New York: Dell Publishing.

Parouse, D. (Producer), and Yu, I. (Director). (1997) *The Living Museum.* New York: Home Box Office.

Parsons, P. (1986). "Outsider art: Patient art enters the art world." *American Journal of Art Therapy 25,* 1, 3–12.

Perdoux, M. (1996) "Art beyond humanism: Non-Western influences on an art therapist's practices." *Art Therapy: Journal of the American Art Therapy Association 13,* 4, 286–8.

Phillips, J. (1992) "Collaboration with one's client." *The Arts in Psychotherapy 19,* 4, 295–8.

Phillips, P.C. (1995). "Maintenance activity: Creating a climate for change." In n. Felshin (ed.) *But is it Art? The Spirit of Art as Activism.* Seattle, WA: Bay Press.

Pinderhughes, E. (1989) *Understanding Race, Ethnicity, & Power: The Key to Efficacy in Clinical Practice.* New York: The Free Press.

Politsky, R.H. (1995) "Acts of last resort: The analysis of offensive and controversial art in an age of cultural transition." *The Arts in Psychotherapy 22,* 2, 111–8.

Richards, M.C. (1995) "Foreword." In P. Allen, *Art is a Way of Knowing: A Guide to Self-knowledge and Personal Fulfillment Through Creativity.* Boston: Shambhala.

Rhyne, J. (1973a) "The gestalt approach to experience, art, and art therapy." *American Journal of Art Therapy 12,* 4, 237–248.

Rhyne, J. (1973b) *The Gestalt Art Experience.* Monteray, CA: Brooks / Cole.

Riley, S. (1993) "Illustrating the family story: Art therapy, a lens for viewing the family's reality." *The Arts in Psychotherapy 20,* 3, 253–64.

Riley, S. (1996) "An art therapy stress reduction group: For therapists dealing with a severely abused client population." *The Arts in Psychotherapy 23,* 5, 407–15.

Riley, S. (1997) "Social constructionism: The narrative approach and clinical art therapy." *Art Therapy: Journal of the American Art Therapy Association 14,* 282–4.

Riley, S. (2000). "Questions to which 'not knowing' is the answer: An exploration of an 'invented reality' called art therapy and the supporting structure known as the 'profession' of art therapy." *Art Therapy: Journal of the American Art Therapy Association 17,* 2, 87–9.

Riley, S., and Malchiodi, C.A. (1994). *Integrative Approaches to Family Art Therapy.* Chicago: Magnolia Street Publishers.

Riley-Hiscox, A. (1997) "Interview – Cliff Joseph: Art therapist, pioneer, artist." *Art Therapy: Journal of the American Art Therapy Association 14,* 4, 273–8.

Rinsley, D.B. (1980) *Treatment of the Severely Disturbed Adolescent.* New York: Jason Aronson.

Robbins, A. (1980) *Expressive Therapy: A Creative Arts Approach to Depth-Oriented Treatment*. New York: Human Sciences Press.

Robbins, A. (1987). *The Artist as Therapist*. New York: Human Sciences Press.

Robbins, A. (1988) "A psychoaesthetic perspective on creative arts therapy and training." *The Arts in Psychotherapy 15*, 2, 95–100.

Robbins, A. (1989) *The Psychoaesthetic Experience*. New York: Human Sciences Press.

Robbins, A. (1992) "The play of psychotherapeutic artistry and psychoaesthetics." *The Arts in Psychotherapy 19*, 3, 177–86.

Robbins, A. and Sibley, L.B. (1976) *Creative Art Therapy*. New York: Brunner/Mazel.

Rosner, I. (1982) "Art therapy with two quadriplegic patients." *American Journal of Art Therapy 21*, 4, 115–20.

Rubin, J.A. (1984) *The Art of Art Therapy*. New York: Brunner/Mazel.

Rubin, J.A. (1986) 'From psychopathology to psychotherapy through art expression:

A focus on Hans Prinzhorn and others. *Art Therapy: Journal of the American Art Therapy Association 3*, 1, 27–33.

Rubin, J.A. (ed.) (1987) *Approaches to Art Therapy: Theory and Technique*. New York: Brunner/Mazel.

Rubin, J.A. (1994) "My wishful vision of art therapy in the next 25 years." *Art Therapy: Journal of the American Art Therapy Association 11*, 4, 253–4.

Saar, B. and Saar. A. (1994) *Conjure Women of the Arts*. Film, Available from L & S Video Enterprises, Inc., Chappaqua, NY.

Sandel, S. (1987) "Moving into management." *The Arts in Psychotherapy 14*, 2, 109–12.

Sang, B.E. (1989) "Psychotherapy with women artists." *The Arts in Psychotherapy 16*, 4, 301–7.

Sarason, S.B. (1990) *The Challenge of Art to Psychology*. New Haven, CT: Yale University Press.

Schaverien, J. (1987) "The scapegoat and the talisman; Transference in art therapy." In T. Dalley, C. Case, J. Schaverien, F. Weir, D. Halliday, P. N. Hall and D. Waller, *Images of Art Therapy*. London: Routledge.

Schaverien, J. (1992) *The Revealing Image: Analytical Art Psychotherapy in Theory and Practice*. London: Tavistock/Routledge.

Schaverien, J. (1995) *Desire and the Female Therapist: Engendered Gazes in Psychotherapy and Art Therapy*. London: Routledge.

Seiden, D. (1997). "Personal art history." *Proceedings of the American Art Therapy Association 28th Annual Conference*, 113. Mundelein, IL: American Art Therapy Association.

Semekoski, S. (1998) "Connecting with the art world – Educational perspectives." In M. Lachman-Chapin, D. Jones, T. Sweig, B. Cohen, S. Semekoski and M. Fleming, "Connecting with the art world: Expanding beyond the mental health world." *Art Therapy: Journal of the American Art Therapy Association 15*, 4, 233–44.

Sexson, L. (1992) *Ordinarily Sacred*. Charlottsville, VA: University Press of Virginia.

Silver, R. (1975) "Children with communication disorders: Cognitive and artistic development." *American Journal of Art Therapy 14*, 2, 39–47.

Silver, R. (1976) "Using art to evaluate and develop cognitive skills." *American Journal of Art Therapy 16*, 1, 11–9.

Silver, R. (1987) "A cognitive approach to art therapy." In J. Rubin (ed.), *Approaches to Art Therapy: Theory and Technique*. New York: Brunner/Mazel.

Simon, R.M. (1982) "Peter: A severely disabled patient's triumph through art." *American Journal of Art Therapy 22,* 1, 13–5.

Skaife, S. (1995) "The dialectics of art therapy." *Inscape: Journal of the British Art Therapy Association 1,* 2–7.

Somer, L.B., and Somer, E. (2000) "Perspectives on the use of glass in therapy." *American Journal of Art Therapy 38,* 3, 75–80.

Spaniol, S. (1990a) "Exhibiting art by people with mental illness: Issues, process, and principles." *Art Therapy: Journal of the American Art Therapy Association 7,* 2, 70–8.

Spaniol, S. (1990b) *Organizing Exhibitions of Art by People with Mental Illness: A Step-By-Step Manuel.* Boston: Boston University Center for Psychiatric Rehabilitation.

Spaniol, S. (1994) "Confidentiality reexamined: Negotiating use of art by clients. *American Journal of Art Therapy 32,* 3, 69–74.

Spaniol, S. (1998) "Towards an ethnographic approach to art therapy research: People with psychiatric disability as collaborators." *Art Therapy: Journal of the American Art Therapy Association 15,* 1, 29–37.

Spaniol, S. (2000) "'The withering of the expert': Recovery through art." *Art Therapy 17,* 2, 78–79.

Spaniol, S. and Cattaneo, M. (1994) "The power of language in the art therapeutic relationship." *Art Therapy: Journal of the American Art Therapy Association 11,* 4, 266–70.

Speert, E. (1989) "Beyond psychic numbing: Child art therapy and the nuclear taboo." *Art Therapy: Journal of the American Art Therapy Association 6,* 3, 106–12.

Speert, E. (1993) "Women and art therapy." In E. Virshup (ed.) *California Art Therapy Trends.* Chicago: Magnolia Street Publishers.

Steinhardt, L. (1998). "Interview with Joy Schaverien." *American Journal of Art Therapy 36,* 4, 107–14.

Surrey, J.L. (1991) "Relationship and empowerment." In J.V. Jordon, A.G. Kaplan, J.B. Miller, I.P. Stiver, and L. Surrey (eds) *Women's Growth in Connection: Writings from the Stone Center.* New York: The Guilford Press.

Sweig, T.L. and Cohen, B.M. (1998) "Outsider art is IN: Implications for art therapists." In M. Lachman-Chapin, D. Jones, T. Sweig, B. Cohen, S. Semekoski and M. Fleming. "Connecting with the art world: Expanding beyond the mental health world." *Art Therapy: Journal of the American Art Therapy Association 15,* 4, 235–7.

Talbott-Green, M. (1989) "Feminist scholarship: Spitting into the mouths of the gods." *The Arts in Psychotherapy 16,* 4, 253–61.

Thomson, M. (1997) *On art and therapy: An exploration.* London: Free Association Books.

Tinnin, L. (1990). "Biological processes in nonverbal communication and their role in the making and interpretation of art." *American Journal of Art Therapy 29,* 1, 9–13.

Timm-Botos, J. (1995) "Artstreet: Joining community through art." *Art Therapy: Journal of the American Art Therapy Association 12,* 3, 184–7.

Ulman, E. (1962) "The war between therapese and English: I. *Bulletin of Art Therapy 2,* 2, 77.

Ulman, E. (1966) "Therapy is not enough: The contribution of art to general hospital psychiatry." *Bulletin of Art Therapy 6,* 1, 3–21.

Ulman, E. (1975) "Art therapy: Problems of definition." In E. Ulman and P. Dachinger (eds) *Art Therapy in Theory and Practice.* New York: Schocken Books.

Vance, L. and Clark, C. (1995) "The myth of collaboration: The peace bridge project." *Proceedings of the American Art Therapy Association 26th Annual Conference,* 155. Mundelein, IL: American Art Therapy Association.

Vick, R. (1996) "The dimensions of service: An elemental model for the application of art therapy." *Art Therapy: Journal of the American Art Therapy Association 13,* 2, 96–101.

Vick, R. (1999) "Utilizing prestructured art elements in brief group art therapy with adolescents." *Art Therapy: Journal of the American Art Therapy Association 16,* 2, 68–77.

Vick, R. (2000) "Creative Dialog: A shared will to create." *Art Therapy: Journal of the American Art Therapy Association 17,* 3, 216–9.

Wadeson, H. (1980) *Art Psychotherapy.* New York: John Wiley and Sons.

Wadeson, H. (1983) "The art in art therapy." *Art Therapy: Journal of the American Art Therapy Association 1,* 1, 50–1.

Wadeson, H. (1986) "The influence of art-making on the transference relationship." *Journal of the American Art Therapy Association 3,* 2, 81–8.

Wadeson, H. (1987) *The Dynamics of Art Psychotherapy.* New York: John Wiley and Sons.

Wadeson, H. (1989) "In a different image: Are male pressures shaping the 'female' professions?" *The Arts in Psychotherapy 16,* 4, 327–30.

Wadeson, H. (1999) "Where are the wetlands?" *The Arts in Psychotherapy 26,* 5, 345–8.

Wadeson, H., Geiser, R.M. and Ramseyer, J. (1990) "Through the looking glass: Dark sides I, II, III." *Art Therapy: Journal of the American Art Therapy Association 7,* 3, 107–18.

Wadeson, H., Junge, M., Kapitan, L., Vick, R. (1999) "Why do you make art? *Proceedings of the American Art Therapy Association 30th Annual Conference,* 157. Mundelein, IL: American Art Therapy Association.

Wallace, E. (1987) "Healing through the visual arts; A Jungian approach." In J. Rubin (ed.) *Approaches to Art Therapy: Theory and Technique.* New York: Brunner / Mazel.

Waller, D. (1991) *Becoming a Profession: The History of Art Therapy in Britain 1940–82.* London: Routledge.

Webster's New World Dictionary (1988) New York: Simon and Schuster.

Weiser, J. (1989) "Stitched to the beat of a heart, to comfort the terrors of the dark." *Art Therapy: Journal of the American Art Therapy Association 6,* 3, 113–4.

Wells, R. (1992) *Little Altars Everywhere.* Seattle, WA: Broken Moon Press.

White, M. and Epston, D. (1990) *Narrative Means to Therapeutic Ends.* Adelaide, South Australia: Dulwich Center.

Wiener, D.R. (1998). "Living within darkness: Psychiatric survivors and the protection of mythical language." *The Arts in Psychotherapy 25,* 3, 167–81.

Wix, L. (1995) "The intern studio: A pilot study." *Art Therapy: Journal of the American Art Therapy Association 12,* 3,175–178.

Wix, L. (1996) "The art in art therapy education: Where is it?" *Art Therapy: Journal of the American Art Therapy Association 13,* 3, 174–180.

Wix, L. (1997) "Picturing the relationship: An image-focused case study of a daughter and her mother." *American Journal of Art Therapy 35,* 3, 74–82.

Wix, L. (2000) "Looking for what's lost: The artistic roots of art therapy: Mary Huntoon." *Art Therapy: Journal of the American Art Therapy Association 17,* 3, 168–176.

Wolf, R. (1985). "Image induction in the countertransference." *Art Therapy: Journal of the American Art Therapy Association 2,* 3, 129–133.

Wolf, R. (1990) "Visceral learning: The integration of aesthetic and creative process in education and psychotherapy." *Art Therapy: Journal of the American Art Therapy Association 7*, 2, 60–9.

Woolf, V. (1929) *A Room of One's Own.* Orlando, FL: Harcourt Brace Jovanovich.

Yon, K. (1993) "Expanding human potential through music." In B. Warren (ed.) *Using the Creative Arts in Therapy* (2nd ed.). London: Routledge.

Zeidenstein, S. (1988) *A Wider Giving: Women Writing After a Long Silence.* Goshen, CT: Chicory Blue Press.

Subject Index

abused clients 82, 152, 218, 226-8, 230, 273, 297
activist art 298-301
adaptive competence 289
adolescents 17, 18, 38–45, 48–9, 78–81, 82, 99–101, 131–3, 193, 201, 218–19, 222–3, 240, 249, 250, 297
adulthood, initiation into 40–1
aesthetic, relational see relational aesthetic
aesthetic bias 146–8
aesthetic/didactic integration 290
aesthetic empathy 48
aesthetic response 135, 193, 247
"aesthetic responsibility" 150–1
aesthetics, art therapy 133–43
alliance 170–2
Alzheimer's disease 35, 234
American Art Therapy Association 19, 201, 274
analyst role 212–13
art, the arts
 as "alternate" language 259
 as a behaviour 137–8, 184
 as compassionate action 307–8
 healing potential 7, 18, 28, 29, 134, 138, 184–5, 188, 240, 281, 289, 306
 immersion in 53–7
 maintaining faith in 240
 as "portable commodity" 75
 redefinition 308
 as social activity 203
 subversive potential 295–6
 as universal language 254–5
 see also art world
art criticism, contemporary 136
art examples, providing 179–80
art making

communal/community 56–7, 170, 217–18, 292, 300–1
 within the context of relationship 139–43
 re-centralization in education 291
 see also therapist art making
art materials
 cultural diversity 95
 decisions on selection and use 117–18, 122–4
 enticing arrangement 95
 mobile 'art cupboards' 73
 providing motivation 178–9
 providing opportunities or obstacles 176–7
art process
 artists' relationship with 172–85
 ebb and flow 183–4
 effects and impact 184–5
 emotional impact 54
 enrichment by daily life 37
 expression and containment 181–2
 motivation 177–81
 opportunities and obstacles 173–7
 resistance and engagement 168–9
art process/product 133, 246
 artist's relationship with 185–95
 interrelationship 181–2, 185–6
 qualities of 187–9
art therapists see therapists
art therapy, expanding our vision of 301–6
art therapy aesthetics 133–43
art therapy education and training 7, 10, 28, 52–3, 59, 211, 282
 class examples 103–8, 284–5
 and social responsibility 284–93
art therapy practice
 activism in 298–301

Author Index

Printed in Great Britain
by Amazon

12901188R00194